GRAPHIC WAR

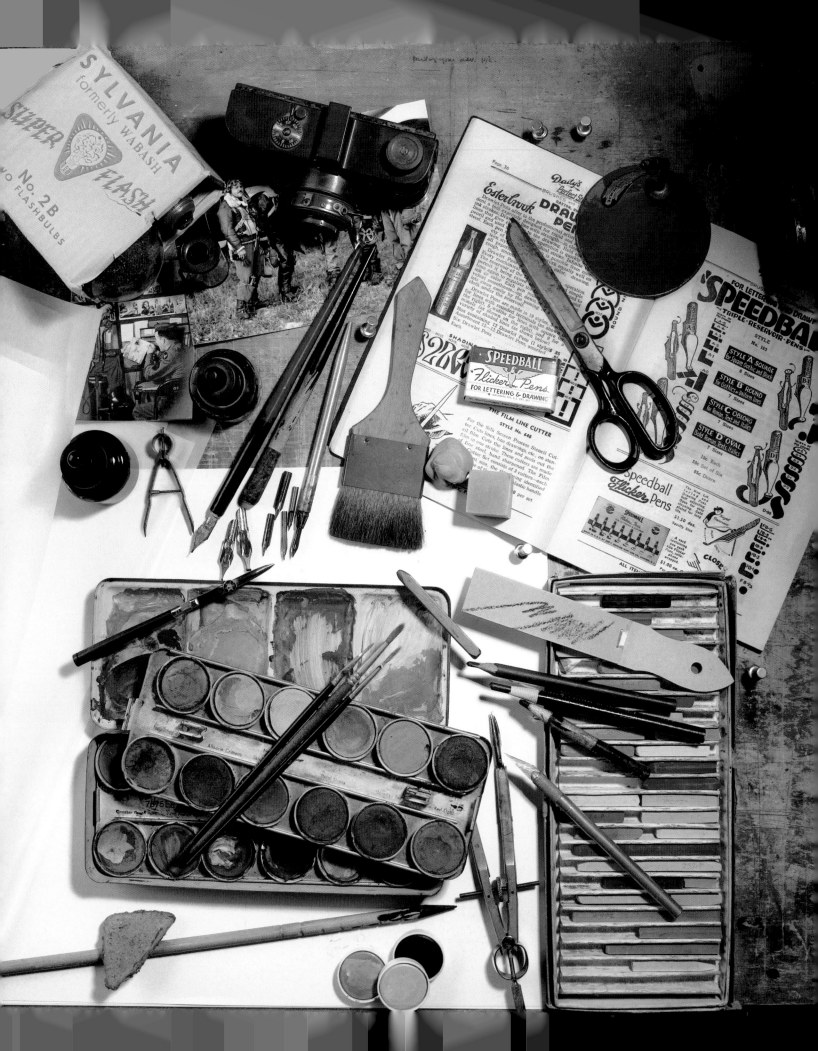

GRAPHIC WAR

The Secret Aviation Drawings and Illustrations of World War II

Donald Nijboer

The BOSTON
MILLS PRESS

A BOSTON MILLS PRESS BOOK
Copyright © 2005 Donald Nijboer

First printing

Library and Archives Canada Cataloguing in Publication
Nijboer, Donald, 1959-
 Graphic war : the secret aviation drawings and illustrations of World War II / Donald Nijboer.

Includes bibliographical references and index.
ISBN 1-55046-424-8

 1. Aeronautics, Military—Drawings. 2. World War, 1939-1945—Aerial operations. I. Title.

UG1240.N535 2005 623.66'09'044 C2005-901542-X

Publisher Cataloging-in-Publication Data (U.S.)
Nijboer, Donald, 1959-
 Graphic war : the secret aviation drawings and illustrations of World War II / Donald Nijboer. –1st ed.
[272] p. : col. ill. , photos. (chiefly col.) ; cm.
Includes bibliographical references and index.

Summary: The secret aviation drawings and illustrations of WWII, including detailed cutaway drawings of the aircraft and airborne weaponry vital to the war efforts of Allied and Axis forces alike, as well as top-secret training manual illustrations and colorful wartime posters.

ISBN 1-55046-427-2
 1. Aeronautics, Military—Drawings. 2. World War, 1939-1945—Aerial operations. I. Title.
623.66'09'044 dc22 UG1240.N55 2005

Published by BOSTON MILLS PRESS, 2005
132 Main Street, Erin, Ontario N0B 1T0
Tel: 519-833-2407 Fax: 519-833-2195
e-mail: books@bostonmillspress.com
www.bostonmillspress.com

IN CANADA:
Distributed by Firefly Books Ltd.
66 Leek Crescent
Richmond Hill, Ontario, Canada L4B 1H1

IN THE UNITED STATES:
Distributed by Firefly Books (U.S.) Inc.
P.O. Box 1338, Ellicott Station
Buffalo, New York, U.S.A. 14205

Design by PageWave Graphics
Printed in Singapore

The publisher gratefully acknowledges the financial support for our publishing program by the Canada Council for the Arts, the Ontario Arts Council and the Government of Canada through the Book Publishing Industry Development Program.

Cover: This highly detailed cutaway drawing by Hubert Redmill shows the Me 110 in the fighter-bomber role. Armed with two 250-kilogram (551 lb) and four 100-kilogram (220 lb) bombs, the Bf 110 proved an extremely effective ground-attack aircraft during the early stages of Russian campaign that began in June 1941.

Backcover: Combat aircraft during World War II were not pressurized (except for the B-29 and small numbers of specialized high-altitude fighters, bombers and reconnaissance aircraft. Above 10,000 feet, oxygen was used at all times. Failure of the oxygen system usually meant a return to base; during the combat mission, crews had to continually check on each other to make sure no one was suffering the effects of anoxia. Without oxygen, the lifespan of a pilot or crew member was measured in minutes.

Previous Page: Artist's tools from the 1940s. Bottom left: pastels and a variety of pencils. The pastels can be blended into an endless and subtle range of colors. Pencils are made in a range of hard and soft leads for a range of tones and sharpness of line. Bottom center: pans of opaque watercolors, which can be used with little water for a solid color or diluted with more water to create a wash of color. Left center: a ruling pen and Speedball pen points, along with glass bottles of ink. Far left: vellum, a much-used translucent paper for refining rough sketches; an artist would place the rough drawing under the vellum and rework the art on the new paper. Many artists shot their own reference photos and the Argus 35 mm camera is from that era, along with the ubiquitous blue flash bulbs. Top right: a 1940s mail-order art-supply catalog, a pencil sharpener and the red can of rubber cement thinner. This commonly available solvent was used for all kinds of art techniques. Final artwork was often glued down with rubber cement or wax. The nature of this type of artwork was, and remains today, a series of changes and alterations up to the time the piece is put onto the printing press. If the rubber cement was too thick, making last-minute changes was difficult. An artist from the period said that "the secret to life is thin rubber cement."

Photograph of artist's tools here and throughout this book by Dan Patterson.

Thanks to George Bussinger of Ken McCallister's Art Supplies, Dayton, Ohio, for supplying some of the artifacts for this image.

Opposite: A dramatic drawing of a P-40 found on the inside cover page of the *P-40 Pilot's Flight Operating Instructions.*

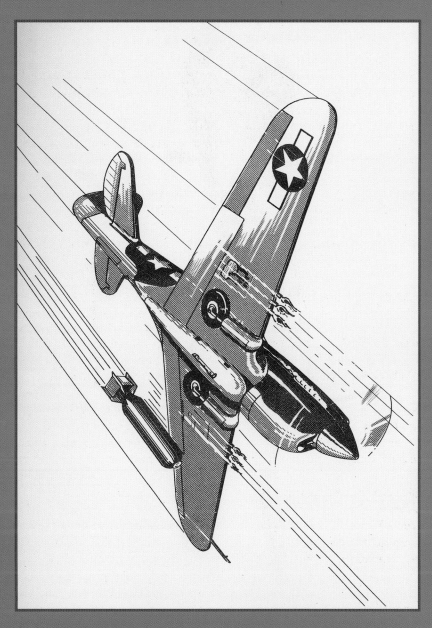

For Eric, Julia and Andrea

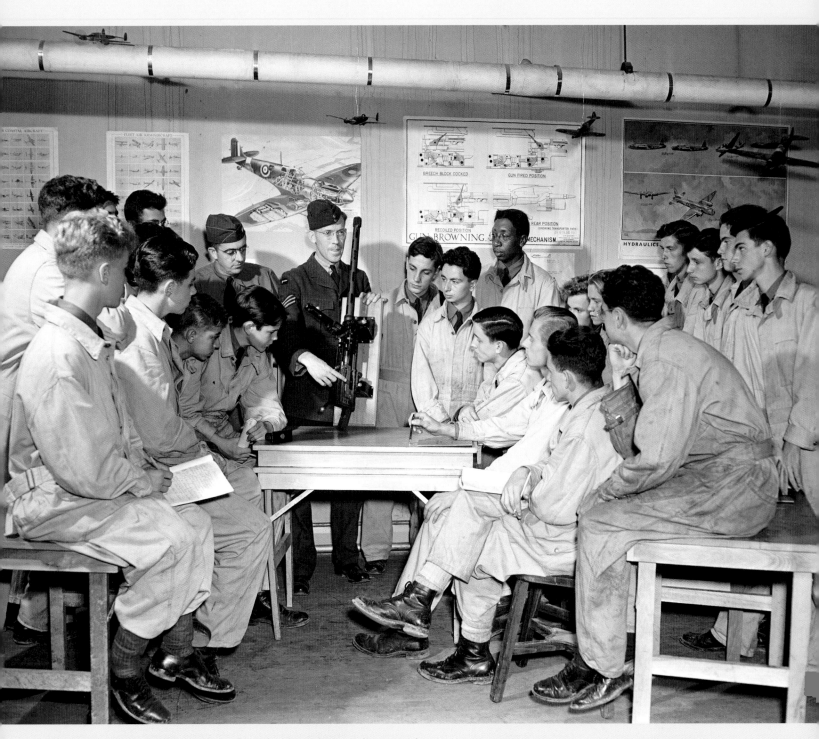

United States Air Cadets train in Canada. Here they are learning the
mechanical details of a machine gun from an armament instructor.

Contents

Foreword illustration from the
Basic Flying Instructor's Manual.

Foreword
by Peter Endsleigh Castle

Congratulations to Donald Nijboer for creating this most interesting tribute to the myriad designers, draftsmen, technical and graphical illustrators, artists and cartoonists who contributed to the millions of images on the pages of wartime technical and training manuals, the wall posters and the vital recognition portrayals of aircraft, ships and armored vehicles. These varied illustrative works covered every aspect of the fighting machinery, weaponry and training programs of the Allied Services in World War II and, as it became available, the detailed and combat-helpful studies of enemy equipment. The wartime illustrative works reproduced in this book were created by keen eyes and skilled hands, done the hard way decades before today's computer imaging, with those in war zones suffering poor facilities and poor-quality art materials to work with.

My own eventual and, as it turned out, quite eventful career as a technical and graphic artist must have started with my immediate interest in aircraft when very young in the 1920s. The khaki-clad RFC had become the blue-clad RAF a week or so before I was born, and early school days were full of the World War I battle images. When leaving my preparatory school, aged twelve in 1930, my final term report read, "He wastes a lot of pencil lead and heaven help us if there is another war."

Little did the teaching staff know that a mere six years later young Castle would have educated himself in things aeronautical and used much more pencil lead to be qualified to join a firm as their draftsman and inventive modeler undertaking classified work for an Air Intelligence Branch of the Air Ministry.

Two and half years later I was invited to join that Branch, but more of that in Chapter 1.

Peter Endsleigh Castle, AMRAes, 2005

1. BEAD SIGHT
2. ·303 IN. MK II BROWNING GUNS
3. RING SIGHT
4. REFLECTOR SIGHT
5. WIND EXCLUDER CLOSING HANDLES AND CATCHES
6. LINK CHUTE
7. GUN CRADLE
8. WIND EXCLUDER
9. FACE SHIELD
10. FACE SUPPORT
11. GUN ADJUSTING PIN
12. INTERRUPTER SHOE
13. GUN STEADY BOLT
14. GUN FIRING SOLENOID
15. SHROUD
16. AMMUNITION FEED DUCT
17. TELESCOPIC EMPTIES CHUTE
18. CINÉ CAMERA RELAY SOCKET
19. FUSE BOX
20. TURRET MOUNTING RING
21. MASTER SWITCH
22. TURRET SUPPORT RING
23. UPPER EMPTIES CHUTES
24. MASTER VALVE CONTROL LEVER
25. ASSISTER LEVER
26. CUPOLA GUIDE TUBES
27. WIND EXCLUDER GUIDE RAIL
28. ARM REST
29. CONTROL HANDLES
30. TOP BEARING BRACKET
31. FRONT SHIELD
32. LOWER EMPTIES CHUTE
33. ELEVATION CONTROL RETURN SPRING
34. MASTER VALVE BOWDEN CONTROL CABLE
35. AMMUNITION BOX
36. SAFETY BELT
37. TURRET ROTATION VALVE CONTROL ROD
38. CENTRALIZING MECHANISM
39. GUN PILLAR
40. CONDUIT FOR ELECTRIC SUPPLY CABLE

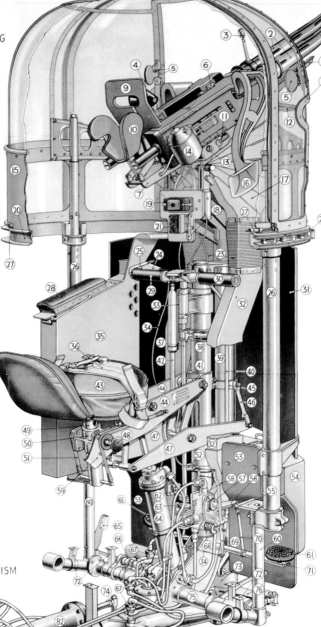

41. MAIN PILLAR
42. ELEVATION VALVE CONTROL ROD
43. AIR GUNNER'S SEAT
44. SEAT ARMS
45. CROSSHEAD
46. GUN ELEVATION CONNECTING ROD
47. GUN ELEVATION ARMS
48. SEAT RELEASE SPINDLE KNOB
49. SEAT PILLAR
50. SEAT PILLAR BRACKET
51. ELASTIC CORD
52. WIND EXCLUDER BOWDEN CABLE
53. LEG SHIELDS
54. EMPTIES CONTAINER
55. AMMUNITION BOX SUPPORT BRACKET
56. GUN ROTATION VALVE LEVER
57. GUN ROTATION VALVE
58. VALVE BOX
59. SEAT PILLAR GRIP
60. LOWER SUPPORT TUBES
61. FOOT LEVER PEDALS
62. ELEVATION VALVE
63. TURRET ROTATION VALVE
64. ELEVATION RAM
65. HYDRAULIC LOCK FOOT LEVER
66. HYDRAULIC LOCK
67. SWIVEL JOINTS
68. MASTER VALVE
69. MASTER VALVE LEVER
70. GUN ROTATION VALVE CONNECTING ROD
71. FOOT LEVER
72. FLOOR SUPPORT BRACKETS
73. BOTTOM BEARING BRACKET
74. DRIVE PIN
75. CROSS-TUBE
76. GUN ROTATION LEVER
77. GUN ROTATION RAM
78. MAIN SPINDLE
79. HYDRAULIC OIL SUPPLY
80. HYDRAULIC OIL RETURN
81. RAM SUPPORT TUBE
82. TURRET ROTATION RAM

CENTRE GUN TURRET
BRISTOL, Type B.I. Mk. V

For further information, see A.P. 2768A, Vol. I and II

AIR DIAGRAM 2510

PREPARED BY MINISTRY OF AIRCRAFT PRODUCTION FOR PROMULGATION BY AIR MINISTRY

APRIL 1943

Introduction

In a war that was so destructive, so much was created...

The idea for *Graphic War* came about when I was writing and assembling my second book, *Gunner: An Illustrated History of World War II Aircraft Turrets and Gun Positions.* While doing research at the RAF Museum, I came across a number of "air diagrams." These were large, poster-sized cutaway drawings of British aircraft turrets. I also discovered a wonderful cutaway of the Junkers Ju 88, drawn by Kerry Lee. The drawings were infinitely fascinating and each illustration a piece of art in itself. While most of the drawings were of machines and equipment, many had an abstract, aesthetic quality to them. So began the idea for this book.

World War II was a highly mechanized war. In a very short period of time, the aircraft of World War II gave way to the stressed-skinned all-metal monoplane fighter and bomber. These complex aircraft required a new level of skill to fly and a whole new training regimen. Aircrew and ground crews now had to deal with greater speeds, higher altitudes, accurate navigation, sophisticated hydraulics, radar, superchargers and more powerful engines. Applicants of the highest degree were recruited for training, and training methods had to be developed to ensure the best and quickest techniques were used to meld these trainees into aircrew of the highest quality.

A big part of the training of aircrew involved the use of visual aids, in poster form and in illustrations found in manuals. Many of these drawings were three-dimensional perspective drawings. Unlike traditional two-dimensional engineers' drawings, these were designed to be easily deciphered by the thousands of new recruits. In Britain, the source for this material was the Air Ministry and the Ministry for Aircraft Production. During the war, thousands of air diagram posters were produced. These 40-by-30-inch works of art are the most impressive pieces in this book. They include everything from multicolored cutaway drawings of enemy aircraft to simple illustrations bearing reminders such as "Beware of the Hun in the Sun." All this material was

Opposite: Bristol Type B.I. Gun Turret
When first fitted to the Bristol Blenheim light bomber, this hydraulically powered turret was a big step forward in bomber defense. In early confrontations with Luftwaffe fighters, gunners complained of the lack of armor and firepower. The Mk IV, shown here, was introduced with added armor and two belt-fed Browning machine guns.

"Restricted — Official Use Only," and most of it has never been published before. In the United States, a wealth of graphic illustrations and cutaway drawings can be found in the thousands of manuals published during the war. The U.S. Air Training Division also created posters, but very few of these have survived. The Axis forces were similarly very busy producing illustrations for their manuals and posters. However, where Allied manuals were lavishly illustrated (with, for instance, the addition of cartoon characters and pen-and-ink drawings of aircraft flying through the copy), German manuals were well illustrated but without the frills. Their posters, however, were just as detailed and as well crafted as those of their Allied counterparts. Many military documents were destroyed just before and after the end of the war, and so illustrations from Germany, China, Russia and Japan in particular are very hard to come by and the examples in this book are rare survivors of that time.

The illustrations included in the Image Collections section of this book are organized by country of origin — Great Britain, Germany, the United States and the Soviet Union. So, for example, you can compare the British renderings of a Junkers Ju 88 (at pages 54–5 and 64–5) with the German drawings of the same aircraft (starting at page 180).

Out of all the artists, illustrators and technical artists employed by the Allies and the other major combatants, most remain anonymous. Almost all of the drawings still in existence are unsigned and uncredited, no doubt primarily because of the top secret nature of the work. Some of the artists had jobs in commercial art and design before the conflict began and found other, similar employment once the war was over; others continued to work as technical artists for aircraft companies in the postwar years.

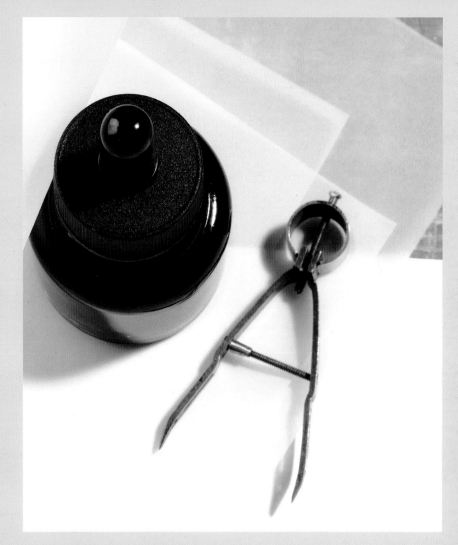

The featured artist for this book is Peter Endsleigh Castle. I had the pleasure of interviewing him in the fall of 2003. His first-hand account of what it was like to work for British Intelligence and the part he played creating illustrations while working for the RAF's 1426 Flight, the Enemy Aircraft Evaluation Unit, is fascinating. His amazing drawings are among the hundreds that can be found this book.

The artwork in this volume is not meant to be viewed as a celebration of war. While today we can calmly view the images and read the instructions on how to abandon a ditched aircraft, we can only imagine what it must have been like to be twenty years old, flying in a stricken aircraft about to crash-land in complete darkness on the surface of the North Sea or Pacific Ocean. The illustrations in this book give us a brief insight into the world of the air and ground crew trainee. All that we see, they had to learn, absorb and memorize. It was an enormous task and one that would have not been possible if not for the talent and creativity of the artists employed.

While most governments employed war artists to record the battles and to further propaganda efforts, the artwork in this book was created for a very different purpose — to help young men win the battles and, it was hoped, survive the war.

Donald Nijboer, 2005

CHAPTER 1

The Sword and the Pen

It was a battle for the high ground – mastery of the skies. World War II proved fertile ground for the advancement of aviation technology. As the warring nations struggled to gain a technological edge with new, more advanced designs they also had to find new ways to train thousands of aircrew to make them capable of flying and using their new aircraft effectively in combat. These new aircraft were equipped with supercharging, which enhanced high-altitude performance of the piston engine; radar, which helped the pilot find his way and search for enemy aircraft at night; and new systems along with rescue equipment that made flying safer and more comfortable for aircrew. To speed up the training process, many air forces turned to graphic design and full-color illustrations to help aircrew understand the new technology. The cutaway drawings, illustrations and schematics created to aid in the training of air and ground crews had to illuminate, simplify, clarify, persuade and, in some cases, amuse their target audience. A good graphic design or illustration was able to do that. Clear illustrations showing a trainee how to do something could and in many cases did save weeks of training. In 1944, U.S. designer Will Burtin produced a series of instructional books to help air gunners in their training. His manuals shortened the gunnery course from six months to six weeks!

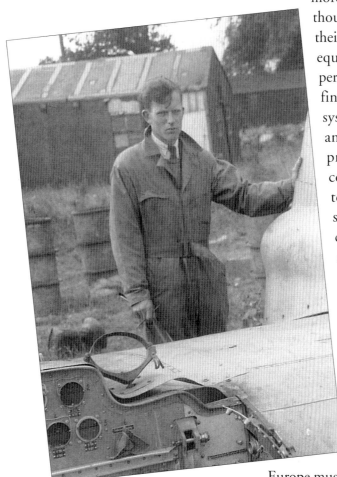

Peter Castle examines the main structure of a German Henschel Hs 129 tank buster. The aircraft had been recovered from the western desert of North Africa.

When war broke out in Europe in September 1939 with the German invasion of Poland, the British magazine *Art and Industry* featured an article entitled "The Artist's Function in Time of War." The editor wrote, "War in Europe must inevitably affect many of those engaged in Art for Industry somewhat adversely. There will be much less advertising; much less call for magazine and newspaper illustrations; industrial design and styling must await the return of peace; and a great many artists, designers, art schools teachers and students will be compelled to find some other outlet for their activities and an alternative source of income." And many did just that, on both sides – they went into military service. Those who did not apply for active service helped the war effort as best they could.

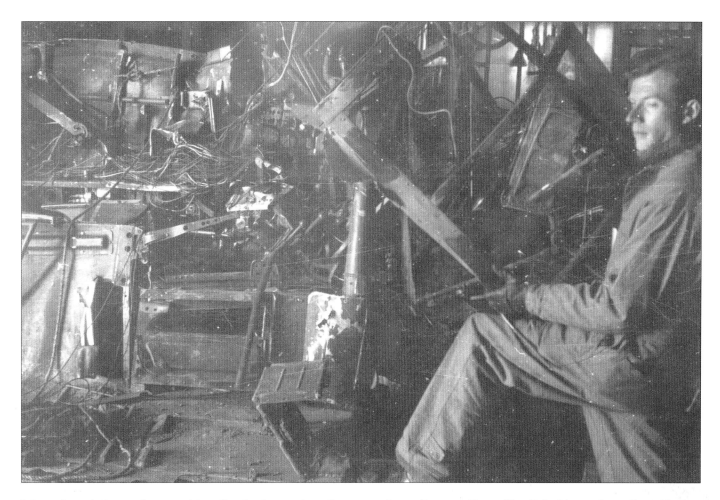

Peter Castle holds up the collapsed frontal cockpit frame of a wrecked Ju 188 at the Royal Aircraft Establishment in May 1944.

Many found themselves working for the large aircraft companies such as Boeing, Consolidated, Grumman, North American, Avro, Supermarine, Handley Page, de Havilland, Junkers, Messerschmitt, Mitsubishi, and Yakovlev. Other artists, like Peter Endsleigh Castle, found themselves working in the shadowy world of British Intelligence.

Just before war broke, accurate information and detailed drawings of German aircraft were almost nonexistent. While many "war artists" would be appointed to record the progress of the war, there were few if any capable of producing an accurate and operationally useful diagram of any enemy aircraft. Much of the RAF material consisted of illustrations found in the publications *Flight* and *The Aeroplane!* In May 1939, Peter Endsleigh Castle was offered employment with MI6's Branch of Air Intelligence A.I.1. (a).

"One Saturday, a buff envelope turned up. I was between jobs and had just moved into a Wimbledon hotel. How they found me, I don't know. It was an invitation to report the following Monday, after taking the Civil Service medical examination on a Sunday, to Air Ministry, Adastral House, Kingsway. When I showed up on the Monday I was asked to take a mapping and lettering test and then was told to report to the Whitehall building in King Charles Street and go the Rotunda in the courtyard.

"This turned out to contain the War Office Map Department, with plenty of drawing tables and cartographers and good light from ceiling windows. I was duly allotted my table and drawing board, a boxed set of drafting instruments, and shown the blue-tinged linen tracing paper used for pen-and-ink work."

To cover the true nature of his work, Peter Castle was classified as a cartographer. Castle was later joined by artists Hubert Redmill, in early 1940, and Kerry Lee, in February 1941. The three men were all gifted artists and each was able use his talents in the creation of well-known posters of aircraft and equipment of the German Luftwaffe. These posters were vital to the RAF, Anti-Aircraft Command, the Army, Navy, Observer Corp, Air Raid Precautions, the Home Guard and anyone else who had to be familiar with the enemy's equipment and performance.

One of Castle's first tasks was to illustrate aircraft recognition booklets covering foreign military aircraft.

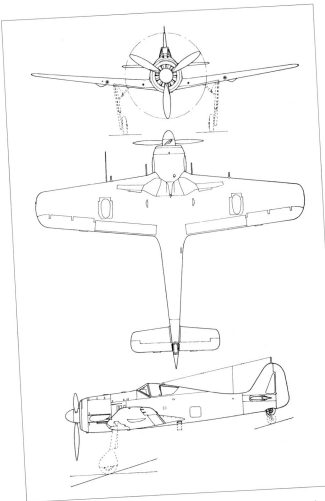

Peter's three-view drawing of the Focke Wulf Fw 190.

"All that summer was spent amending or preparing up-to-date pages of foreign military aircraft recognition silhouettes for the eighteen loose-leaf booklets in the Air Publication series, doing French, some American and even a few Japanese, but never anything German, which, I presumed, was the reason for my sudden enrolment. All through the summer we worked to the background noise of pneumatic drilling beneath us. It was Churchill's war bunker under construction, secret at the time."

After the Battle of Britain, Castle began working on his first cutaway drawings. Like many cutaway artists of the period, he was self-taught. He and his fellow artists also had to work under less than ideal conditions.

"Needless to say, our six months or more back at Adastral House was the time of the main blitz on London, sometimes causing difficulties getting home with bombing having commenced before our 8 A.M. to 6 P.M. workday (six days a week) ended. By now we were quite busy turning out poster-style aircraft recognition monotone views of enemy aircraft and doing technical diagrams of incoming daily bits and pieces.

"The first cutaway drawing I did was very poor. I think it was a Dornier Do 217, black and white. I'm ashamed of that one. When one came straight from drafting type of work to illustration — it was a real change.

"We had no facilities for getting good materials. I think the colors I used for the Ju 188 cutaway drawing were poster colors — little pots. They weren't even these nice smooth designer gouache colors, which I use now. Later on we acquired an airbrush."

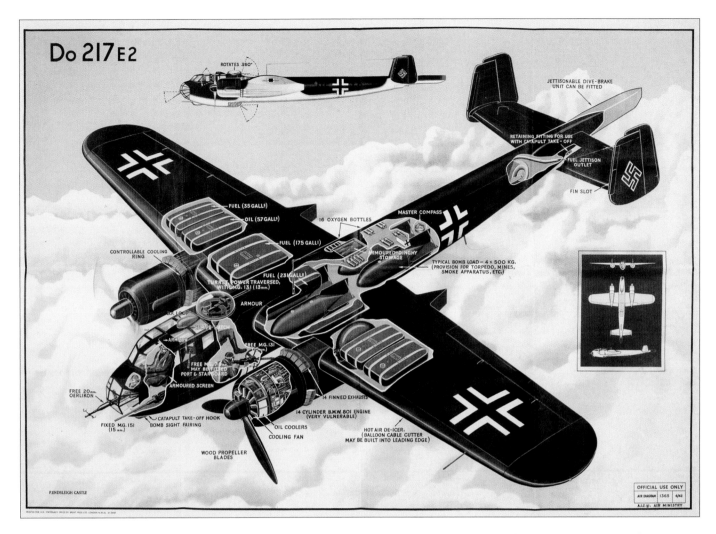

Do 217 E2

ROTATES 360°

JETTISONABLE DIVE-BRAKE UNIT CAN BE FITTED

RETAINING FITTING FOR USE WITH CATAPULT TAKE-OFF

FUEL JETTISON OUTLET

FIN SLOT

FUEL (35 GALLS)

OIL (57 GALLS)

16 OXYGEN BOTTLES

MASTER COMPASS

CONTROLLABLE COOLING RING

FUEL (175 GALLS)

ARMOURED DINGHY STOWAGE

FUEL (231 GALLS)

TURRET POWER TRAVERSED, WITH MG. 131 (13 m.m.)

ARMOUR

TYPICAL BOMB LOAD – 4 × 500 KG. (PROVISION FOR TORPEDO, MINES, SMOKE APPARATUS, ETC.)

ESCAPE HATCH

ARMOUR

FREE MG. 131

FREE MG.??? MAY BE FITTED PORT & STARBOARD

ARMOURED SCREEN

FREE 20 m.m. OERLIKON

14 FINNED EXHAUSTS

FIXED MG. 151 (15 m.m.)

CATAPULT TAKE-OFF HOOK

BOMB SIGHT FAIRING

14 CYLINDER B.M.W. 801 ENGINE (VERY VULNERABLE)

OIL COOLERS

COOLING FAN

HOT AIR DE-ICER. (BALLOON CABLE CUTTER MAY BE BUILT INTO LEADING EDGE)

WOOD PROPELLER BLADES

P. ENDSLEIGH CASTLE

OFFICIAL USE ONLY
AIR DIAGRAM 1365 6/42
A.I.2.(g). AIR MINISTRY

PRINTED FOR H.M. STATIONERY OFFICE BY BRIGHT PRESS LTD. LONDON N.W.IO. 51-2481

Attempts were also made to get these artists commissioned in the RAF to ensure a living wage, but this idea was met with the usual bureaucratic excuses. A great part of Castle's work was examining crashed and captured German aircraft. Working with 1426 Flight, the Enemy Aircraft Evaluation Unit nicknamed the "Rafwaffe," Castle was able to examine and sit in some of the enemy's most feared aircraft. During this period Castle produced numerous cutaway drawings, including renderings of the Ju 188, Fiesler V1 Flying Bomb and Fw 190D.

"It was all done the hard way. We had everything from a hole in the ground and nothing but pieces, to flyable aircraft. I had access to all the aircraft and parts that were left over from crashes. The first thing I did when drawing an aircraft was to make a general three-view drawing. Three of us would go down with a long tape measure and measure the aircraft in order to get the overall dimensions. I would then produce a general line drawing, which was as near accurate as could be. From that drawing, models were made for aircraft recognition. Of course, the silhouette illustrations went out straight away for distribution everywhere.

"The first cutaway drawing I did was very poor. It was the Dornier 217, black and white. I'm ashamed of that one. When one came straight from drafting type work to illustration… it was a real change."

Peter Castle's technique improved rapidly. Compare his Do 217 cutaway to the Ju 188 illustration on pages 68–69 and you can see the startling difference.

Opposite: Peter Castle's preliminary sketch work on the V1 flying bomb. Above is the basic outline with compressed air spheres in place, and below, the detail work has begun showing the air intake for the V1's Argus pulse jet engine. The completed drawing is on pages 70–71.

Castle's preliminary sketch of the Ju 188 cutaway drawing. The final is on pages 68–9.

"We also had a photographer with us, which was a great help. We also had material fed to us from espionage sources and that sort of thing. We had access to German flight manuals. A lot of material came from Spain through Lisbon. Sometimes all we had was a photograph of, say, a new aircraft, and if we knew the dimension of the tail wheel we could then do an approximate overall side-view dimension drawing. Once the sketches and photographs were completed, I would then start on the larger master drawing. This drawing would be about $1/24$ scale or something of that nature."

One of Castle's most important pieces was a cutaway drawing of the Fiesler Fi 103 Flying Bomb, or V1 — the world's first operational cruise missile. In November 1943, Flight Officer Constance Babington Smith at the RAF Photographic Interpretation Unit discovered something very unusual. After examining a new set of photos of the Luftwaffe Experimental Station at Peenemunde, Smith found a very small

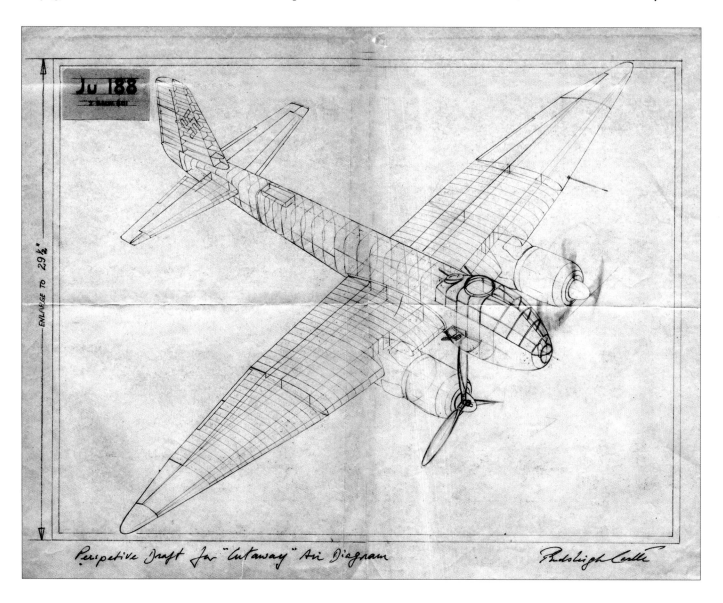

Perspective Draft for "Cutaway" Air Diagram Rudoleigh Castle

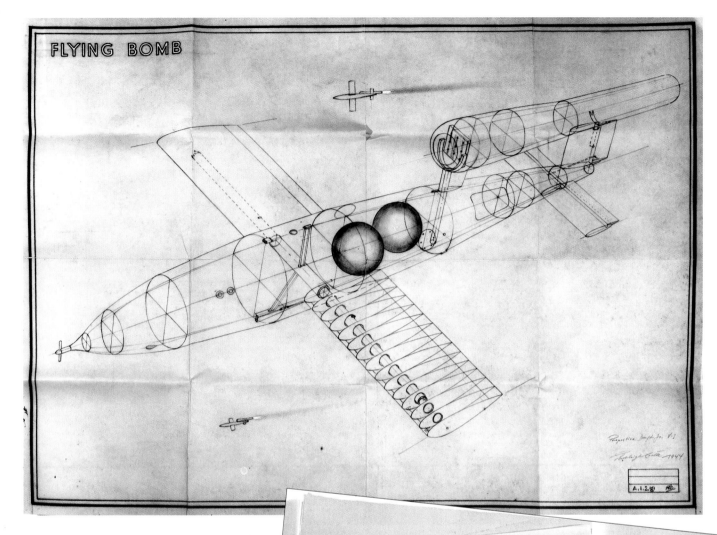

FLYING BOMB

cruciform shape on a catapult ramp that was similar to the many "ski sites" that were appearing ominously along the French Channel coast. This was the first evidence that the world's first flying bomb was about to be launched at Britain. A copy of this photo was sent to Air Intelligence in the hope that a provisional drawing could be prepared and distributed as quickly as possible. Squadron Leader Michael Golovine and Peter Castle paid a visit to the Royal College of Science. There they used a traveling microscope in the hope that accurate measurements could be obtained. The image was greatly halated due to the great height from which the photo was taken. It was not much to work with, but after a diligent and lengthy afternoon spent traveling the microscope back and forth over the fuzzy image, an

estimated wingspan was calculated. They estimated the wingspan of the new V1 to be 16 feet, 9 inches. Subsequent examination of the first crashed example of the Flying Bomb to land in England revealed that the wingspan was 17 feet, 6 inches. Further information was obtained from a crashed V1 site in Sweden. Squadron Leader Heath of Air Intelligence was dispatched to photograph the wreckage.

"We had one in Sweden. One of our men flew over to Sweden to photograph the wreckage. We got the form of the thing and I was able to produce a three-quarter-view sketch. That went out to all the home defence services. After the V1s started coming over, we quite soon found one intact. This was brought up to the Manor, Harrow Weald, and dumped in the drive. I have some photographs of me actually sitting on the bloody thing. It had about five fuses on the thing and I assumed they all had been coped with. I worked very quickly on that drawing. I got it out in about three weeks. It was very intense work and I believe almost every last thing I could illustrate is in that drawing. That was in July, because the V1s started coming over in June 1944. In spite of the urgency of the information, Civil Service printers failed to issue this air diagram to defence services immediately — it is marked as issued September 1944."

The work done by Peter and his fellow artists proved a great contribution to the war effort. Their accurate drawings and illustrations provided the British and Americans with a clear picture of German aircraft development and provided Allied aircrews with valuable information regarding performance, armaments, protective armor and arcs of fire. In ready rooms and briefing halls across England, the accurate drawings created by Peter and his fellow artists were seen by thousands of Allied aircrew. For new and inexperienced aircrew, these illustrations were tools upon which their survival depended, to be closely studied; for battle-weary crews, these images were merely glanced at. The jarring reality of combat had taught them another lesson — one that could never be illustrated with a simple poster or drawing in a field manual.

After the war, these drawings were soon forgotten and most were destroyed. Today some of Peter's original artwork can be found at the Imperial War Museum in London.

In late 1945, Peter began working with USAAF Air Document Research Center in London. There he helped evaluate the postwar documents captured from the Luftwaffe and German aircraft manufacturers. As World War II ended and the Cold War began to heat up, Peter continued to work with Britain's MI6 Technical Air Intelligence for another five years. Today, Peter is retired but continues to draw in his home in Tunbridge Wells, England.

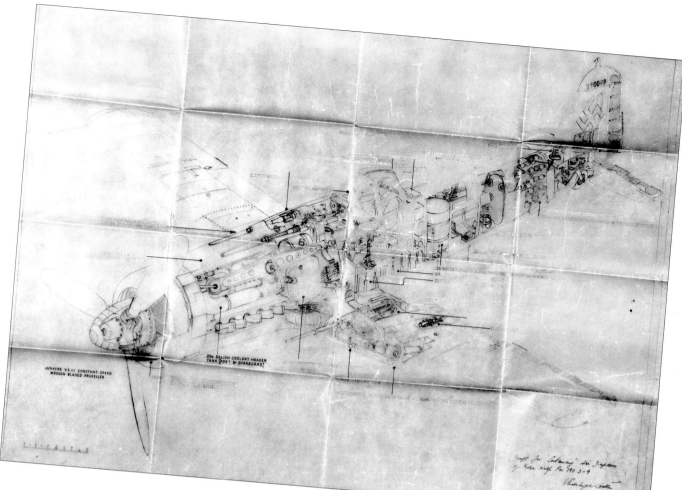

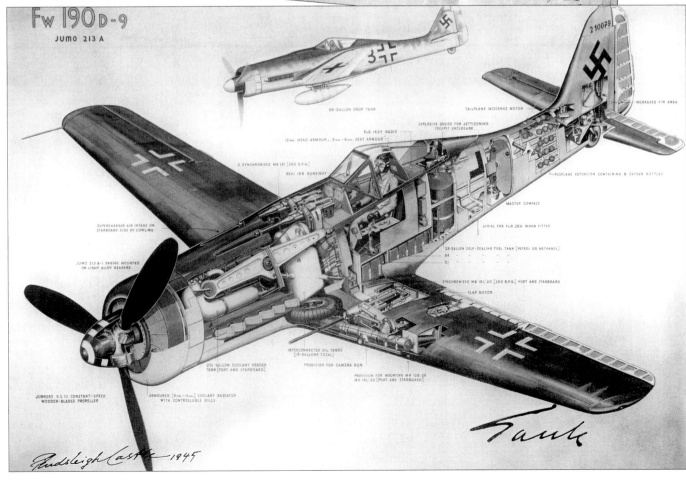

Today Is Not a Job

"Flying is one of the few activities where training and preparation exact a casualty rate comparable with combat."

–Stafford-Clark, "Morale," 18

INSTRUCTION

TODAY IS NOT A JOB

IT'S A RESPONSIBILITY

WE'RE AT WAR

GENERAL, U. S. ARMY,
COMMANDING GENERAL,
ARMY AIR FORCES

3

A message to the troops found on the inside of the *Basic Flying Instructor's Manual.*

Air combat in World War II was in many ways a race. The pursuit for speed, altitude and destructive capability drove designers, engineers and scientists to improve the airplane and enhance its deadly capabilities. During the war, many firsts were accomplished — the first jet fighters took to the air; the helicopter made its appearance, "smart" bombs drew first blood, and the world's first ballistic missile made a limited but horrifying entrance. It was also a total war, a war in which industry and education played a major role. Industry for its part was able to supply the aircraft, guns and tanks needed to wage war. Nations were tasked with training the millions of men and women needed to use these new and sophisticated machines, and the one piece of equipment that demanded the most highly trained personnel was the airplane. These individuals, almost all men, were chosen for their fitness and intelligence. Women were also trained to pilot these aircraft but primarily to fly the new aircraft from the factory to the forward supply depots and air bases. Their training also allowed them to fly almost anything — from a single-seat fighter to a four-engine bomber. Considered the cream of the crop, only a fraction of the recruits who signed up for flight training ever made it to a front-line squadron. Of the 193,440 pilots trained in the United States, another 124,000 failed to make the grade.

Aircraft development in the early 1930s was slowly beginning to break away from its WWI origins. The fabric-covered biplane fighter of the 1930s, although faster than its older cousins, was still only armed with two machine guns and was equipped with fixed landing gear. Bombers of that era fared even worse. It was not until the introduction of the stressed-skinned monoplane that the true fighting capability of the airplane was slowly realized. These new fighters and bombers were all metal in construction, with enclosed cockpits, retractable landing gear, flaps and increased armament. When first introduced into service, the new all-metal Supermarine Spitfire Mk I was powered by a 1,030-horsepower Rolls Royce Merlin engine with a top speed of over 350 miles per hour. Its biplane stable-mate, the Gloster Gladiator, which was still in service when the war began, had a top speed of only 253 miles per hour (407 km/h). The differences were startling, but the degree of sophistication and skill required to fly the new Spitfire called for a pilot with enhanced skills and abilities.

Aircrew training in the 1930s was in no way ready to cope with wartime requirements. New aircraft such as the Spitfire, Bf 109, Curtiss P-40, Ju 88 and Mitsubishi Zero required pilots with at least 250 to 300 hours of flying time before they began operational training on their new mounts. The training of crew had to strike a balance between quality and quantity, and during World War II it also had to have the flexibility to change depending on wartime requirements. When the war began, the Germans had some 4,300 aircraft manned by highly trained crews. The Luftwaffe training scheme was producing between 10,000 and 15,000 pilots a year. The British, in comparison, produced 5,300 pilots in 1940. At the outbreak of the war, aircrew training in the RAF had no command status or representation the way Fighter Command and Bomber Command did on the Air Council. In September 1939, the RAF had only fourteen Service Training Schools, including one in Egypt.

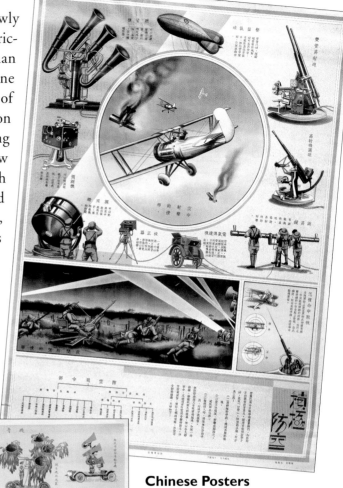

Chinese Posters

In the early 1930s Japan began to make plans to become the masters of Greater Asia. In 1931 Japan seized Manchuria from China. Following the invasion, thousands of Japanese colonists soon followed. Anti-Japanese sentiments in China finally came to a head when Japanese and Chinese troops clashed on the Marco Polo Bridge near Beijing on July 7, 1937. (Some historians regard this as the real beginning of World War II.) This local firefight gave the Japanese the excuse they wanted to seize more Chinese territory. The Chinese Air Force and ground forces were no match against the Japanese. Various provincial warlords also had their own squadrons and when they were not fighting the Japanese, they were fighting each other.

Three of these Chinese posters deal exclusively with anti-aircraft defenses and were produced sometime in the mid-1930s. These training posters highlight the equipment required and the methods needed for a successful defense: searchlights, a sound locator, a predictor, a range-finder, guns, and barrage balloons. The other poster, below, deals with aircraft and the emergence of the aircraft carrier. The aircraft shown are from Britain, France, Italy and the United States, and all are of late 1920s and early 1930s design. The Chinese Air Force used a varied collection of aircraft, all imported from Europe, the Soviet Union and the United States.

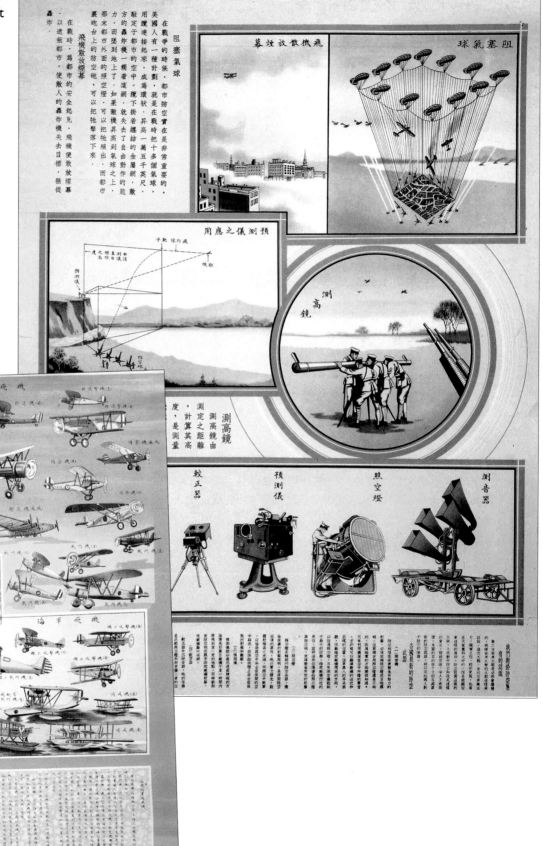

These schools were operating obsolete biplane aircraft such as the Hawker Hart, Hind and Fury. All were open-cockpit aircraft with limited navigational instruments and no radios. As the war progressed, the monoplane Miles Master and North American Harvard trainer became readily available. These two aircraft were ideal for the training of fighter pilots, while the twin-engined Avro Anson and Airspeed Oxford proved their worth training thousands of twin- and multi-engined aircrew. Britain also suffered another handicap — the weather. Every daylight hour had to be used, and so dawn-to-dusk flying became routine. Britain's maritime weather disrupted flying training, and aerodromes with grass became unserviceable after prolonged rains. A solution had to be found and soon Britain turned to Canada and its Commonwealth allies. Shortly after the outbreak of World War II, Canada embarked on a massive aircrew-training program known as the British Commonwealth Air Training Plan (BCATP). Flight training schools were also set up in South Africa, Rhodesia and Australia.

In the dark days of late 1940, when Britain stood alone, Winston Churchill could "only see one path to victory… an absolutely devastating, exterminating attack by very heavy bombers upon the Nazi homeland." For the proponents of strategic bombing, "there were no limits on the size of the force required." Churchill's belief that the war could be won through strategic bombing and that heavy ground casualties could be avoided found many supporters in the United States Army Air Force. Absolute priority was given for Anglo-American bomber production and aircrew and ground-crew training. New aircraft plants were built and hundreds of training airfields were constructed. And thousands upon thousands of flight manuals, maintenance and familiarization manuals, how-to posters, cutaway drawings, electronic and hydraulic schematics were produced. In the United States, when an aircraft left the plant it was issued with what were called "Four Tech Orders." This consisted of the Handbook of Operations and Flight Instruction, the Handbook of Service Instructions, a Handbook of

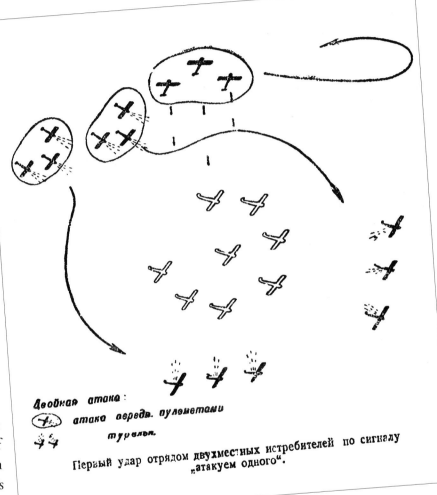

Fighter Tactics
This rather crude Soviet prewar sketch showing potential fighter pilots how to attack an incoming bomber raid is revealing in its simplicity. When German forces invaded Russia in June of 1941, the Red Air Force was completely overwhelmed and suffered grievous losses.

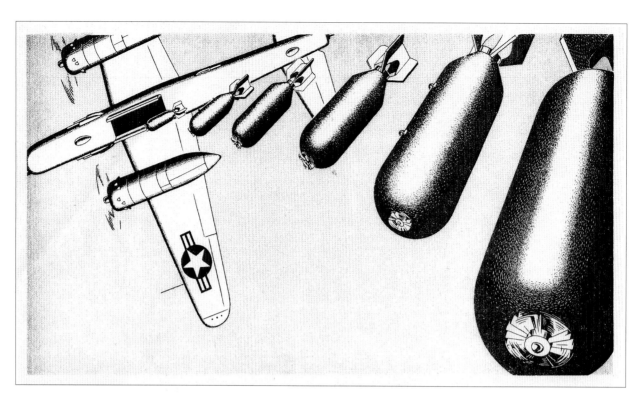

Above: This illustration taken from the *B-25 Flight Operating Instructions Handbook* shows what it would like to be bombed by a B-25. The fuse-arming vanes on the bombs are shown spinning as they fall.

Right: The cover of the *Pilot Training Manual* for the B-26.

Far right: The cover of the pilot's instruction manual for the Il-2 powered by the AM-38 engine. The Il-2 is probably the best known Soviet aircraft of World War II and was the most widely produced aircraft of all time.

Overhaul Instruction; and an Illustrated Parts List. However, once produced, Tech Orders were rarely final — they were constantly being updated as new methods of maintenance emerged and new versions of the same aircraft left the assembly line. During World War II, the United States alone produced 299,293 military aircraft.

Soon, thousands of illustrators, graphic and technical artists in Canada, America, Germany, Russia and Britain were busy churning out many thousands of illustrations,

GRAPHIC WAR

all designed to help speed up the training process. A great number of the artists were doing this type of work for the first time and had to learn on the job. Styles and the degree of sophistication for these drawings varied greatly. Some were simple line drawings of poor quality while others were rich in detail and exploded with color. To take one example, the *Service Aircrew Manual* created for the British Commonwealth Air Training Plan was a crude effort, by Allied standards, with a common typewriter typeface and line drawings that were either simple in nature or quite detailed. There was no continuity and the paper it was printed on was of a low standard, no doubt in part due to wartime shortages. On the other hand, the British did have the wherewithal to produce large, full-color instructional posters known as "air diagrams," which were issued by the Air Ministry. Each was rich in detail and wonderfully illustrated. These consisted of everything from aircraft cutaway drawings of enemy aircraft and engines, to how-to and reminder posters. (Some of the finest artwork included in the Image Collections of this book are examples of these air diagrams.) However, when it came to ensuring any kind of continuity and consistency in the presentation of flight and maintenance manuals, that was left to the manufacturer.

Vultee Pilot's Reference Notes Vengeance I Dive Bomber
This confusing drawing of the Vengeance's emergency equipment and exits appears in the *Pilot's Reference Notes*. The Vengeance existed only because of the British Purchasing Commission. The aircraft was first ordered in September 1940, but never saw combat in Europe. Most of the 200 aircraft were shipped directly to India, where they equipped four RAF squadrons, and squadrons with the Indian Air Force and Royal Australian Air Force. The USAAF used the Vengeance as an air gunner trainer and target tug.

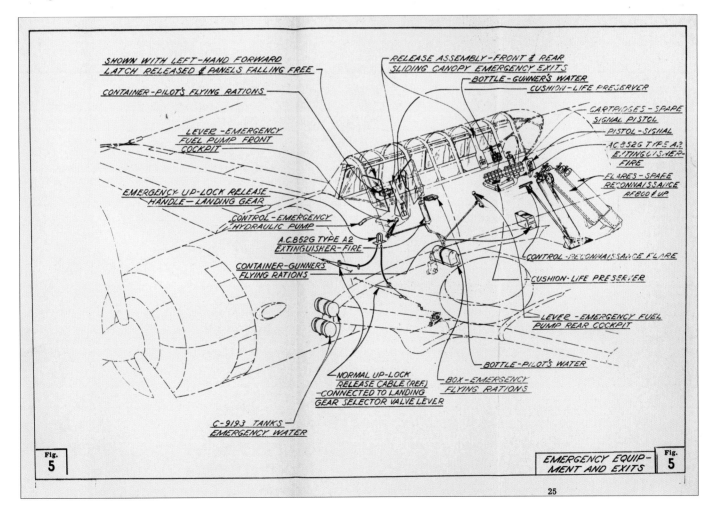

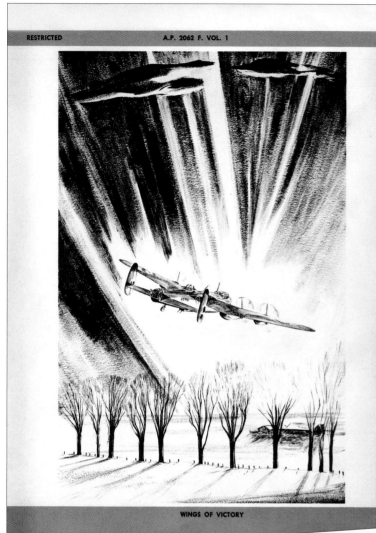

WINGS OF VICTORY

Because of this, the quality of the manuals varied according to the resources available to each company. A survey of the surviving material reveals that some were well done but others look rushed and are somewhat lacking. On the whole, the German manuals were the most consistent in their drawings and illustrations. Where the Allied manuals and illustrations differed the most from those produced by the Axis powers was in their optimism and humor. Sprinkled throughout their manuals were drawings of aircraft in flight with titles such as "Wings for Victory." Cartoon characters were also used to highlight dangers and inspire the aircrew trainees. The German manuals, however, were very straightforward and well illustrated, but with no mention of final victory.

As British industry geared up for the mass production of aircraft and weapons, there was a need for skilled artists to create comprehensive illustrated instruction manuals. One of those artists was a young Roy Cross. In 1942, the *Air Training Corps Gazette* accepted Roy Cross's first work for publication. Like most young men at the time, Cross wanted to be a pilot, but at his

Above: Optimistic illustrations such as "Wings of Victory" were not uncommon in British manuals.

Right: These two drawings come from the Mitsubishi Ki-46-II maintenance manual. On the right is a cutaway of a propeller governor and the other is a radio schematic. Compared to manuals produced by the Allies, the Japanese illustrations are rather crude.

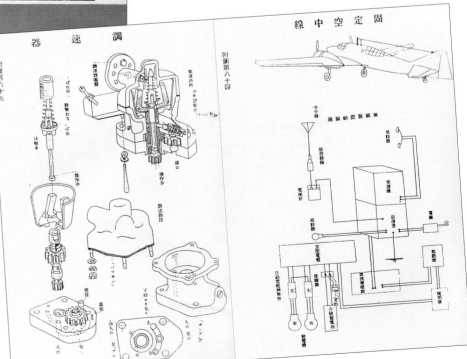

medical in 1942 he was classified an A2 and offered the opportunity to join the RAF as a radio mechanic. By this time Cross had contributed several illustrations to the *Air Training Corps Gazette*, and James Hay Stevens, who also contributed to the *Gazette*, suggested that Cross lend his considerable talents to the aircraft industry. Cross soon found himself working for the Fairey Aircraft Company, where he began work in the embryonic Technical Publications Department.

"This business of air publications was to some extent in its infancy, certainly compared to what went on in the states. The artwork first of all was rather crude indeed. We gradually learned our trades on the job! Most of the drawings I did were structural and one of my first cutaway drawings was of the Firefly. Being a beginner, I used the usual slightly top three-quarter front view, that being the best view to show the aircraft. I was very influenced by Jimmy Clark of the *Aeroplane*. As a youngster, I was using him as a master, if you like.

"We worked on Bristol board, which was a nice shiny sort of thick board, and used pen and ink to create the cutaways. Of course, the drawing office was right across the yard from the production line, so

Roy Cross's cutaway drawing of the Firefly Mk I carrier-borne fighter.

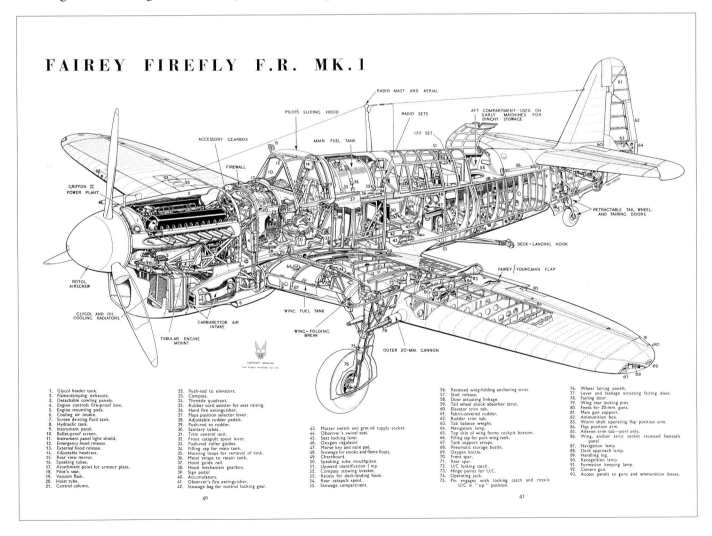

FAIREY FIREFLY F.R. MK.1

1. Glycol header tank.
2. Flame-damping exhausts.
3. Detachable cowling panels.
4. Engine controls fire-proof box.
5. Engine mounting pads.
6. Cooling air intake.
7. Screen de-icing fluid tank.
8. Hydraulic tank.
9. Instrument panel.
10. Bullet-proof screen.
11. Instrument panel light shield.
12. Emergency hood release.
13. External hood release.
14. Adjustable headrest.
15. Rear view mirror.
16. Speaking tubes.
17. Attachment point for armour plate.
18. Pilot's seat.
19. Vacuum flask.
20. Hoist tube.
21. Control column.

22. Push-rod to elevators.
23. Compass.
24. Throttle quadrant.
25. Rubber cord assister for seat raising.
26. Hand fire extinguisher.
27. Flaps position selector lever.
28. Adjustable rudder pedals.
29. Push-rod to rudder.
30. Sanitary tubes.
31. Trim control unit.
32. Front catapult spool lever.
33. Push-rod roller guides.
34. Filling cap for main tank.
35. Hoisting loops for removal of tank.
36. Metal straps to retain tank.
37. Hood guide rail.
38. Hood mechanism gearbox.
39. Sign pistol.
40. Accumulators.
41. Observer's fire extinguisher.
42. Stowage bag for control locking gear.

43. Master switch and ground supply socket.
44. Observer's swivel seat.
45. Seat locking lever.
46. Oxygen regulator.
47. Morse key and note pad.
48. Stowage for smoke and flame floats.
49. Chartboard.
50. Speaking tube mouthpiece.
51. Upward identification l mp.
52. Compass stowing bracket.
53. Recess for deck-landing hook.
54. Rear catapult spool.
55. Stowage compartment.

56. Recessed wing-folding anchoring strut.
57. Stud release.
58. Door actuating linkage.
59. Tail wheel shock absorber strut.
60. Elevator trim tab.
61. Fabric-covered rudder.
62. Rudder trim tab.
63. Tab balance weight.
64. Navigation lamp.
65. Top skin of wing forms cockpit bottom.
66. Filling cap for port wing tank.
67. Tank support straps.
68. Pneumatic storage bottle.
69. Oxygen bottle.
70. Front spar.
71. Rear spar.
72. U/C locking catch.
73. Hinge points for U/C.
74. Operating jack.
75. Pin engages with locking catch and retails U/C in " up " position.

76. Wheel fairing panels.
77. Lever and leakage actuating fairing door.
78. Fairing door.
79. Wing rear locking pins.
80. Feeds for 20-mm. guns.
81. Main gun support.
82. Ammunition box.
83. Worm shaft operating flap position arm.
84. Flap position arm.
85. Aileron trim tab—port only.
86. Wing, anchor strut socket recessed beneath panel.
87. Navigation lamp.
88. Deck approach lamp.
89. Handling lug.
90. Recognition lamp.
91. Formation keeping lamp.
92. Camera gun.
93. Access panels to guns and ammunition boxes.

40 41

Each manual was different. Depending on time, resources and the talent of the men working on them, manuals were either sparse and very straightforward or they were well laid out with colorful diagrams and interesting artwork. The *B-17 Field Service Manual* was one of those manuals with atmospheric pen-and-ink drawings sprinkled throughout the copy (opposite).

Below: Cover and inside cover page of *B-29 Gunner's Information File.*

were able create sketches on the spot. We also had access to all the blueprint drawings whenever we needed them."

In October 1942 the British Chiefs of Staff Committee gave the British bomber fleet "absolute priority of Anglo-American production" until 1943. The political decision to use strategic bombing as a means to win the war in both Europe and the Pacific ensured that the giant Allied bomber fleets would receive first priority when it came to vital strategic use of resources, and the majority of aircrew and ground crew trained in the United States, Britain and Canada were streamed for bomber service. RAF Bomber Command grew until it was the RAF's largest component, comprising one-fifth of all RAF personnel and one the largest Allied forces capable of attacking targets deep into Germany. The air forces felt they had captured the best and brightest and left the army and navy with what was left over. During the war it took one to three years to train aircrew to operational standards, compared to just months for infantry training.

The Japanese attack on Pearl Harbor on December 7, 1941, thrust America into war. Even before the attack, American flight schools were busy training both British and Canadian aircrew. To circumvent the Taft Act, British cadets were issued Canadian visas and crossed into the United States from Canada. Officially civilians when off-station, the British cadets had to follow U.S. Army Air Corp rules and regulations at all times when back on base. German pilots had used a similar method when circumventing the Treaty of Versailles. Posing as tourists, they secretly crossed the border into Italy and trained with the Regia Aeronautica.

Even before war had engulfed Europe, the U.S. Army Air Force had laid plans to expand pilot and aircrew training — to 1,200 pilots a year by 1941. This was later revised to 7,000 a year in 1940 and up to 30,000 a year in 1941. It was estimated that more than 500 separate skills were required to contribute to the success of a routine bombing mission. What the U.S. Army Air Force meant by "routine" is not entirely clear. What was clear, however, was that in order to fly and fight in a modern fighter or bomber with a good chance for survival, a new understanding of each combat aircraft and its abilities was necessary, in concert with a training regime that could produce quality aircrew in the shortest amount of time. In World War I, most pilots went to the front still learning how to fly their aircraft, but the pilots of World War II had to spend hundreds of hours in both the air and on the ground before being posted to a frontline squadron. Captivated by the romantic image of the World War I fighter pilot and the belief that flying would be safer than joining the infantry (although according to RCAF figures, 92 percent of all air force casualties were fatal, compared to 30 percent for the Canadian Army) thousands of young men flooded the recruitment depots. Many were rejected and thousands more washed out during training. As the war evolved, new requirements placed continually changing demands on the pilot training system, and the pressure to meet quotas had an adverse effect on the quality of graduates. Surprisingly, before 1944, when large numbers of aircrew were needed, flight school commanders were routinely replaced for not meeting numerical goals. The inevitable result was the lowering of graduation standards. When fewer aircrews were needed, failure rates were deliberately increased.

Below: "Time Flies Too!" An example of the cartoon art used in the *Service Aircrew Manual*. The artist is unknown.

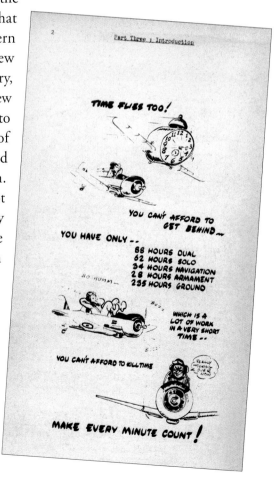

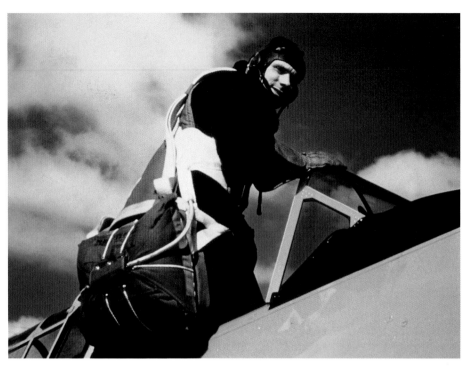

The long process of the British Commonwealth Air Training Plan (BCATP) training began with the aircrew selection board. There the young volunteer would face two or three officers, and within minutes his fate would be decided. There were no second chances, and if he failed to impress the board his feet would remain firmly on the ground. For the successful candidate, the assembly-line process of aircrew training would begin. The manning depot was the next stop for a new trainee, where he once again faced a succession of interviews, lectures, tests and countless hours of drills. There he also spent one or two hours in the Link trainer, the 1940s version of today's simulator. Developed in the United States during the 1930s, the Link was used to train pilots in instrument flying, and for its time was a very sophisticated machine. If the aspiring pilot showed little aptitude for coordinating its controls, he soon found himself being asked to become a navigator, bomb-aimer or wireless operator / air gunner, or air gunner. Those who survived the Link experience soon found themselves at Elementary Flying Training School (EFTS). Those eager to get their hands on a Spitfire were disappointed. Waiting for them was the two-seat de Havilland Tiger Moth, or the Fleet Finch — both fabric-covered biplanes with an open cockpit.

Above: A young pilot trainee enters the cockpit of his Harvard.

Below: Principles of flight; this illustration shows the four forces critical for flight.

Opposite: **Pilot Qualification Form** The pilot qualification form of 2nd Lieutenant Robert Boucher reveals exactly how many hours were required to produce a highly skilled night fighter pilot in 1944.

In his book *A Thousand Shall Fall*, Murray Peden describes his early training on the Tiger Moth. "Outside, everywhere one looked there were Tiger Moths. I never counted them, but I guessed there were about 60 all told on the station.

"The slow flying aircraft were perfect for the job, but they did have their quirks. Because of the abundance of wing, they were tricky to land in windy weather and they had to be 'flown' constantly. I gradually developed a modicum of confidence, although at first, when I was simply trying to keep the aircraft straight and level, it seemed to me that

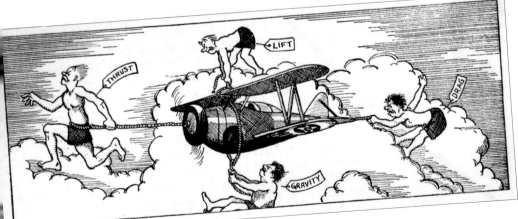

the moment I got the rudder centered and stopped the Tiger's yawing, two or three other problems appeared."

It was at EFTS that the young student pilot, for the first time, came face to face with mysteries of heavier-than-air flight. Learning in three dimensions was the name of the game. The first step was to be shown how the stick and rudder pedals could be used to tame the invisible aerodynamic forces at play and keep an aircraft from doing what it wanted to do. The student pilot faced a barrage of information about drag and lift, longitudinal stability, angle of incidence, stalling, spinning, side slipping — why they happen and the correct way to deal with them. On the ground it all made sense. Of course, once in the air, the chalkboard words quickly vanished and the young pilot soon found himself fighting a new force — panic. But it was the only way. Squeezed into a tiny cockpit and blasted by hurricane-force winds, the young recruit had to master his fear and then take control of the aircraft. Many did not. On average, one in four washed out during elementary training.

After three months of flying and logging approximately 78 hours, the new cadet was then posted to Service Flying Training School (SFTS). SFTS meant bigger, more powerful aircraft such as the North American Harvard or Yale. Those selected for multi-engined aircraft moved on to Ansons, Oxfords or Cranes. As the new pilot advanced in his flight training, the aircraft he flew presented a greater challenge. With a fully enclosed cockpit, the Harvard was a sea of instruments powered by a big Pratt & Whitney radial engine, and at low speeds it sometimes dropped a wing and snapped into a spin. If you could handle a Harvard, you could then progress to a high-performance fighter. Another three and half months would pass. After logging 120 hours, including 20 hours of night flying, the cadet was finally awarded his wings. Total hours, 200.

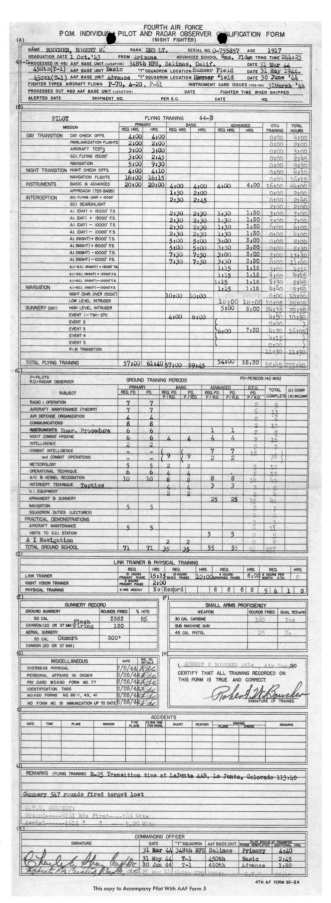

LESTER B. BONER

Lester Boner is one of those guys
Who tries to impress you as being wise.
As a technician he's not so bright;
He makes no effort to see if he's right.
On critical jobs he's so likely to fail,
We can trust him only with mop and pail.

But flight school was not just about flying. Ground school was also a major component. There the new aircrew recruits had to learn about their aircraft and how they worked. They had to master navigation, aircraft recognition, principles of flight, radio codes and communication, first aid, hydraulics and electrical systems. Pilots had to know everything about them and more. Upon their arrival in England, many of the crews that were trained overseas were assigned to Advanced Flying Units (AFU). There they learned to fly under British weather and in blackout conditions. For many it was an unnerving experience. Compared to flying conditions in Canada, the mist, rain and poor visibility over Britain was appalling. The second last step before being assigned to a front-line squadron was the Operational Training Unit (OTU). If he was a bomber pilot, he would be joined by the rest of his crew for the first time. Here he would learn to how to work with the rest of his crewmates as a team. Many hours would be spent flying over the blacked-out English countryside in

Above: **B-24D Service and Instruction Manual** This illustration and poem, found in the front pages of the B-24D manual are clearly designed to show trainees their fate if they fail in their attempts.

Right: This rare wartime color photograph shows a Fairey Battle trainer warming up for a training flight. The Battle was used to train gunners and bombardiers.

aircraft that had long since retired from operational flying. Many of the (OTU) aircraft were "de-rated," meaning that the pilot could not open the throttles to full power, otherwise the engines might blow up. If the young pilot and his crew survived this part of their training, the next and last step before operational training was the Heavy Conversion Unit (HCU). Here the new, or "sprog," crews would fly learn to fly the aircraft they would use on operations. Again, these aircraft were well worn and long past their prime. It was not unusual for aircraft to take off and simply disappear. Well-trained crews were killed because the aircraft they flew simply broke apart. (There were 8,195 Bomber Command aircrew killed during the war because of flying or ground accidents.)

In Spencer Dunmore and William Carter's book *Reap the Whirlwind,* RAF Fitter Bill Johnson describes the war-weary aircraft. "The old, well-worn planes needed every yard of the runway to lift off; their worn-out Merlins, although sounding just as sweet as ever, didn't have the power any more. I've seen both Halifaxes and Lancasters as far away as three miles away and still only about two hundred feet off the ground."

The demands of the training system were so intense that of the 5,300 medium and heavy bombers in RAF Bomber Command in early 1943, more were being used for training than in combat. After this intense period of training, the new pilot, with 300 hours or more of flight time under his belt, would be posted to an operational squadron. Many of the pilots who failed at this late stage reentered the training program and became navigators, wireless operators, bomb aimers and air gunners. These courses

B-26 Synchronous Bombing
The bombsight, with data computed by the bombardier set into the mechanism, determines the correct point in space at which a specific type of bomb must be released to strike a selected target.

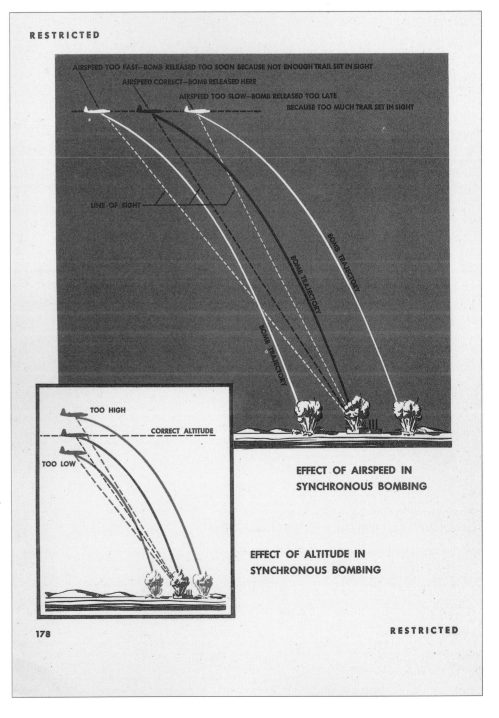

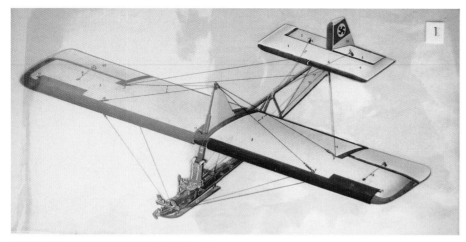

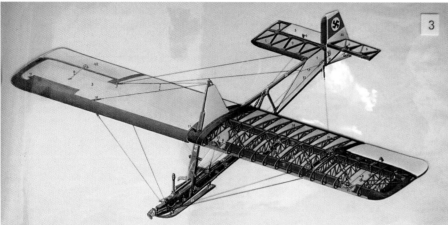

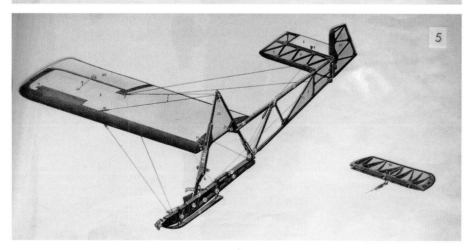

After World War I, German soaring clubs were formed in order to circumvent the Treaty of Versailles, which banned German military aircraft. The *Nationalsozialistisches Fliegerkorps (NSFK)* was established to encourage boys in the Hitler Youth, aged twelve to seventeen, to fly. This cutaway drawing shows the simple wood-canvas construction of the SG-38, the primary glider they used.

lasted as long as six weeks for gunners and up to twenty-six weeks for navigators and bomb aimers.

The other major player in the air war against Germany was the Soviet Union. The invasion of Russia by Germany in 1941 graphically illustrated the inferiority of Soviet fighters and bombers and also revealed the woeful training system in place at the time. Stalin's purges in the late 1930s stripped the Soviet Air Force of its best commanders. By September 1941, Soviet aviation losses had reached an estimated 7,500 aircraft. By 1943, German evaluations of the Soviet Air Force confirmed the dramatic improvement of Soviet fighter and bomber formations. Luftwaffe fighter and bomber pilots could no longer operate with the freedom they had experienced during the first two years of combat. By the end of World War II, the Soviet Air Force emerged as the most powerful tactical air arm in the world. At the beginning of the war the Soviet Air Force numbered 7,321 aircraft, most of them obsolete. In the final attack on Berlin alone the Soviet Air Force deployed more than 7,500 modern combat aircraft.

Training in the United States followed the same pattern: EFTS was Primary Flying Training; SFTS, Advanced Flying Training; and OUT, Transition Flying Training.

For the German, Japanese and Italians, flight-crew training went from excellent to horrendous in a very short period of time. At the beginning of the war, most front-line Japanese fighter pilots had over

600 hours of flight time, with squadron leaders averaging 2,000, many with combat experience gained in China. By 1945 that figure had dropped to 250 hours with a minimum of 150. The Germans were in a similar situation, having gained valuable combat experience during the Spanish Civil War. But as the war progressed and losses mounted, the Axis Air Forces were unable to match the pilot and aircrew output of the combined British, American, Canadian, Australian and Russian air forces.

By the end of 1942 the Luftwaffe was fighting on three fronts — the Soviet Union, the Mediterranean and the Atlantic. The Germans did manage to double the number of new fighter pilots from 1,662 in 1942 to 3,276 in 1943. But it was barely enough to cover the losses on three fronts (2,870). The attrition of pilots and skilled aircrews was probably the most important factor in the final destruction of the Luftwaffe. Heavy losses forced the Germans to curtail training in a desperate move to fill empty cockpits. The results were pitiful. New pilots with less skill than their predecessors were lost at a faster rate. This forced the training establishments to produce more pilots with even less skill. It was a death spiral with no escape. A telling statistic reveals that only eight of Germany's 107 aces to score more than 100 victories were operational after mid-1942. The Luftwaffe in 1943 was in reality two separate air forces: the remaining *experten* — the Hartmans, Galands and Ralls — and the rest, who for the most part still had great difficulty landing their aircraft.

In the Pacific, Japanese expansion had been checked after the naval battle of Midway and the air and land battles at Guadalcanal and New Guinea. During these critical battles many of Japan's most experienced pilots were killed. Interviews of Japanese personnel conducted after the war by the Air Technical Intelligence Group reveal a stark reality. "The *Hiryu* [the *Hiryu* was one of four Japanese aircraft carriers sunk at Midway] was making 30 knots when she was hit and maintained that speed for some time thereafter, but gradually came to a stop because, as Captain Kawaguchi stated, the engineering personnel were all killed by the fires and explosions below.

Covers for the Parts List Manual for the Mercedes Benz Doppelmotor DB 610 engine and the Schul-Gleiter 38 Glider.

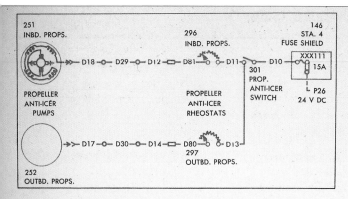

251
INBD. PROPS.

296
INBD. PROPS.

146
STA. 4
FUSE SHIELD

→ D18 → D29 → D12 → D81 → D11 → D10 → XXX111 15A

PROPELLER
ANTI-ICER
PUMPS

PROPELLER
ANTI-ICER
RHEOSTATS

301
PROP.
ANTI-ICER
SWITCH

P26
24 V DC

→ D17 → D30 → D14 → D80 → D13

297
OUTBD. PROPS.

252
OUTBD. PROPS.

FIGURE 173—PROPELLER ANTI-ICER PUMP CIRCUIT

Service Information—No lubrication of the pump is required between overhauls.

Every 60 hours inspect the motor brushes for binding and wear. Replace the brushes if worn to a length of 11/32 inch, or if they will exceed this minimum length before the next overhaul period. If brushes bind, wipe them clean with a gasoline moistened cloth. Inspect the wiring and wiring connections

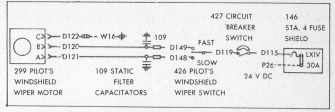

427 CIRCUIT
BREAKER
SWITCH

146
STA. 4 FUSE
SHIELD

C → D122 → W16 → 109
B → D120 → D149 → FAST
A → D121 → D148 → SLOW → D119 → D115 → LXIV
P26 30A

299 PILOT'S
WINDSHIELD
WIPER MOTOR

109 STATIC
FILTER
CAPACITORS

426 PILOT'S
WINDSHIELD
WIPER SWITCH

24 V DC

FIGURE 174—PILOT'S WINDSHIELD WIPER CIRCUIT

249

RESTRICTED

VACUUM AND DEICER SYSTEM

This evocative pen-and-ink drawing appears in the *B-17 Field Service Manual.*

Of the 150 flying personnel attached to the *Hiryu,* only 20 survived the action and returned to Japan."

The Germans and Japanese, unlike the British and Americans, did not have tours of duty for their aircrew. While experienced American and Commonwealth aircrew were rotated out of the combat zone and back into the training system, German and Japanese aircrew flew until they were killed or listed as unfit to fly. More and more pilots were forced to the front with fewer and fewer hours of flight time. Lack of instructors, fuel and aircraft only added to the chaos. The shortages were so severe that the Japanese were forced to use cadets as flight instructors; in final desperation, thousands were used as Kamikaze pilots. As the Allied system improved and grew, the Axis forces faced only shortages, slaughter and defeat.

The Air Technical Air Intelligence Group again discovered that "All Japanese training and accident personnel interrogated were asked finally what they would do to prevent aircraft accidents if given time, facilities, and a free hand. Major Iijima (representing the best informed Army viewpoint) proposed: Wider and more effective use of motion pictures, posters, illustrated textbooks."

By the end of the war, the reservoir of trained Allied pilots measured in the thousands. After some 10,000 parachute and glider-borne troops had landed at Arnhem in Holland in September 1944, and fewer than 3,000 came out, the army was desperately short of glider pilots. The army was able to borrow some 1,500 RAF pilots for conversion to gliders and demonstrated that the overseas flying training program had provided a reservoir of talent that had not been planned for or even contemplated. In the end, the RAF was able to train 88,000 aircrew in England. Under the British Commonwealth Air Training Plan, 340,000 Commonwealth aircrew were trained from 1939 to 1945. The Canadian contribution was huge; more than 130,000 aircrew from every Allied nation, representing 44 percent of the total, were trained in Canada. Included in that number were 2,000 French, 900 Czech, 677 Norwegian, 450 Poles and approximately the same number of Belgians and Dutch aircrews. In the United States, between July 1, 1939,

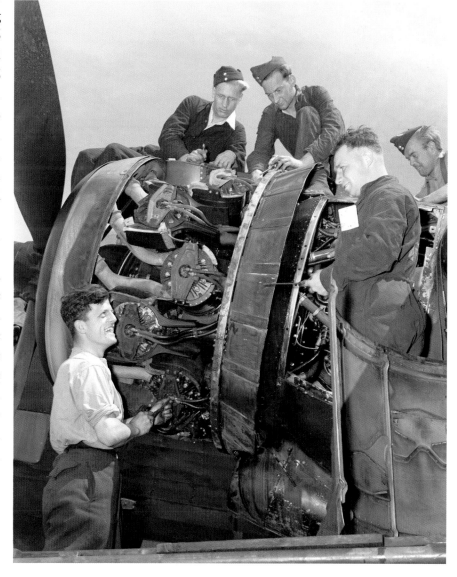

Fitters of 420 Squadron work on the Hercules engine of a Halifax bomber in the summer of 1944.

and August 31, 1945, 193,440 pilots graduated from AAF advanced flying training schools along with 347,236 gunners, 497,533 mechanics, 195,422 radio mechanics and operators, 50,976 navigators, and 47,354 bombardiers. Thousands of Allied aircrew also passed through the American system. From May 1941 to the end of 1945, 21,302 airmen from thirty-one foreign nations graduated from flying and technical schools in the USA: 12,561 were British, 2,238 were Chinese, 4,113 French and 532 Dutch.

Air power in World War II proved decisive. The Allied Air Forces were the best equipped, most well trained and lead by outstanding commanders. The expansion and sophistication of the Allied Air Forces is reflected in the time that it took to train a pilot, which changed as the war progressed. In 1940 it took 25 weeks to train a pilot, in 1942 it was increased to 38 weeks and by February 1944 it was 50 weeks.

CHAPTER 3

Lessons Learned — Into the Fire

"There is no place among combat outfits for prima donnas."
—Pilot Training Manual for the B-26

Success in air warfare during World War II depended heavily on the skills of the aircrew and ground crew involved. Well-trained aircrew matched with effective fighters and bombers made for a very formidable fighting force. The aircraft the major combatants possessed at the beginning of the war were very similar. Single-seat fighters such the Bf 109, Spitfire and Mitsubishi Zero, all designed in the late 1930s, were similarly equipped with cockpit instruments and reflector gunsight, multiple gun installations including cannons and arming circuits, radio for both air-to-ground and air-to-air communication, electrical generator and circuits to power other equipment, hydraulic and undercarriage operating systems, oxygen systems and radar for navigation and night fighting.

But as the war progressed, the complexity and sophistication of the warplane continued to evolve in leaps and bounds. Aircrew were continually trained and retrained to meet the increasing demand. A memorandum written in June 1945 by Wing Commander F.G. Grant, 143 Typhoon Wing, describes the importance of constant training:

> In training pilots for a ground attack role using bombs and cannon, flying under simulated operational conditions should be constantly carried out; dive-bombing particularly needs constant practice as it is experience only which enables the present day pilot to hit a target because he has no trick sight to guide him. A dive-bombing range with quadrants and ground-to-air control should be available, and the following "DON'TS" adhered to:

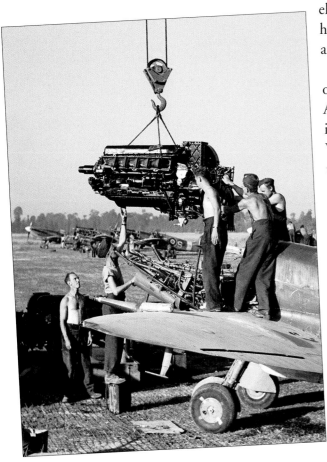

A No. 442 Squadron Spitfire undergoes an engine change in August 1944.

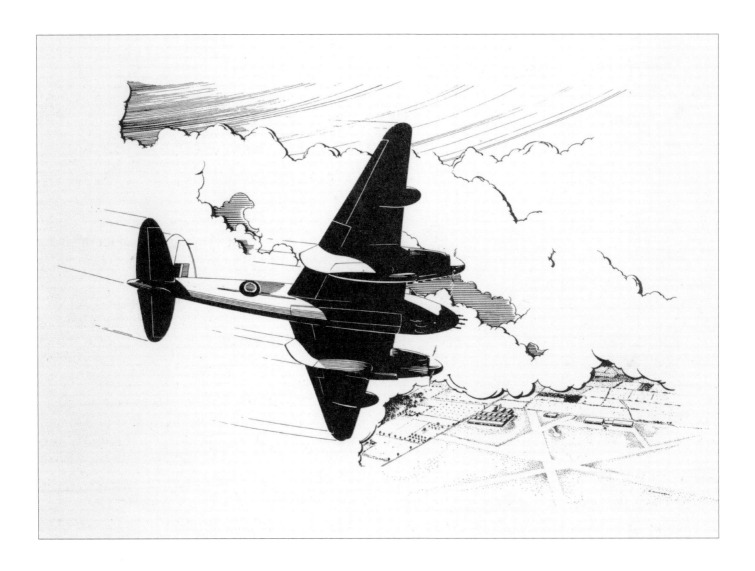

DON'T break formation during the run-in to the target.

DON'T dive too shallow. Make it at least 60 degrees.

DON'T release too high or you will miss for sure; release at 2,500–2,000 ft.

DON'T pop all the rivets pulling out, the ground crew become most unhappy.

DON'T embarrass your squadron by not being able to find them when you pull up and re-form.

For ground strafing practice, a suitable ground range should be provided which possesses normal bulls-eye targets; scattered MET and tanks for realistic strafing should be laid out.

Mosquito FB Mk 26 Servicing and Descriptive Handbook
This fine pen-and-ink drawing shows a Mosquito fighter-bomber soaring through the clouds. There were 338 examples of this variant built during World War II.

For the first time, the aircraft became well-equipped weapons platforms capable of very specific roles. For example, the radar-equipped night-fighter required both an extremely skilled pilot with many hours of flying time and a well-trained radar operator each working in concert with ground-based radar to guide them to their target.

The standard of skill required in the modern night-fighter squadron is extremely high, and proficiency in bad weather flying must be developed until crews are capable of operating in extremely adverse flying conditions. Such efficiency can be achieved only by developing teamwork and the crew spirit. It is not enough to have a pilot and navigator who are both excellent at their own particular jobs, but who fail to work as a harmonious team. On the other hand, it is not uncommon to find a pilot and a navigator, each of average ability, whose personalities and temperaments blend so effectively that the whole is transformed into a fighting unit of potential effectiveness far in excess of that displayed by either individual.

On arriving at a night-fighter Operational Training Unit in Great Britain, the pilot and navigator meet for the first time. The pilot has completed a special A.F.U. course, during which he has flown a service-type aircraft both day and by night; the navigator has completed a full dead reckoning navigation course and has successfully passed through a specialized school giving instruction in the basic principles of interception by night. Altogether, 75 hours flying — of which 25 are by night — are completed during the course.

It has been found through experience that it requires at least six months in a squadron for a crew to reach a pitch of maximum efficiency.

—*Aircrew Training Bulletin No. 19, August 1944.*

Below: The inside cover page of *The Service Aircrew Manual Part One.*

Bottom: A rigger cleans the cockpit Perspex while an armorer rods the barrels of a Boulton Paul Type C Mk I nose turret.

Part One : Title Page

THE SERVICE AIRCREW PART ONE

"The Service Aircrew", Part One, covers the Initial Training of Service Pilots, Navigators and Air Bombers.

Issued on the authority of

Air Marshal, Chief of the Air Staff.

NOTE : One of the chief aims of "The Service Aircrew" is to provide an outlet for the original ideas of individual instructors.

Therefore, suggestions for amendment or addition to text or illustrations are not merely welcome, but solicited.

They should be submitted to the Editorial Staff at Air Force Headquarters through Training Command Headquarters.

Amendments will be issued at frequent intervals.

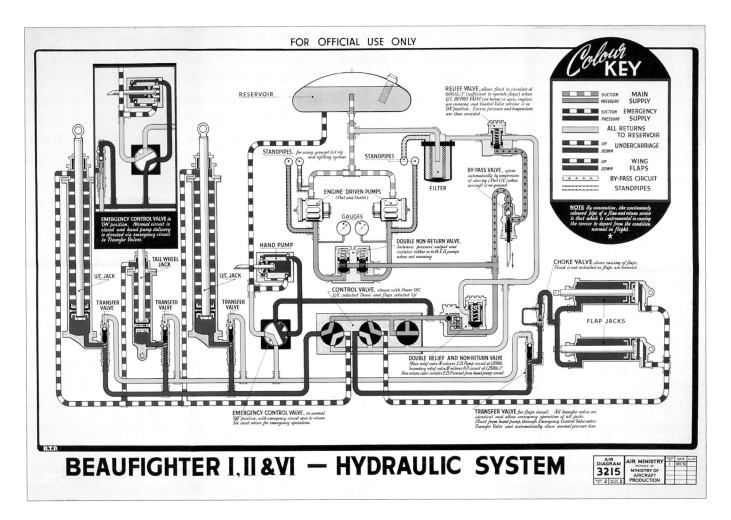

BEAUFIGHTER I, II & VI — HYDRAULIC SYSTEM

Beaufighter Hydraulic System
A simplified diagram of the hydraulic system in a Bristol Beaufighter.

While aircrew were the most highly trained combatants of World War II and seen as the "glory guys," there was another group without whose skills and abilities the flyboys would never take to the air. These were the ground crew, earthbound and on call twenty-four-hours a day, seven days a week, until the war ended. No matter what the nationality, all wartime fliers held their ground crews in the highest esteem. In all theaters of war these men battled excessive heat and bitter cold, and fought against disease, mud, dust, boredom and fatigue. In 1943, Air Chief Marshal Harris of Bomber Command praised his ground crews with this message: "On January 20th, 1,030 aircraft were serviceable out of an establishment of 1,038. When the work has to be done under such trying conditions this record is almost incredible. My thanks and congratulations to all concerned in this achievement. You, after the aircrew, are playing the leading part in getting on with this war." Ground crews in the Pacific had it far worse than their brothers in the European theater. For the ground crews, the maintenance manual was their bible and the reason the thousands upon thousands of illustrations, drawings and schematics were created — to help them keep their aircraft flying.

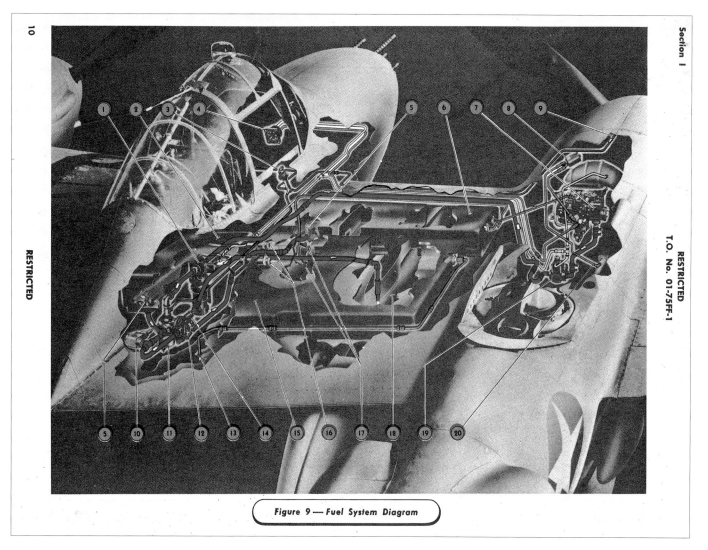

Figure 9 — Fuel System Diagram

P-38 Fuel System

Some American manuals mixed photographs with graphic elements to good effect. This exploded cutaway shows the fuel system of the P-38 Lightning.

A typical American four-engine bomber consisted of as many as 12,000 individual parts, all needing replacement at some time due to wear and tear and or battle damage. While the crew of a B-17 consisted of ten individuals, the number of ground crew needed to keep it flying exceeded that number. The heavy bomber of World War II was a complex instrument of war. It needed well-trained ground crew members specializing in superchargers, power plants, fabric and dope, armaments, hydraulics, electrical systems, flight instruments, propellers, parachute rigging, sheet metal and welding and woodworks.

Every airplane had a ground crew and was supervised by a crew chief. It was their job to keep their aircraft serviceable and ready for the next mission. And the job was a daunting one. If you were to take 150 bombers and 75 escort fighters and put them through a hypothetical daylight bombing mission, the numbers would look something like this: Assume 10 aircraft shot down over enemy territory, 6 forced to land at alternate airfields, 25 extensively damaged, 50 moderately damaged, 25 with minor damage, and 109 unscathed. The 6 forced landings would

require 7,200 man-hours for maintenance; the 25 extensively damaged would average 450 man-hours apiece, totaling 11,250 man-hours; the 50 moderately damaged, at an average of 300 man-hours, would total 3,750. The total maintenance required for repairs alone (not service) would be 37,200 man-hours, or a 48-hour workweek for 775 men. Much of the repair and servicing work had to be done at night and in all kinds of weather, on both sides. Exhaustion was a constant companion, and while American and British aircrew could fly their allotted missions and go home, the ground crew were stuck where they were for the duration. Ground crews took great pride in the work and considered the aircraft they worked on as their own. If it was not for the dedication and abilities of these men, the great strides made by the Allied Air Forces in World War II would have not been possible.

At war's end, the manuals, posters and illustrations that were so vital for the war effort were soon forgotten. Like the war machines that were being melted down, they too were being destroyed and turned to ash. For the thousands of air and ground crew who returned home, thoughts of war turned to hopes for new beginnings and a better life. Most of them never wanted to see another cutaway drawing or how-to poster again. Those illustrators and artists whose creative force was harnessed and used for the purpose of war moved on to other endeavors and their work is barely remembered over half a century later. Yet for a few very critical years, these artists put pen to paper and created a "how to" guide to wage and also to survive war. The images in the following pages do offer a glimpse into the machinations of war — the resources and technology required and the intellectual forces brought to bear — but they should also remind us that war is not fought by machines alone. War is fought by humans and the greatest cost is life itself.

Black Widow Gunnery Equipment, in Black Widow Pilot's Manual
The crew for the formidable P-61 Black Widow consisted of a pilot, radar operator and gunner. It was the most heavily armed Allied night-fighter to see service and the only one equipped with a four-gun dorsal turret.

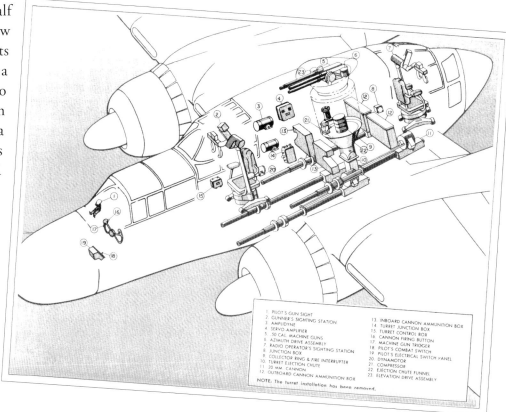

1. PILOT'S GUN SIGHT
2. GUNNER'S SIGHTING STATION
3. AMPLIDYNE
4. SERVO-AMPLIFIER
5. .50 CAL. MACHINE GUNS
6. AZIMUTH DRIVE ASSEMBLY
7. RADIO OPERATOR'S SIGHTING STATION
8. JUNCTION BOX
9. COLLECTOR RING & FIRE INTERRUPTER
10. TURRET EJECTION CHUTE
11. 20 MM. CANNON
12. OUTBOARD CANNON AMMUNITION BOX
13. INBOARD CANNON AMMUNITION BOX
14. TURRET JUNCTION BOX
15. TURRET CONTROL BOX
16. CANNON FIRING BUTTON
17. MACHINE GUN TRIGGER
18. PILOT'S COMBAT SWITCH
19. PILOT'S ELECTRICAL SWITCH PANEL
20. DYNAMOTOR
21. COMPRESSOR
22. EJECTION CHUTE FUNNEL
23. ELEVATION DRIVE ASSEMBLY

NOTE: The turret installation has been removed.

HE WHO SEES FIRST

Systematic SCANNING is essential

VISION TRAINING FO

RTP Nº 51-1313 HS&S

GREAT BRITAIN

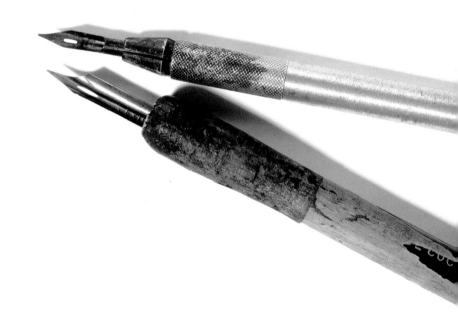

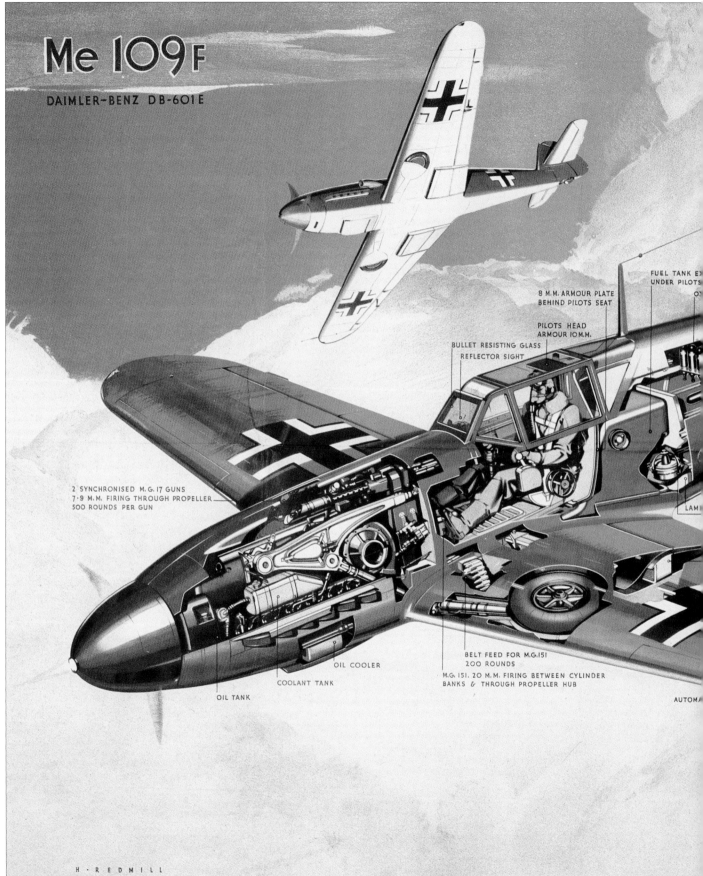

Me 109F

DAIMLER-BENZ DB-601E

FUEL TANK E[X]
UNDER PILOTS

8 M.M. ARMOUR PLATE
BEHIND PILOTS SEAT

PILOTS HEAD
ARMOUR 10 M.M.

BULLET RESISTING GLASS
REFLECTOR SIGHT

2 SYNCHRONISED M.G. 17 GUNS
7·9 M.M. FIRING THROUGH PROPELLER
500 ROUNDS PER GUN

LAM

BELT FEED FOR M.G.151
200 ROUNDS

M.G. 151. 20 M.M. FIRING BETWEEN CYLINDER
BANKS & THROUGH PROPELLER HUB

OIL COOLER

COOLANT TANK

OIL TANK

AUTOMA

H · REDMILL

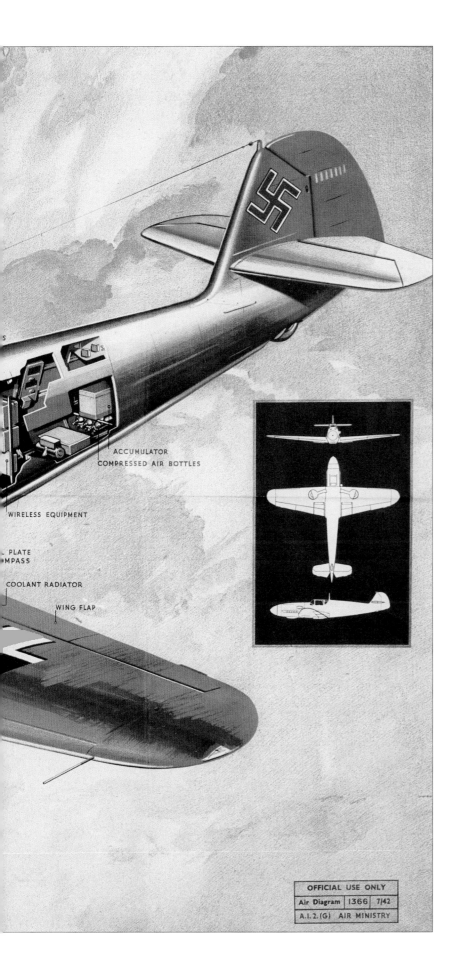

ACCUMULATOR
COMPRESSED AIR BOTTLES

WIRELESS EQUIPMENT

PLATE
MPASS

COOLANT RADIATOR

WING FLAP

OFFICIAL USE ONLY
Air Diagram | 1366 | 7/42
A.I.2.(G) AIR MINISTRY

Messerschmitt Me 109F

The more powerful and aerodynamically refined Bf 109F was considered by many to have reached its developmental zenith in the spring of 1941. Introduced at the same time as the Spitfire V, the Friedrich-2 had a maximum speed of 373 miles per hour at 19,700 feet — making it remarkably close to the Spitfire V in capabilities at height. At low level, however, the new Bf 109F was the superior aircraft, 27 miles per hour faster than the Spitfire V at 10,000 feet. It also had a better rate of climb.

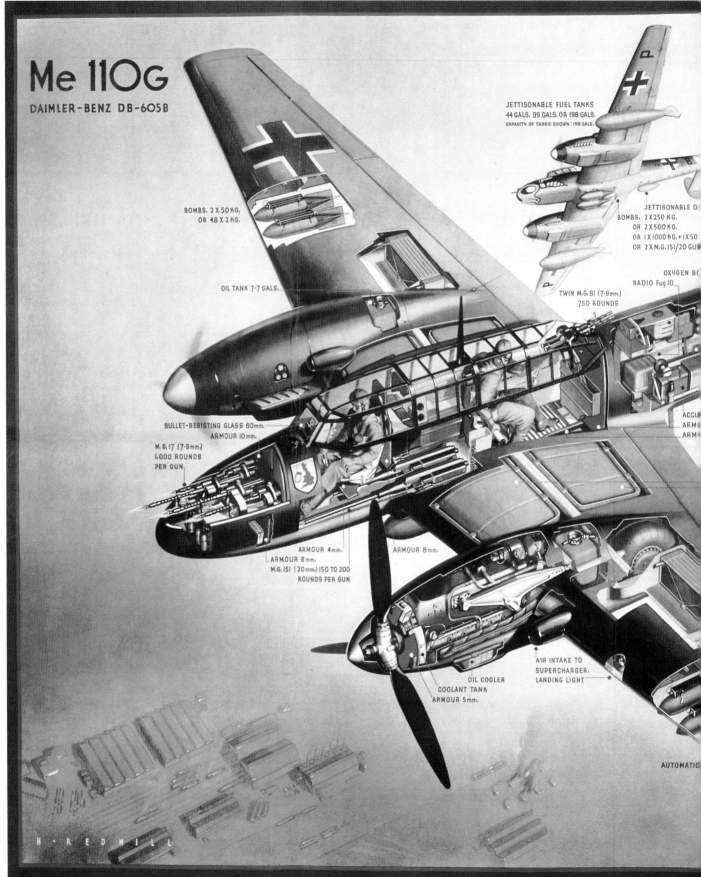

Me 110G
DAIMLER-BENZ DB-605B

JETTISONABLE FUEL TANKS
44 GALS, 99 GALS, OR 198 GALS,
CAPACITY OF TANKS SHOWN: 198 GALS.

BOMBS, 2 X 50 KG,
OR 48 X 2 KG.

JETTISONABLE O
BOMBS, 2 X 250 KG,
OR 2 X 500 KG,
OR 1 X 1000 KG, + 1 X 50
OR 2 X M.G.151/20 GUN

OIL TANK 7·7 GALS.

OXYGEN BO
RADIO Fug 10

TWIN M.G.81 (7·9mm.)
750 ROUNDS

BULLET-RESISTING GLASS 60mm.
ARMOUR 10mm.

ACCU
ARMO
ARM

M.G.17 (7·9mm.)
1,000 ROUNDS
PER GUN

ARMOUR 4mm.
ARMOUR 8mm.
M.G.151 (20mm.) 150 TO 200
ROUNDS PER GUN

ARMOUR 8mm.

AIR INTAKE TO
SUPERCHARGER,
LANDING LIGHT

OIL COOLER
COOLANT TANK
ARMOUR 5mm.

AUTOMATIC

H·REDMILL

GRAPHIC WAR

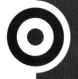

Messerschmitt Me 110G

Before the outbreak of the war there was a wealth of material describing Luftwaffe aircraft available, most of it published in open literature between 1936 and 1940. As war clouds gathered, British knowledge of Luftwaffe equipment was shockingly inadequate. There were no "official" cutaway drawings and the ones that did appear in the public press were inaccurate at best. In January 1940, a number of Me 110s had crashed in France and were available for study, and after the Battle of Britain the RAF had a number of Me 110s to study. In 1943, Hubert Redmill's full-color and highly detailed and accurate cutaway drawing finally appeared.

The Me 110G model was powered by two DB-605 engines and was one of the most heavily armed fighters of the war. It was also the most successful night-fighter, shooting down more RAF heavy bombers than all other night-fighters combined. A total of 6,050 Me 110s were delivered.

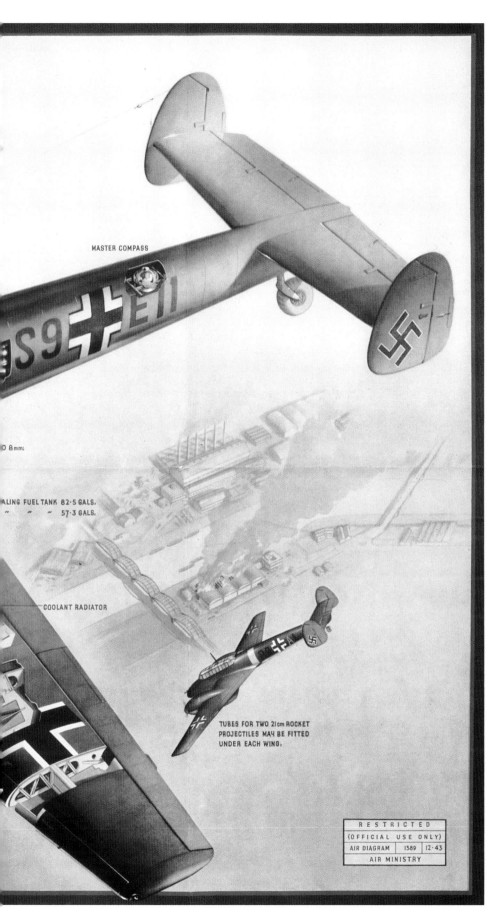

MASTER COMPASS

D 8mm.

ALING FUEL TANK 82·5 GALS.
" " 57·3 GALS.

COOLANT RADIATOR

TUBES FOR TWO 21cm ROCKET
PROJECTILES MAY BE FITTED
UNDER EACH WING.

RESTRICTED
(OFFICIAL USE ONLY)
AIR DIAGRAM 1389 12·43
AIR MINISTRY

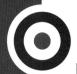

Fw 190

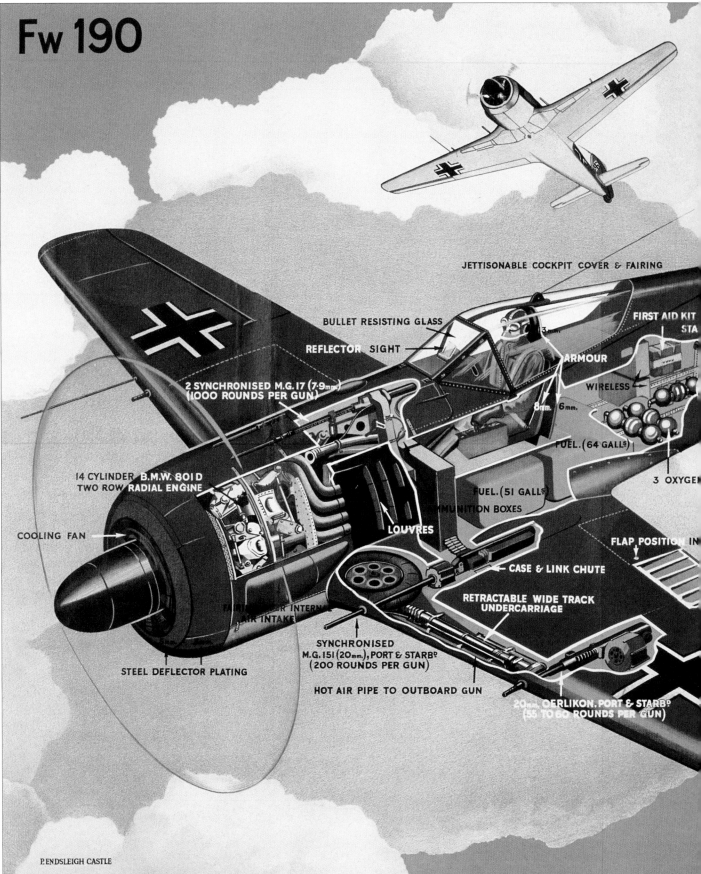

JETTISONABLE COCKPIT COVER & FAIRING

FIRST AID KIT STA

BULLET RESISTING GLASS

ARMOUR

REFLECTOR SIGHT

WIRELESS

2 SYNCHRONISED M.G. 17 (7.9mm)
(1000 ROUNDS PER GUN)

FUEL.(64 GALLS)

3 OXYGEN

14 CYLINDER B.M.W. 801 D
TWO ROW RADIAL ENGINE

FUEL.(51 GALLS)

LOUVRES

AMMUNITION BOXES

COOLING FAN

FLAP POSITION IN

CASE & LINK CHUTE

RETRACTABLE WIDE TRACK
UNDERCARRIAGE

FAIRING OVER INTERNAL
AIR INTAKE

SYNCHRONISED
M.G. 151 (20mm.), PORT & STARBᵈ
(200 ROUNDS PER GUN)

STEEL DEFLECTOR PLATING

HOT AIR PIPE TO OUTBOARD GUN

20mm. OERLIKON. PORT & STARBᵈ
(55 TO 60 ROUNDS PER GUN)

P. ENDSLEIGH CASTLE

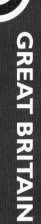
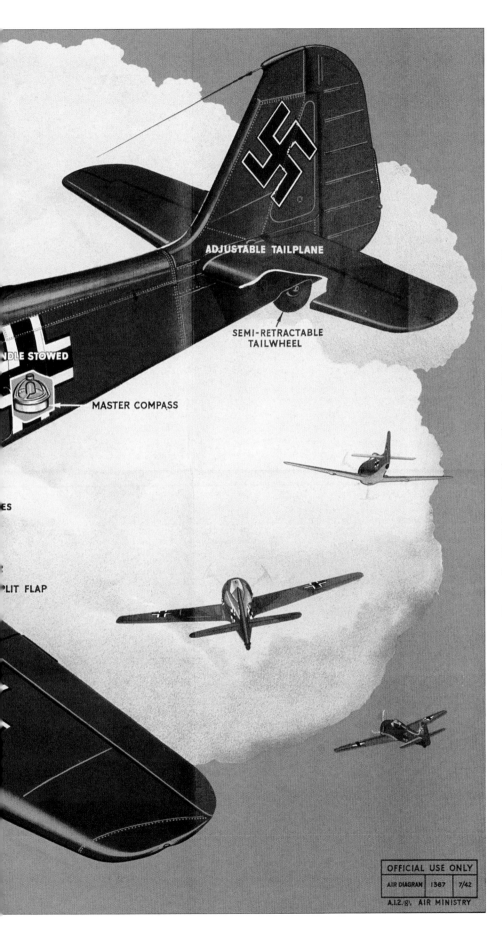

ADJUSTABLE TAILPLANE

SEMI-RETRACTABLE
TAILWHEEL

NDLE STOWED

MASTER COMPASS

ES

LIT FLAP

OFFICIAL USE ONLY

AIR DIAGRAM | 1367 | 7/42

A.I.2.(g), AIR MINISTRY

Focke Wulf Fw 190

"This cutaway was ordered completed during a weekend in June 1942 as an urgent requirement after Arnim Faber had force-landed his Fw 190 at Pembrey Wales. Fw 190s were downing Spitfires at that time, and this was our first specimen for evaluation and detailed illustration for distribution to fighter units. The hasty artwork included hand lettering for all the captioned technical features. After all the rushed effort, the Civil Service Reproduction Branch managed to delay issue till September 1942."

PETER CASTLE, 2004

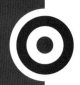

Junkers Ju 88C

In December 1940, *Flight* magazine described the Ju 88 as "a collection of numerous 'brainwaves', but it is not a good aeroplane, since it has failed in its function." It was a damning statement for an aircraft that many consider Germany's equivalent of the Mosquito.

The Ju 88 proved one of the most versatile combat aircraft ever built. In the skies above Germany the Ju 88 excelled in the night-fighter role. It had excellent range, was well armed and had adequate space to accommodate the extra equipment necessary for the tasks assigned it. During the war the German night-fighter force claimed 7,400 enemy aircraft destroyed.

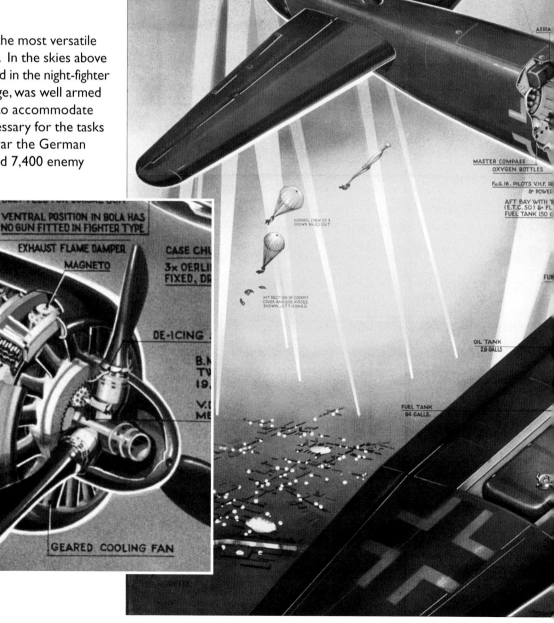

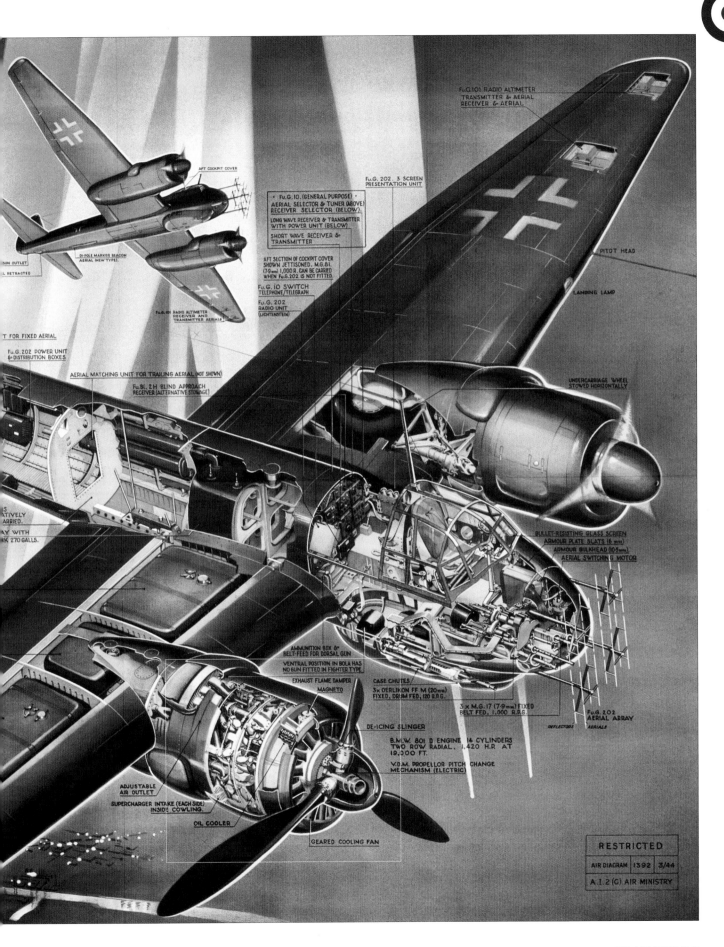

Fu.G.101 RADIO ALTIMETER
TRANSMITTER & AERIAL
RECEIVER & AERIAL

AFT COCKPIT COVER

Fu.G.202. 3 SCREEN
PRESENTATION UNIT

• Fu.G. 10. (GENERAL PURPOSE)
AERIAL SELECTOR & TUNER (ABOVE)
RECEIVER SELECTOR (BELOW).

LONG WAVE RECEIVER & TRANSMITTER
WITH POWER UNIT (BELOW)

SHORT WAVE RECEIVER &
TRANSMITTER

DI-POLE MARKER BEACON
AERIAL (NEW TYPE).

AFT SECTION OF COCKPIT COVER
SHOWN JETTISONED. M.G.81.
(7·9 mm) 1,000 R. CAN BE CARRIED
WHEN Fu.G.202 IS NOT FITTED.

Fu.G. IO SWITCH
TELEPHONE/TELEGRAPH

Fu.G. 202
RADIO UNIT
(LICHTENSTEIN)

SON OUTLET

Fu.G.101 RADIO ALTIMETER
RECEIVER AND
TRANSMITTER AERIALS

PITOT HEAD

L RETRACTED

LANDING LAMP

T FOR FIXED AERIAL

Fu.G. 202 POWER UNIT
& DISTRIBUTION BOXES

AERIAL MATCHING UNIT FOR TRAILING AERIAL (NOT SHOWN)

Fu.Bl. 2 H BLIND APPROACH
RECEIVER (ALTERNATIVE STOWAGE)

UNDERCARRIAGE WHEEL
STOWED HORIZONTALLY

ATIVELY
ARRIED.

AY WITH
NK 270 GALLS.

BULLET-RESISTING GLASS SCREEN

ARMOUR PLATE SLATS (6 mm)

ARMOUR BULKHEAD (10·5 mm)

AERIAL SWITCHING MOTOR

AMMUNITION BOX &
BELT-FEED FOR DORSAL GUN

VENTRAL POSITION IN BOLA HAS
NO GUN FITTED IN FIGHTER TYPE.

EXHAUST FLAME DAMPER

MAGNETO

CASE CHUTES

3 x OERLIKON FF M (20 mm)
FIXED, DRUM FED., 120 R.P.G.

3 x M.G. 17 (7·9 mm) FIXED
BELT FED, 1,000 R.P.G.

Fu.G. 202
AERIAL ARRAY

REFLECTORS AERIALS

DE-ICING SLINGER

B.M.W. 801 D ENGINE 14 CYLINDERS
TWO ROW RADIAL, 1,420 H.P. AT
19,000 FT.

V.D.M. PROPELLOR PITCH CHANGE
MECHANISM (ELECTRIC)

ADJUSTABLE
AIR OUTLET

SUPERCHARGER INTAKE (EACH SIDE)
INSIDE COWLING.

OIL COOLER

GEARED COOLING FAN

RESTRICTED

AIR DIAGRAM 1392 3/44

A.I.2 (G) AIR MINISTRY

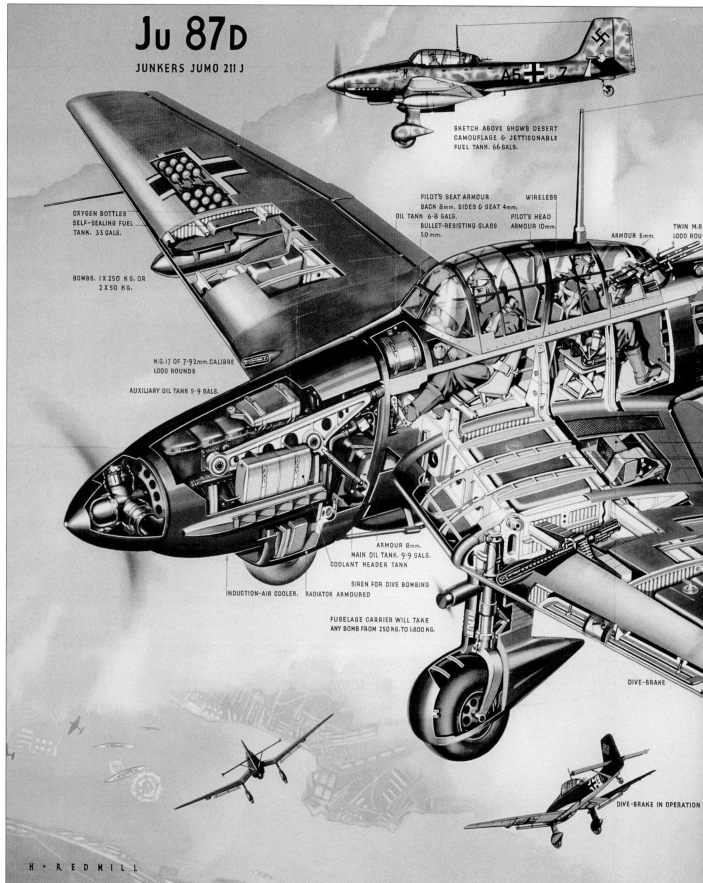

Ju 87D
JUNKERS JUMO 211 J

SKETCH ABOVE SHOWS DESERT
CAMOUFLAGE & JETTISONABLE
FUEL TANK. 66 GALS.

OXYGEN BOTTLES
SELF-SEALING FUEL
TANK. 33 GALS.

PILOT'S SEAT ARMOUR WIRELESS
BACK 8mm. SIDES & SEAT 4mm.
OIL TANK 6·8 GALS. PILOT'S HEAD
BULLET-RESISTING GLASS ARMOUR 10mm.
50 mm.

ARMOUR 5mm. TWIN M.G
1,000 ROU

BOMBS. 1 X 250 K.G. OR
2 X 50 K.G.

M.G.17 OF 7·92mm. CALIBRE
1,000 ROUNDS

AUXILIARY OIL TANK 5·9 GALS.

ARMOUR 8mm.
MAIN OIL TANK, 9·9 GALS.
COOLANT HEADER TANK

SIREN FOR DIVE BOMBING

INDUCTION-AIR COOLER. RADIATOR ARMOURED

FUSELAGE CARRIER WILL TAKE
ANY BOMB FROM 250 KG. TO 1,800 KG.

DIVE-BRAKE

DIVE-BRAKE IN OPERATION

H · REDMILL

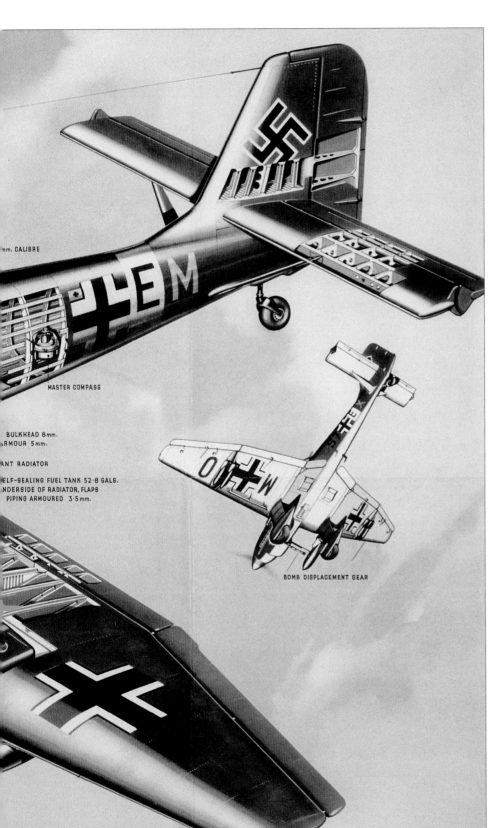

mm. CALIBRE

MASTER COMPASS

BULKHEAD 8mm.
ARMOUR 5mm.

NT RADIATOR

ELF-SEALING FUEL TANK 52·8 GALS.
NDERSIDE OF RADIATOR, FLAPS
PIPING ARMOURED 3·5mm.

BOMB DISPLACEMENT GEAR

OFFICIAL USE ONLY
AIR DIAGRAM /372 4·42
A.1.2 (G) AIR MINISTRY

Junkers Ju 87

Commonly known as the "Stuka" (from Sturzkampfflugzeug, German for dive-bomber) the Ju 87 was selected to carry out the very first operation of World War II. Twenty minutes before the official outbreak of hostilities a *Kette* of Ju 87s (meaning three of them) took off from their forward base in East Prussia. The bridge at Dirschau (Tczew) in Poland was vital to both the Germans and Poles. But the bridge itself was not the target; the object was to take out the demolition ignition points situated in the blockhouses close to the bridge. The Stukas completed their mission, but they were not successful. The Poles managed to destroy the bridge before the Germans could reach it.

By the time the Ju 87D variant entered service, the Stuka was all but obsolete. Slow and not very maneuverable, the Stuka was extremely vulnerable to fighter attack and only saw success once the Luftwaffe had gained local air superiority.

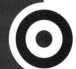

PROVISIONAL DRAWING OF

Me 210

DAIMLER BENZ DB-601F

RETRACTABLE LANDING LIGHT

DIVE BRAKES EXTENDED

TROUGH FOR FLOTATION GEAR.

GUN PORTS

BOMB DOORS OPEN

PROVISION FOR EXTERNAL BOMBS

TAIL WHEEL FULLY RETRACTABLE.

AIR INTAKE

ARMOUR

ARMOUR

BULLET-RESISTING GLASS
(MAY BE FITTED)

ARMOUR EACH SIDE

TRANSPARENT PANELS

GUN PORTS

ARMOUR
HEAD SHIELD BULKHEAD
PILOTS SEAT. FLOOR

AMMUNITION BOXES
TOTAL 7-9mm 1000 rds
TOTAL 20mm 600-1000 rds

TYPICAL BOMB LOAD:
2 x 250 kg or 2 x 500 kg
or 1 x 1000 kg or 1 x PC
1000 RS. ROCKET BOMB.

2 x MG 17 (7·9mm)
2 x MG 151 (20mm)
FIRING THROUGH NOSE

ARMOUR

CASE CHUTES

EXHAUST SHIELD

INBOARD FUEL TANKS
(SELF-SEALING 2 TANKS
TOTAL 238 GALLS.

OIL RADIATOR

LINK & CASE CHUTES

OUTBOARD FUEL TANKS
SELF SEALING · 40 GALLS.

MG 131 (15
70° ELEVATIO
TOTAL 13 m

PLAIN FLAP

LEADING EDGE SLAT
SHOWN SLIGHTLY OPEN

WHEEL STOWED HORIZONTALLY

ARMOUR
(ON UPPER & LOWER SURFACES

OXYGEN CYLINDERS
(3 IN EACH WING)

KERRY LEE.

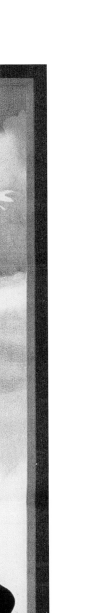

DIVE-BRAKES
ON UPPER & LOWER SURFACES.

DUCTED COOLANT RADIATOR
WITH ADJUSTABLE (ARMOURED) FLAPS.

IL TANK
S GALLS.

ET RESISTING GLASS
RMOUR BULKHEAD.

ED 'BLISTER' EACH SIDE
SION · 45° TRAVERSE
000 ROUNDS (ESTIMATED).

OFFICIAL USE ONLY		
AIR DIAGRAM	1369	10/42

A.12.(g), AIR MINISTRY

Messerschmitt Me 210

The Me 210 was designed to replace Messerschmitt's first twin-engine fighter, the Bf 110. It was meant to be a heavy fighter with a secondary capability as a fighter-bomber/dive-bomber. When introduced into service, Me 210 units suffered a protracted and expensive wastage of aircraft due to accidents. In June 1941 production of the Me 210 was finalized with the Hungarians. The original plan called for the production of 557 Me 210s and 817 Me 410s, but in the end only 176 aircraft were built. The Royal Hungarian Air Force was the only other nation to use the Me 210 in combat during World War II. After a short operational life the Me 210 was replaced by the improved Me 410.

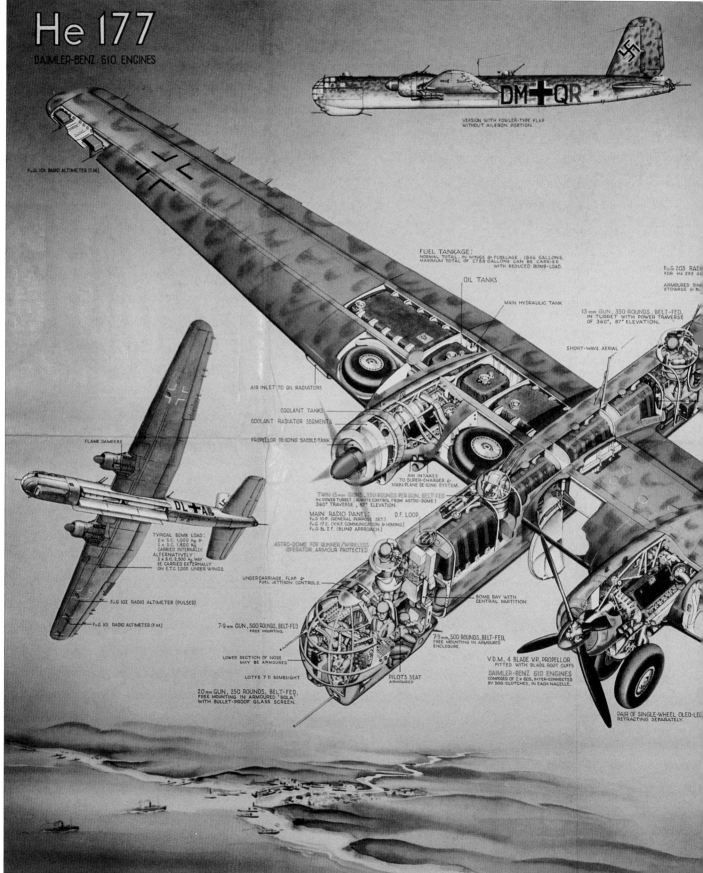

He 177

DAIMLER-BENZ 610 ENGINES

VERSION WITH FOWLER-TYPE FLAP
WITHOUT AILERON PORTION.

Fu.G 101 RADIO ALTIMETER (F.M.)

FUEL TANKAGE:
NORMAL TOTAL, IN WINGS & FUSELAGE, 1946 GALLONS.
MAXIMUM TOTAL OF 2788 GALLONS CAN BE CARRIED
WITH REDUCED BOMB-LOAD.

OIL TANKS

MAIN HYDRAULIC TANK

FuG 203 RADI
FOR He 293 G

ARMOURED DIN
STOWAGE & BL

13 mm GUN, 350 ROUNDS, BELT-FED,
IN TURRET WITH POWER TRAVERSE
OF 360°, 87° ELEVATION.

SHORT-WAVE AERIAL

AIR INLET TO OIL RADIATORS

COOLANT TANKS

COOLANT RADIATOR SEGMENTS

PROPELLOR DE-ICING SADDLE-TANK

AIR INTAKES
TO SUPER-CHARGER &
MAIN-PLANE DE-ICING SYSTEM.

FLAME DAMPERS

TWIN 13 mm GUNS, 350 ROUNDS PER GUN, BELT-FED,
IN POWER TURRET (REMOTE CONTROL FROM ASTRO-DOME)
360° TRAVERSE, 87° ELEVATION.

MAIN RADIO PANEL: D.F. LOOP
FuG 10 P. (GENERAL PURPOSE SET.)
FuG 17 Z. (V.H.F. COMMUNICATION & HOMING)
FuG BL 2 F. (BLIND APPROACH.)

ASTRO-DOME FOR GUNNER/WIRELESS
OPERATOR, ARMOUR PROTECTED

TYPICAL BOMB LOAD:
2 x S.C. 1,000 Kg. &
2 x S.C. 1,800 Kg.
CARRIED INTERNALLY.
ALTERNATIVELY:
2 x S.C. 2,500 Kg. MAY
BE CARRIED EXTERNALLY
ON E.T.C. 2,000 UNDER WINGS.

UNDERCARRIAGE, FLAP &
FUEL JETTISON CONTROLS.

BOMB BAY WITH
CENTRAL PARTITION

FuG 102 RADIO ALTIMETER (PULSED)

FuG 101 RADIO ALTIMETER (F.M.)

7·9 mm GUN, 500 ROUNDS, BELT-FED
FREE MOUNTING.

7·9 mm, 500 ROUNDS, BELT-FED,
FREE MOUNTING IN ARMOURED
ENCLOSURE.

LOWER SECTION OF NOSE
MAY BE ARMOURED

V.D.M., 4 BLADE V.P. PROPELLOR
FITTED WITH BLADE ROOT CUFFS

LOTFE 7 D BOMBSIGHT

DAIMLER-BENZ 610 ENGINES
COMPOSED OF 2 x 605, INTER-CONNECTED
BY DOG-CLUTCHES, IN EACH NACELLE.

PILOTS SEAT
ARMOURED

20 mm GUN, 250 ROUNDS, BELT-FED,
FREE MOUNTING IN ARMOURED 'BOLA'
WITH BULLET-PROOF GLASS SCREEN.

PAIR OF SINGLE-WHEEL OLEO-LEG
RETRACTING SEPARATELY.

Heinkel He 177

Aerodynamically, in terms of handling and performance, the He 177 strategic bomber had a sound design that received favorable reports from most pilots. The long wings and sleek fuselage gave the He 177 a healthy range of 3,417 miles (5500 km). However, its twin-engine appearance concealed a major flaw. The He 177 was in fact a four-engine bomber with two coupled engines in each nacelle driving a single propeller. This engine arrangement was a total failure. The engines overheated and frequently caught fire, earning the bomber the nickname the "Flaming Coffin" from its crews. Because of the pressure to get the He 177 into action, the engine problems were never fully addressed and early production models of the He 177 were in fact dangerous to fly. The most important units to use the He 177 were KG 40 and KG 100 for maritime attack and reconnaissance based on the French coast. Anti-shipping operations from France came to an end in the summer of 1944. Just over 1,000 He 177s were produced.

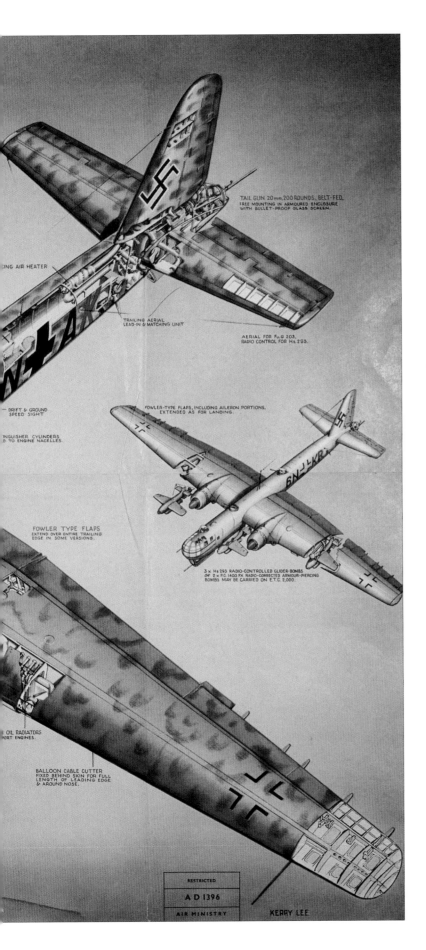

TAIL GUN 20 mm, 200 ROUNDS, BELT-FED, FREE MOUNTING IN ARMOURED ENCLOSURE WITH BULLET-PROOF GLASS SCREEN.

ING AIR HEATER

TRAILING AERIAL LEAD-IN & MATCHING UNIT

AERIAL FOR Fu.G 203, RADIO CONTROL FOR Hs 293.

— DRIFT & GROUND SPEED SIGHT

INGUISHER CYLINDERS .D TO ENGINE NACELLES.

FOWLER-TYPE FLAPS, INCLUDING AILERON PORTIONS, EXTENDED AS FOR LANDING.

FOWLER TYPE FLAPS EXTEND OVER ENTIRE TRAILING EDGE IN SOME VERSIONS.

3 x Hs 293 RADIO-CONTROLLED GLIDER-BOMBS OR 2 x P.C. 1400 FX RADIO-CORRECTED ARMOUR-PIERCING BOMBS MAY BE CARRIED ON E.T.C. 2,000.

OIL RADIATORS ORT ENGINES.

BALLOON CABLE CUTTER FIXED BEHIND SKIN FOR FULL LENGTH OF LEADING EDGE & AROUND NOSE.

RESTRICTED

A D 1396

AIR MINISTRY

KERRY LEE

Messerschmitt Me 410

The Me 410 was a direct descendant of the unsuccessful Me 210. This "new" design was really just a continuation of the Me 210. With slight physical changes — an 8-inch (20 cm) extension of the engine cowlings to accommodate the larger DB603 engines, a rear fuselage extension of 14 inches (36 cm) and wing slats — the Me 410 had similar performance and better flight characteristics. The Me 410 entered operational service during the spring of 1943. Originally designed to replace the Bf 110, the Me 210/410 never did live up to expectations and served for only a short period of time. Only 702 Me 410s were delivered to Luftwaffe units before production ceased.

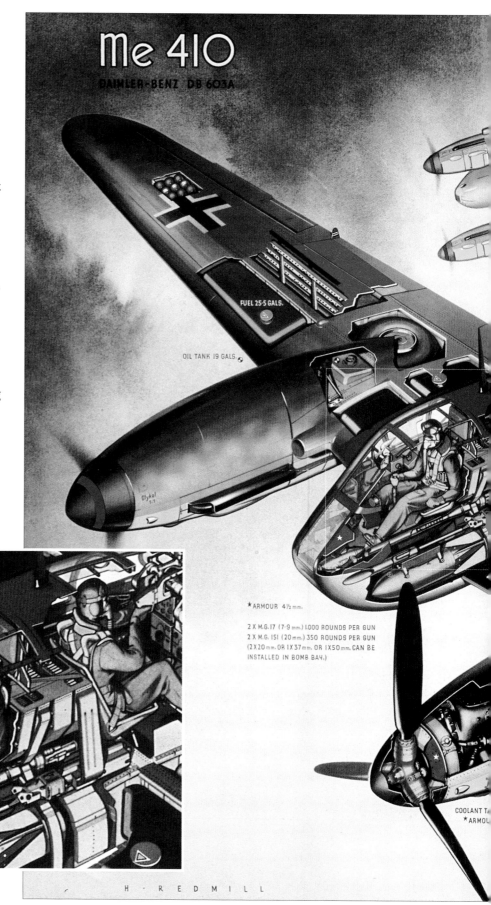

Me 410
DAIMLER-BENZ DB 603A

FUEL 25·5 GALS.

OIL TANK 19 GALS.

Glykol 1:1

*ARMOUR 4½ mm.

2 X M.G.17 (7·9 mm.) 1,000 ROUNDS PER GUN
2 X M.G. 151 (20 mm.) 350 ROUNDS PER GUN
(2X20 mm. OR 1X37mm. OR 1X50 mm. CAN BE
INSTALLED IN BOMB BAY.)

COOLANT T
*ARMOU

H · REDMILL

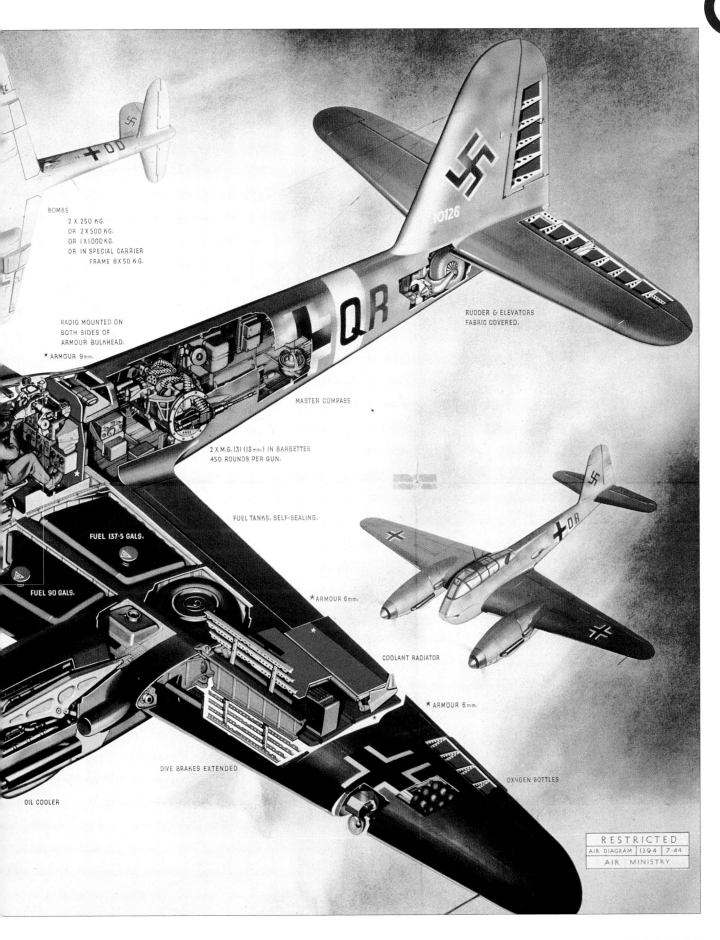

BOMBS
2 X 250 KG.
OR 2 X 500 KG.
OR 1 X 1,000 KG.
OR IN SPECIAL CARRIER
 FRAME 8 X 50 KG.

RADIO MOUNTED ON
BOTH SIDES OF
ARMOUR BULKHEAD.

★ ARMOUR 9mm.

RUDDER & ELEVATORS
FABRIC COVERED.

MASTER COMPASS

2 X M.G. 131 (13mm.) IN BARBETTES
450 ROUNDS PER GUN.

FUEL TANKS, SELF-SEALING.

FUEL 137·5 GALS.

FUEL 90 GALS.

★ ARMOUR 6mm.

COOLANT RADIATOR

★ ARMOUR 6mm.

DIVE BRAKES EXTENDED

OIL COOLER

OXYGEN BOTTLES

RESTRICTED
AIR DIAGRAM | 1394 | 7·44
AIR MINISTRY

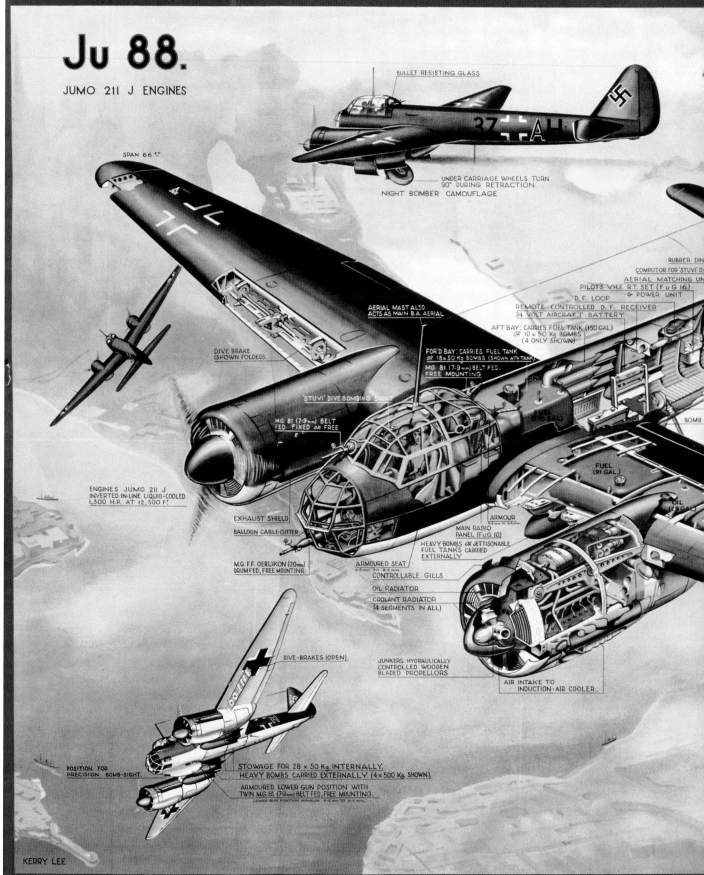

Ju 88.

JUMO 211 J ENGINES

BULLET RESISTING GLASS

UNDER CARRIAGE WHEELS TURN 90° DURING RETRACTION

NIGHT BOMBER CAMOUFLAGE

SPAN 66'

AERIAL MAST ALSO ACTS AS MAIN B.A. AERIAL

DIVE BRAKE (SHOWN FOLDED).

RUBBER DIN

COMPUTOR FOR 'STUVI' D

AERIAL MATCHING UN

PILOTS V.H.F. R.T. SET (FuG 16)
& POWER UNIT

D. F. LOOP

REMOTE CONTROLLED D. F. RECEIVER

24 VOLT AIRCRAFT BATTERY

AFT BAY: CARRIES FUEL TANK (150 GAL)
OR 10 x 50 Kg BOMBS (4 ONLY SHOWN)

FOR'D BAY: CARRIES FUEL TANK
OR 18 x 50 Kg BOMBS (SHOWN WITH TANK)

MG 81 (7·9 mm) BELT FED.
FREE MOUNTING.

'STUVI' DIVE BOMBING SIGHT

MG 81 (7·9 mm) BELT
FED FIXED OR FREE

ENGINES JUMO 211 J
INVERTED IN-LINE LIQUID-COOLED
1,300 H.P. AT 12,500 F.

EXHAUST SHIELD

BALLOON CABLE-CUTTER

M.G. F.F. OERLIKON (20 mm)
DRUM FED, FREE MOUNTING.

FUEL
(415 GAL.)

BOMB

FUEL
(91 GAL.)

OIL
(29 GAL.)

ARMOUR
5 mm TO 8·5 mm.

MAIN RADIO
PANEL (FuG 10)

HEAVY BOMBS OR JETTISONABLE
FUEL TANKS CARRIED
EXTERNALLY

ARMOURED SEAT
4·5 mm TO 8·5 mm.

CONTROLLABLE GILLS

OIL RADIATOR

COOLANT RADIATOR
(4 SEGMENTS IN ALL)

JUNKERS HYDRAULICALLY
CONTROLLED WOODEN
BLADED PROPELLORS

AIR INTAKE TO
INDUCTION-AIR COOLER.

DIVE-BRAKES (OPEN).

POSITION FOR
PRECISION BOMB-SIGHT

STOWAGE FOR 28 x 50 Kg INTERNALLY.
HEAVY BOMBS CARRIED EXTERNALLY (4 x 500 Kg. SHOWN).

ARMOURED LOWER GUN POSITION WITH
TWIN M.G. 81 (7·9 mm) BELT FED, FREE MOUNTING.
LOWER GUN POSITION ARMOUR 5·5 mm TO 8·5 mm.

KERRY LEE

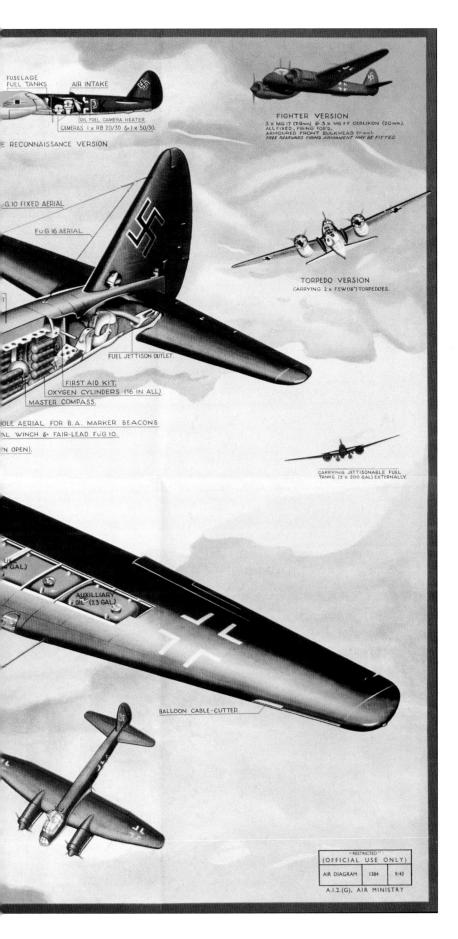

FUSELAGE
FUEL TANKS
AIR INTAKE

OIL FUEL CAMERA HEATER.
CAMERAS 1 x RB 20/30 & 1 x 50/30.

E RECONNAISSANCE VERSION

FIGHTER VERSION
3 x MG 17 (7.9 mm) & 3 x MG FF OERLIKON (20 mm).
ALL FIXED, FIRING FOR'D.
ARMOURED FRONT BULKHEAD (11 mm).
FREE REARWARDS FIRING ARMAMENT MAY BE FITTED

.G. 10 FIXED AERIAL

FuG 16 AERIAL

FUEL JETTISON OUTLET.

TORPEDO VERSION
CARRYING 2 x F5W (18") TORPEDOES.

FIRST AID KIT.
OXYGEN CYLINDERS (16 IN ALL)
MASTER COMPASS.

OLE AERIAL FOR B.A. MARKER BEACONS
AL WINCH & FAIR-LEAD FuG 10.

N OPEN).

CARRYING JETTISONABLE FUEL
TANKS (2 x 200 GAL) EXTERNALLY.

GAL)

AUXILLIARY
OIL (23 GAL)

BALLOON CABLE-CUTTER

"RESTRICTED"
(OFFICIAL USE ONLY)

| AIR DIAGRAM | 1384 | 9/43 |

A.I.2.(G), AIR MINISTRY

Junkers Ju 88

The Ju 88 was designed as a tactical bomber with a moderate range. Normal fuel capacity was only 1,677 liters (369 Imp gal) in tanks between the spars inboard and outboard of the engines. To increase its range, many versions of the Ju 88 were plumbed with a large fuel tank in the bomb bay. At the bottom right of this air diagram under the "Official Use Only" box is the designation A.I. 2 (G). The A.I. stood for Air Intelligence. The Number 2 designated the intelligence section, which dealt with four different areas: (A) Aircraft Industries and Production, (B) Airfields, (C) Liaison with Ministry of Economic Warfare and Ministry of Aircraft Production, and (G) Aircraft and Aeronautical Equipment.

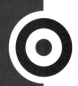

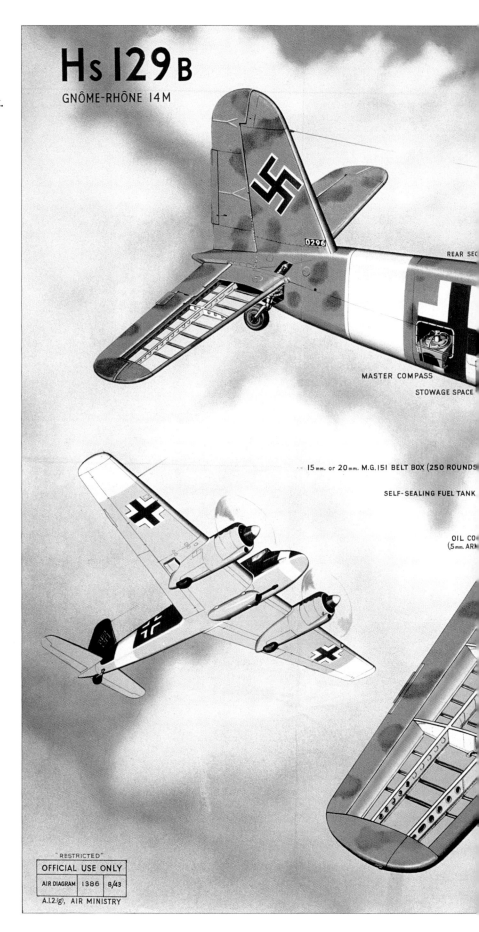

Henschel Hs 129B

The Hs 129 was not built in great numbers. It served for a short time in North Africa and on the Eastern Front. Armed with a 30 mm cannon, the Hs 129 proved a very effective anti-tank aircraft. In the summer of 1943 a captured example from North Africa was brought to Britain, where Peter Castle had a chance to sketch the unassembled pieces.

Hs 129B

GNÔME-RHÔNE 14M

0296

REAR SEC

MASTER COMPASS

STOWAGE SPACE

15 mm. or 20 mm. M.G. 151 BELT BOX (250 ROUNDS

SELF-SEALING FUEL TANK

OIL CO
(5 mm. ARM

"RESTRICTED"
OFFICIAL USE ONLY
AIR DIAGRAM 1386 8/43
A.I.2.(g), AIR MINISTRY

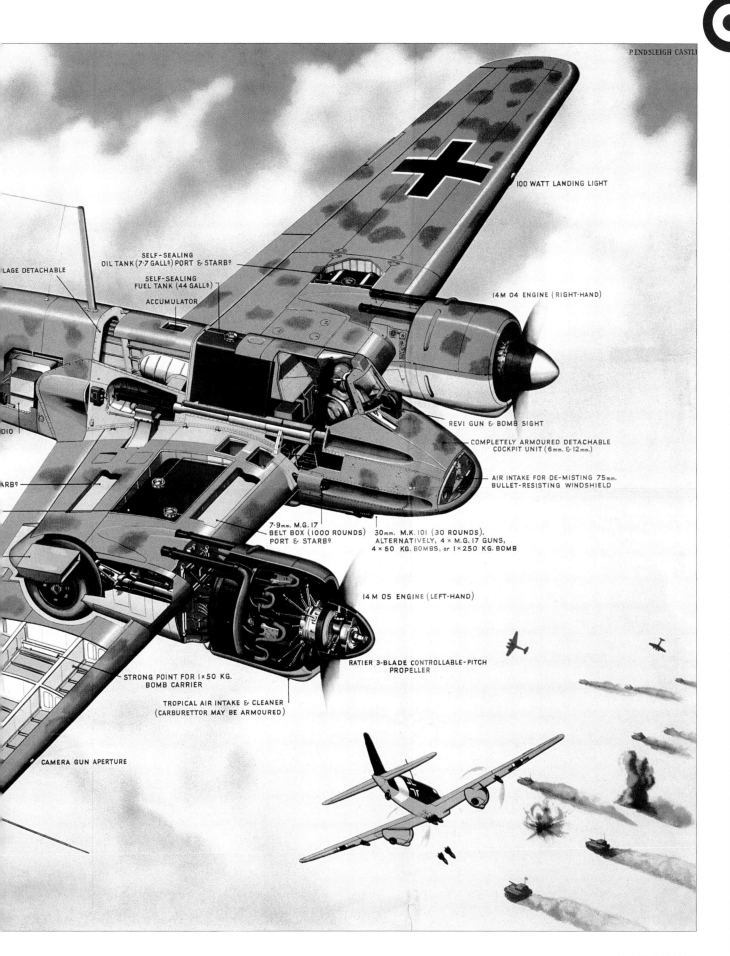

P. ENDSLEIGH CASTLE

100 WATT LANDING LIGHT

SELF-SEALING
OIL TANK (7·7 GALL^S) PORT & STARB^D

SELF-SEALING
FUEL TANK (44 GALL^S)

ACCUMULATOR

LAGE DETACHABLE

14M 04 ENGINE (RIGHT-HAND)

DIO

REVI GUN & BOMB SIGHT

COMPLETELY ARMOURED DETACHABLE
COCKPIT UNIT (6mm. & 12mm.)

ARB^D

AIR INTAKE FOR DE-MISTING 75mm.
BULLET-RESISTING WINDSHIELD

7·9mm. M.G. 17
BELT BOX (1000 ROUNDS)
PORT & STARB^D

30mm. M.K. 101 (30 ROUNDS).
ALTERNATIVELY, 4 × M.G. 17 GUNS,
4 × 50 KG. BOMBS, or 1 × 250 KG. BOMB

14 M 05 ENGINE (LEFT-HAND)

RATIER 3-BLADE CONTROLLABLE-PITCH
PROPELLER

STRONG POINT FOR 1 × 50 KG.
BOMB CARRIER

TROPICAL AIR INTAKE & CLEANER
(CARBURETTOR MAY BE ARMOURED)

CAMERA GUN APERTURE

Junkers Ju 188

The Ju 188 was probably the best medium bomber produced by Germans during the war. It was also a sign that the Germans were losing. By the time the Ju 188 entered service in May 1943, aircraft production was shifting rapidly to fighter production. The need for more fighters meant the Germans were bolstering their defenses and not investing in offensive weapons such as bombers.

The Ju 188 was a great improvement over the famous Ju 88. It handled better, was able to perform better at high weights and was able to use the more powerful BMW 801 engines to their full extent. While 15,000 Ju 88s were produced during the war, only 1,076 Ju 188s left the production line. At the end of the war the French recognized the excellent qualities of the Ju 188. The new French Air Force put at least 30 Ju 188s back into service for a short period of time. The camouflage pattern on Peter Castle's Ju 188 seems to be the standard maritime finish of blue-gray meander over dark green.

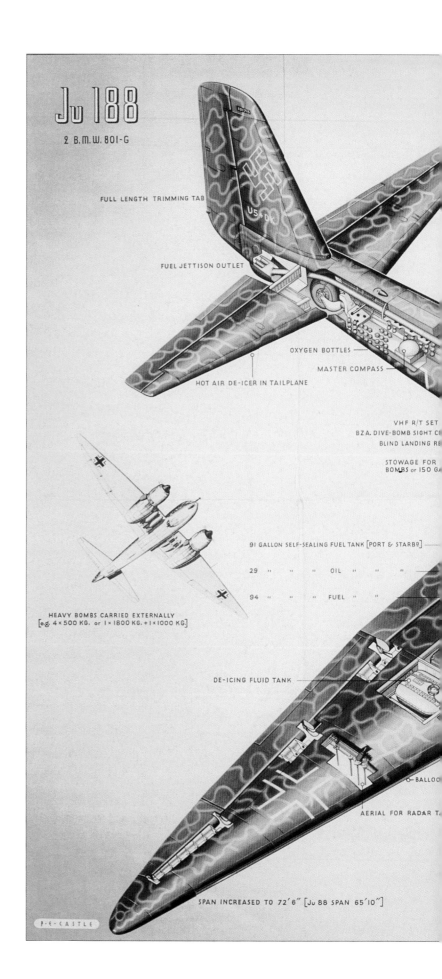

Ju 188
2 B.M.W. 801-G

FULL LENGTH TRIMMING TAB

FUEL JETTISON OUTLET

OXYGEN BOTTLES

MASTER COMPASS

HOT AIR DE-ICER IN TAILPLANE

VHF R/T SET
B.Z.A. DIVE-BOMB SIGHT C
BLIND LANDING RE

STOWAGE FOR
BOMBS or 150 GA

91 GALLON SELF-SEALING FUEL TANK [PORT & STARB⁰]

29 " " " OIL " " "

94 " " " FUEL " "

HEAVY BOMBS CARRIED EXTERNALLY
[e.g. 4 × 500 KG. or 1 × 1800 KG. + 1 × 1000 KG.]

DE-ICING FLUID TANK

BALLOO

AERIAL FOR RADAR T

SPAN INCREASED TO 72'6" [Ju 88 SPAN 65'10"]

P·E·CASTLE

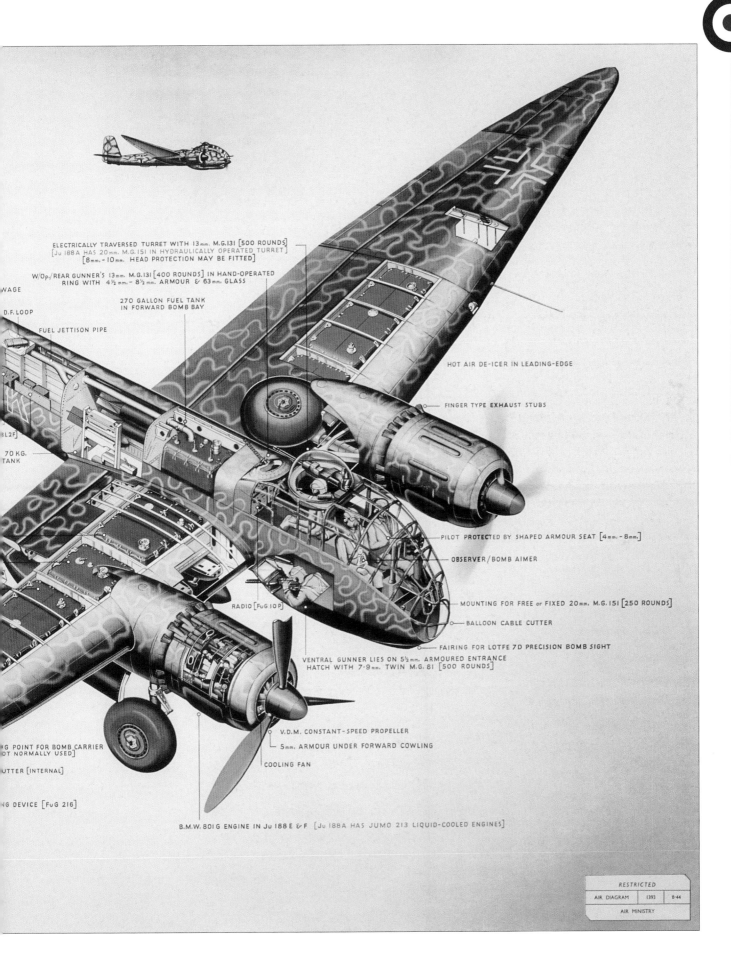

ELECTRICALLY TRAVERSED TURRET WITH 13mm. M.G.131 [500 ROUNDS]
[Ju 188A HAS 20mm. M.G.151 IN HYDRAULICALLY OPERATED TURRET]
[8mm.–10mm. HEAD PROTECTION MAY BE FITTED]

W/Op./REAR GUNNER'S 13mm. M.G.131 [400 ROUNDS] IN HAND-OPERATED
RING WITH 4½mm. – 8½mm. ARMOUR & 63mm. GLASS

WAGE

D.F. LOOP

FUEL JETTISON PIPE

270 GALLON FUEL TANK
IN FORWARD BOMB BAY

BL2F]

70 KG.
TANK

HOT AIR DE-ICER IN LEADING-EDGE

FINGER TYPE EXHAUST STUBS

PILOT PROTECTED BY SHAPED ARMOUR SEAT [4mm. – 8mm.]

OBSERVER/BOMB AIMER

RADIO [FuG 10 P]

MOUNTING FOR FREE or FIXED 20mm. M.G.151 [250 ROUNDS]

BALLOON CABLE CUTTER

FAIRING FOR LOTFE 7D PRECISION BOMB SIGHT

VENTRAL GUNNER LIES ON 5½mm. ARMOURED ENTRANCE
HATCH WITH 7·9mm. TWIN M.G. 81 [500 ROUNDS]

G POINT FOR BOMB CARRIER
OT NORMALLY USED]

UTTER [INTERNAL]

G DEVICE [FuG 216]

V.D.M. CONSTANT-SPEED PROPELLER

5mm. ARMOUR UNDER FORWARD COWLING

COOLING FAN

B.M.W. 801 G ENGINE IN Ju 188 E & F [Ju 188A HAS JUMO 213 LIQUID-COOLED ENGINES]

RESTRICTED

AIR DIAGRAM	1393	B·44
AIR MINISTRY		

Flying Bomb

The first cruise missile used in action was the Vergeltungswaffe 1 (Revenge No. 1 or V1), alias Fieseler Fi 103. Nicknamed "Doodlebug" in Britain, the V1 was launched in large numbers against London and other targets starting in June 1944.

The V1 was not manufactured to normal aircraft tolerances. This made for large variations in performance. The majority of V1s flew at around 350 miles per hour, others were tracked at 420, and the slowest came in at around 320. Launch time from the Pas de Calais in France to London averaged between 20 and 25 minutes.

Just over 10,000 V1s were launched against England. Of the 7,488 that crossed the British coast, 3,957 were shot down short of their targets (more than 10 percent of all V1s launched crashed shortly after takeoff). Of the 3,531 that made it through the defenses, 2,419 reached London, 30 of them hitting Southampton and Portsmouth. There were 6,184 people killed during the first cruise missile attack in history.

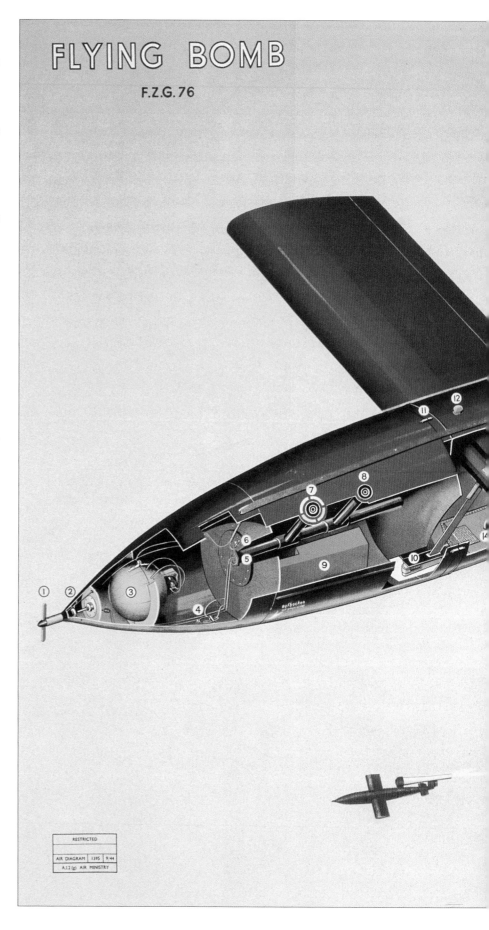

FLYING BOMB

F.Z.G.76

RESTRICTED

AIR DIAGRAM	1395	9/44

A.12 (g) AIR MINISTRY

GRAPHIC WAR

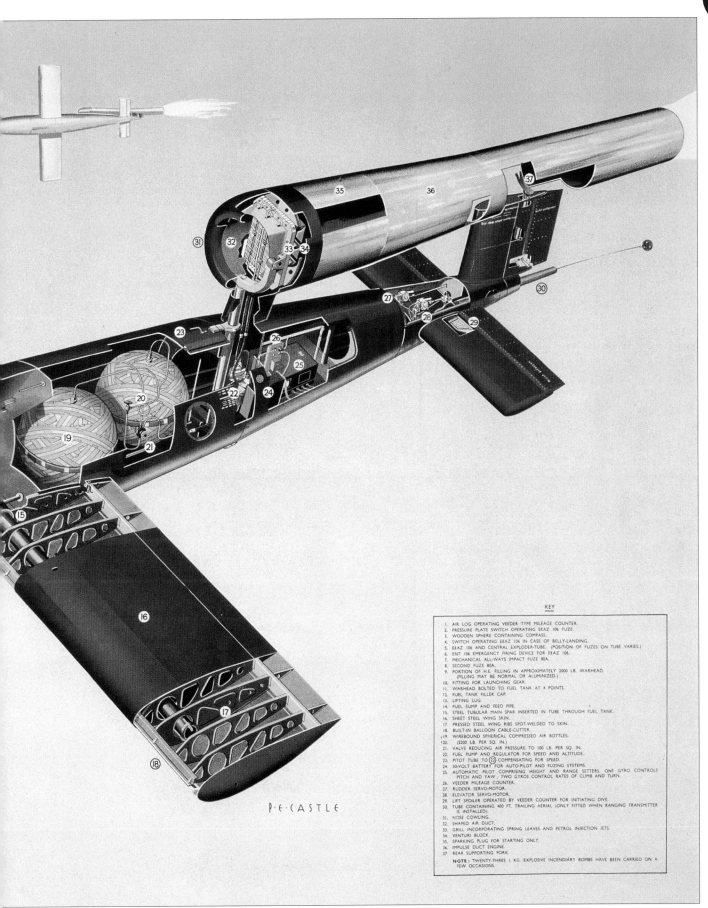

GREAT BRITAIN

P·E·CASTLE

KEY

1. AIR LOG OPERATING VEEDER TYPE MILEAGE COUNTER.
2. PRESSURE PLATE SWITCH OPERATING EEAZ 106 FUZE.
3. WOODEN SPHERE CONTAINING COMPASS.
4. SWITCH OPERATING EEAZ 106 IN CASE OF BELLY-LANDING.
5. EEAZ 106 AND CENTRAL EXPLODER-TUBE. (POSITION OF FUZES ON TUBE VARIES.)
6. ENT 106. EMERGENCY FIRING DEVICE FOR EEAZ 106.
7. MECHANICAL ALL-WAYS IMPACT FUZE 80A.
8. SECOND FUZE 80A.
9. PORTION OF H.E. FILLING IN APPROXIMATELY 2000 LB. WARHEAD. (FILLING MAY BE NORMAL OR ALUMINIZED.)
10. FITTING FOR LAUNCHING GEAR.
11. WARHEAD BOLTED TO FUEL TANK AT 4 POINTS.
12. FUEL TANK FILLER CAP.
13. LIFTING LUG.
14. FUEL SUMP AND FEED PIPE.
15. STEEL TUBULAR MAIN SPAR INSERTED IN TUBE THROUGH FUEL TANK.
16. SHEET STEEL WING SKIN.
17. PRESSED STEEL WING RIBS SPOT-WELDED TO SKIN.
18. BUILT-IN BALLOON CABLE-CUTTER.
19. WIREBOUND SPHERICAL COMPRESSED AIR BOTTLES.
20. (2200 LB. PER SQ. IN.)
21. VALVE REDUCING AIR PRESSURE TO 100 LB. PER SQ. IN.
22. FUEL PUMP AND REGULATOR FOR SPEED AND ALTITUDE.
23. PITOT TUBE TO (22) COMPENSATING FOR SPEED.
24. 30-VOLT BATTERY FOR AUTO-PILOT AND FUZING SYSTEMS.
25. AUTOMATIC PILOT COMPRISING HEIGHT AND RANGE SETTERS. ONE GYRO CONTROLS PITCH AND YAW; TWO GYROS CONTROL RATES OF CLIMB AND TURN.
26. VEEDER MILEAGE COUNTER.
27. RUDDER SERVO-MOTOR.
28. ELEVATOR SERVO-MOTOR.
29. LIFT SPOILER OPERATED BY VEEDER COUNTER FOR INITIATING DIVE.
30. TUBE CONTAINING 400 FT. TRAILING AERIAL (ONLY FITTED WHEN RANGING TRANSMITTER IS INSTALLED).
31. NOSE COWLING.
32. SHAPED AIR DUCT.
33. GRILL INCORPORATING SPRING LEAVES AND PETROL INJECTION JETS.
34. VENTURI BLOCK.
35. SPARKING PLUG FOR STARTING ONLY.
36. IMPULSE DUCT ENGINE.
37. REAR SUPPORTING FORK.

NOTE : TWENTY-THREE 1 KG. EXPLOSIVE INCENDIARY BOMBS HAVE BEEN CARRIED ON A FEW OCCASIONS.

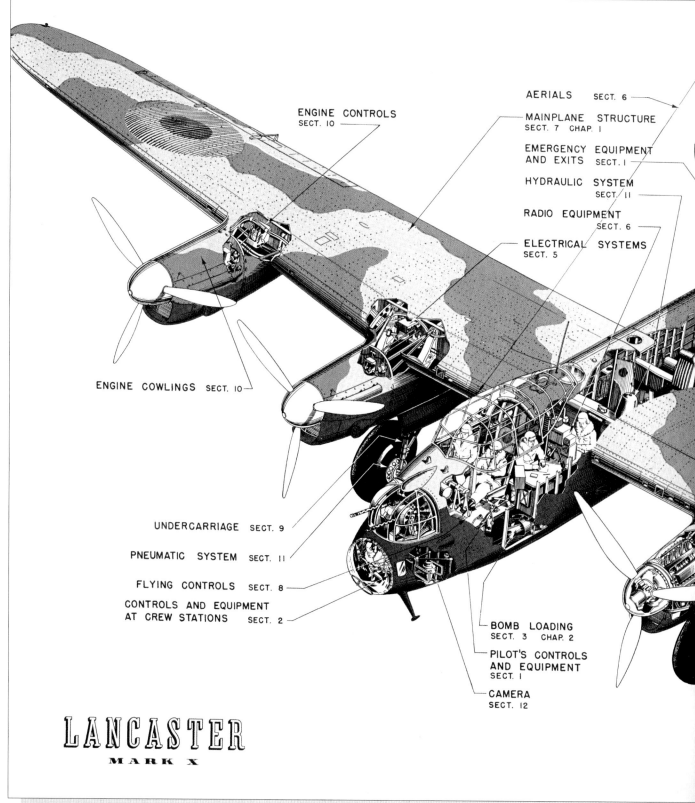

ENGINE CONTROLS
SECT. 10

AERIALS SECT. 6

MAINPLANE STRUCTURE
SECT. 7 CHAP. 1

EMERGENCY EQUIPMENT
AND EXITS SECT. 1

HYDRAULIC SYSTEM
SECT. 11

RADIO EQUIPMENT
SECT. 6

ELECTRICAL SYSTEMS
SECT. 5

ENGINE COWLINGS SECT. 10

UNDERCARRIAGE SECT. 9

PNEUMATIC SYSTEM SECT. 11

FLYING CONTROLS SECT. 8

CONTROLS AND EQUIPMENT
AT CREW STATIONS SECT. 2

BOMB LOADING
SECT. 3 CHAP. 2

PILOT'S CONTROLS
AND EQUIPMENT
SECT. 1

CAMERA
SECT. 12

LANCASTER
MARK X

Lancaster Mk X

This richly detailed partial cutaway drawing appears in the
Lancaster Mk X maintenance and descriptive handbook.

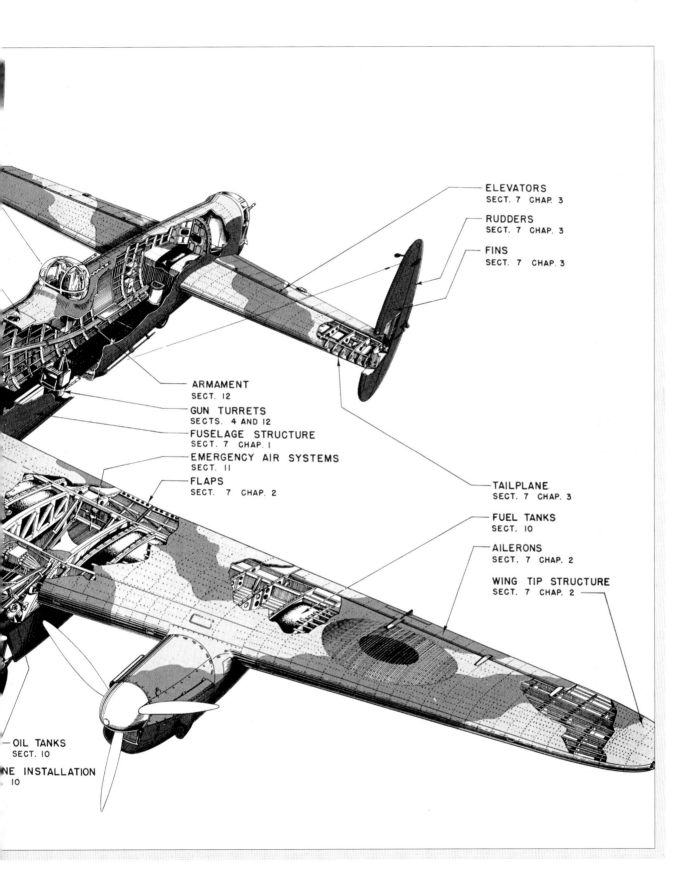

ELEVATORS
SECT. 7 CHAP. 3

RUDDERS
SECT. 7 CHAP. 3

FINS
SECT. 7 CHAP. 3

ARMAMENT
SECT. 12

GUN TURRETS
SECTS. 4 AND 12

FUSELAGE STRUCTURE
SECT. 7 CHAP. 1

EMERGENCY AIR SYSTEMS
SECT. 11

FLAPS
SECT. 7 CHAP. 2

TAILPLANE
SECT. 7 CHAP. 3

FUEL TANKS
SECT. 10

AILERONS
SECT. 7 CHAP. 2

WING TIP STRUCTURE
SECT. 7 CHAP. 2

OIL TANKS
SECT. 10

NE INSTALLATION
10

COLOUR key

- Breaking Down Points
- Plywood Surfaces
- Solid and Laminated Spruce Construction
- Spruce Struts, Balsa Filling Birch Ply Skin
- Ash Stiffeners (Main Spar)
- Metal Structure
- Balsa Wood Planking

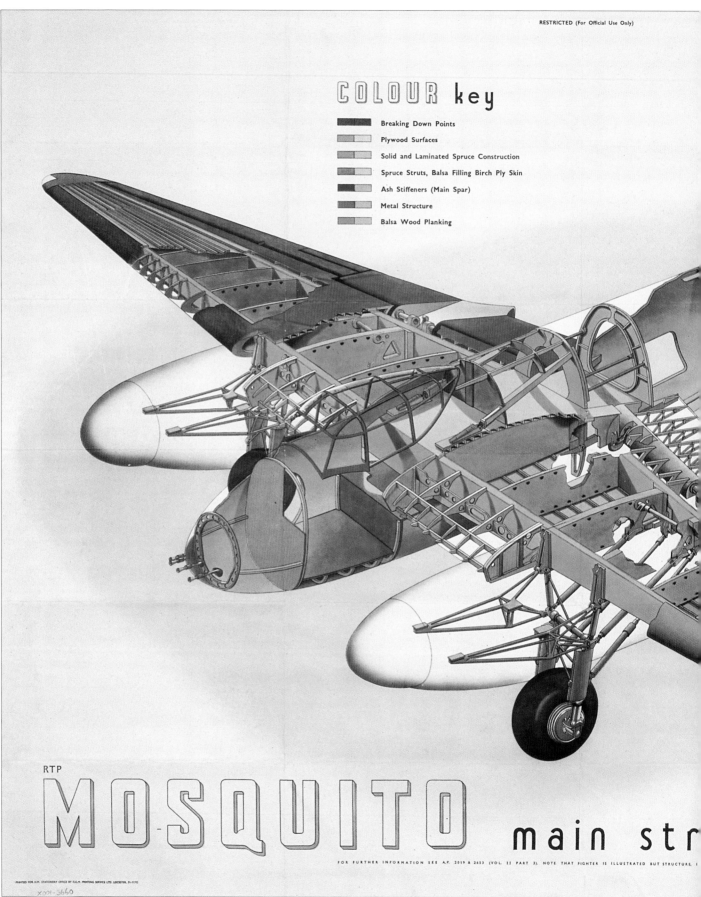

RTP

MOSQUITO main str

FOR FURTHER INFORMATION SEE A.P. 2019 & 2653 (VOL. II PART 3). NOTE THAT FIGHTER IS ILLUSTRATED BUT STRUCTURE, I

PRINTED FOR H.M. STATIONERY OFFICE BY R.C.H. PRINTING SERVICE LTD. LEICESTER. 51-1170

X001-3660

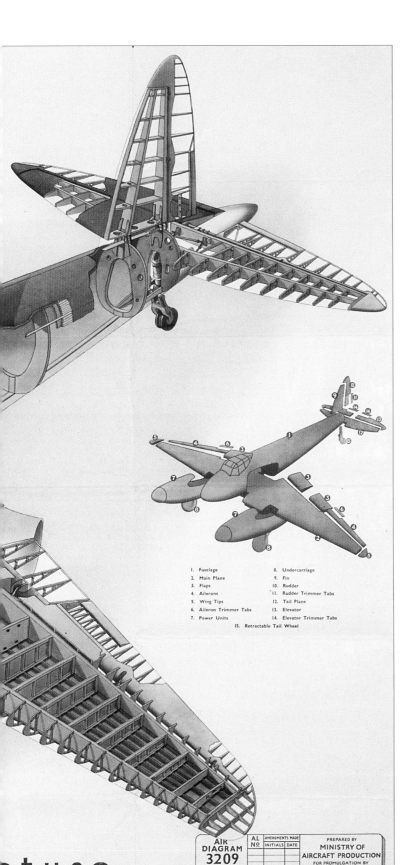

1. Fuselage
2. Main Plane
3. Flaps
4. Ailerons
5. Wing Tips
6. Aileron Trimmer Tabs
7. Power Units
8. Undercarriage
9. Fin
10. Rudder
11. Rudder Trimmer Tabs
12. Tail Plane
13. Elevator
14. Elevator Trimmer Tabs
15. Retractable Tail Wheel

AIR DIAGRAM 3209
SHEET No. 1 No. OF SHEETS 1
JAN. 1945

AL No. | AMENDMENTS MADE | INITIALS | DATE

PREPARED BY
MINISTRY OF
AIRCRAFT PRODUCTION
FOR PROMULGATION BY
AIR MINISTRY

cture
IDENTICAL ON ALL MARKS

Mosquito Main Structure

The de Havilland Mosquito was the first modern all-wood aircraft to enter RAF service and was one of the most successful aircraft of World War II. Through the use of nonstrategic materials, the Mosquito was produced quickly and cheaply, built using a ply-balsa-ply "eggshell" construction. The Mosquito was the fastest operational aircraft of its type to enter service anywhere in the world. The use of wood also meant that spares and serviceable repairs could be readily accessed through subcontracting to firms employing carpenters of average skill. The last of 7,781 Mosquitoes built was completed on November 15, 1950.

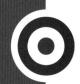

Mosquito F Mk II

This marvelous cutaway drawing highlights the four 20 mm cannon armament of the Mosquito F Mk II fighter. Notably, all fighter versions of the Mosquito were equipped with a fighter-type stick control column and not the bomber-type hand wheel. Maximum speed of de Havilland's first fighter version was an impressive 370 miles per hour (596 km/h).

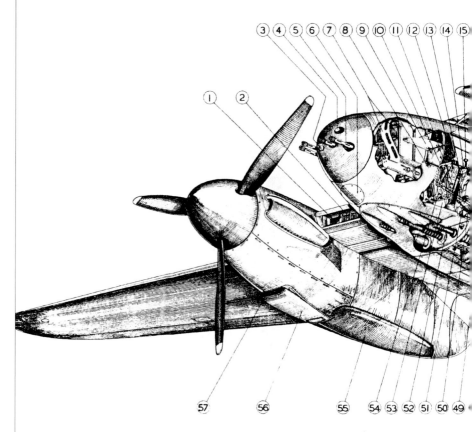

1 OIL COOLER
2 COOLANT RADIATOR
3 NAVIGATION HEADLAMP
4 CAMERA GUN SPOUT
5 ·303 GUNS (FOUR)
6 COVER TO USED CARTRIDGE-CASE CHAMBER
7 AMMUNITION BOXES & FEED CHUTES FOR ·303 GUNS
8 HINGE FOR GUN LOADING DOOR
9 INSPECTION DOOR FOR INSTRUMENT PANEL
10 FOLDING LADDER
11 VENTILATOR CONTROL
12 COMPASS
13 CONTROL COLUMN
14 BRAKE LEVER

15 FIRING SWITCHES
16 SLIDING WINDOW
17 OXYGEN REGULATOR
18 EMERGENCY EXIT
19 ENGINE & PROPELLER C
20 COCKPIT LAMP
21 PILOT'S SEAT AND HAF
22 OBSERVER'S SEAT AND
23 CONSTANT SPEED UNIT
24 FLAME-TRAP EXHAUST
25 OUTBOARD FUEL TANKS
26 LANDING LAMP
27 NAVIGATION LAMP
28 FORMATION KEEPING L
29 PITOT HEAD (PRESSURE
30 AERIAL FOR T.R.1133
31 TAIL NAVIGATION LAMP

MOSC

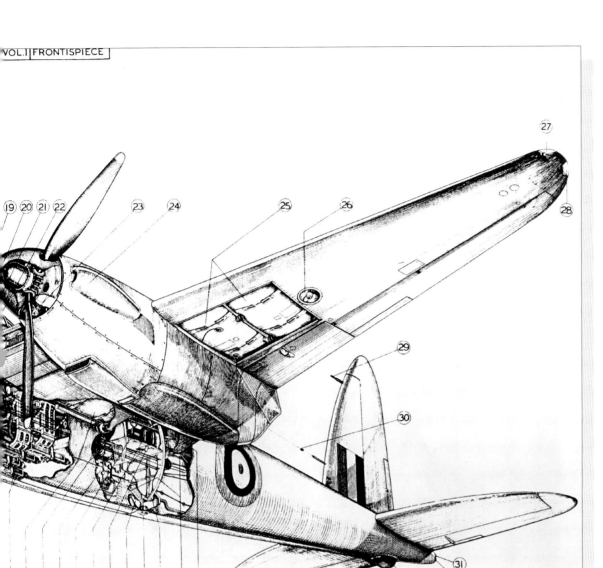

32 FORMATION KEEPING LAMP
33 TAIL-WHEEL (RETRACTED)
34 BLIND APPROACH UNIT
35 T.R.1133 WIRELESS (DUPLICATED)
36 CRASH SWITCH (R.3078)
37 DOWNWARD IDENTIFICATION LAMP
38 ENTRANCE DOOR TO
 REAR FUSELAGE
39 LONG RANGE FUEL-
 TANK BEARER
40 OXYGEN BOTTLES
41 ACCUMULATORS
42 HYDRAULIC - PNEUMATIC PANEL
43 COMPRESSED AIR CYLINDERS
44 INBOARD FUEL TANKS
45 AMMUNITION BOXES & FEED CHUTES
 FOR 20MM. GUNS

46 LINK AND CARTRIDGE CASE
 CHUTES
47 DE-ICING TANK
48 ELEVATOR TRIM HAND-WHEEL
49 PILOT'S SEAT ADJUSTING-LEVER
50 SANITARY CONTAINER
51 FIRST-AID BOX
52 20 MM. GUNS (FOUR)
53 ENTRANCE DOOR
54 RUDDER PEDALS
55 UNDERCARRIAGE WHEEL DOORS
56 AIR INTAKE
57 ICE GUARD

BOX

ITO F. MK II

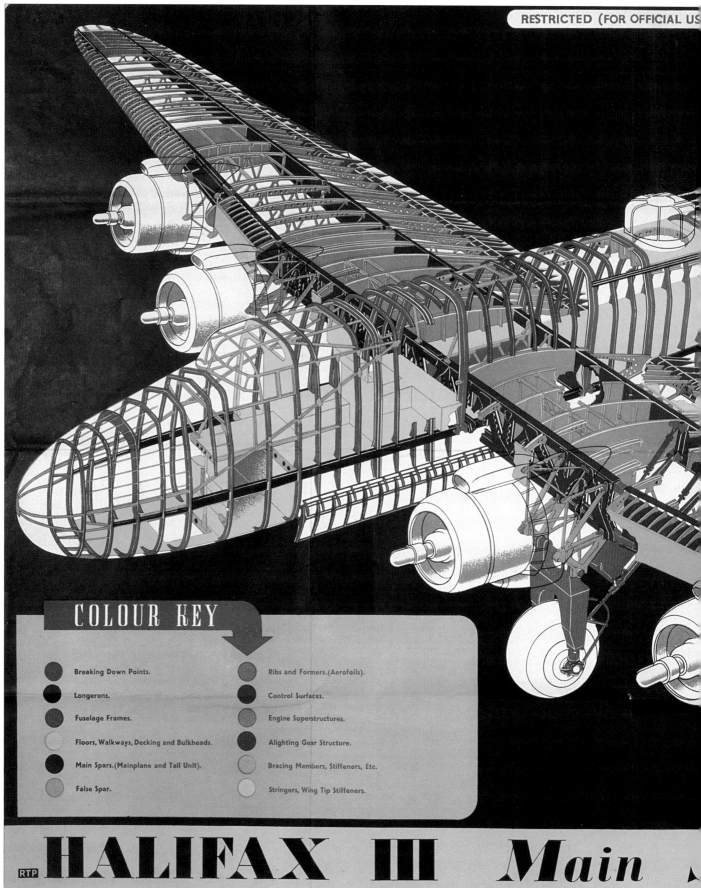

RESTRICTED (FOR OFFICIAL US

COLOUR KEY

- Breaking Down Points.
- Longerons.
- Fuselage Frames.
- Floors, Walkways, Decking and Bulkheads.
- Main Spars.(Mainplane and Tail Unit).
- False Spar.

- Ribs and Formers.(Aerofoils).
- Control Surfaces.
- Engine Superstructures.
- Alighting Gear Structure.
- Bracing Members, Stiffeners, Etc.
- Stringers, Wing Tip Stiffeners.

RTP HALIFAX III *Main*

Halifax III Main Structure

The Halifax bomber was a robust and versatile aircraft. Its construction was quite conventional, but it was designed to be built in about fifteen main components. This allowed for a highly dispersed manufacturing base — a safeguard against enemy attack — but also resulted in a slightly heavier airframe because of the number of transport joints.

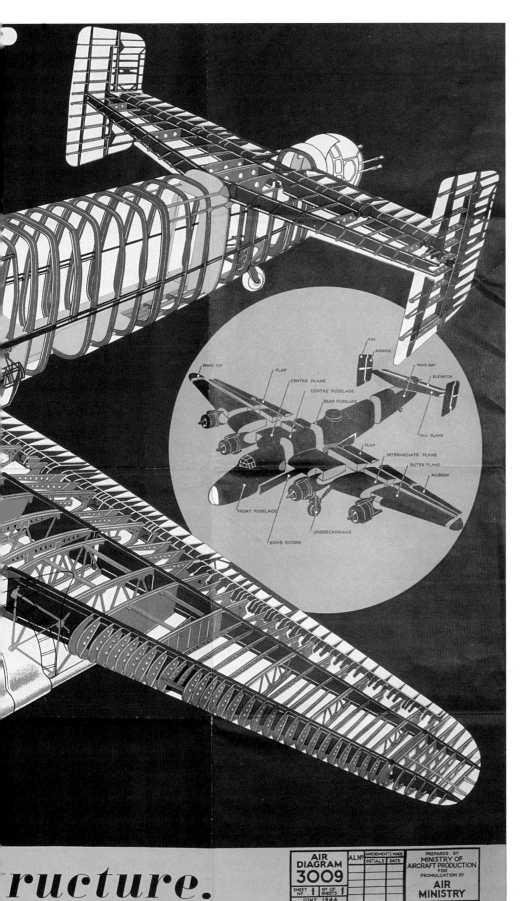

WING TIP · FLAP · CENTRE PLANE · CENTRE FUSELAGE · REAR FUSELAGE · FIN · RUDDER · REAR BAY · ELEVATOR · TAIL PLANE · FLAP · INTERMEDIATE PLANE · OUTER PLANE · AILERON · FRONT FUSELAGE · BOMB DOORS · UNDERCARRIAGE

ructure.

AIR DIAGRAM 3009	A.L.Nº	AMENDMENTS MADE		PREPARED BY MINISTRY OF AIRCRAFT PRODUCTION FOR PROMULGATION BY
		INITIALS	DATE	
SHEET Nº 1	Nº OF SHEETS 1			AIR MINISTRY
JUNE 1944				

Vol. III.—No. 4

AIRCRAFT

RE

THE INTER-SERVICES JOURNAL

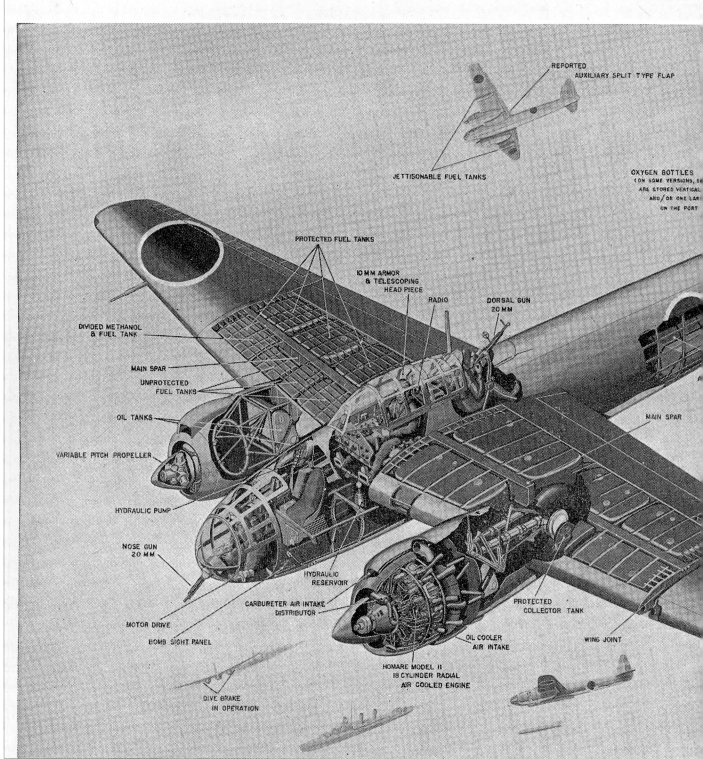

REPORTED
AUXILIARY SPLIT TYPE FLAP

JETTISONABLE FUEL TANKS

OXYGEN BOTTLES
(ON SOME VERSIONS, SE
ARE STORED VERTICAL
AND/OR ONE LAR
ON THE PORT

PROTECTED FUEL TANKS

10 MM ARMOR
& TELESCOPING
HEAD PIECE

RADIO

DORSAL GUN
20 MM

DIVIDED METHANOL
& FUEL TANK

MAIN SPAR

UNPROTECTED
FUEL TANKS

MAIN SPAR

OIL TANKS

VARIABLE PITCH PROPELLER

HYDRAULIC PUMP

NOSE GUN
20 MM

HYDRAULIC
RESERVOIR

PROTECTED
COLLECTOR TANK

MOTOR DRIVE

CARBURETER AIR INTAKE
DISTRIBUTOR

OIL COOLER
AIR INTAKE

WING JOINT

BOMB SIGHT PANEL

DIVE BRAKE
IN OPERATION

HOMARE MODEL II
18 CYLINDER RADIAL
AIR COOLED ENGINE

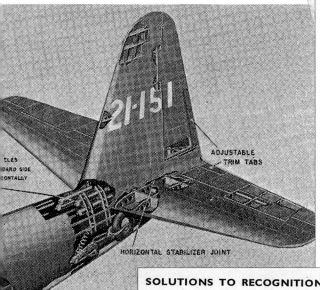

DECEMBER,

OGNITION

TLES
OARD SIDE
IONTALLY

ADJUSTABLE
TRIM TABS

HORIZONTAL STABILIZER JOINT

ED UNPROTECTED FUEL TANK
TTED

FIXED TRIM TAB

CONTROLLAE
TRIM TAI

Aircraft Recognition
The Inter-Services Journal

Aircraft Recognition was a monthly journal published by the Ministry of Aircraft Production. It was lavishly illustrated with aircraft photographs and sillographs. Each month there were numerous identification quizzes with the answers appearing in the back. This cutaway drawing shows a Japanese Yokosuka P1Y1 Ginga twin-engine bomber, code-named Frances by the Allies.

GREAT BRITAIN

SOLUTIONS TO RECOGNITION TESTS IN THIS ISSUE

FRONT COVER : FIREFLY

No. 101 (SILLOGRAPHS)

481.	P–61	491.	Helldiver	501.	B–29
482.	Me 110	492.	Fw 200c	502.	Dakota
483.	Tempest	493.	B–17G	503.	" Oscar "
484.	Hamilcar	494.	Kingcobra	504.	Lancaster
485.	Me 410	495.	He 177	505.	Barracuda
486.	Me 323	496.	P–51	506.	" Zeke "
487.	B–24	497.	Lancaster	507.	" Tony "
488.	Spitfire XII	498.	Ju 290	508.	" Helen "
489.	Hellcat	499.	" Emily "	509.	A–20
490.	Fw 190	500.	Lightning	510.	Ju 52

No. 102 (RECOGNITO) :
Reading from left to right : " Nell," " Tojo," " Lily," B–29.

No. 103 (FLYING PHOTOGRAPHS) :

802.	Fortress	811.	" Betty " 22	821.	" Rufe "
803.	Liberator	812.	Beaufighter	822.	Me 109
804.	Me 410	813.	Me 410	823.	Typhoon
805.	Dakota	814.	" Dinah "	824.	" Nell "
806.	Ju 52	815.	Lancaster	825.	Ju 88
807.	Mitchell	816.	Albemarle	826.	Corsair I
808.	Dakota	817.	Spitfire	827.	IL–2
809.	Avenger	818.	" Tony "	828.	Mosquito
810.	" Emily "	819.	Hurricane	829.	A–20J
		820.	" Sally "		

WE MOVE AGAIN

Please note that the Editorial Offices of the Journal have been moved again. They are now back at :— Ministry of Aircraft Production, Room 202G, 2, Hyde Park Street, London, W.2. Telephone : Ambassador 1290, Ext. 3 & 4.

DON'T HIDE IT !

This Journal, although an official issue, contains no information in a security classification. For this reason it should be given the widest possible circulation among the Services and the R.O.C. for whom it is produced. The text and illustrations are Crown Copyright and the permission of the Controller of H.M. Stationery Office must be obtained before any reproduction is made.

THE EDITORIAL COMMITTEE

The Inter-Services Journal on Aircraft Recognition is published on the first of each month. It is prepared and produced by an Editorial Committee in conjunction with the Aircraft Recognition Branch of the Ministry of Aircraft Production. The members of the Editorial Committee are :—Peter G. Masefield, M.A., A.F.R.Ae.S. (Chairman) ; Leonard Bridgman ; G. Geoffrey Smith, M.B.E. ; D. Jenkins ; Obs./Lt. C. Charles Tapp, M.B.E. ;

Sqd. Ldr. C. H. Blyth, R.A.F.V.R. ; H. L. Gaunt ; Sqd. Ldr. H. F. King, R.A.F.V.R. ; and Mrs. Joan Bradbrooke. All contributions should be addressed to the Inter-Services Journal on Aircraft Recognition, Ministry of Aircraft Production, Room 202G, 2, Hyde Park Street, London, W.2. Telephone Number : Ambassador 1290. Ext. 3 and 4. Articles submitted for publication should not exceed about 1,000 words in length.

2404/Wt. 8199/Dmd. R7108/Gp. 34-224. 168M. 12/44. *Printed under the authority of H.M. Stationery Office by Samson Clark & Co., Ltd., Mortimer Street, London, W.1*

He Who Sees First

"Probably the biggest thing to a fighter pilot is being able to see things — not only to see them, but to interpret them. When he sees fighters too far away to recognize, he should have a fairly good idea whether they are friendly or not by the way they act — by the way they circle a bomber formation or by the way they act when near other fighters that are known to be friendly. This is something that comes pretty much with experience, but a thing that can be practised is just looking and recognizing what you see."

CAPTAIN D. W. BEESON,
334TH FIGHTER
SQUADRON

(RESTRICTED) FOR OFFICIAL USE ONLY

RST LIVES LONGEST

FOR AIRCREWS A.D.2824 SHEET 4

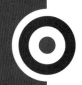

Browning .303 Machine Gun

The Browning .303, Mark II, was the gun fitted to most of the turrets used by the Royal Air Force. Accepted by the Air Staff in the mid-1930s, the Colt-Browning machine gun became the main weapon for all British military aircraft. The Browning was a recoil-operated belt-fed weapon with a cyclic rate of 1,100 to 1,200 rounds per minute. These colorful drawings show the inner workings of the Browning .303 Mk II machine gun.

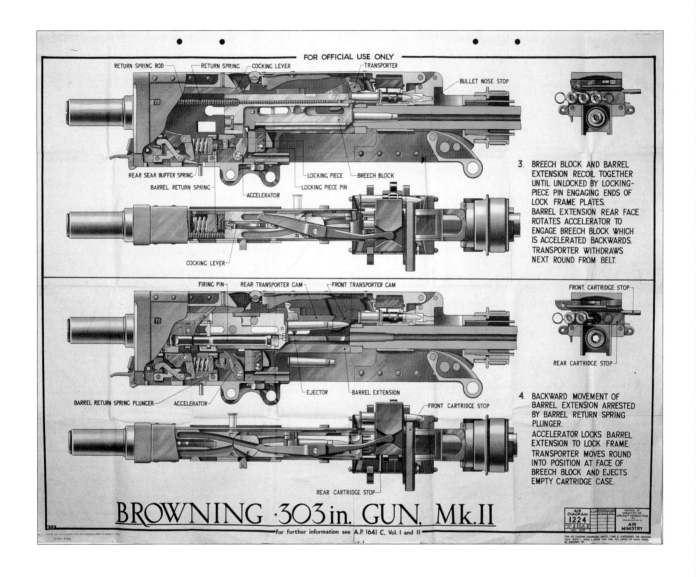

BROWNING ·303 in. GUN, Mk.II

For further information see A.P. 1641 C, Vol. I and II

3. BREECH BLOCK AND BARREL EXTENSION RECOIL TOGETHER UNTIL UNLOCKED BY LOCKING-PIECE PIN ENGAGING ENDS OF LOCK FRAME PLATES. BARREL EXTENSION REAR FACE ROTATES ACCELERATOR TO ENGAGE BREECH BLOCK WHICH IS ACCELERATED BACKWARDS. TRANSPORTER WITHDRAWS NEXT ROUND FROM BELT.

4. BACKWARD MOVEMENT OF BARREL EXTENSION ARRESTED BY BARREL RETURN SPRING PLUNGER. ACCELERATOR LOCKS BARREL EXTENSION TO LOCK FRAME. TRANSPORTER MOVES ROUND INTO POSITION AT FACE OF BREECH BLOCK AND EJECTS EMPTY CARTRIDGE CASE.

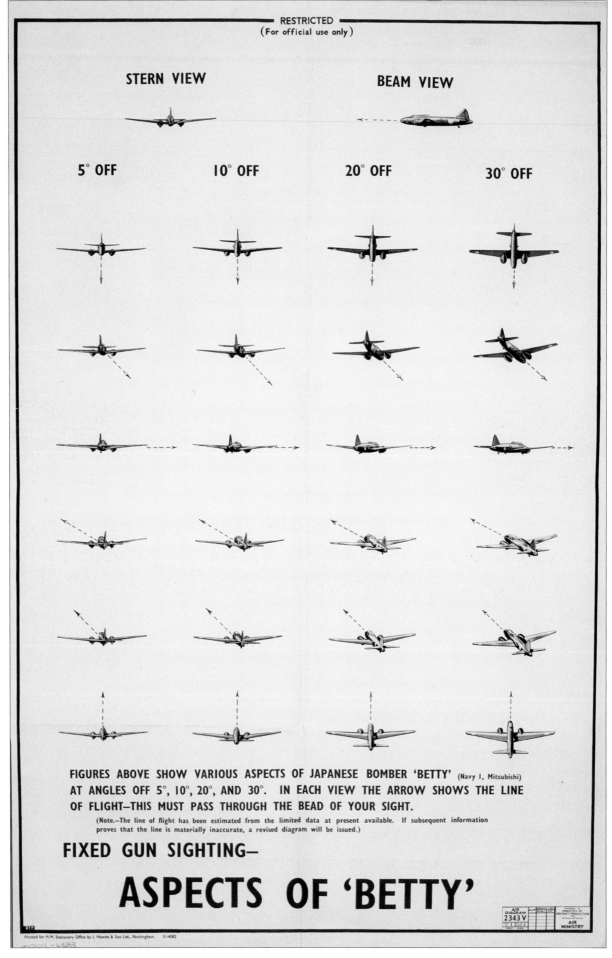

FIXED GUN SIGHTING—

ASPECTS OF 'BETTY'

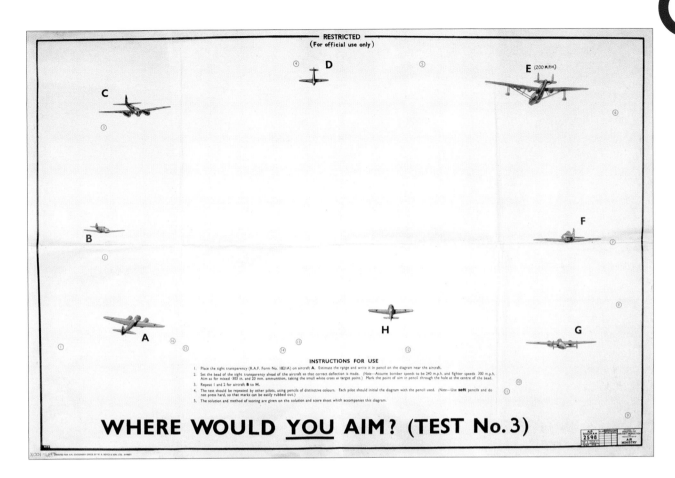

WHERE WOULD YOU AIM? (TEST No. 3)

Where Would You Aim?

"If possible I would avoid deflection shots. The average pilot has a hard time with a lot of deflection. Of course, there are often lucky hits that destroy the Jerry, but there is nothing so effective as a good astern shot."

1ST LIEUTENANT JESSE W. GONNAM, 352ND FIGHTER SQUADRON

"If we, and I speak of the Air Forces as a whole, could only shoot perfectly, we would double our score with no effort at all."

MAJOR WALKER M. MAHURIN, 56TH FIGHTER GROUP

Aspects of Betty (opposite)

World War II fighters were gun platforms. Their striking range was limited to a maximum of 1,000 yards, but in practice this figure was overly optimistic. One of the hardest shots to make in aerial combat was the deflection shot. In order to shoot at a target with high deflection, the attacker had to aim at a point in space somewhere in front of his intended victim. If his aim was true, his bullets and the intended victim would meet at the same time. Under any circumstances this was an extremely difficult shot to make and the vast majority of fighter pilots could not master the art. This chart was designed to help pilots quickly recognize the angle of deflection for a particular type of aircraft.

Lewis Gun

The first aircraft gun turrets of the mid-1930s were armed with the .303-inch Lewis gun. Designed by talented ordnance engineer Colonel Isaac Lewis, the Lewis gun was a gas-operated automatic weapon fed by a drum-shaped magazine. It was air cooled, lightweight and had a self-contained feed system that worked when inverted, making it an ideal aircraft gun.

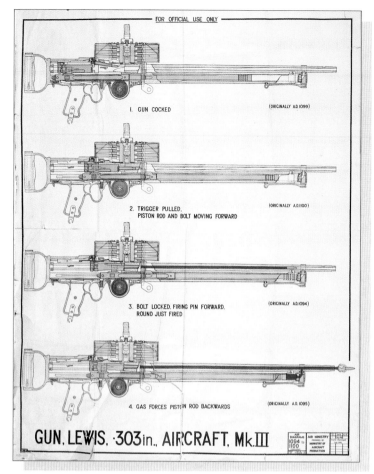

Bullet Trail

Hitting a fast-moving aircraft from another fast-moving aircraft is an extremely difficult task. Gunners had to allow for their own forward speed, plus deflection — the distance the target covered after the bullet left the barrel. The gunner also had to estimate the range to allow for bullet drop. In 1944 a new sight was introduced that greatly improved the gunner's aim. The new Mk II gyro sight gave the pilot/gunner a point of aim allowing for range, bullet drop, and, most important, deflection.

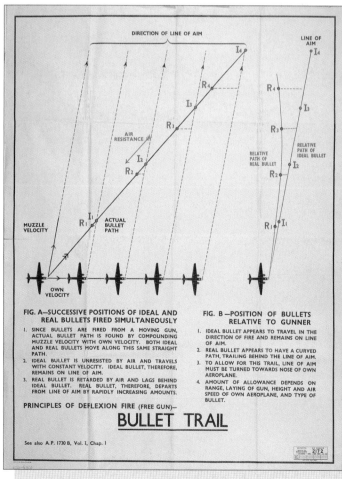

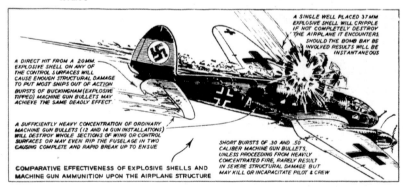

APPROXIMATE EFFECTIVE RANGES OF TYPICAL PROJECTILES COMPARED
NOTE:- SHELL-FIRING FIGHTERS A & B OUTRANGE BOMBER E UNLESS LATTER IS SIMILARLY ARMED — FIGHTERS C & D FIRING EITHER HEAVY OR RIFLE CALIBER BULLETS ARE ALWAYS WITHIN RANGE OF COUNTER FIRE FROM E. DURING ATTACK REGARDLESS OF LATTER'S ARMAMENT.

fully risen, resulting in only a partial engagement of the bents, then as the rear sear is carried forward in this low position, a projection towards the rear strikes an inclined ramp forcing the bents into full engagement.

ADJUSTMENTS

Breeching up of the Barrel

1. "Breeching up" is the term applied to the correct positioning of the breech end of the barrel in relation to the front of the breech block when the breech locking piece is fully engaged in the locking recess.

2. As the efficiency of the gun depends to a great extent on the accuracy with which this adjustment is carried out, it is essential that great care is exercised.

3. When breeching up, ensure that no dummy cartridge or empty case is in the chamber.

4. Assuming that the gun is completely assembled, the following sequence of operations is to be complied with :-

 (a) Raise the locking spring and support it on the side of the barrel extension to prevent it engaging with the notches when screwing up the barrel.

 (b) Start the barrel threads into the barrel extension and stop before the barrel is right home.

Armament: Service Aircrew Manual

These two drawings in the armament section of the *Canadian Service Aircrew Manual* compare the effectiveness of machine gun over cannon shells.

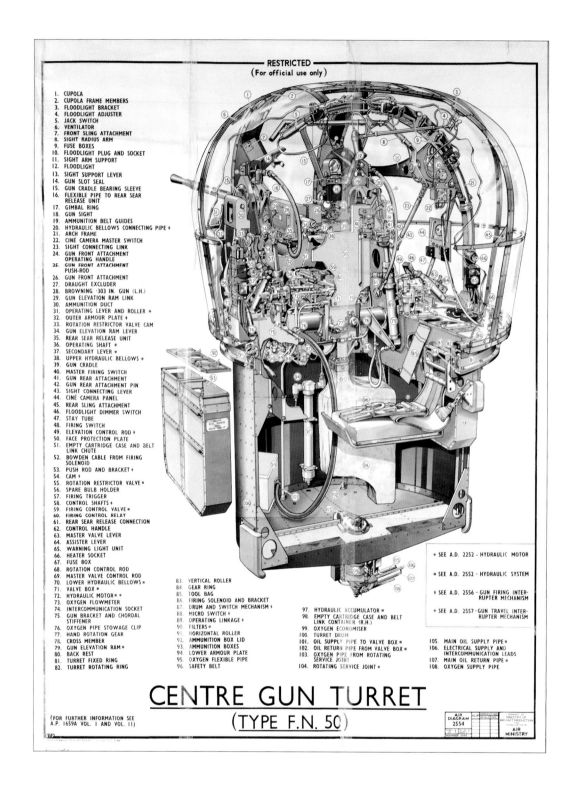

1. CUPOLA
2. CUPOLA FRAME MEMBERS
3. FLOODLIGHT BRACKET
4. FLOODLIGHT ADJUSTER
5. JACK SWITCH
6. VENTILATOR
7. FRONT SLING ATTACHMENT
8. SIGHT RADIUS ARM
9. FUSE BOXES
10. FLOODLIGHT PLUG AND SOCKET
11. SIGHT ARM SUPPORT
12. FLOODLIGHT
13. SIGHT SUPPORT LEVER
14. GUN SLOT SEAL
15. GUN CRADLE BEARING SLEEVE
16. FLEXIBLE PIPE TO REAR SEAR RELEASE UNIT
17. GIMBAL RING
18. GUN SIGHT
19. AMMUNITION BELT GUIDES
20. HYDRAULIC BELLOWS CONNECTING PIPE ◆
21. ARCH FRAME
22. CINÉ CAMERA MASTER SWITCH
23. SIGHT CONNECTING LINK
24. GUN FRONT ATTACHMENT OPERATING HANDLE
25. GUN FRONT ATTACHMENT PUSH-ROD
26. GUN FRONT ATTACHMENT
27. DRAUGHT EXCLUDER
28. BROWNING ·303 IN. GUN (L.H.)
29. GUN ELEVATION RAM LINK
30. AMMUNITION DUCT
31. OPERATING LEVER AND ROLLER *
32. OUTER ARMOUR PLATE ◆
33. ROTATION RESTRICTOR VALVE CAM
34. GUN ELEVATION RAM LEVER
35. REAR SEAR RELEASE UNIT
36. OPERATING SHAFT *
37. SECONDARY LEVER *
38. UPPER HYDRAULIC BELLOWS *
39. GUN CRADLE
40. MASTER FIRING SWITCH
41. GUN REAR ATTACHMENT
42. GUN REAR ATTACHMENT PIN
43. SIGHT CONNECTING LEVER
44. CINÉ CAMERA PANEL
45. REAR SLING ATTACHMENT
46. FLOODLIGHT DIMMER SWITCH
47. STAY TUBE
48. FIRING SWITCH
49. ELEVATION CONTROL ROD ◆
50. FACE PROTECTION PLATE
51. EMPTY CARTRIDGE CASE AND BELT LINK CHUTE
52. BOWDEN CABLE FROM FIRING SOLENOID
53. PUSH ROD AND BRACKET ◆
54. CAM ◆
55. ROTATION RESTRICTOR VALVE ※
56. SPARE BULB HOLDER
57. FIRING TRIGGER
58. CONTROL SHAFTS ◆
59. FIRING CONTROL VALVE ※
60. FIRING CONTROL RELAY
61. REAR SEAR RELEASE CONNECTION
62. CONTROL HANDLE
63. MASTER VALVE LEVER
64. ASSISTER LEVER
65. WARNING LIGHT UNIT
66. HEATER SOCKET
67. FUSE BOX
68. ROTATION CONTROL ROD
69. MASTER VALVE CONTROL ROD
70. LOWER HYDRAULIC BELLOWS ※
71. VALVE BOX ※
72. HYDRAULIC MOTOR ※ ＊
73. OXYGEN FLOWMETER
74. INTERCOMMUNICATION SOCKET
75. GUN BRACKET AND CHORDAL STIFFENER
76. OXYGEN PIPE STOWAGE CLIP
77. HAND ROTATION GEAR
78. CROSS MEMBER
79. GUN ELEVATION RAM ※
80. BACK REST
81. TURRET FIXED RING
82. TURRET ROTATING RING

83. VERTICAL ROLLER
84. GEAR RING
85. TOOL BAG
86. FIRING SOLENOID AND BRACKET
87. DRUM AND SWITCH MECHANISM ◆
88. MICRO SWITCH ◆
89. OPERATING LINKAGE ◆
90. FILTERS ※
91. HORIZONTAL ROLLER
92. AMMUNITION BOX LID
93. AMMUNITION BOXES
94. LOWER ARMOUR PLATE
95. OXYGEN FLEXIBLE PIPE
96. SAFETY BELT

97. HYDRAULIC ACCUMULATOR ※
98. EMPTY CARTRIDGE CASE AND BELT LINK CONTAINER (R.H.)
99. OXYGEN ECONOMISER
100. TURRET DRUM
101. OIL SUPPLY PIPE TO VALVE BOX ※
102. OIL RETURN PIPE FROM VALVE BOX ※
103. OXYGEN PIPE FROM ROTATING SERVICE JOINT
104. ROTATING SERVICE JOINT ※

105. MAIN OIL SUPPLY PIPE ※
106. ELECTRICAL SUPPLY AND INTERCOMMUNICATION LEADS
107. MAIN OIL RETURN PIPE ※
108. OXYGEN SUPPLY PIPE

＊ SEE A.D. 2252 - HYDRAULIC MOTOR

※ SEE A.D. 2552 - HYDRAULIC SYSTEM

◆ SEE A.D. 2556 - GUN FIRING INTER-RUPTER MECHANISM

＊ SEE A.D. 2557 - GUN TRAVEL INTER-RUPTER MECHANISM

CENTRE GUN TURRET
(TYPE F.N. 50)

(FOR FURTHER INFORMATION SEE A.P. 1659A VOL. I AND VOL. II)

AIR DIAGRAM 2554

AIR MINISTRY

Centre Gun Turret

The FN 50 upper turret equipped both the famous Lancaster bomber and the Short Stirling. The turret was described as roomy and comfortable with an excellent field of view. The controls were well coordinated and many Luftwaffe fighters were shot down by alert Lancaster and Stirling mid-upper gunners.

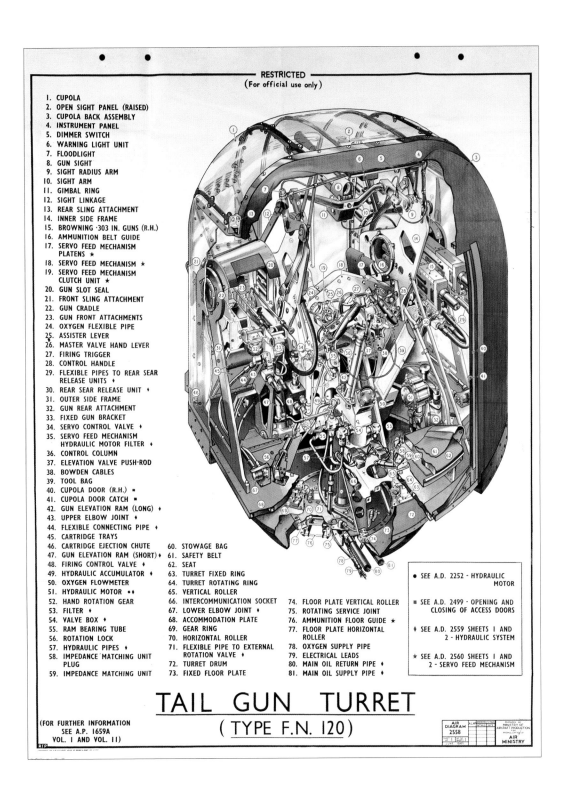

RESTRICTED
(For official use only)

1. CUPOLA
2. OPEN SIGHT PANEL (RAISED)
3. CUPOLA BACK ASSEMBLY
4. INSTRUMENT PANEL
5. DIMMER SWITCH
6. WARNING LIGHT UNIT
7. FLOODLIGHT
8. GUN SIGHT
9. SIGHT RADIUS ARM
10. SIGHT ARM
11. GIMBAL RING
12. SIGHT LINKAGE
13. REAR SLING ATTACHMENT
14. INNER SIDE FRAME
15. BROWNING ·303 IN. GUNS (R.H.)
16. AMMUNITION BELT GUIDE
17. SERVO FEED MECHANISM PLATENS ★
18. SERVO FEED MECHANISM ★
19. SERVO FEED MECHANISM CLUTCH UNIT ★
20. GUN SLOT SEAL
21. FRONT SLING ATTACHMENT
22. GUN CRADLE
23. GUN FRONT ATTACHMENTS
24. OXYGEN FLEXIBLE PIPE
25. ASSISTER LEVER
26. MASTER VALVE HAND LEVER
27. FIRING TRIGGER
28. CONTROL HANDLE
29. FLEXIBLE PIPES TO REAR SEAR RELEASE UNITS ♦
30. REAR SEAR RELEASE UNIT ♦
31. OUTER SIDE FRAME
32. GUN REAR ATTACHMENT
33. FIXED GUN BRACKET
34. SERVO CONTROL VALVE ♦
35. SERVO FEED MECHANISM HYDRAULIC MOTOR FILTER ♦
36. CONTROL COLUMN
37. ELEVATION VALVE PUSH-ROD
38. BOWDEN CABLES
39. TOOL BAG
40. CUPOLA DOOR (R.H.) ■
41. CUPOLA DOOR CATCH ■
42. GUN ELEVATION RAM (LONG) ♦
43. UPPER ELBOW JOINT ♦
44. FLEXIBLE CONNECTING PIPE ♦
45. CARTRIDGE TRAYS
46. CARTRIDGE EJECTION CHUTE
47. GUN ELEVATION RAM (SHORT) ♦
48. FIRING CONTROL VALVE ♦
49. HYDRAULIC ACCUMULATOR ♦
50. OXYGEN FLOWMETER
51. HYDRAULIC MOTOR ●♦
52. HAND ROTATION GEAR
53. FILTER ♦
54. VALVE BOX ♦
55. RAM BEARING TUBE
56. ROTATION LOCK
57. HYDRAULIC PIPES ♦
58. IMPEDANCE MATCHING UNIT PLUG
59. IMPEDANCE MATCHING UNIT

60. STOWAGE BAG
61. SAFETY BELT
62. SEAT
63. TURRET FIXED RING
64. TURRET ROTATING RING
65. VERTICAL ROLLER
66. INTERCOMMUNICATION SOCKET
67. LOWER ELBOW JOINT ♦
68. ACCOMMODATION PLATE
69. GEAR RING
70. HORIZONTAL ROLLER
71. FLEXIBLE PIPE TO EXTERNAL ROTATION VALVE ♦
72. TURRET DRUM
73. FIXED FLOOR PLATE

74. FLOOR PLATE VERTICAL ROLLER
75. ROTATING SERVICE JOINT
76. AMMUNITION FLOOR GUIDE ★
77. FLOOR PLATE HORIZONTAL ROLLER
78. OXYGEN SUPPLY PIPE
79. ELECTRICAL LEADS
80. MAIN OIL RETURN PIPE ♦
81. MAIN OIL SUPPLY PIPE ♦

● SEE A.D. 2252 - HYDRAULIC MOTOR

■ SEE A.D. 2499 - OPENING AND CLOSING OF ACCESS DOORS

♦ SEE A.D. 2559 SHEETS 1 AND 2 - HYDRAULIC SYSTEM

★ SEE A.D. 2560 SHEETS 1 AND 2 - SERVO FEED MECHANISM

TAIL GUN TURRET
(TYPE F.N. 120)

(FOR FURTHER INFORMATION SEE A.P. 1659A VOL. I AND VOL. II)

AIR DIAGRAM 2558

PREPARED BY MINISTRY OF AIRCRAFT PRODUCTION

AIR MINISTRY

Tail Gun Turret

Introduced in late 1944, the FN 120 was a slightly modified version of the FN 20 turret, which incorporated new parts and was slightly lighter by 40 pounds. The FN 20 and FN 120 were the standard tail defense of the Avro Lancaster.

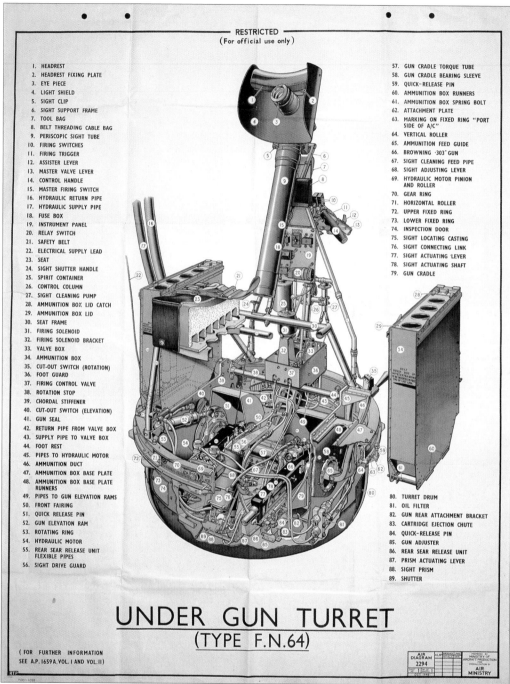

RESTRICTED
(For official use only)

1. HEADREST
2. HEADREST FIXING PLATE
3. EYE PIECE
4. LIGHT SHIELD
5. SIGHT CLIP
6. SIGHT SUPPORT FRAME
7. TOOL BAG
8. BELT THREADING CABLE BAG
9. PERISCOPIC SIGHT TUBE
10. FIRING SWITCHES
11. FIRING TRIGGER
12. ASSISTER LEVER
13. MASTER VALVE LEVER
14. CONTROL HANDLE
15. MASTER FIRING SWITCH
16. HYDRAULIC RETURN PIPE
17. HYDRAULIC SUPPLY PIPE
18. FUSE BOX
19. INSTRUMENT PANEL
20. RELAY SWITCH
21. SAFETY BELT
22. ELECTRICAL SUPPLY LEAD
23. SEAT
24. SIGHT SHUTTER HANDLE
25. SPIRIT CONTAINER
26. CONTROL COLUMN
27. SIGHT CLEANING PUMP
28. AMMUNITION BOX LID CATCH
29. AMMUNITION BOX LID
30. SEAT FRAME
31. FIRING SOLENOID
32. FIRING SOLENOID BRACKET
33. VALVE BOX
34. AMMUNITION BOX
35. CUT-OUT SWITCH (ROTATION)
36. FOOT GUARD
37. FIRING CONTROL VALVE
38. ROTATION STOP
39. CHORDAL STIFFENER
40. CUT-OUT SWITCH (ELEVATION)
41. GUN SEAL
42. RETURN PIPE FROM VALVE BOX
43. SUPPLY PIPE TO VALVE BOX
44. FOOT REST
45. PIPES TO HYDRAULIC MOTOR
46. AMMUNITION DUCT
47. AMMUNITION BOX BASE PLATE
48. AMMUNITION BOX BASE PLATE RUNNERS
49. PIPES TO GUN ELEVATION RAMS
50. FRONT FAIRING
51. QUICK RELEASE PIN
52. GUN ELEVATION RAM
53. ROTATING RING
54. HYDRAULIC MOTOR
55. REAR SEAR RELEASE UNIT FLEXIBLE PIPES
56. SIGHT DRIVE GUARD

57. GUN CRADLE TORQUE TUBE
58. GUN CRADLE BEARING SLEEVE
59. QUICK-RELEASE PIN
60. AMMUNITION BOX RUNNERS
61. AMMUNITION BOX SPRING BOLT
62. ATTACHMENT PLATE
63. MARKING ON FIXED RING "PORT SIDE OF A/C"
64. VERTICAL ROLLER
65. AMMUNITION FEED GUIDE
66. BROWNING ·303" GUN
67. SIGHT CLEANING FEED PIPE
68. SIGHT ADJUSTING LEVER
69. HYDRAULIC MOTOR PINION AND ROLLER
70. GEAR RING
71. HORIZONTAL ROLLER
72. UPPER FIXED RING
73. LOWER FIXED RING
74. INSPECTION DOOR
75. SIGHT LOCATING CASTING
76. SIGHT CONNECTING LINK
77. SIGHT ACTUATING LEVER
78. SIGHT ACTUATING SHAFT
79. GUN CRADLE

80. TURRET DRUM
81. OIL FILTER
82. GUN REAR ATTACHMENT BRACKET
83. CARTRIDGE EJECTION CHUTE
84. QUICK-RELEASE PIN
85. GUN ADJUSTER
86. REAR SEAR RELEASE UNIT
87. PRISM ACTUATING LEVER
88. SIGHT PRISM
89. SHUTTER

UNDER GUN TURRET
(TYPE F.N.64)

(FOR FURTHER INFORMATION
SEE A.P. 1659A, VOL. I AND VOL. II)

AIR DIAGRAM 2294

PREPARED BY MINISTRY OF AIRCRAFT PRODUCTION

AIR MINISTRY

Under Gun Turret

The Nash and Thompson Type FN 64 did not see widespread use in RAF
Bomber Command. Originally fitted to the first production Lancasters, it
was soon discontinued. The old problem of aiming through the periscope
sight proved too difficult to overcome and the turret was cancelled. It
was reintroduced when daylight operations resumed in June 1944. Only
four Polish Lancaster Squadrons in No. 5 Group were fitted with the
FN 64 in place of the H2S radar scanner. The turret had a 180-degree
traverse and offered little drag. The gunner sat in a rearward-facing seat
and used a periscope sight to aim the twin Brownings.

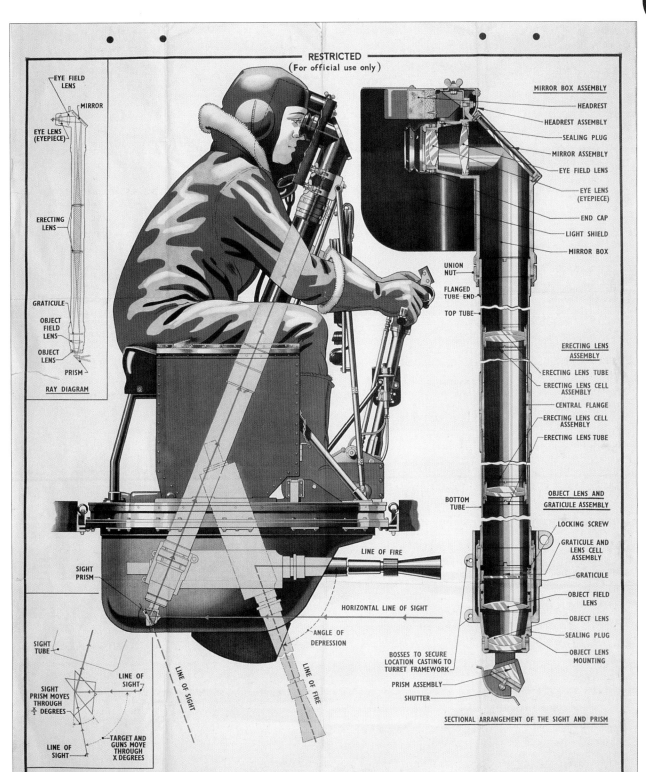

RESTRICTED
(For official use only)

RAY DIAGRAM

EYE FIELD LENS
MIRROR
EYE LENS (EYEPIECE)
ERECTING LENS
GRATICULE
OBJECT FIELD LENS
OBJECT LENS
PRISM

MIRROR BOX ASSEMBLY
HEADREST
HEADREST ASSEMBLY
SEALING PLUG
MIRROR ASSEMBLY
EYE FIELD LENS
EYE LENS (EYEPIECE)
END CAP
LIGHT SHIELD
MIRROR BOX

UNION NUT
FLANGED TUBE END
TOP TUBE

ERECTING LENS ASSEMBLY
ERECTING LENS TUBE
ERECTING LENS CELL ASSEMBLY
CENTRAL FLANGE
ERECTING LENS CELL ASSEMBLY
ERECTING LENS TUBE

BOTTOM TUBE

OBJECT LENS AND GRATICULE ASSEMBLY
LOCKING SCREW
GRATICULE AND LENS CELL ASSEMBLY
GRATICULE
OBJECT FIELD LENS
OBJECT LENS
SEALING PLUG
OBJECT LENS MOUNTING

BOSSES TO SECURE LOCATION CASTING TO TURRET FRAMEWORK
PRISM ASSEMBLY
SHUTTER

SECTIONAL ARRANGEMENT OF THE SIGHT AND PRISM

LINE OF FIRE
HORIZONTAL LINE OF SIGHT
ANGLE OF DEPRESSION
LINE OF FIRE
LINE OF SIGHT
SIGHT PRISM

SIGHT TUBE
SIGHT PRISM MOVES THROUGH X/2 DEGREES
LINE OF SIGHT
LINE OF SIGHT
TARGET AND GUNS MOVE THROUGH X DEGREES

PERISCOPIC GUN SIGHT (TYPE B. MK. II)
UNDER GUN TURRET (TYPE F.N.64)

(FOR FURTHER INFORMATION
SEE A.P. 1659A, VOL. I AND VOL. II)

RTP
X001-6591

AIR DIAGRAM 2296

PREPARED BY
MINISTRY OF AIRCRAFT PRODUCTION
AND PROMULGATED BY
AIR MINISTRY

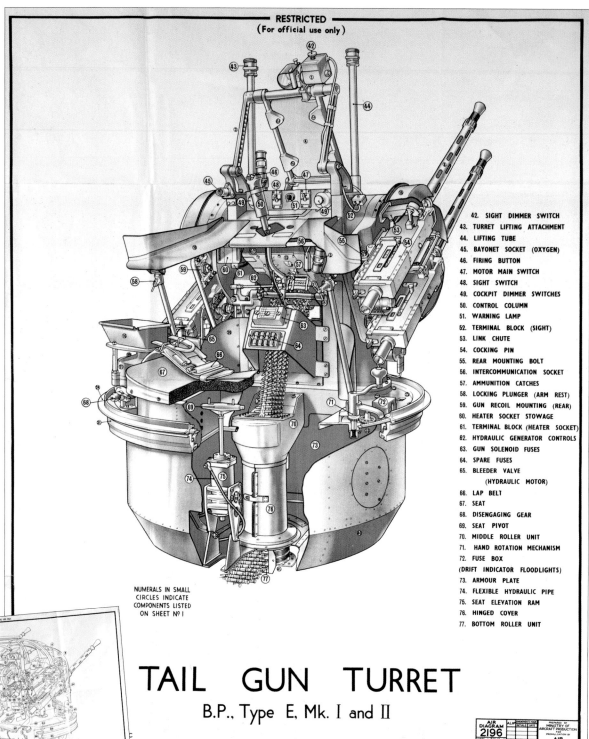

42. SIGHT DIMMER SWITCH
43. TURRET LIFTING ATTACHMENT
44. LIFTING TUBE
45. BAYONET SOCKET (OXYGEN)
46. FIRING BUTTON
47. MOTOR MAIN SWITCH
48. SIGHT SWITCH
49. COCKPIT DIMMER SWITCHES
50. CONTROL COLUMN
51. WARNING LAMP
52. TERMINAL BLOCK (SIGHT)
53. LINK CHUTE
54. COCKING PIN
55. REAR MOUNTING BOLT
56. INTERCOMMUNICATION SOCKET
57. AMMUNITION CATCHES
58. LOCKING PLUNGER (ARM REST)
59. GUN RECOIL MOUNTING (REAR)
60. HEATER SOCKET STOWAGE
61. TERMINAL BLOCK (HEATER SOCKET)
62. HYDRAULIC GENERATOR CONTROLS
63. GUN SOLENOID FUSES
64. SPARE FUSES
65. BLEEDER VALVE
 (HYDRAULIC MOTOR)
66. LAP BELT
67. SEAT
68. DISENGAGING GEAR
69. SEAT PIVOT
70. MIDDLE ROLLER UNIT
71. HAND ROTATION MECHANISM
72. FUSE BOX
(DRIFT INDICATOR FLOODLIGHTS)
73. ARMOUR PLATE
74. FLEXIBLE HYDRAULIC PIPE
75. SEAT ELEVATION RAM
76. HINGED COVER
77. BOTTOM ROLLER UNIT

NUMERALS IN SMALL
CIRCLES INDICATE
COMPONENTS LISTED
ON SHEET Nº I

TAIL GUN TURRET
B.P., Type E, Mk. I and II

AIR DIAGRAM 2196
AIR MINISTRY

CENTRE GUN TURRET (TYPE A. MK. II.D) DEFIANT I

Tail Gun Turret

The Boulton Paul Type E tail turret was one of the most successful turrets every produced. Over 8,000 Type E turrets were built and equipped both the Halifax and British version of the B-24 Liberator.

Centre Gun Turret Defiant I (left)

The Boulton Paul Mk IID turret proved to be an efficient design. Its low profile caused minimum drag. Each gun was supplied with 600 rounds of ammunition.

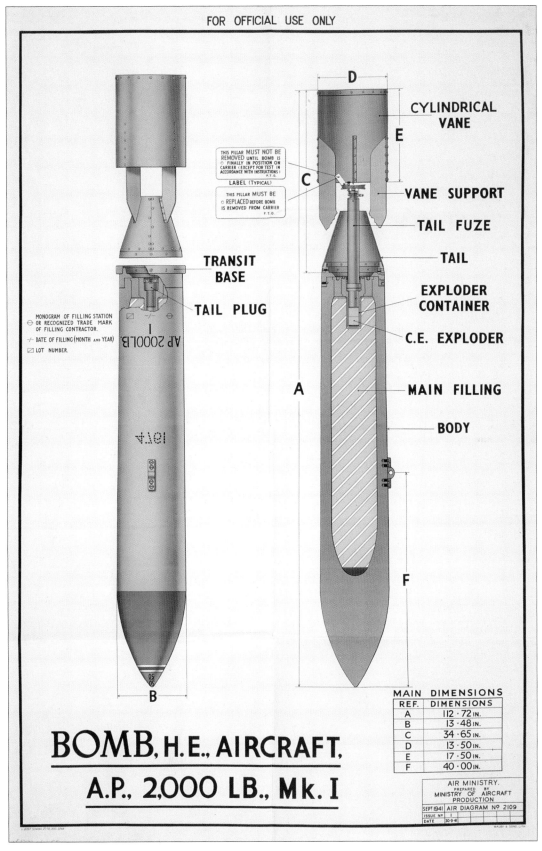

THIS PILLAR MUST NOT BE
REMOVED UNTIL BOMB IS
○ FINALLY IN POSITION ON
CARRIER (EXCEPT FOR TEST IN
ACCORDANCE WITH INSTRUCTIONS)
P. T. O.
LABEL (TYPICAL)

THIS PILLAR MUST BE
○ REPLACED BEFORE BOMB
IS REMOVED FROM CARRIER
P. T. O.

CYLINDRICAL VANE

D

E

C

A

B

VANE SUPPORT

TAIL FUZE

TAIL

EXPLODER CONTAINER

C.E. EXPLODER

MAIN FILLING

BODY

F

TRANSIT BASE

TAIL PLUG

⊖ MONOGRAM OF FILLING STATION
OR RECOGNIZED TRADE MARK
OF FILLING CONTRACTOR.
⊹ DATE OF FILLING (MONTH AND YEAR)
⊠ LOT NUMBER.

AP 2000LB.

MAIN DIMENSIONS

REF.	DIMENSIONS
A	112·72 IN.
B	13·48 IN.
C	34·65 IN.
D	13·50 IN.
E	17·50 IN.
F	40·00 IN.

AIR MINISTRY.
PREPARED BY
MINISTRY OF AIRCRAFT
PRODUCTION

SEPT 1941	AIR DIAGRAM Nº 2109
ISSUE Nº	1
DATE	30·9·41

MALBY & SONS. LITH

BOMB, H.E., AIRCRAFT,
A.P., 2,000 LB., Mk. I

2,000-Pound Bomb

This air diagram clearly shows a high explosive armor-piercing 2,000-pound bomb. Most of the weight of this type of bomb is taken up by the thick outer casing. The armor-piercing bomb was designed to defeat armored navel vessels, hence the solid-steel nose and low explosive-filling-to-weight ratio.

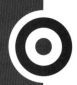

LENGTH OVERALL — 14·5″.
LENGTH BELOW SHOULDER — 3″.
ARMING VANE 5·8″ OVER BLADES.

9. REDUCTION GEAR.
9A. ROTATABLE PINION.
9B. FIXED GEAR WHEEL.
9C. ROTATABLE GEAR WHEEL.
9D. COUNTER WEIGHT.
10. ARMING SPINDLE.
11. POSITIONING PIN.
12. STOP PINS (ANTI-JAMMING.)
13. INERTIA PELLET.
14. GUIDE SCREW.
15. SHUTTER LOCKING ROD.
16. CREEP SPRING.
17. IGNIFEROUS DETONATOR. 1·7 GRAIN.
18. POWDER PELLET.
19. FLASH CHANNEL.
20. FLASH PLUG.
21. DETONATOR GAS ESCAPE HOLE.
22. SHUTTER.
23. DETONATOR. 5 GRAIN.
24. SHUTTER SPRING.
25. PIVOT PINS.
26. FIRE CHANNEL. (STEMMED C.E.)
27. MAGAZINE FILLING. (C.E.)
28. PAWL LOCKING PLUNGER.
29. PAWL SPRING.
30. SHUTTER LOCKING PAWL.
31. NEEDLE.
32. DELAY FITTING.

1. ARMING VANE.
2. LEAD SEAL & WIRE.
3. SAFETY PILLAR.
4. ARMING VANE SPIGOT.
5. SPLIT PIN SECURING ARMING VANE.
6. OILED BOXCLOTH WASHERS.
7. SAFETY CLIP.
8. ARMING VANE SPINDLE & FLANGE.

SHUTTER MOVEMENT.

DELAY SYSTEM.

FUZE, PERCUSSION, AIRCRAFT BOMB, TAIL, No 30, MK II.

AIR MINISTRY.
DIRECTORATE OF TECHNICAL DEVELOPMENT
AIR DIAGRAM No 1145

Bomb Fuze

The standard bomb fuse had to do two things extremely well. The first was to keep the bomb from exploding while in flight and the other was to cause the bomb to explode when it hit the target. The bombs on board a bomber had three safety devices to insure against an accidental explosion: (1) the first was a cotter key that had to be removed by hand from the fuse mechanism of each bomb just before the bomb run began; (2) as the bombs were released, an arming wire was pulled out of the fuse assembly; (3) with the arming wire removed, the impellor or arming vane would spin off due to the action of the wind as the bomb fell. At this point the bomb was live and ready to explode.

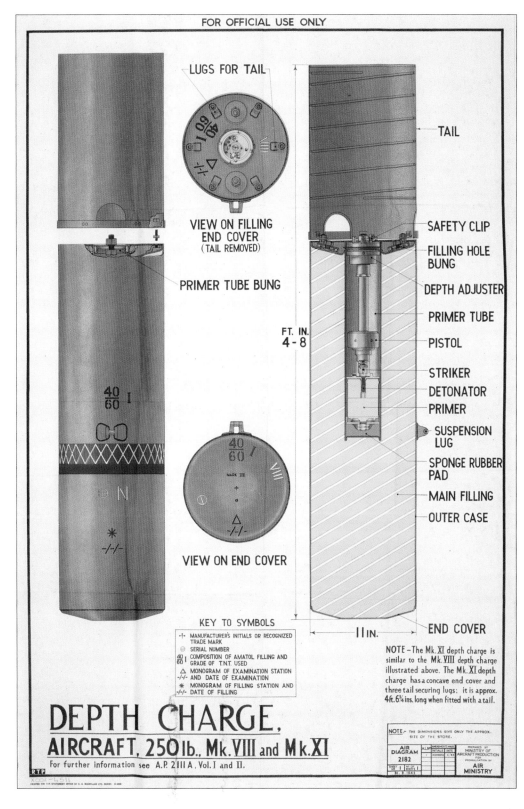

LUGS FOR TAIL

VIEW ON FILLING
END COVER
(TAIL REMOVED)

PRIMER TUBE BUNG

TAIL

SAFETY CLIP

FILLING HOLE
BUNG

DEPTH ADJUSTER

PRIMER TUBE

PISTOL

STRIKER

DETONATOR

PRIMER

SUSPENSION
LUG

SPONGE RUBBER
PAD

MAIN FILLING

OUTER CASE

FT. IN.
4 - 8

40/60 I

40/60 I
MARK VII
VIII

VIEW ON END COVER

KEY TO SYMBOLS

MANUFACTURER'S INITIALS OR RECOGNIZED
TRADE MARK
SERIAL NUMBER
40/60 I COMPOSITION OF AMATOL FILLING AND
GRADE OF T.N.T. USED
MONOGRAM OF EXAMINATION STATION
-/-/- AND DATE OF EXAMINATION
MONOGRAM OF FILLING STATION AND
-/-/- DATE OF FILLING

11 IN.

END COVER

NOTE – The Mk. XI depth charge is
similar to the Mk. VIII depth charge
illustrated above. The Mk. XI depth
charge has a concave end cover and
three tail securing lugs; it is approx.
4ft. 6¾ ins. long when fitted with a tail.

NOTE – THE DIMENSIONS GIVE ONLY THE APPROX.
SIZE OF THE STORE.

AIR
DIAGRAM
2182

PREPARED BY
MINISTRY OF
AIRCRAFT PRODUCTION

AIR
MINISTRY

DEPTH CHARGE,
AIRCRAFT, 250 lb., Mk. VIII and Mk. XI
For further information see A.P. 2111 A, Vol. I and II.

Depth Charge

During the interwar period, aircraft design and construction improved at an amazing rate, but anti-submarine weaponry was still of World War I vintage. The first depth charge used by Coastal Command was the 450-pound Mark VII. It was far too bulky to be carried by any Coastal Command aircraft of the time other than the large flying boats. The lighter, more compact 250-pound Mark VIII was introduced in the spring of 1941, but its Amatol filling had only 30 to 50 percent of the explosive force of the Torpex-filled Mk XI that would succeed it in 1942. These depth charges were fitted with a pressure-sensitive detonator that was set at 50 feet — too deep to destroy submarines close to the surface. In 1942 the new Star "pistol" detonator was introduced, capable of detonating in 15 feet of water. Because of these limitations, the early anti-submarine campaign was very similar to the anti-submarine campaign of the World War I. By 1941 Coastal Command made 245 attacks against submarines but had only three sinkings to report.

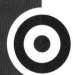

RESTRICTED
(For official use only)

1 RELEASE UNIT TESTED

2 STROP TENSIONED CORRECTLY, TORPEDO RIGID IN CARRIER AND CARRIER PADS CORRECTLY LINED UP

3 TURBINE TROUGH COVER SECURELY IN PLACE AND SEALED. CORRECT FIRING SETTING MADE, OR REMOTE CONTROL CABLE CONNECTED

4 SPEED & RANGE SETTINGS CORRECT, DEPTH SETTING O.K. OR REMOTE CONTROL CONNECTED AND LINED-UP

11 OPEN STOP VALVE

5 AIR LEVER FID INSERTED & LANYARD SECURELY ANCHORED TO AIRCRAFT, SAFETY PIN REMOVED FROM BEHIND AIR LEVER

9 AIR TAIL FITTED CORRECTLY AND SECURELY, LANYARD ANCHORED TO AIRCRAFT AND SUFFICIENTLY SLACK TO PREVENT PREMATURE RELEASE OF FID

6 AIR DELAY VALVE COCKED, I.E. FLAP FORWARD

7 IF GYRO-ANGLING GEAR IS IN USE CHECK FOR FUNCTIONING AND LINING-UP, AND THAT LOCKING PIN IS REMOVED

8 PROPELLERS SET TO STARTING POSITION AND CLAMPS REMOVED

12 CHECK THAT TORPEDO SIGHT IS LINED UP & WORKS CORRECTLY

10 IF DRUM CONTROL FITTED CHECK THAT NEW WIRES ARE ATTACHED TO AIR-TAIL, HOOKS CLOSED, GEAR COCKED, INERTIA WHEEL LOADED CORRECTLY, AND CONFIRM THAT TEST HAS BEEN MADE

THE AIRCRAFT TORPEDO –
POINTS TO CHECK – BEFORE TAKE-OFF

For further information see A.P. 2495 A

AIR DIAGRAM 2384

PREPARED BY MINISTRY OF AIRCRAFT PRODUCTION FOR PROMULGATION BY AIR MINISTRY

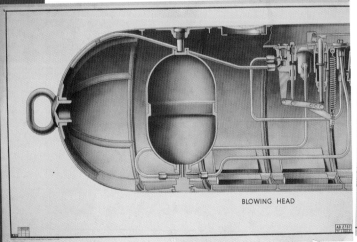

BLOWING HEAD

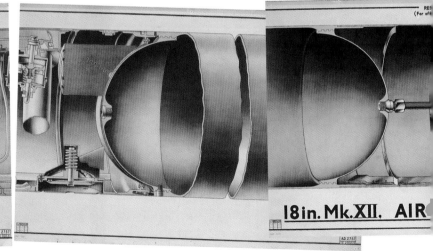

18in. Mk.XII. AIR

Aircraft Torpedo — Points to Check (opposite)

Torpedoes were extremely sophisticated and sensitive weapons. Not only did they have to sustain the rough handling on aircraft carrier decks, but they had to withstand the elements while hung from an attacking torpedo bomber. Many things could go wrong and many did — during the war the British dropped 609 aircraft torpedoes. Of that number, only 167 were certain hits, and 37 probable, for a 33.5 percent probable/certain rate.

Mk XII Aircraft Torpedo (below)

This five-piece air diagram illustration is in fact a life-size depiction of the Mk XII torpedo. The Mk XII was the standard airborne torpedo for the both the RAF and Fleet Air Arm for the first half of the war. It weighed 1,548 pounds (702 kg) with a warhead of 388 pounds (176 kg) of TNT. Larger warheads could be fitted but they were limited to shore-based aircraft.

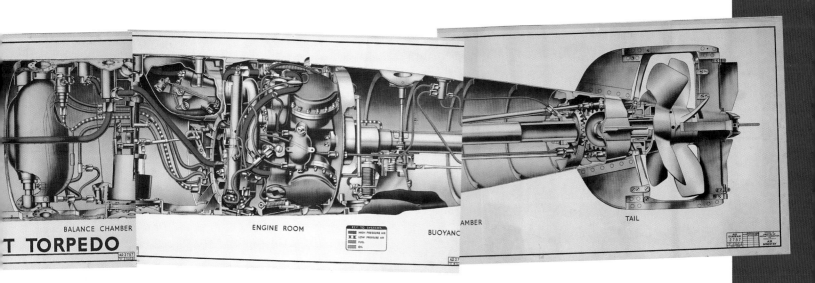

GREAT BRITAIN

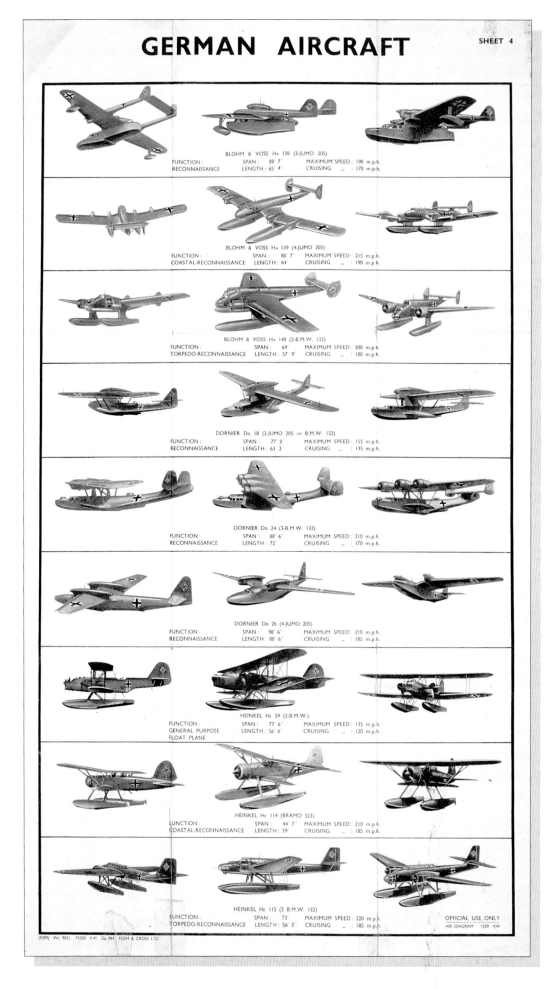

GERMAN AIRCRAFT

SHEET 4

BLOHM & VOSS Ha 138 (3-JUMO 205)
FUNCTION: SPAN: 88' 7" MAXIMUM SPEED: 190 m.p.h.
RECONNAISSANCE LENGTH: 65' 4" CRUISING .. : 170 m.p.h.

BLOHM & VOSS Ha 139 (4-JUMO 205)
FUNCTION: SPAN: 80' 7" MAXIMUM SPEED: 215 m.p.h.
COASTAL-RECONNAISSANCE LENGTH: 64' CRUISING .. : 190 m.p.h.

BLOHM & VOSS Ha 140 (2-B.M.W. 132)
FUNCTION: SPAN: 69' MAXIMUM SPEED: 200 m.p.h.
TORPEDO-RECONNAISSANCE LENGTH: 57' 9" CRUISING .. : 180 m.p.h.

DORNIER Do 18 (2-JUMO 205 or B.M.W. 132)
FUNCTION: SPAN: 77' 8" MAXIMUM SPEED: 155 m.p.h.
RECONNAISSANCE LENGTH: 63' 2" CRUISING .. : 135 m.p.h.

DORNIER Do 24 (3-B.M.W. 132)
FUNCTION: SPAN: 88' 6" MAXIMUM SPEED: 210 m.p.h.
RECONNAISSANCE LENGTH: 72' CRUISING .. : 170 m.p.h.

DORNIER Do 26 (4-JUMO 205)
FUNCTION: SPAN: 98' 6" MAXIMUM SPEED: 210 m.p.h.
RECONNAISSANCE LENGTH: 80' 6" CRUISING .. : 185 m.p.h.

HEINKEL He 59 (2-B.M.W.)
FUNCTION: SPAN: 77' 6" MAXIMUM SPEED: 135 m.p.h.
GENERAL PURPOSE LENGTH: 56' 6" CRUISING .. : 120 m.p.h.
FLOAT PLANE

HEINKEL He 114 (BRAMO 323)
FUNCTION: SPAN: 44' 7" MAXIMUM SPEED: 210 m.p.h.
COASTAL-RECONNAISSANCE LENGTH: 39' CRUISING .. : 185 m.p.h.

HEINKEL He 115 (2 B.M.W. 132)
FUNCTION: SPAN: 73' MAXIMUM SPEED: 220 m.p.h.
TORPEDO-RECONNAISSANCE LENGTH: 56' 8" CRUISING .. : 185 m.p.h.

OFFICIAL USE ONLY
AIR DIAGRAM 1359 4/41

(F299) Wt. 9021. 71000 4/41 Gp. 961 FOSH & CROSS LTD.

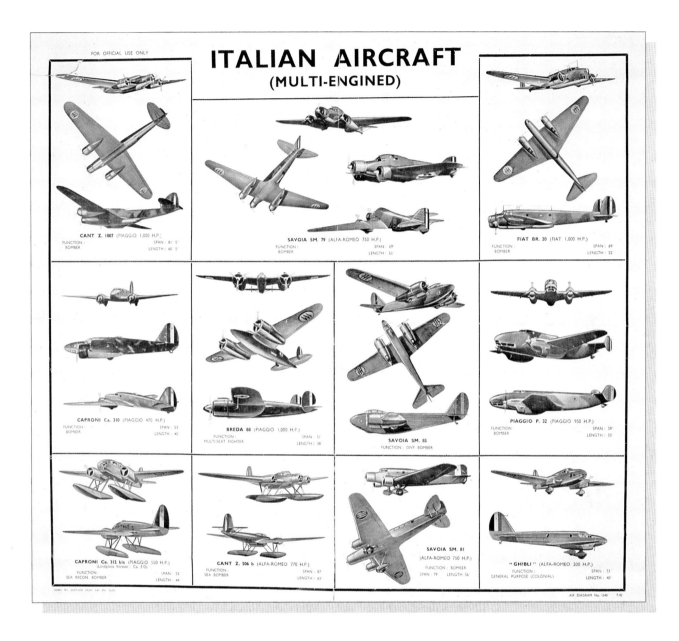

Italian Aircraft — Multi-engined
German Aircraft — Float Planes

A pilot's ability to recognize and identify the enemy quickly often meant the difference between victory and defeat. Anti-aircraft crews also had to be proficient in aircraft recognition. Thousands of aircraft recognition books and posters like these were produced during the war to aid in this process. Sadly, many aircraft were shot down on both sides by over-eager anti-aircraft gunners and pilots unable to recognize friend from foe.

Back from X Country

Crew fatigue could be just as deadly as flak and enemy fighters. After flying eight hours or more over enemy territory it was natural for crews to relax once they reached friendly airspace. Fatigue mixed with relief could spell disaster. Crews were constantly reminded to be just as vigilant at the end of a raid as they were at the beginning.

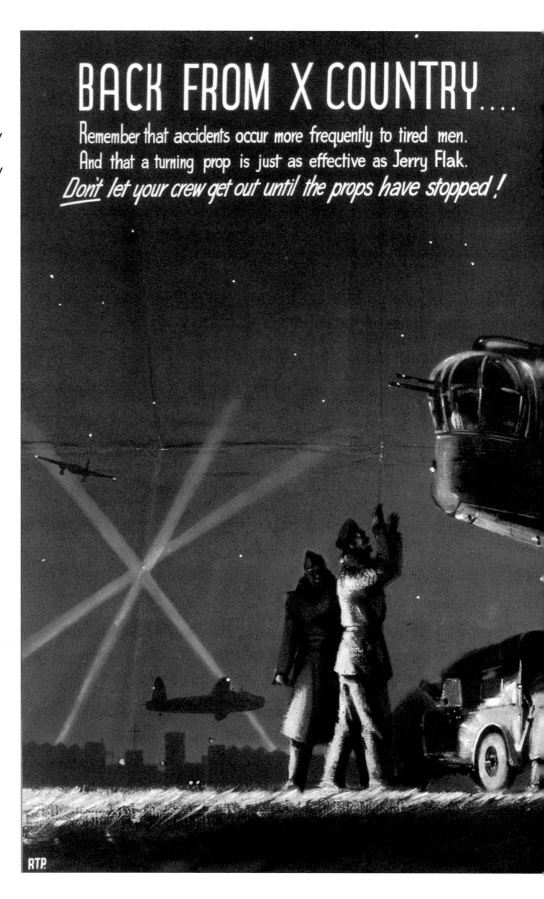

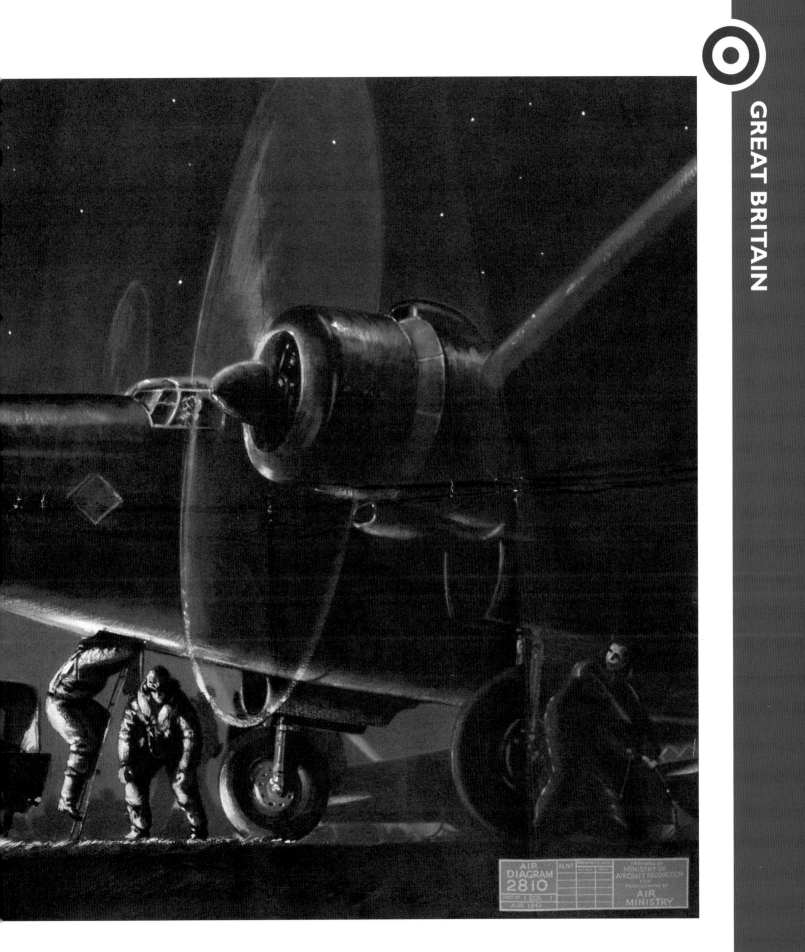

AIR
DIAGRAM
2810

ALN°

SHEET N° 1

AUG 1943

PREPARED BY
MINISTRY OF
AIRCRAFT PRODUCTION
FOR
PROMULGATION BY
AIR
MINISTRY

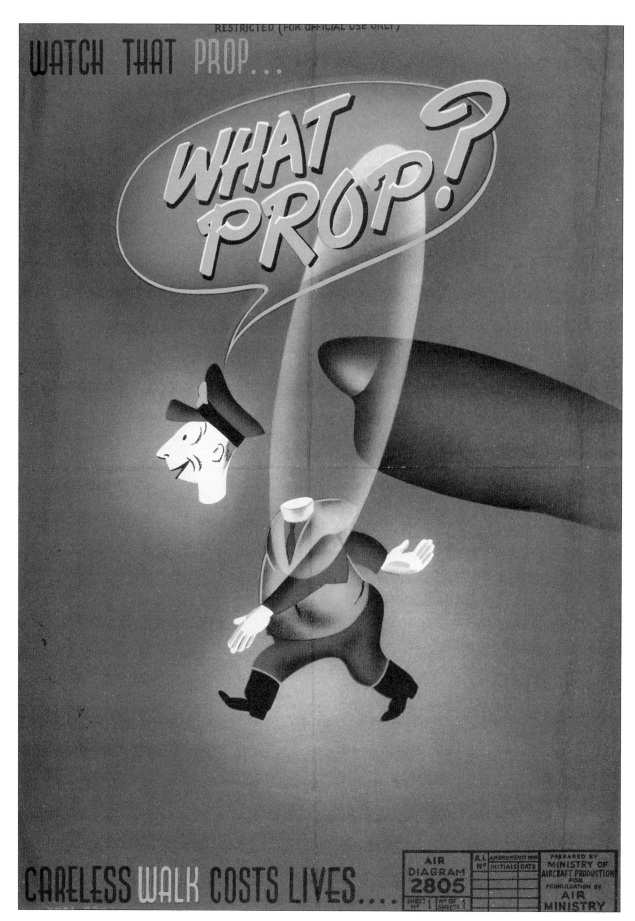

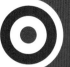

Flight Safety Posters

Flight safety was a serious matter, but in order to reinforce the message, humor and cartoon images were used throughout the war.

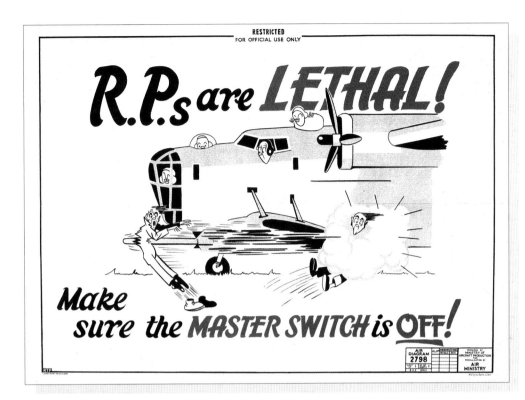

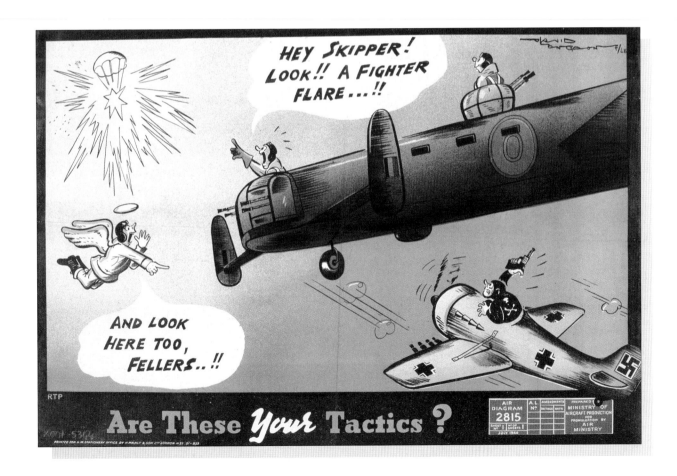

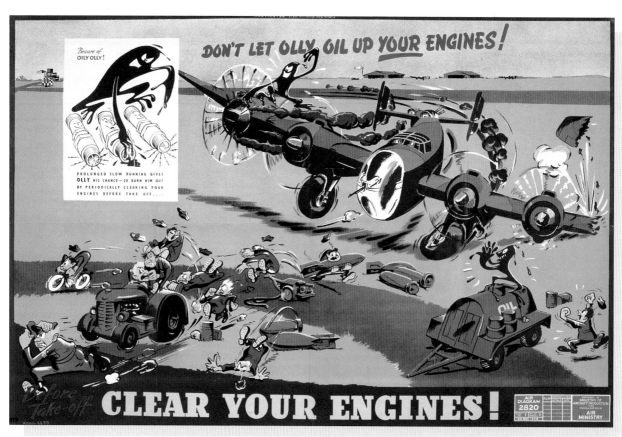

Clear your Engines!
Once is Too Often

Air safety was always a major concern during the war. The RAF listed 8,195 killed in flying and ground accidents alone. While these two posters use humor to drive the point home, the grim fact remained that flight operations, even away from combat, was always a dangerous undertaking.

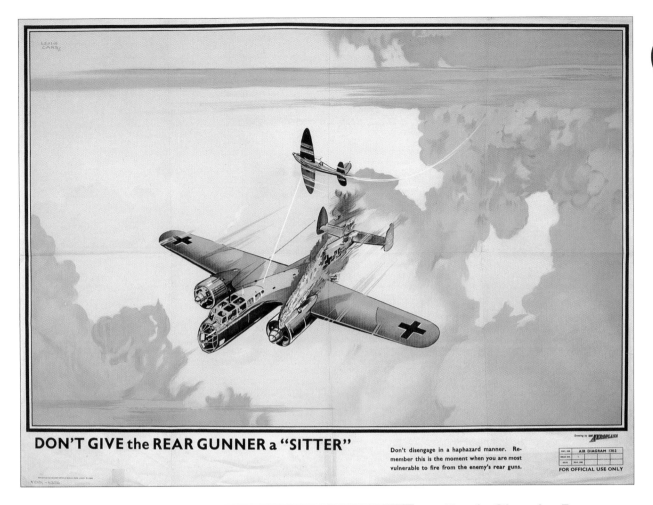

DON'T GIVE the REAR GUNNER a "SITTER"

Don't disengage in a haphazard manner. Remember this is the moment when you are most vulnerable to fire from the enemy's rear guns.

AIR DIAGRAM 1302
FOR OFFICIAL USE ONLY

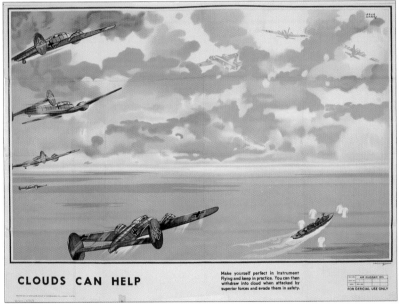

CLOUDS CAN HELP

Make yourself perfect in Instrument Flying and keep in practice. You can then withdraw into cloud when attacked by superior forces and evade them in safety.

AIR DIAGRAM 1213
FOR OFFICIAL USE ONLY

Don't Give the Rear Gunner a Sitter

Defensive fire from bombers was limited, but in some cases, when all the elements came together, a rear gunner could score a lethal blow. Liquid-cooled engines like the Merlin were extremely vulnerable to defensive fire. A single hit in the glycol tank (located at the front of the engine) or oil tank (located under the engine) would cause the engine to quickly overheat and catch fire. This Spitfire is shown exposing the vulnerable underside of his aircraft.

Clouds Can Help

"If there is cloud handy, use it, but change your course once inside."

LIEUTENANT COLONEL HARRY J. DAYHUFF, 78TH FIGHTER GROUP

"When popping out of a cloud, always do a turn and look back. You may have jumped out directly in front of a gun barrel."

COLONEL HUBERT ZEMKE, COMMANDING OFFICER, 56TH FIGHTER GROUP

GREAT BRITAIN

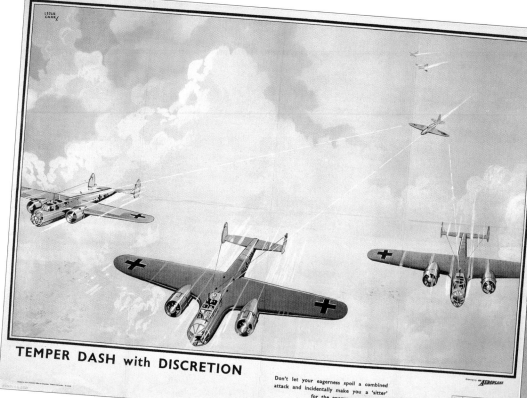

TEMPER DASH with DISCRETION

Don't let your eagerness spoil a combined attack and incidentally make you a 'sitter' for the enemy.

Temper Dash with Discretion

German bombers were lightly armed with handheld rifle-caliber machine guns. When flying in large formations with no fighter escort, their only effective method of defense was close formation flying. This provided a degree of mutual fire support, and over-eager fighter pilots attacking on their own would be met with defensive fire from more than one aircraft.

Beware of the Hun in the Sun

"The sun is the most effective offensive weapon and the Hun loves to use it. Whenever possible I always try to make all turns into the sun and try never to fly with it at my back."

LIEUTENANT COLONEL JOHN C. MEYER, COMMANDING OFFICER, 352ND FIGHTER GROUP

"I attack out of the sun, coming up slightly underneath, with my wingman in trail and slightly to one side, watching our tails. I attempt to close as rapidly as possible to about 600-800 yards, then I chop throttle and close slowly — I find this prevents overshooting."

MAJOR DON BODENHAMER JR, 78TH FIGHTER GROUP

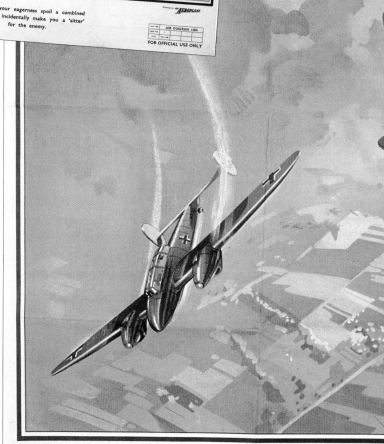

BEWARE of the HUN in

PRINTED FOR H.M. STATIONERY OFFICE BY FLEMINGS, LEICESTER. 51-3166

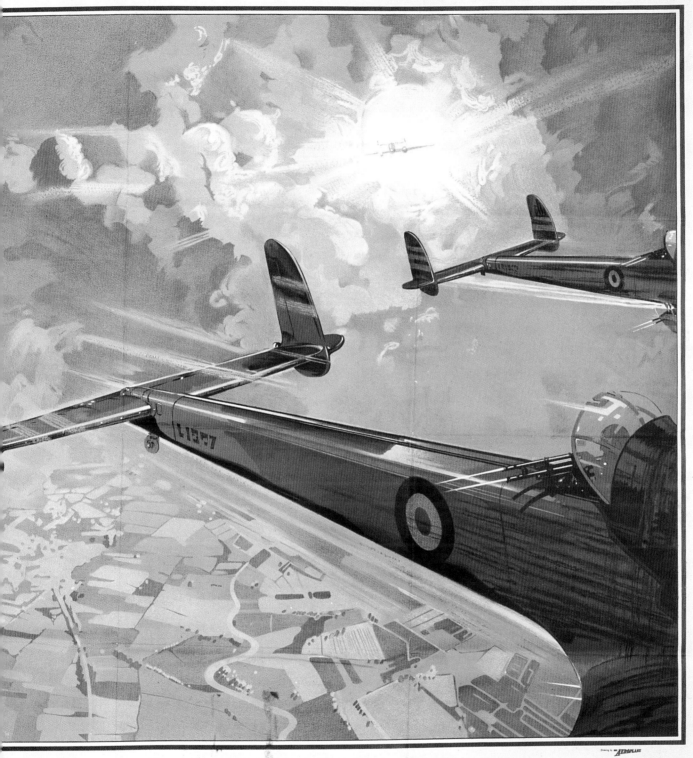

SUN

In a surprise attack the enemy may "come out of the sun" where it is difficult to see him. Remember to look for this especially when about to engage another aircraft that may prove to be a decoy.

MAY. 1940	AIR DIAGRAM 1297			
ISSUE NO.	1			
DATE	MAY. 1940			

FOR OFFICIAL USE ONLY

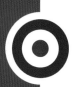

Safety Height for Bombing

When bombs are dropped they are traveling at the same speed as the aircraft. If the aircraft continues on the same line as the bombs dropped and is too low over the target when they explode the results could be disastrous.

On September 5, 1939, just two days after the outbreak of the war, a Coastal Command Anson released a couple of 100-pound bombs on a surfaced submarine. The bombs were dropped at low level and entered the water's surface at a shallow angle. This caused the bombs to skip back into the air like a couple of flat stones. The impact had started their time fuses, and after a few seconds both bombs exploded in the air beneath the Anson. The aircraft was severely damaged and was forced to ditch. Ironically, the boat that was attacked was in fact the Royal Navy submarine HMS *Seahorse*.

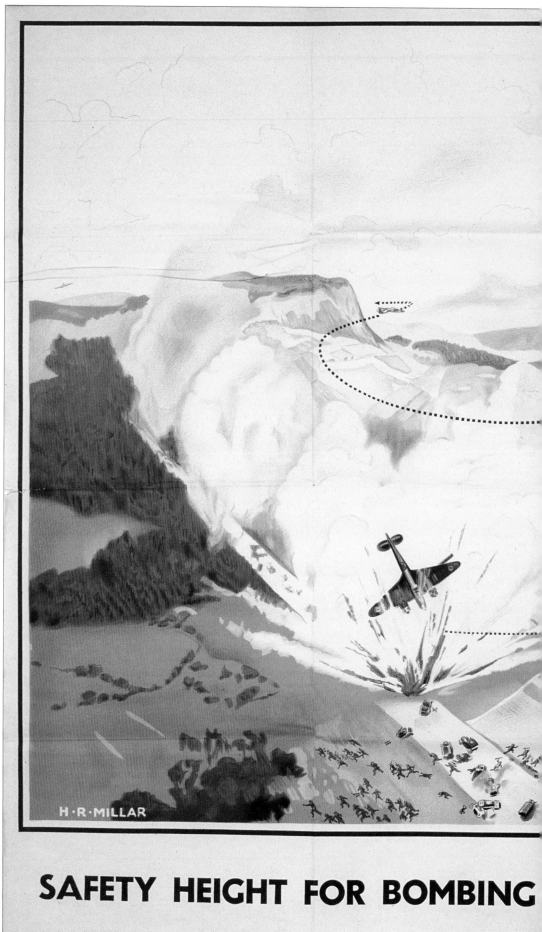

H · R · MILLAR

SAFETY HEIGHT FOR BOMBING

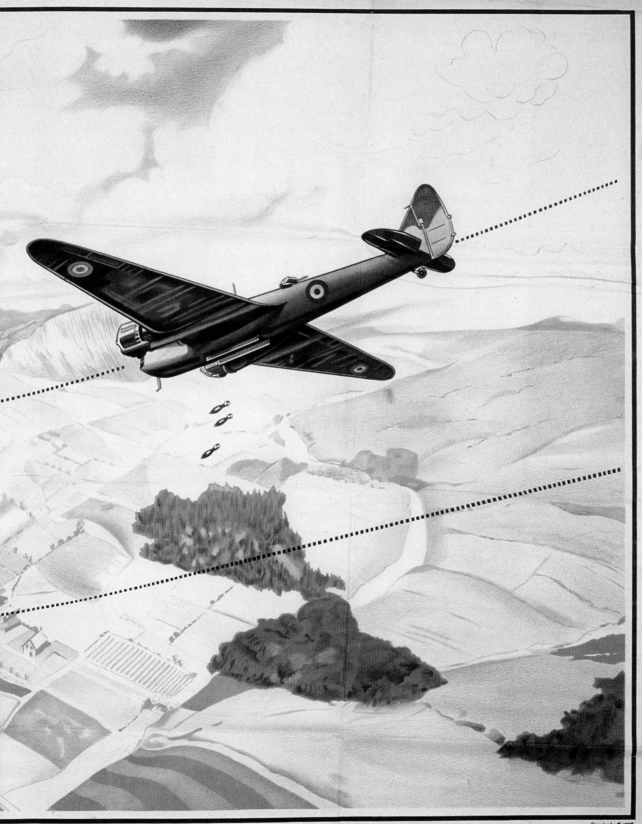

Do not let enthusiasm or excitement affect your judgment. Remember the safety of your crew. When using instantaneous or short delay fuses, do not come below the safe height for the bombs you are using.

Drawing by FLIGHT

MAY, 1941	AIR DIAGRAM 1295		
ISSUE NO.	1		
DATE	MAY, 1941		

FOR OFFICIAL USE ONLY

Emergency Landing Service

As RAF Bomber Command grew in strength and became capable of sending hundreds of bombers to targets in Germany, there was also an increase in the number that returned with battle damage. It was quickly realized that emergency airfields were needed on the east coast of England to help these stricken aircraft. Between 1942 and 1944 three runways were constructed. Much wider than normal runways, these emergency strips were divided into three lanes divided by lights. The runways ran from east to west, making it easy for pilots to line up on the runway. If an aircraft crash-landed there would still be two lanes open. Bulldozers were on hand to push any damaged aircraft off the airfield.

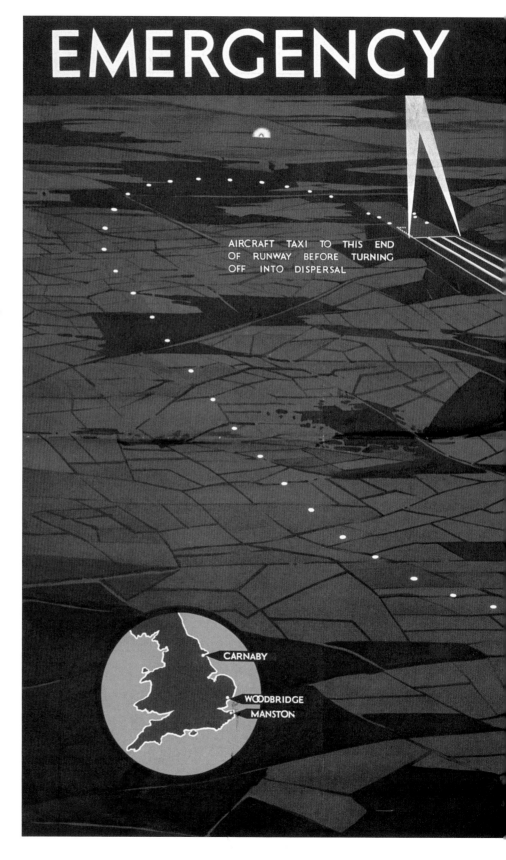

EMERGENCY

AIRCRAFT TAXI TO THIS END OF RUNWAY BEFORE TURNING OFF INTO DISPERSAL

CARNABY

WOODBRIDGE

MANSTON

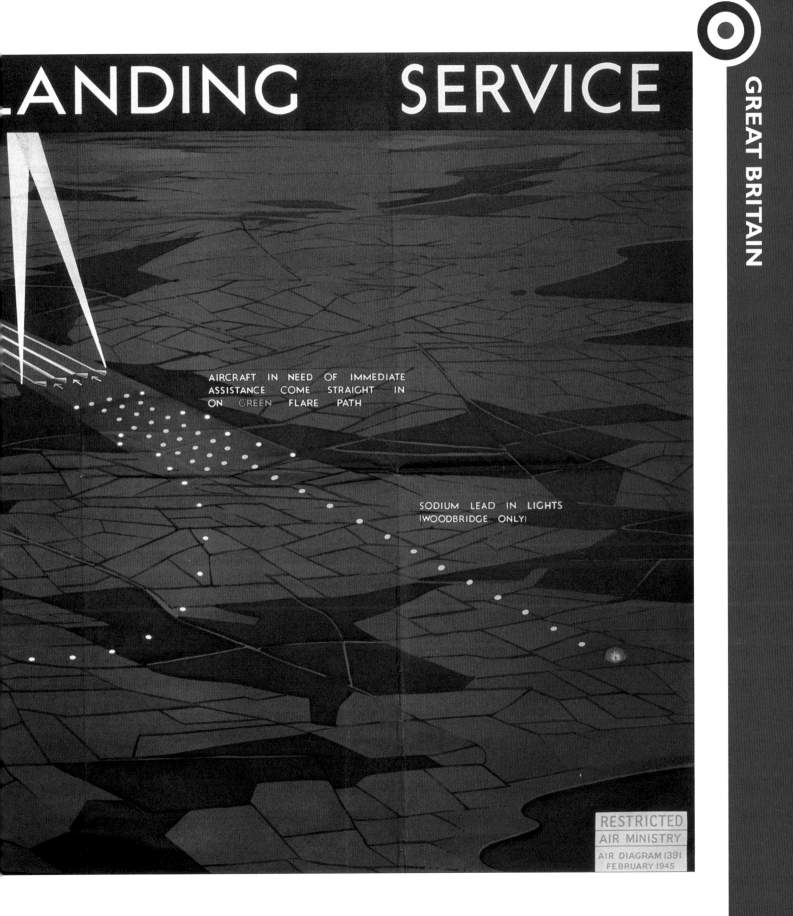

LANDING SERVICE

AIRCRAFT IN NEED OF IMMEDIATE ASSISTANCE COME STRAIGHT IN ON GREEN FLARE PATH

SODIUM LEAD IN LIGHTS (WOODBRIDGE ONLY)

RESTRICTED
AIR MINISTRY
AIR DIAGRAM 1391
FEBRUARY 1945

SEARCHLIGHT ASSISTANCE TO LOST AIRCRAFT

1 Sandra or Canopy Lights

2 Searchlights homing to Sandra or Canopy Lights

3 Searchlight fence round a balloon barrage

Searchlight Assistance

Damaged aircraft returning from a night raid over Germany faced an arduous journey home. Prowling night-fighters and flak were a constant danger, but a damaged electrical system meant that radio navigation aids and radar were of no use in finding the way home. It was up to the navigator with his compass and sextant to guide the aircraft home (if the pilot could keep the aircraft straight and level long enough). As they approached Britain they would be met with a number of searchlight patterns to help shepherd them home.

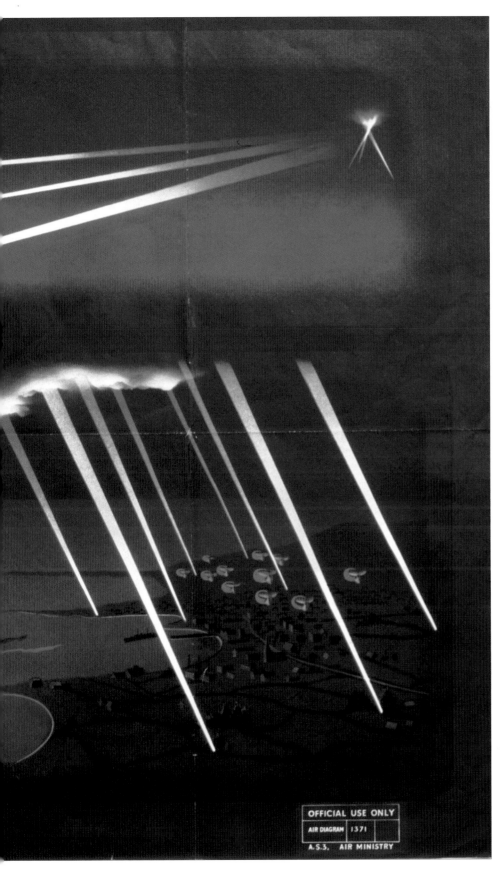

OFFICIAL USE ONLY
AIR DIAGRAM 1371
A.S.3. AIR MINISTRY

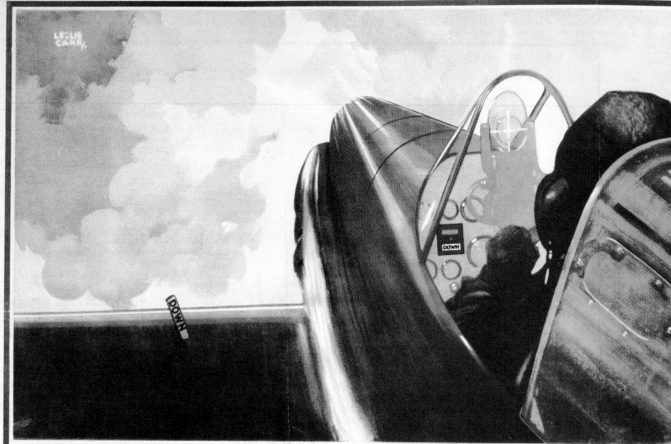

REMEMBER YOUR UNDERCARRIAGE

CHECK YOUR UNDERCARRIAGE OPERATION BEFORE ATTEMPTING TO LAND, ESPECIALLY

(i) AFTER AN ENGAGEMENT
(ii) WHEN YOUR APPROACH HAS BEEN BAULKED.

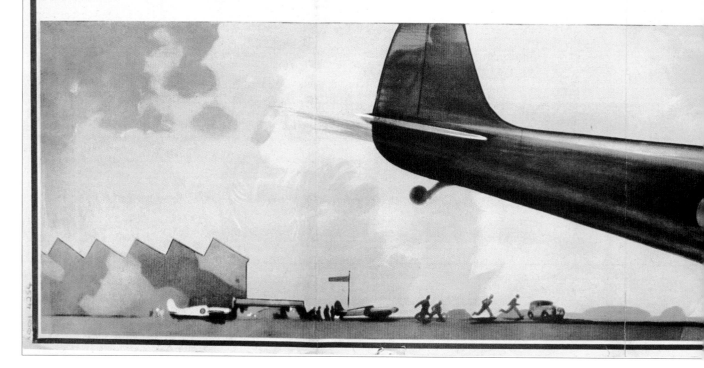

Drawing by THE AEROPLANE

MAY. 1940	AIR DIAGRAM 1300			
ISSUE NO.	1			
DATE	MAY. 1940			

FOR OFFICIAL USE ONLY

THIS PILOT DIDN'T !

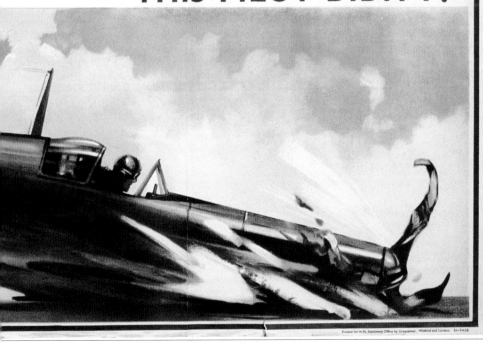

Printed for H.M. Stationery Office by Greycaine, Watford and London. 51-3428

Remember Your Undercarriage

Fatigue and inexperience were major causes of aircraft accidents. A great deal of skill was required to fly a high-powered fighter; flying it effectively in combat required even more!

Early models of the Spitfire were equipped with a mechanical undercarriage position indicator. This was a rod that extended through the top surface of the main plane and was fitted to each undercarriage unit. When the wheels were down, the rods protruded through the top of the main planes and were painted red. Later variants of the Spitfire had both mechanical and electrical visual undercarriage indicators.

At the start of World War II, 306 Spitfires had been delivered to the RAF. Of those, 187 aircraft were in squadron service, 71 were held at maintenance units, 11 served as test machines, one was used for the writing of the Pilot's Notes, and 36 aircraft struck off charge due to flying accidents.

Do You Know?

The ability to identify enemy aircraft, tanks and ships quickly before and during an engagement was crucial. It could mean the difference between victory and never being able to fight another day. Identifying a ship on the ocean's surface was an extremely difficult task. Not only did the observer have to identify the type of ship but also its nationality and its speed and direction. Misidentification was common.

During the pursuit of the German battleship *Bismarck* the aircraft carrier HMS *Ark Royal* launched fourteen torpedo-armed Swordfish aircraft. After an hour's flight the Swordfish sighted a large ship. The aircraft broke formation and went into the attack. Only after eleven torpedoes were in the water did they realize their mistake. The ship they thought was the *Bismarck* was in fact the Royal Navy cruiser HMS *Sheffield*. No damage was inflicted.

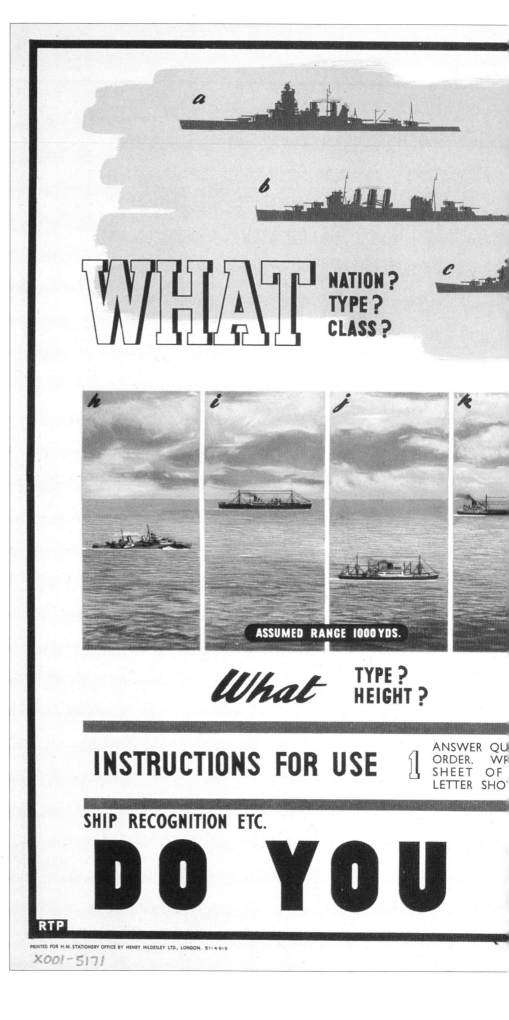

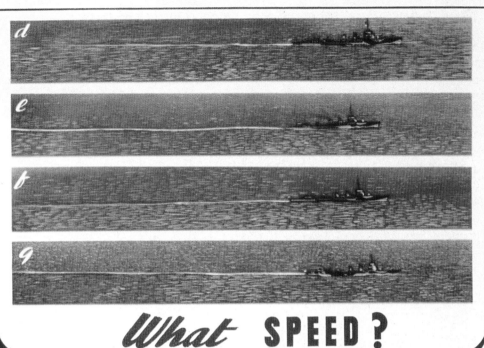

d

e

f

g

What SPEED?

l

m

n

o

WHAT

ANGLE ON NATION?
THE BOW? TYPE?

IS IN LETTER
NSWERS ON
R AGAINST

2 CHECK RESULTS ON SOLUTION
AND SCORE SHEET ACCOMPANY-
ING THIS DIAGRAM AND MARK
UP YOUR SCORE.

3 IF SCORE LESS THAN BOGEY
MORE PRACTICE IS REQUIRED.
WHEN RUN AS A COMPETITION
HIGHEST SCORE WINS.

KNOW?

QUIZ SHEET No.1

AIR DIAGRAM 2690	A.L.N?	AMENDMENTS MADE		PREPARED BY MINISTRY OF AIRCRAFT PRODUCTION FOR PROMULGATION BY
		INITIALS	DATE	
SHEET N? 1 N? OF SHEETS 1				AIR MINISTRY
MARCH 1944				

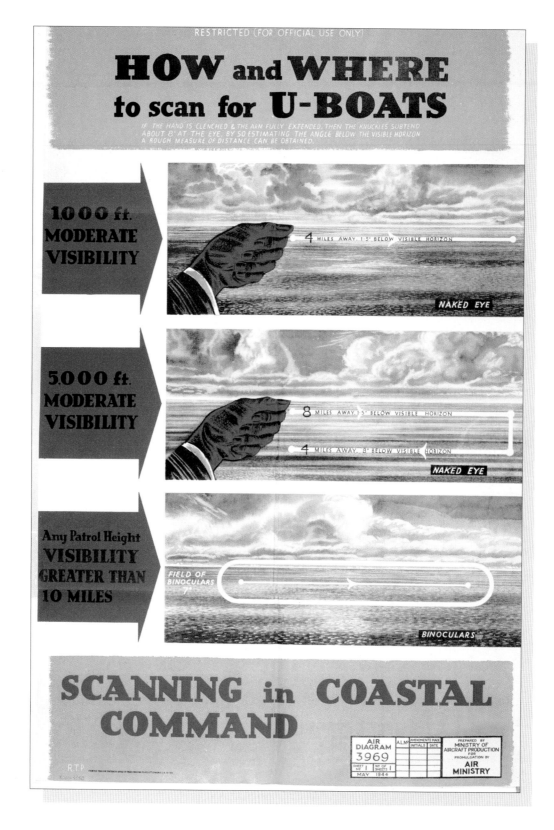

How and Where to Scan for U-boats

It was extremely difficult to sight a U-boat on the surface of the ocean with only the human eye. In poor visibility, or at night, or if the U-boat was submerged in any but the clearest of waters, U-boats were almost completely immune from attack. It was not until the advent of effective airborne radar that anti-submarine aircraft had effective means to "see" U-boats on the surface.

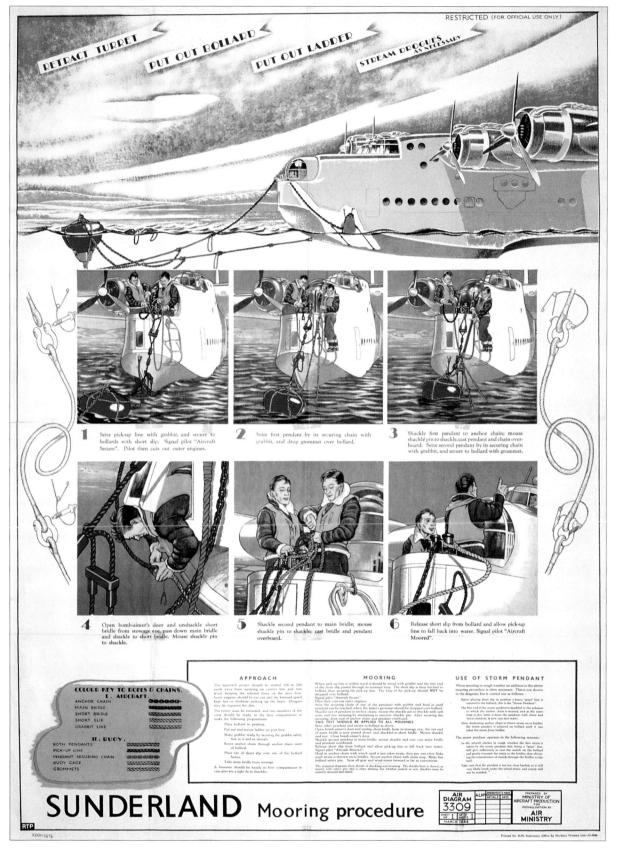

Sunderland Mooring Procedure

The Sunderland Mooring Procedure was "one of the coldest, wettest and dirtiest jobs" in the wartime RAF. After a twelve-hour patrol, mooring the 58,000-pound Sunderland was a particularly arduous task.

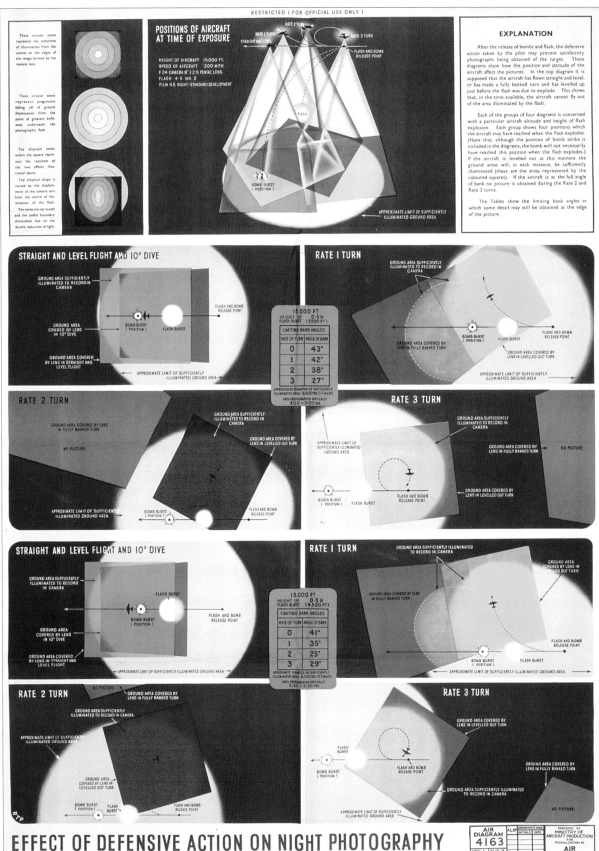

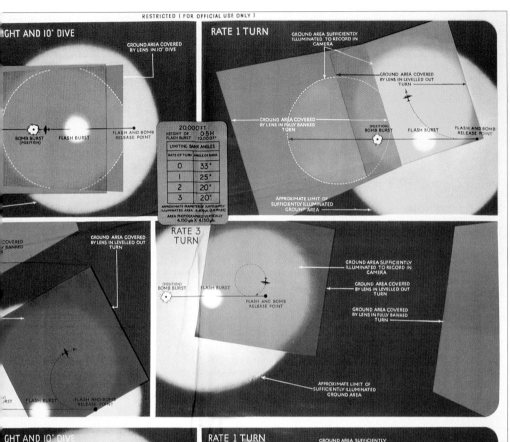

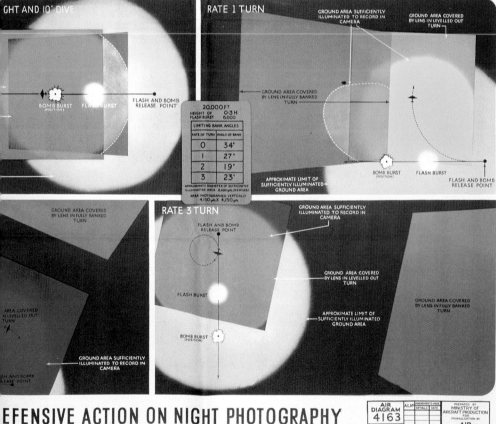

Night Photography with Bombing

RAF bomber crews in World War II faced a daunting task. Not only did they have to fly an aircraft full of bombs and fuel over enemy territory for eight or nine hours, but they had to evade heavily armed night-fighters, fly through unexpected bad weather, and when they finally reached their target, had to fly straight and level in order to drop their bombs. This was one of the most dangerous parts of the mission. Radar guided anti-aircraft fire and searchlights quickly found the range, but once the bombs were released, it was not over. All crews were required to produce a "bombing photo." This photograph would show height, heading and whether or not the crew had hit the target. When the bomb release mechanism was activated, the camera was engaged. At the same time as the bombs were released a bomb-shaped photoflash was also dropped. This fell at the same speed as bombs and when it reached 4,000 feet it exploded. The exposed film recorded the ground picture moments before the bombs impacted.

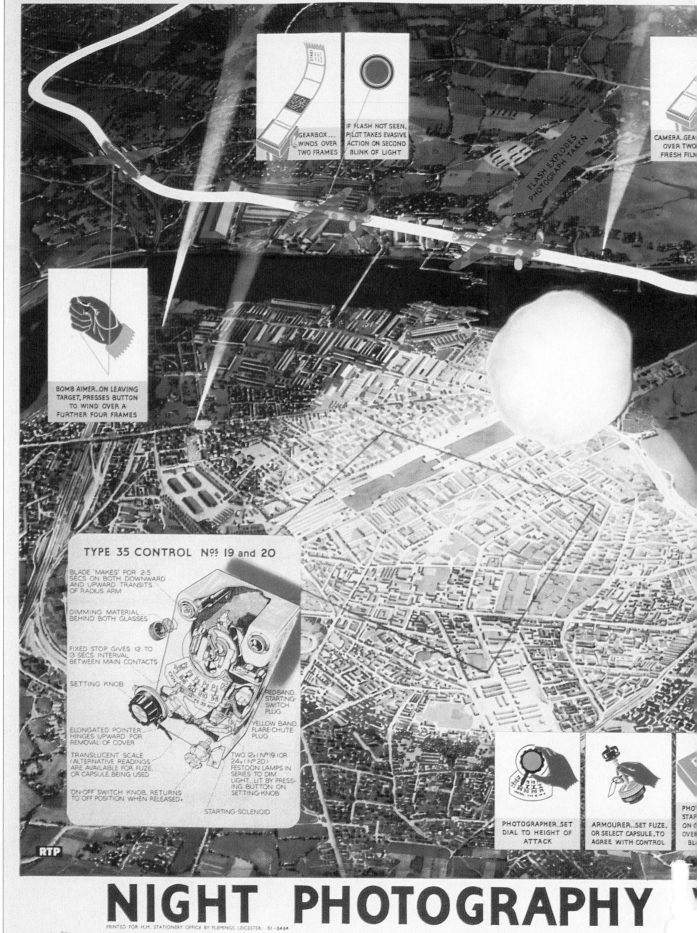

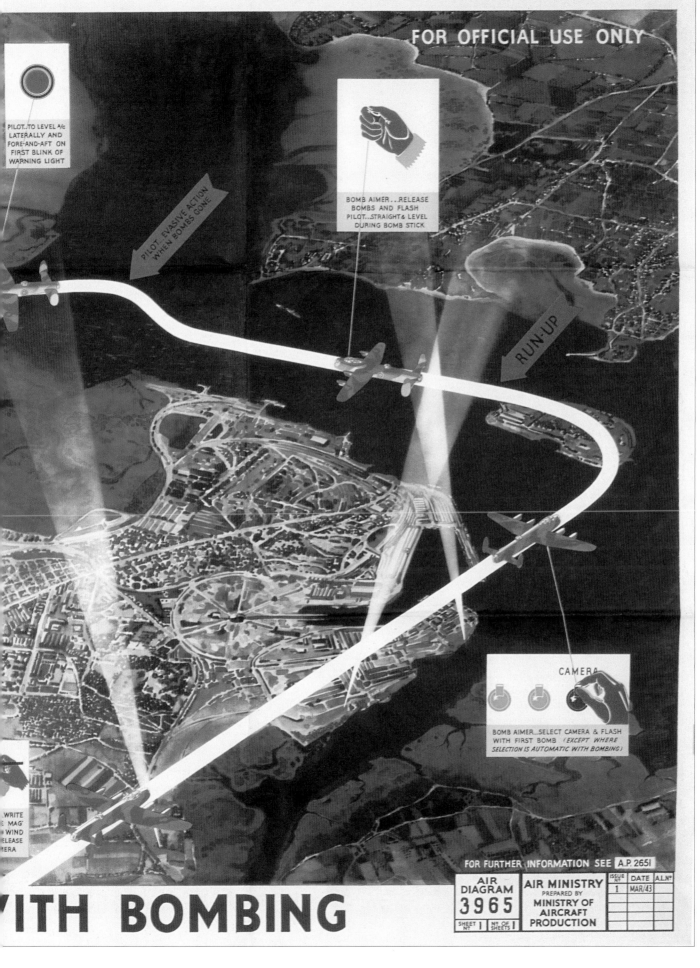

FOR OFFICIAL USE ONLY

PILOT..TO LEVEL A/c
LATERALLY AND
FORE-AND-AFT ON
FIRST BLINK OF
WARNING LIGHT

BOMB AIMER...RELEASE
BOMBS AND FLASH
PILOT...STRAIGHT & LEVEL
DURING BOMB STICK

PILOT EVASIVE ACTION
WHEN BOMBS GONE

RUN-UP

CAMERA

BOMB AIMER...SELECT CAMERA & FLASH
WITH FIRST BOMB (EXCEPT WHERE
SELECTION IS AUTOMATIC WITH BOMBING)

..WRITE
MAG
WIND
ELEASE
MERA

FOR FURTHER INFORMATION SEE A.P. 2651

ITH BOMBING

AIR DIAGRAM 3965	AIR MINISTRY PREPARED BY MINISTRY OF AIRCRAFT PRODUCTION	ISSUE Nº	DATE	A.L.Nº
SHEET Nº 1	Nº OF SHEETS 1	1	MAR/43	

GREAT BRITAIN

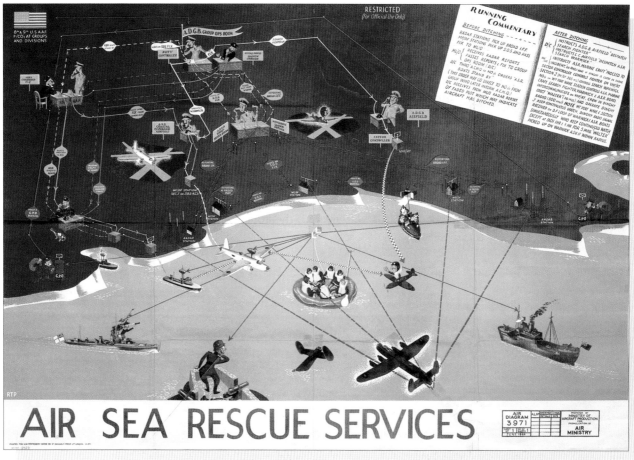

Air Sea Rescue

The Air Sea Rescue (ASR) Service in World War II was a great asset to the Allies.

"Almost every operational flight made from Great Britain includes a flight over the sea, so an extensive and well-equipped air-sea rescue organization has been built up round our coasts. This service have become remarkably efficient in itself, but in the end its effectiveness depends on the ability of air crews to make the best of the facilities and equipment available — on their ability, in fact, to give themselves the best possible chance of being rescued."

AIRCREW TRAINING BULLETIN NO. 22, FEBRUARY 1945

During the war, the Air Sea Rescue Service saved 5,721 aircrew members, enough men to operate 572 B-17s or 817 Lancaster heavy bombers.

Lancaster Emergency Equipment

The emergency equipment and exits for the Lancaster I may be clearly marked and color-coded in this air diagram, but one has to consider how well the seven crew members of a damaged Lancaster about to ditch in the North Sea at night might fare. The most important items were the aircrew's parachutes and dinghy. British aircrews not only had to know where these items were, and which items were to be used together — they had to do it all in the dark.

During World War II, American, British and German aircraft were well equipped with first-aid kits and emergency equipment. The Japanese, on the other hand, paid little attention to crew survival.

"During the earlier part of the war little was given to the implementation of the flyer's life with an array of 'survival equipment'… The average JNAF flyer wore a kapok life preserver beneath his parachute harness. In the latter years of the war, some of his airplanes carried either 1-man, 3-man, or 5-man life rafts equipped with CO_2 cylinders, bellows pumps, fishing kit, signal mirror, signal flag, and paddles."

AIR TECHNICAL INTELLIGENCE GROUP REPORT NO. 223
SUBJECT: SURVIVAL EQUIPMENT SUPPLIED AIRCREW MEN BY JNAF, DECEMBER 18, 1945

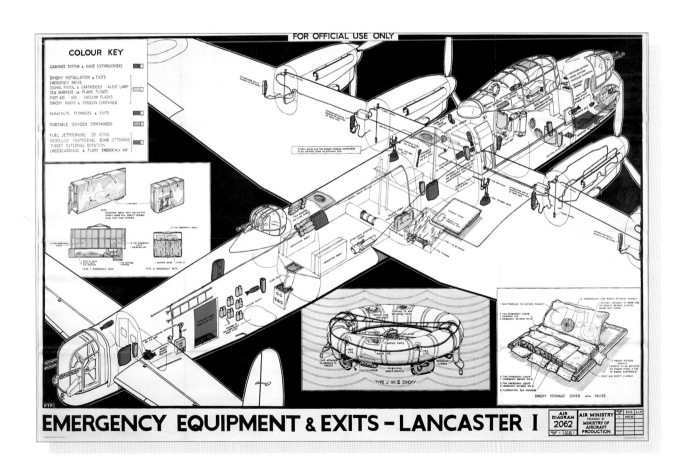

Halifax Emergency Equipment

More versatile than the famed Avro Lancaster, the Handley Page Halifax also offered its crew a better chance of survival. Twenty-nine percent of Halifax crews shot down survived the experience, compared to 17 percent of Stirling crews and only 11 percent of Lancaster crews. Compared to the Lancaster, the Halifax had a larger, more spacious fuselage. This made movement in the aircraft much easier and made bailing out and exiting a ditched aircraft less difficult. At its peak the Halifax equipped thirty-five RAF squadrons with a total of 1,500 aircraft.

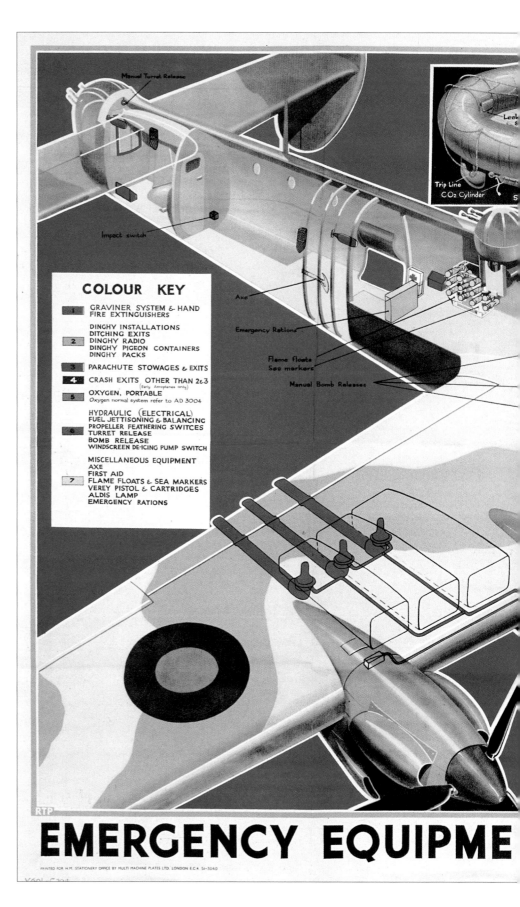

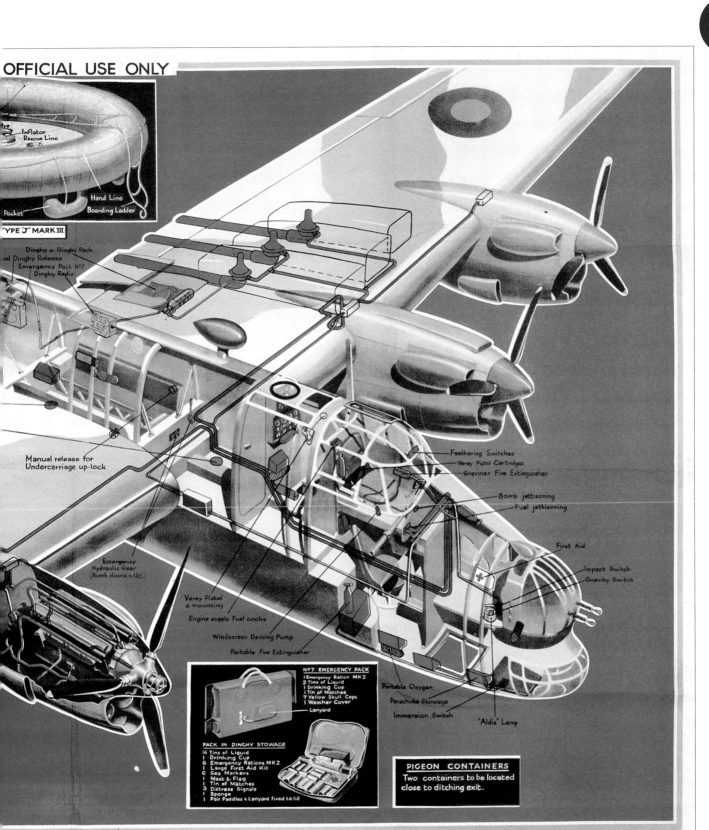

OFFICIAL USE ONLY

Inflator
Rescue Line

Pocket

Hand Line

Boarding Ladder

TYPE "J" MARK III

Dinghy & Dinghy Pack
ual Dinghy Release
Emergency Pack Nº7
Dinghy Radio

Manual release for
Undercarriage up-lock

Emergency
Hydraulic Gear
(Bomb doors & U/C.)

Verey Pistol
& mounting

Engine supply Fuel cocks

Windscreen De-icing Pump

Portable Fire Extinguisher

Feathering Switches
Verey Pistol Cartridges
Graviner Fire Extinguisher

Bomb jettisoning
Fuel jettisoning

First Aid

Impact Switch
Gravity Switch

Portable Oxygen
Parachute Stowage

Immersion Switch

"Aldis" Lamp

Nº7 EMERGENCY PACK
1 Emergency Ration MK2
2 Tins of Liquid
1 Drinking Cup
1 Tin of Matches
7 Yellow Skull Caps
1 Weather Cover
Lanyard

PACK IN DINGHY STOWAGE
16 Tins of Liquid
1 Drinking Cup
6 Emergency Rations MK2
1 Large First Aid Kit
6 Sea Markers
1 Mast & Flag
1 Tin of Matches
3 Distress Signals
1 Sponge
1 Pair Paddles & Lanyard Fixed to lid

PIGEON CONTAINERS
Two containers to be located
close to ditching exit.

& EXITS - HALIFAX II

AIR DIAGRAM 3002	AIR MINISTRY PREPARED BY MINISTRY OF AIRCRAFT PRODUCTION	ISSUE Nº	DATE	A.LNº
SHEET Nº 1	Nº OF SHEETS 1	1	AUG.42	

GREAT BRITAIN

GREAT BRITAIN

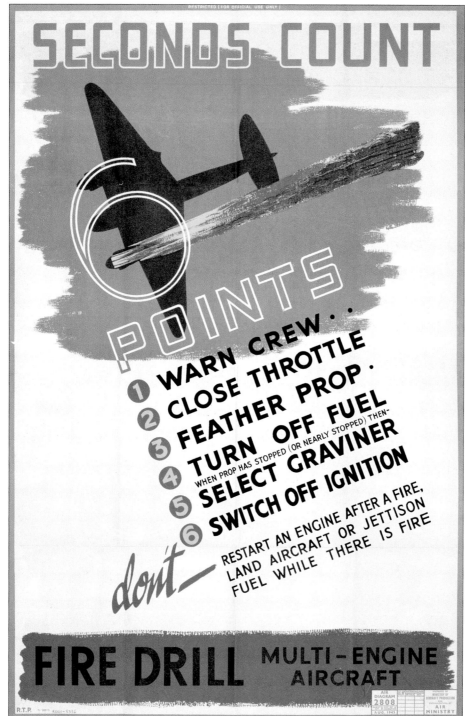

Seconds Count

Engine fires on a training mission over friendly territory were serious enough, but engine fires caused by enemy fighters or flak could be fatal. Damage was not always limited to one engine, and a pilot facing an engine fire had to react quickly in order to save the aircraft and crew. The six steps listed in this poster sound simple enough, but in many instances the pilot of a damaged bomber was faced with more than just an engine fire. If the fire was not too severe and the fire extinguishers worked, the aircraft could be flown home on the remaining engines.

Engines in most German, British and American aircraft had their own fire extinguishers. For the British, these were known as Graviners because of the maker's name. Hence step five: select Graviner.

Mosquito Parachute Drill (opposite)

Fortunately for most Mosquito crews, they never had to bail out. Compared to other aircraft in Bomber Command, the loss rate for the Mosquito was extremely low. Its high-speed, high-altitude performance made it extremely difficult to intercept. In 1945 alone, 3,988 night sorties were dispatched to Berlin for a loss of just 14 aircraft — a rate of 0.99 percent!

RESTRICTED (FOR OFFICIAL USE ONLY)

MOSQUITO
P.F.F. & MAIN FORCE BOMBERS
Parachute Drill

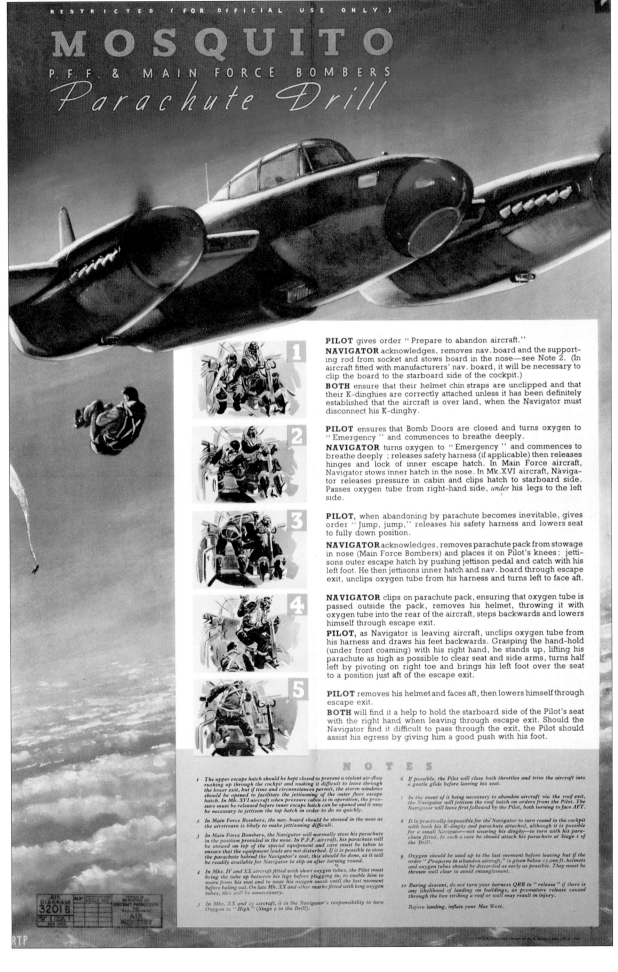

1 **PILOT** gives order "Prepare to abandon aircraft."

NAVIGATOR acknowledges, removes nav. board and the supporting rod from socket and stows board in the nose—see Note 2. (In aircraft fitted with manufacturers' nav. board, it will be necessary to clip the board to the starboard side of the cockpit.)

BOTH ensure that their helmet chin straps are unclipped and that their K-dinghies are correctly attached unless it has been definitely established that the aircraft is over land, when the Navigator must disconnect his K-dinghy.

2 **PILOT** ensures that Bomb Doors are closed and turns oxygen to "Emergency" and commences to breathe deeply.

NAVIGATOR turns oxygen to "Emergency" and commences to breathe deeply ; releases safety harness (if applicable) then releases hinges and lock of inner escape hatch. In Main Force aircraft, Navigator stows inner hatch in the nose. In Mk.XVI aircraft, Navigator releases pressure in cabin and clips hatch to starboard side. Passes oxygen tube from right-hand side, *under* his legs to the left side.

3 **PILOT**, when abandoning by parachute becomes inevitable, gives order "Jump, jump," releases his safety harness and lowers seat to fully down position.

NAVIGATOR acknowledges, removes parachute pack from stowage in nose (Main Force Bombers) and places it on Pilot's knees ; jettisons outer escape hatch by pushing jettison pedal and catch with his left foot. He then jettisons inner hatch and nav. board through escape exit, unclips oxygen tube from his harness and turns left to face aft.

4 **NAVIGATOR** clips on parachute pack, ensuring that oxygen tube is passed outside the pack, removes his helmet, throwing it with oxygen tube into the rear of the aircraft, steps backwards and lowers himself through escape exit.

PILOT, as Navigator is leaving aircraft, unclips oxygen tube from his harness and draws his feet backwards. Grasping the hand-hold (under front coaming) with his right hand, he stands up, lifting his parachute as high as possible to clear seat and side arms, turns half left by pivoting on right toe and brings his left foot over the seat to a position just aft of the escape exit.

5 **PILOT** removes his helmet and faces aft, then lowers himself through escape exit.

BOTH will find it a help to hold the starboard side of the Pilot's seat with the right hand when leaving through escape exit. Should the Navigator find it difficult to pass through the exit, the Pilot should assist his egress by giving him a good push with his foot.

NOTES

1 The upper escape hatch should be kept closed to prevent a violent air-flow rushing up through the cockpit and making it difficult to leave through the lower exit, but if time and circumstances permit, the storm windows should be opened to facilitate the jettisoning of the outer floor escape hatch. In Mk. XVI aircraft when pressure cabin is in operation, the pressure must be released before inner escape hatch can be opened and it may be necessary to jettison the top hatch in order to do so quickly.

2 In Main Force Bombers, the nav. board should be stowed in the nose as the airstream is likely to make jettisoning difficult.

3 In Main Force Bombers, the Navigator will normally stow his parachute in the position provided in the nose. In P.F.F. aircraft, his parachute will be stowed on top of the special equipment and care must be taken to ensure that the equipment leads are not disturbed. If it is possible to stow the parachute behind the Navigator's seat, this should be done, as it will be readily available for Navigator to slip on after turning round.

4 In Mks. IV and XX aircraft fitted with short oxygen tubes, the Pilot must bring the tube up between his legs before plugging in, to enable him to move from his seat and to wear his oxygen mask until the last moment before baling out. On late Mk. XX and other marks fitted with long oxygen tubes, this will be unnecessary.

5 In Mks. XX and 25 aircraft, it is the Navigator's responsibility to turn Oxygen to "High" (Stage 2 in the Drill).

6 If possible, the Pilot will close both throttles and trim the aircraft into a gentle glide before leaving his seat.

7 In the event of it being necessary to abandon aircraft via the roof exit, the Navigator will jettison the roof hatch on orders from the Pilot. The Navigator will leave first followed by the Pilot, both turning to face AFT.

8 It is practically impossible for the Navigator to turn round in the cockpit with both his K-dinghy and parachute attached, although it is possible for a small Navigator—not wearing his dinghy—to turn with his parachute fitted. In such a case he should attach his parachute at Stage 1 of the Drill.

9 Oxygen should be used up to the last moment before leaving but if the order "Prepare to abandon aircraft," is given below 15,000 ft. helmets and oxygen tubes should be discarded as early as possible. They must be thrown well clear to avoid entanglement.

10 During descent, do not turn your harness QRB to "release" if there is any likelihood of landing on buildings, as premature release caused through the box striking a roof or wall may result in injury.

Before landing, inflate your Mae West.

AIR DIAGRAM 3201B

RTP

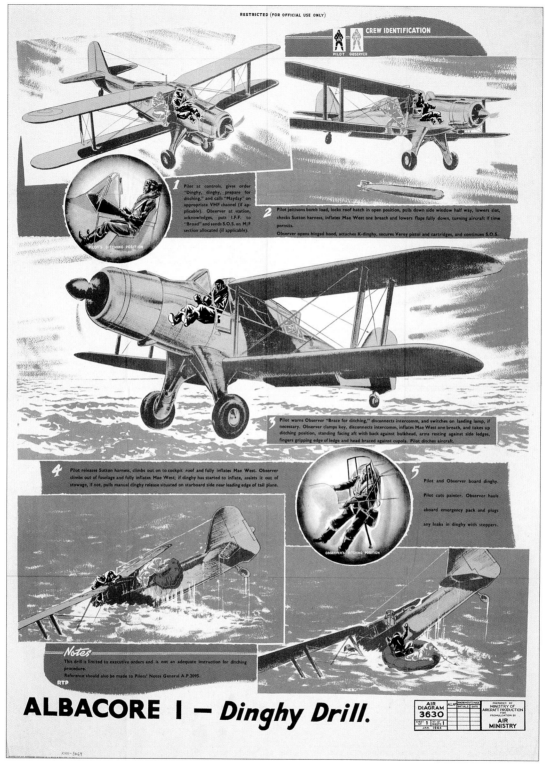

Fairey Albacore Dinghy Drill

Carrier operations during World War II suffered from severe aircraft attrition. Many aircraft, short on fuel after a long mission, were forced to ditch — close to their carrier was best. Designed as a replacement for the antiquated Fairey Swordfish, the Fairey Albacore did not live up to expectations, but it did have the luxury of an automatic emergency dinghy ejection system.

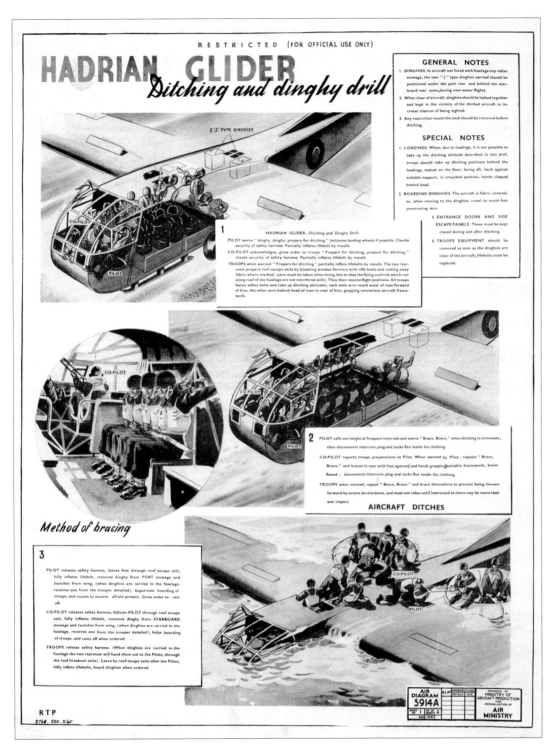

Hadrian Glider Ditching

The first large-scale use of airborne and glider troops by the Allies in World War II was a disaster. On the night of July 9, 1943, British and American airborne troops in 147 Waco (Hadrian) and Horsa gliders took off from bases in Tunisia bound for Sicily. Only twelve reached their landing zones. Sixty-nine were released early and landed in the sea, drowning 600 men. One landed in Malta, and one in Sardinia, while the rest were scattered about Southern Sicily. There were 14,000 Waco CG-4As produced during the war. They were capable of carrying thirteen troops or light vehicles and guns.

Abandoning by Parachute Hampden I

It was not uncommon for crews to bail out immediately after an aircraft was hit. If a man did not jump within seconds, he knew that he might not have a second chance. But not all hits were fatal. There were many instances of damaged aircraft making it home with only half the crew aboard.

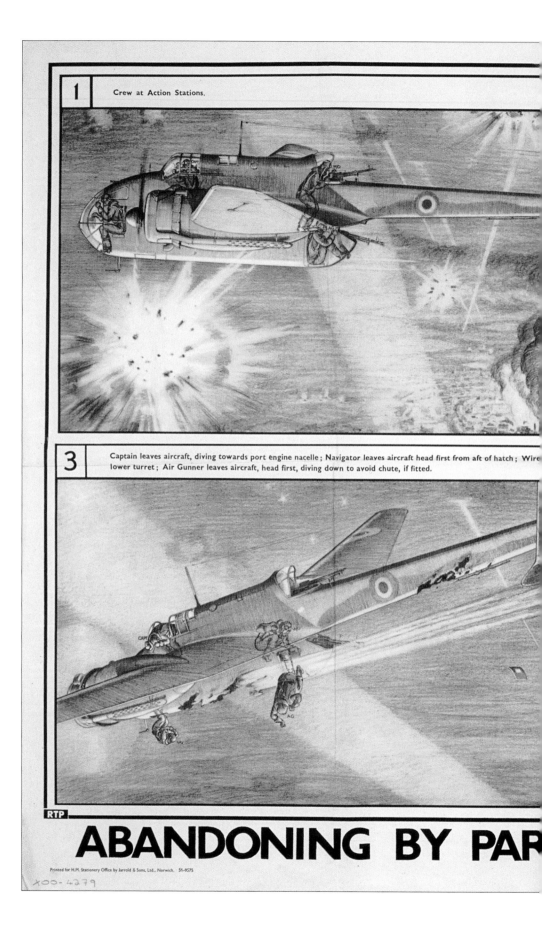

1 Crew at Action Stations.

3 Captain leaves aircraft, diving towards port engine nacelle; Navigator leaves aircraft head first from aft of hatch; Wire lower turret; Air Gunner leaves aircraft, head first, diving down to avoid chute, if fitted.

RTP

ABANDONING BY PAR

Printed for H.M. Stationery Office by Jarrold & Sons, Ltd., Norwich. 51-9575

GREAT BRITAIN

OFFICIAL USE ONLY

2 Captain gives order "Emergency Jump," destroys I.F.F. and slides back top hatch; Navigator fits pack and opens emergency hatch; Wireless Operator collects and fits pack; Air Gunner fits pack and jettisons door.

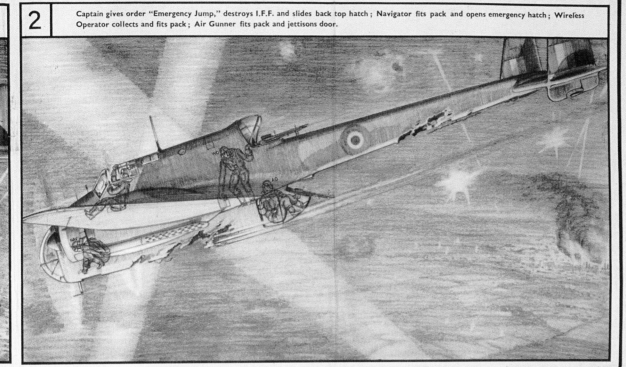

or moves to

4 Captain taken by slipstream over trailing edge of port wing; Wireless Operator leaves aircraft through door, head first, diving down to avoid chute, if fitted.

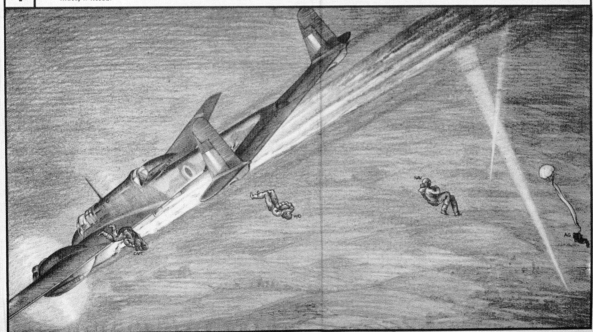

CHUTE — HAMPDEN I
ERGENCY METHOD)

AIR DIAGRAM 1333	AIR MINISTRY PREPARED BY MINISTRY OF AIRCRAFT PRODUCTION	ISSUE	DATE	A.L.Nº
SHEET Nº 3	Nº OF SHEETS 4	1	FEB 41	
		2	SEPT 41	

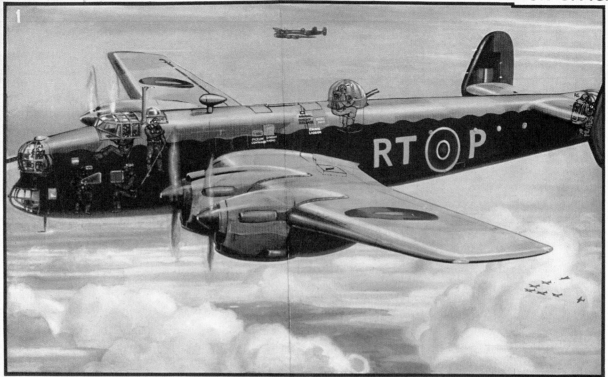

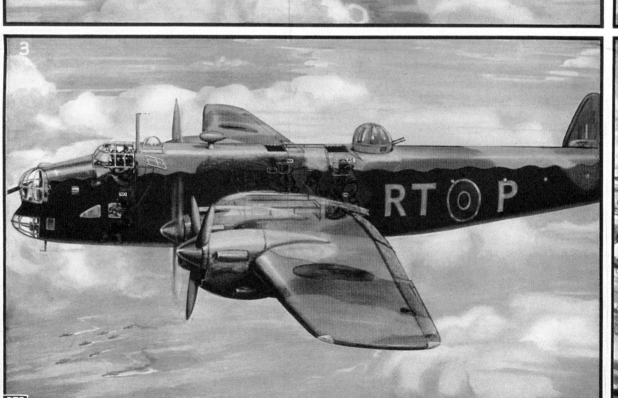

ABANDONING BY DINGHY – H

PRINTED FOR H.M. STATIONERY OFFICE BY FLEMINGS, LEICESTER. 51-2625

X001-5382

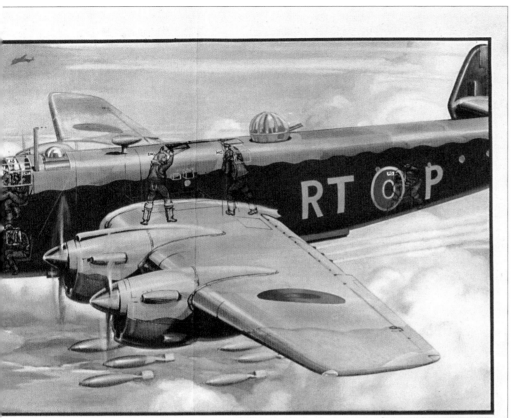

Halifax Ditching and Dinghy Drill

"Dinghy, dinghy, prepare to ditch; Last one out is a son of a bitch."

Many bomber crew found practising the dinghy drill in the local pool an annoying or amusing use of time. Ditching a large four-engine bomber into the North Sea or English Channel at night required at great degree of skill and a great deal of luck. It will never be known how many warplanes ditched in the waters around England.

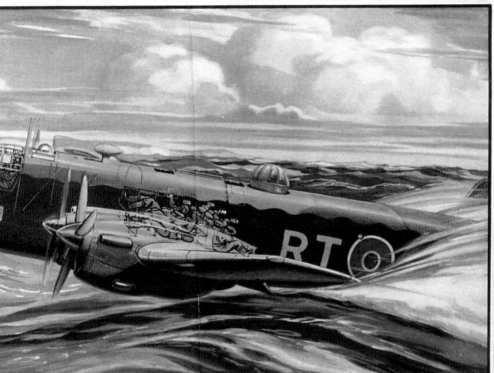

ALIFAX II

AIR DIAGRAM 3000	AIR MINISTRY PREPARED BY MINISTRY OF AIRCRAFT PRODUCTION	ISSUE Nº	DATE	A.LNº
		1	JULY '42	
SHEET Nº 1 Nº OF SHEETS 3				

GREAT BRITAIN

Airborne Lifeboat

The Air/Sea Rescue Service was inaugurated in May 1941. One of the first aircraft to carry the airborne lifeboat was the Lockheed Hudson. This was followed by more powerful and longer-ranged Vickers Warwick. When a downed crew was spotted, the normal bombsight and release mechanisms were used for aiming and releasing the lifeboat. Around Britain, 5,721 British and American aircrew were saved. In other theaters of war over 3,000 lives were saved.

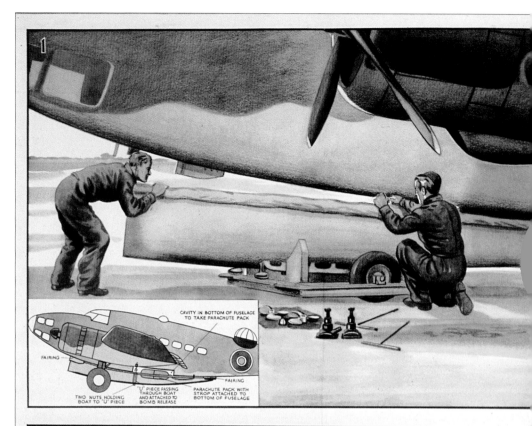

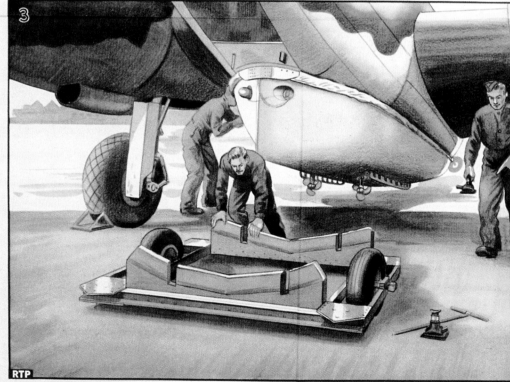

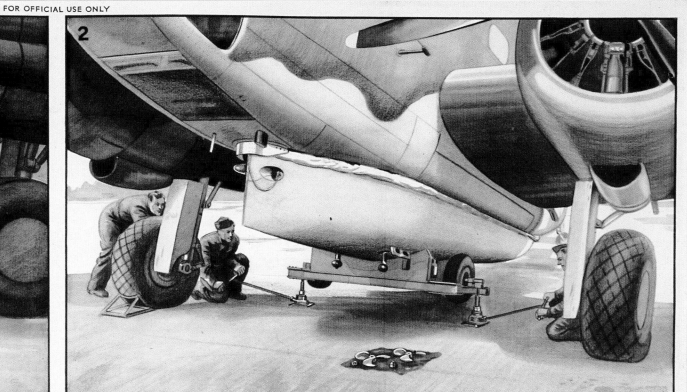

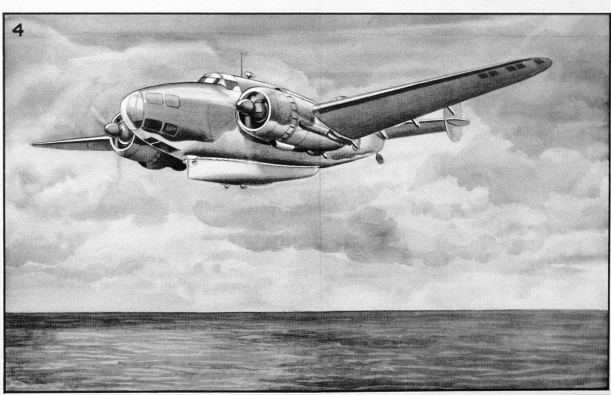

Mk I - *Bombing Up*

AIR DIAGRAM 3983	AIR MINISTRY PREPARED BY MINISTRY OF AIRCRAFT PRODUCTION	ISSUE Nº	DATE	A.LNº
		I	MAR.43	

SHEET Nº 2 | Nº OF SHEETS 4

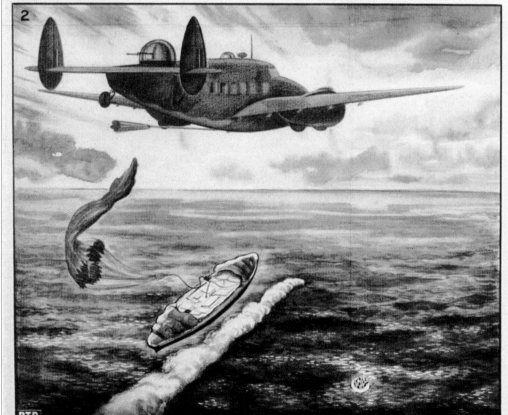

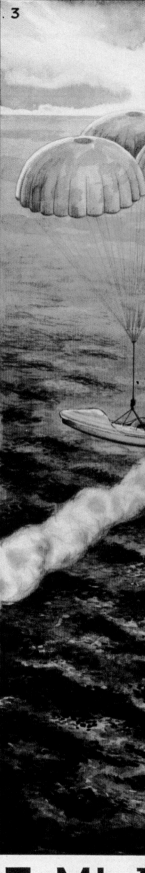

FOR OFF

AIRBORNE LIFE BOAT Mk I

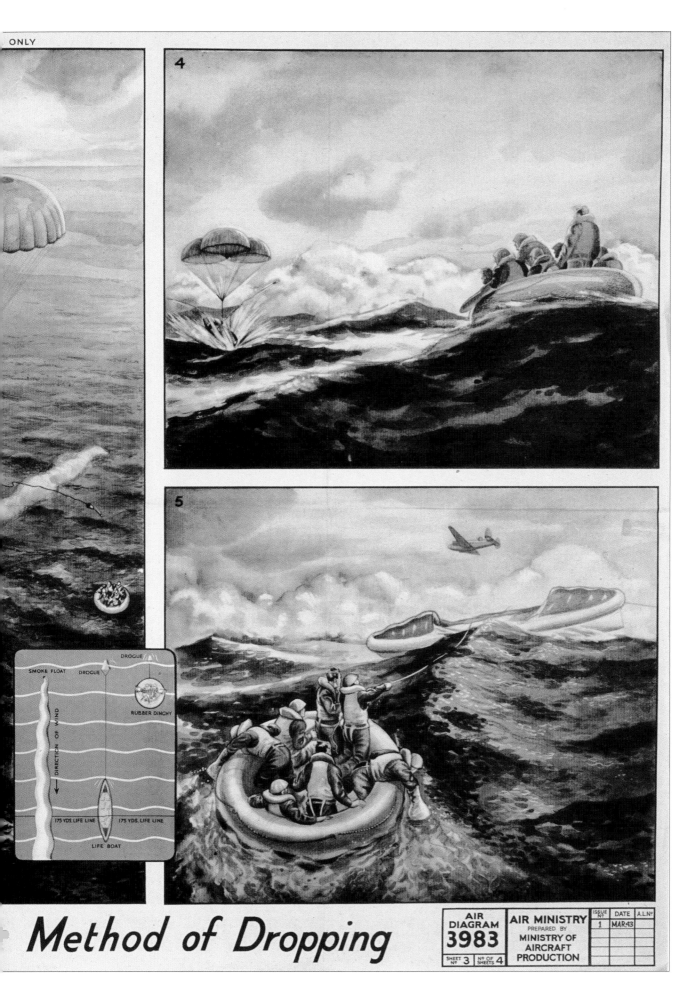

Method of Dropping

Airborne Lifeboat

The celebrated yachtsman Uffa Fox designed the Airborne Lifeboat. Equipped with food, water and other vital supplies, this lifeboat gave downed aircrew the best chance for survival. The boat itself was 23 feet, 6 inches (7.17 m) long and 5 feet, 6 inches (1.67 m) wide. It weighed 1,700 pounds (222 kg) and was dropped on six 32-foot-diameter (9.76 m) parachutes.

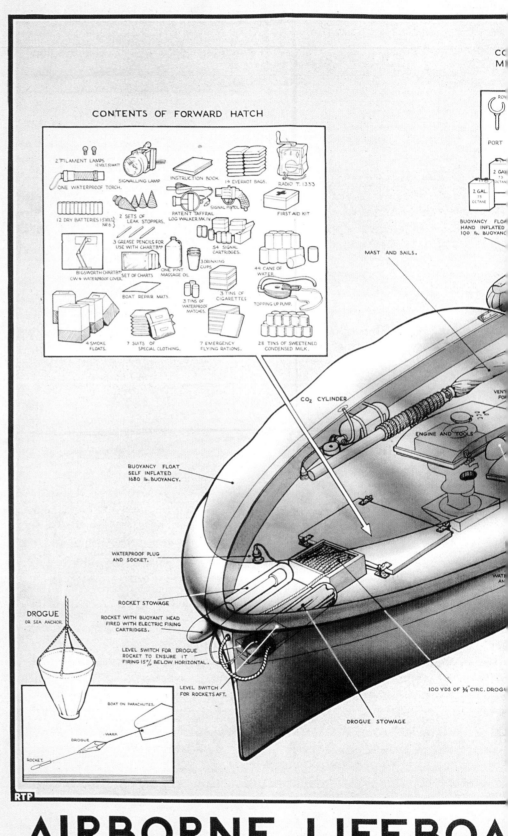

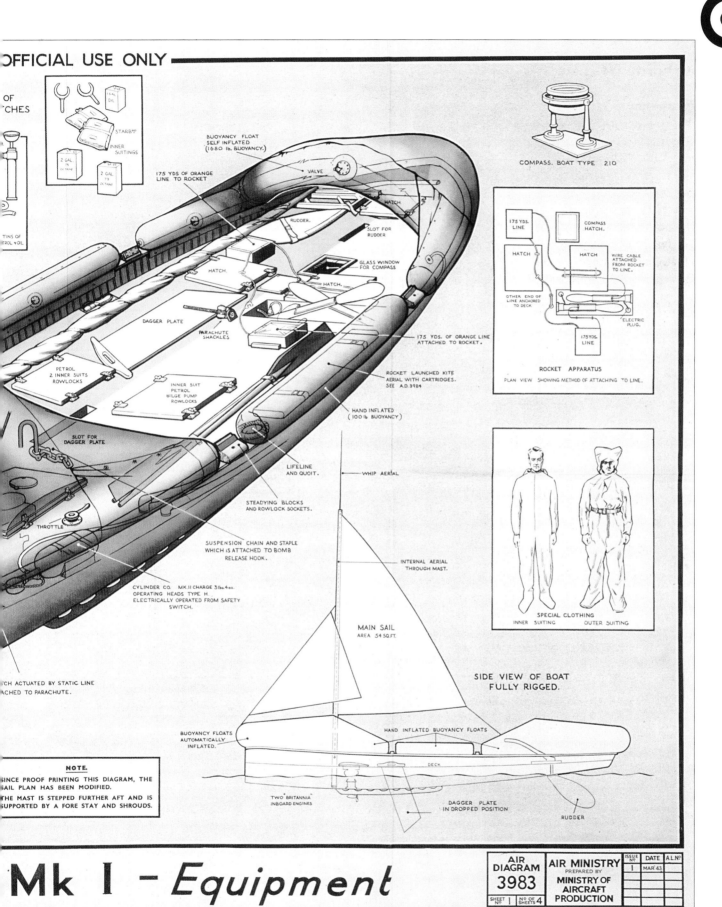

OFFICIAL USE ONLY

OF
...CHES

STARB'D
INNER
SUITINGS

2 GAL
73
OCTANE

2 GAL
73
OCTANT

TINS OF
...TROL +OIL

BUOYANCY FLOAT
SELF INFLATED
(1680 lb. BUOYANCY.)

VALVE

175 YDS OF ORANGE
LINE TO ROCKET

RUDDER.

HATCH

SLOT FOR
RUDDER

HATCH.

GLASS WINDOW
FOR COMPASS

HATCH.

DAGGER PLATE

PARACHUTE
SHACKLES

PETROL
2 INNER SUITS
ROWLOCKS

INNER SUIT
PETROL
BILGE PUMP
ROWLOCKS

175 YDS. OF ORANGE LINE
ATTACHED TO ROCKET.

ROCKET LAUNCHED KITE
AERIAL WITH CARTRIDGES.
SEE A.D. 3984

HAND INFLATED
(100 lb BUOYANCY.)

SLOT FOR
DAGGER PLATE

LIFELINE
AND QUOIT.

STEADYING BLOCKS
AND ROWLOCK SOCKETS.

THROTTLE

SUSPENSION CHAIN AND STAPLE
WHICH IS ATTACHED TO BOMB
RELEASE HOOK.

CYLINDER CO. MK.II CHARGE 3 lbs.4 oz.
OPERATING HEADS TYPE H
ELECTRICALLY OPERATED FROM SAFETY
SWITCH.

...CH ACTUATED BY STATIC LINE
...ACHED TO PARACHUTE.

COMPASS. BOAT TYPE 210

175 YDS.
LINE

COMPASS
HATCH.

HATCH

HATCH

WIRE CABLE
ATTACHED
FROM ROCKET
TO LINE.

OTHER END OF
LINE ANCHORED
TO DECK

ELECTRIC
PLUG.

175 YDS.
LINE

ROCKET APPARATUS
PLAN VIEW SHOWING METHOD OF ATTACHING TO LINE.

SPECIAL CLOTHING
INNER SUITING OUTER SUITING

WHIP AERIAL

INTERNAL AERIAL
THROUGH MAST.

MAIN SAIL
AREA 54 SQ.FT.

SIDE VIEW OF BOAT
FULLY RIGGED.

BUOYANCY FLOATS
AUTOMATICALLY
INFLATED.

HAND INFLATED BUOYANCY FLOATS

DECK

TWO BRITANNIA
INBOARD ENGINES

DAGGER PLATE
IN DROPPED POSITION

RUDDER

NOTE.
SINCE PROOF PRINTING THIS DIAGRAM, THE
SAIL PLAN HAS BEEN MODIFIED.
THE MAST IS STEPPED FURTHER AFT AND IS
SUPPORTED BY A FORE STAY AND SHROUDS.

Mk I - *Equipment*

AIR DIAGRAM 3983	AIR MINISTRY PREPARED BY MINISTRY OF AIRCRAFT PRODUCTION	ISSUE Nº	DATE	A.L.Nº
SHEET Nº 1	Nº OF SHEETS 4	I	MAR 43	

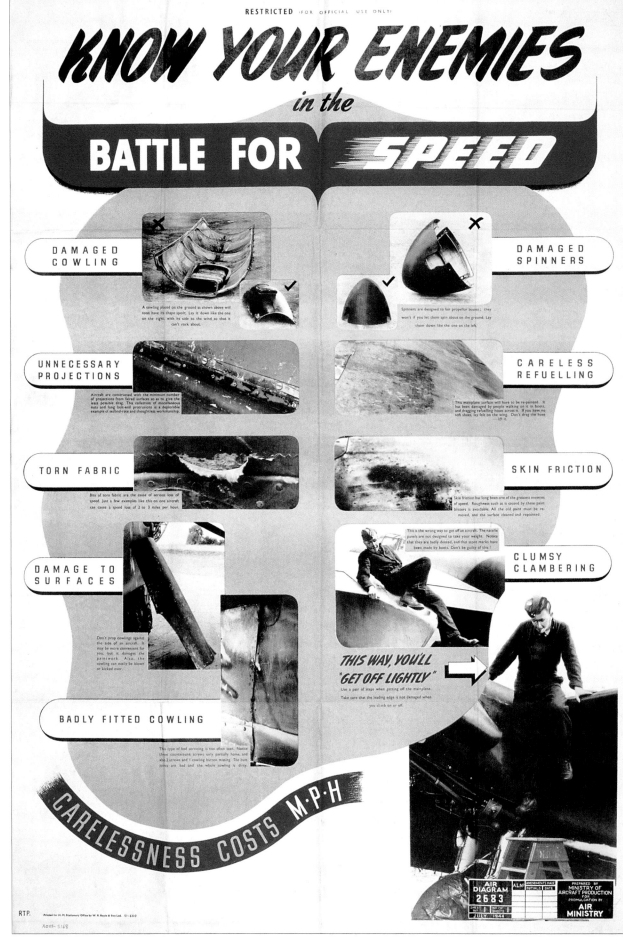

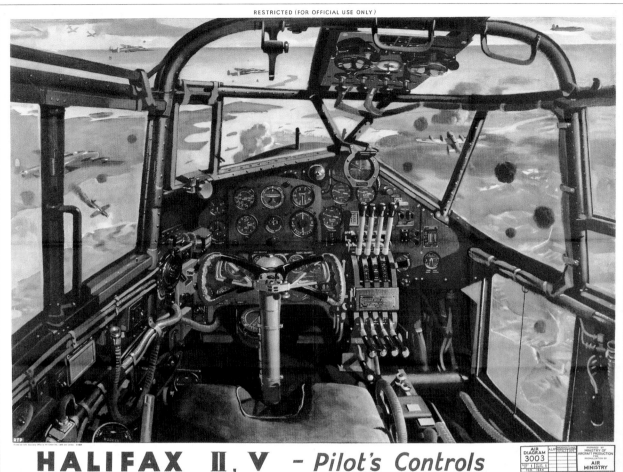

RESTRICTED (FOR OFFICIAL USE ONLY)

HALIFAX Ⅱ, Ⅴ - *Pilot's Controls*

Battle for Speed (opposite)

Speed, or the lack of it, could mean the difference between life and death in the combat zone. The many bomber aircraft serving Bomber Command had different airspeeds, and the ones with the best, the Mosquito and Lancaster, had the better chance of survival. The slower and lower-flying Halifax suffered greater losses than the Lancaster, and the Short Stirling suffered even more! It was finally withdrawn from Bomber Command operations in November 1943. When a four-engine bomber was freed of its bomb load, its speed was greatly increased. As German night-fighters added more and more electronic equipment and new radars, air resistance increased and, with it, a corresponding loss of speed. The Bf 110, which performed well at the beginning of the war, could barely outpace the Lancaster and Halifax, particularly when they were free of their bombs.

Halifax Pilot's Controls

The heavy bomber pilot of World War II had much to learn. It was also a very physically demanding occupation. Diagrams enabled trainees to study the controls without having to use the actual aircraft. This helped free aircraft for other more important duties. For no apparent reason, the artist for this illustration decided to situate this cockpit in the middle of a battle scene.

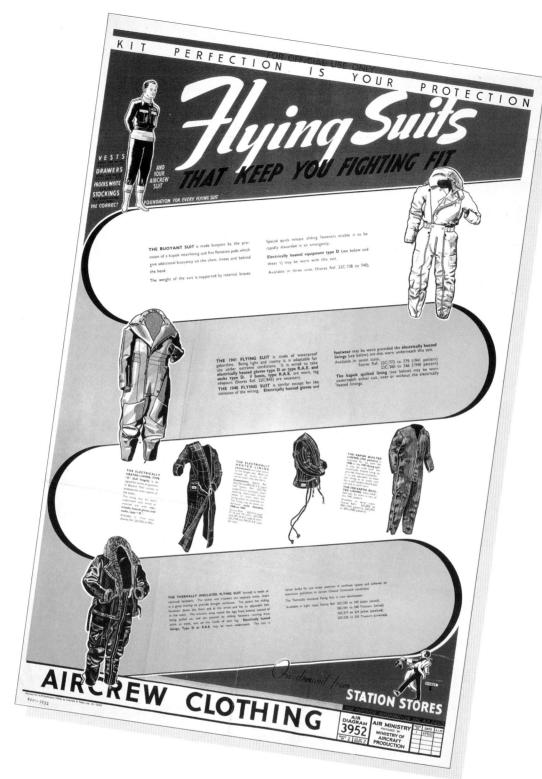

Aircrew Clothing

In the European theater of operations aircrew had to face atrocious weather and extreme cold as well. At altitude, flying in a non-pressurized bomber or fighter meant outside temperatures of up to minus 50° Fahrenheit. Frostbite was a constant enemy, and flying in a cramped bomber for seven or eight hours at a time only added to the danger. The right clothing was vital for survival and performance. Air gunners were provided with electrically heated suits, but these did not always work as advertised. Surprisingly, American aircrew preferred the British-type flying boot. If one had to bail out, the standard American flying boot was useless for walking long distances and were an obvious giveaway in enemy-held territory. The British flying boot had a concealed hacksaw blade, which could be used to cut away the leggings to reveal a conventional shoe.

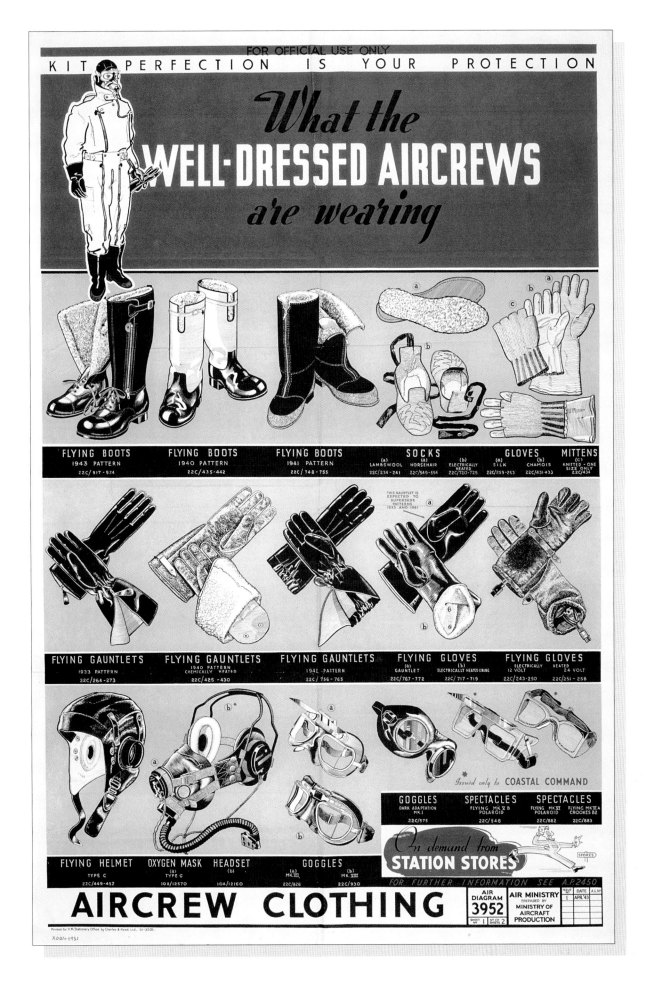

Check Your Mask Fit

Combat aircraft during World War II were not pressurized, except for the B-29 and small numbers of specialized high-altitude fighters, bombers and reconnaissance aircraft. Above 10,000 feet, oxygen was used at all times. Failure of the oxygen system usually meant a return to base; during the combat mission, crews had to continually check on each other to make sure no one was suffering the effects of anoxia. Without oxygen, the lifespan of a pilot or crew member was measured in minutes.

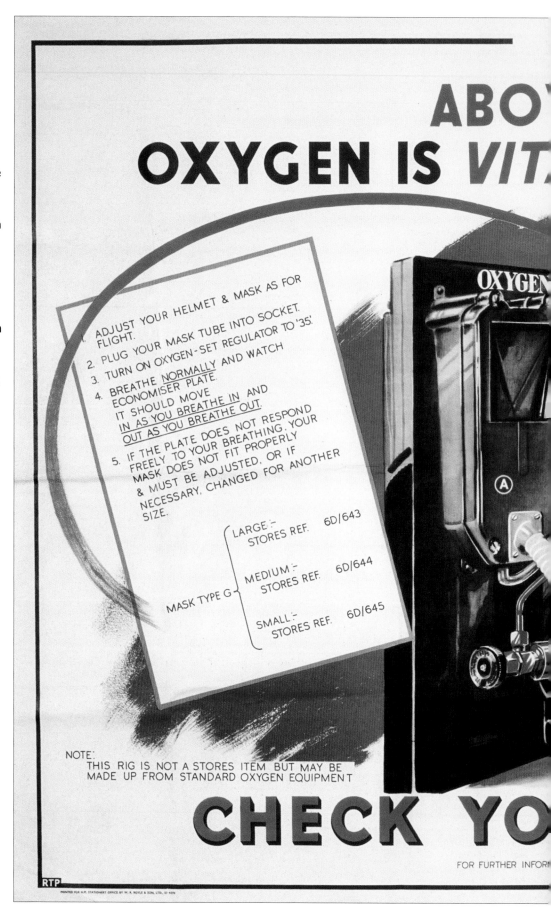

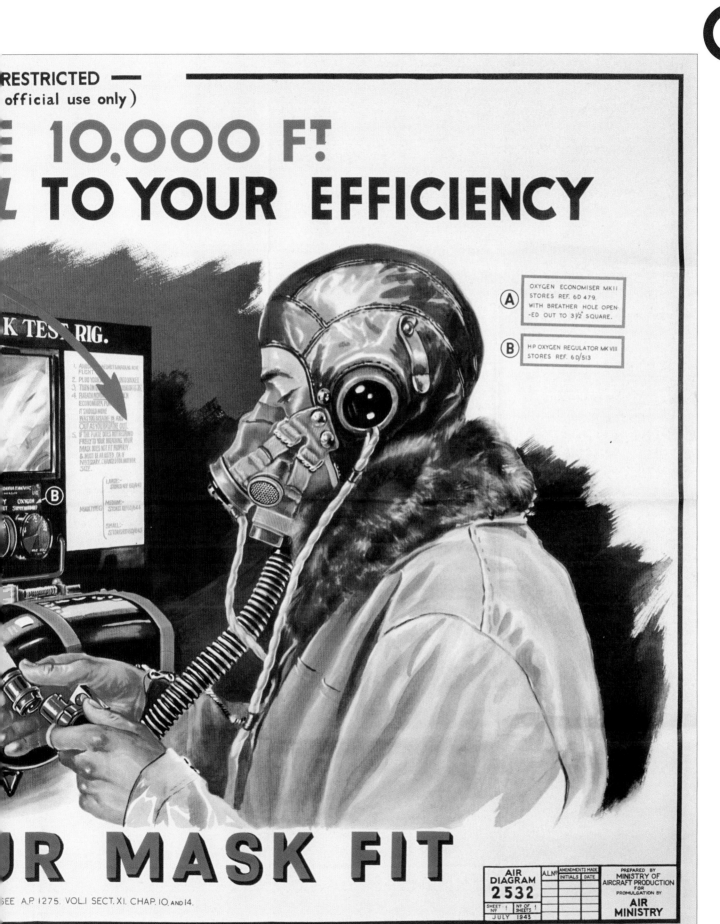

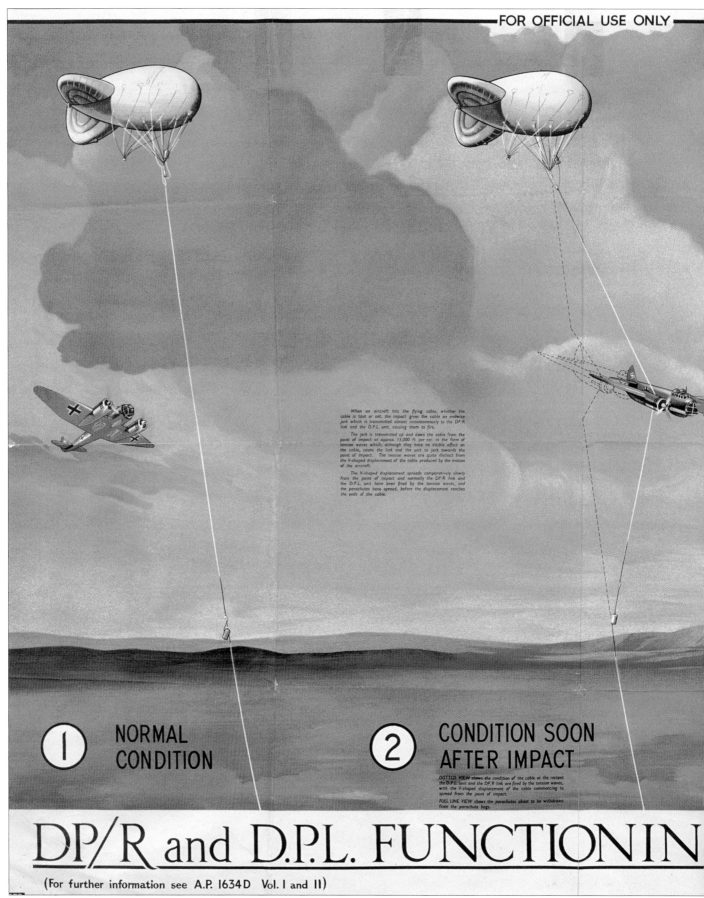

When an aircraft hits the flying cable, whether the cable is taut or not, the impact gives the cable an endwise jerk which is transmitted almost instantaneously to the DP/R link and the D.P.L. unit, causing them to fire.

The jerk is transmitted up and down the cable from the point of impact at approx. 15,000 ft. per sec. in the form of tension waves which, although they have no visible effect on the cable, cause the link and the unit to jerk towards the point of impact. The tension waves are quite distinct from the V-shaped displacement of the cable produced by the motion of the aircraft.

The V-shaped displacement spreads comparatively slowly from the point of impact and normally the DP/R link and the D.P.L. unit have been fired by the tension waves, and the parachutes have opened, before the displacement reaches the ends of the cable.

① NORMAL CONDITION

② CONDITION SOON AFTER IMPACT

DOTTED VIEW shows the condition of the cable at the instant the D.P.L. unit and the DP/R link are fired by the tension waves, with the V-shaped displacement of the cable commencing to spread from the point of impact.

FULL LINE VIEW shows the parachutes about to be withdrawn from the parachute bags.

DP/R and D.P.L. FUNCTIONIN

(For further information see A.P. 1634D Vol. I and II)

DP/R and DPL Static Barrage Balloon

"The primary function of a balloon barrage is to provide a combination of lethal and moral effect constituting a powerful deterrent against low-flying attack by aircraft on an area which may include a number of vulnerable targets. The actual destruction of enemy aircraft through impact with the balloon cable is therefore of secondary importance provided the presence of the balloons has the effect of preventing any attack on the target area from below the operational height of the barrage."

AIR DEFENSE PAMPHLET NUMBER EIGHT, NOVEMBER 1942

The DPL parachute link was designed with an explosive cable cutter and a heavy-duty parachute attached at both ends of the cable. Its purpose was to inflict as much damage as possible upon striking an aircraft. The whole system was triggered when an aircraft hit the cable. Explosive cutters would ignite, releasing a long section of cable; at each end of the cable was a small but strong parachute that would open, slowing the aircraft down and, it was hoped, cause it to crash.

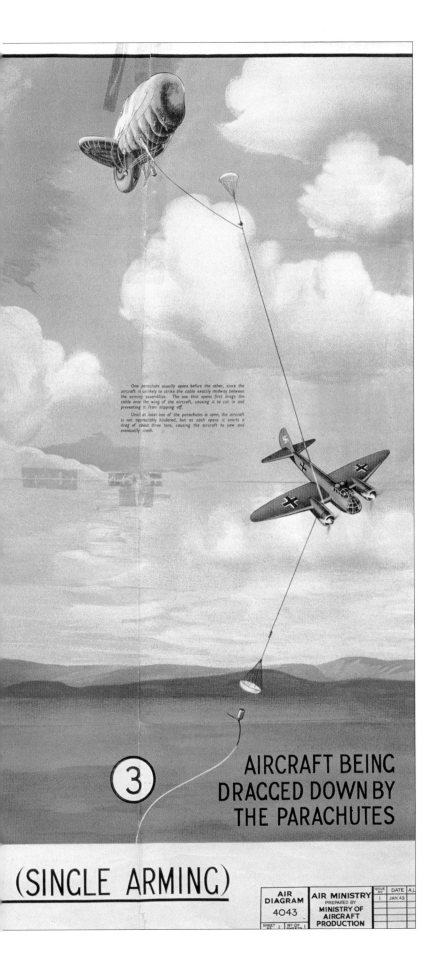

One parachute usually opens before the other, since the aircraft is unlikely to strike the cable exactly midway between the arming assemblies. The one that opens first drags the cable over the wing of the aircraft, causing it to cut in and preventing it from slipping off.

Until at least one of the parachutes is open, the aircraft is not appreciably hindered, but as each opens it exerts a drag of about three tons, causing the aircraft to yaw and eventually crash.

③ AIRCRAFT BEING DRAGGED DOWN BY THE PARACHUTES

(SINGLE ARMING)

AIR DIAGRAM 4043	AIR MINISTRY PREPARED BY MINISTRY OF AIRCRAFT PRODUCTION	ISSUE Nº	DATE	A.L
		1	JAN. 43	
SHEET Nº	Nº OF SHEETS			

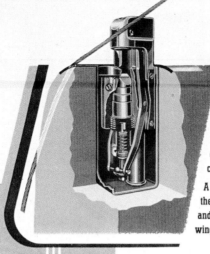

The triggers are cocked, i.e., a roller fitted between the trigger levers is in engagement with the mushroom head of the firing pin, thus preventing any movement of the pin towards the cartridge.

A barrage cable has struck the wing leading edge and is slipping along the wing towards the cutter.

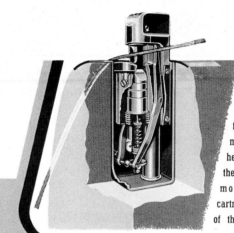

The barrag... into the jaw... has deflec... levers. Th... forces the rolle... ment with t... head of the fi... the pin, free fro... moves towa... cartridge under... of the compresse...

Cut away view showing locating wire in the single-head cable cutter, Mk. VI*

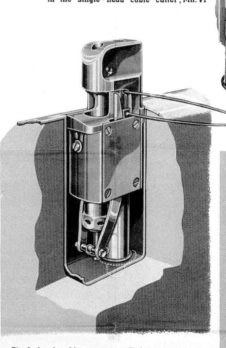

Single-head cable cutter installed in aircraft wing with safety locking spring in position. Safety locking spring is removed before the aircraft takes off.

CABLE CUTTERS

Note. - A Mk. VI* single-head cable cutter only is illustrated, but the operation of the Mk. VI* double-head cutter is similar.

Cable Cutters

One of the hazards of low-level flying was the ever-present danger of barrage balloons. It wasn't the balloons themselves that were a danger; the threat came from the thick steel cables they carried aloft. These cables could inflict severe damage or cause an aircraft to crash. Barrage balloon cable cutters were standard equipment on most medium and heavy bombers.

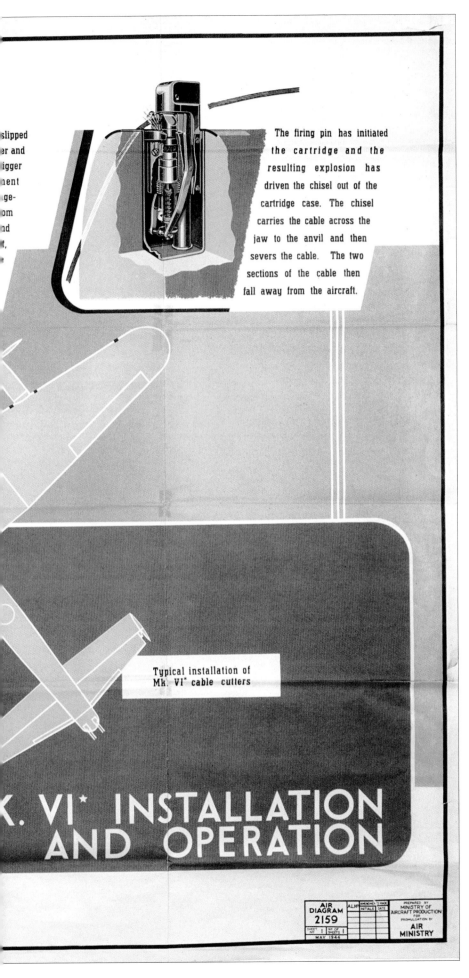

slipped
er and
igger
nent
ge-
om
nd

The firing pin has initiated the cartridge and the resulting explosion has driven the chisel out of the cartridge case. The chisel carries the cable across the jaw to the anvil and then severs the cable. The two sections of the cable then fall away from the aircraft.

Typical installation of Mk. VI* cable cutters

K. VI* INSTALLATION AND OPERATION

AIR DIAGRAM 2159

PREPARED BY MINISTRY OF AIRCRAFT PRODUCTION FOR PROMULGATION BY AIR MINISTRY

MAY 1946

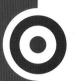

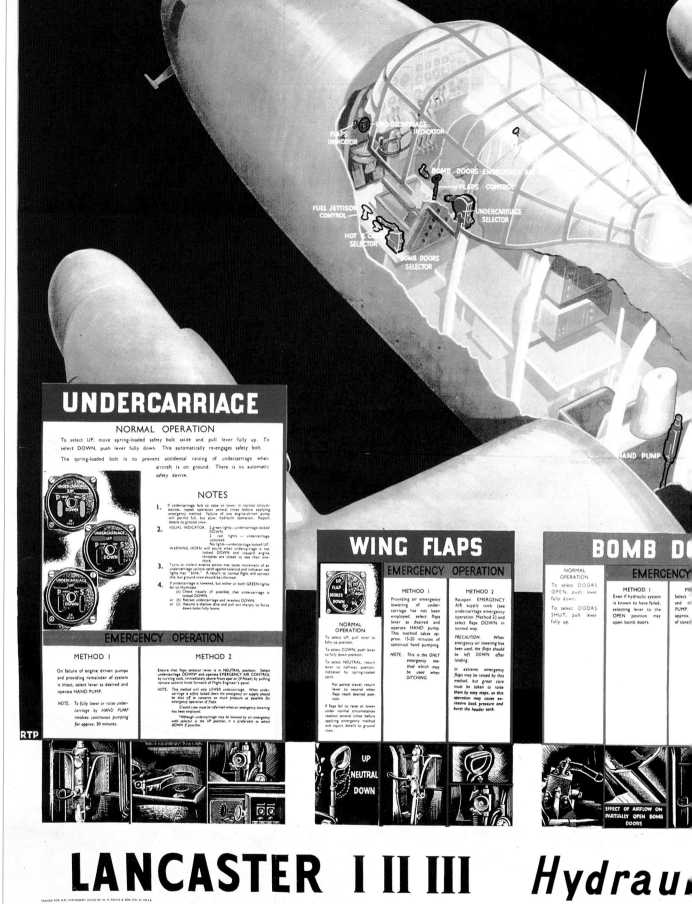

Lancaster Hydraulic Controls

In 1941, the heavy bomber was a complex flying machine, but compared to the standards of today's aircraft, the Lancaster was relatively simple. The main hydraulic system was fed from pumps on the inboard engines. These operated the landing gear, flaps and bomb doors. The pneumatic brakes and electrical system were also fed from the inboard engines. This clever arrangement meant that a Lancaster could lose either inboard engine and continue functioning.

Colour KEY

- UNDERCARRIAGE
- WING FLAPS
- BOMB DOORS
- CARB. AIR INTAKE
- FUEL JETTISON
- EMERGENCY

EMERGENCY AIR CONTROL
(ALTERNATIVE TYPES)

METHOD 3
Emergency air system (Mod. LANCASTER 757 Class 2). Select lever as desired and open bomb door emergency air valve. When operation is complete, air valve must be closed.

PRECAUTION. Before every subsequent operation by this method, it is essential that air previously introduced into the system is dissipated gradually to prevent violent backpressure damaging the reservoir, with the air valve closed, manipulate the selector lever fully up and down several times.

CARBURETTOR AIR INTAKE

NORMAL OPERATION
To select HOT AIR, turn control 90 degrees to port.

To select COLD AIR, return lever to aft position in line with CL of fuselage.

EMERGENCY OPERATION
Select as desired and operate HAND PUMP.

FUEL JETTISON

NORMAL OPERATION
To jettison fuel from No. 1 tanks port and starboard, lift control and turn anti-clockwise 70 degrees. Return control to normal to cease jettisoning.

NOTE. If possible, fly aircraft at 150 m. p. h. A. S. I. with 15° flaps down.

EMERGENCY OPERATION
Select jettison control and operate HAND PUMP.

Controls

AIR DIAGRAM 3015A		A.L.No	AMENDMENTS MADE		PREPARED BY MINISTRY OF AIRCRAFT PRODUCTION
			INITIALS	DATE	FOR PROMULGATION BY
SHEET No	No OF SHEETS				AIR MINISTRY
FEB 1944					

Centaurus Engine

The Centaurus should have followed the Rolls-Royce Merlin as one of the most important piston engines ever built by the British. Surprisingly, only about 400 were ever built! When the prototype first ran in July 1938, nobody thought it would make a useful engine for single-seat fighters. Sydney Camm did fit one into his Tornado prototype and achieved a speed of 421 mph, making it the fastest military aircraft in the world in 1941. Sadly, no one noticed. The Centaurus finally powered the Hawker Tempest II and the Sea Fury, but they were too late to see action in World War II.

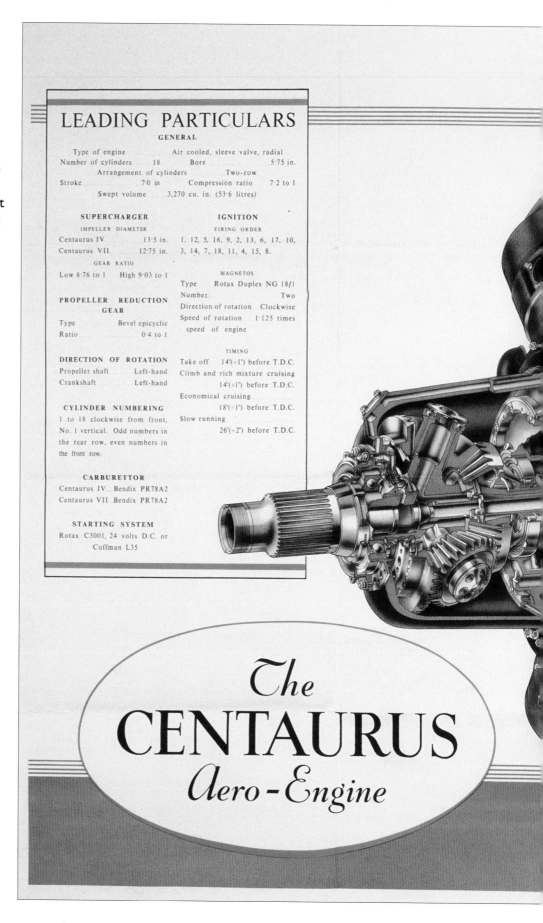

LEADING PARTICULARS

GENERAL

Type of engine	Air cooled, sleeve valve, radial
Number of cylinders 18	Bore 5·75 in.
Arrangement of cylinders	Two-row
Stroke 7·0 in	Compression ratio 7·2 to 1
Swept volume	3,270 cu. in. (53·6 litres)

SUPERCHARGER

IMPELLER DIAMETER

Centaurus IV 13·5 in.
Centaurus VII 12·75 in.

GEAR RATIO

Low 6·76 to 1 High 9·03 to 1

PROPELLER REDUCTION GEAR

Type Bevel epicyclic
Ratio 0·4 to 1

DIRECTION OF ROTATION

Propeller shaft Left-hand
Crankshaft Left-hand

CYLINDER NUMBERING

1 to 18 clockwise from front, No. 1 vertical. Odd numbers in the rear row, even numbers in the front row.

CARBURETTOR

Centaurus IV Bendix PR78A2
Centaurus VII Bendix PR78A2

STARTING SYSTEM

Rotax C3001, 24 volts D.C. or Coffman L35

IGNITION

FIRING ORDER

1, 12, 5, 16, 9, 2, 13, 6, 17, 10, 3, 14, 7, 18, 11, 4, 15, 8.

MAGNETOS

Type Rotax Duplex NG 18/1
Number Two
Direction of rotation Clockwise
Speed of rotation 1·125 times speed of engine

TIMING

Take off 14°(±1°) before T.D.C.
Climb and rich mixture cruising
 14°(±1°) before T.D.C.
Economical cruising
 18°(±1°) before T.D.C.
Slow running
 26°(±2°) before T.D.C.

The CENTAURUS Aero-Engine

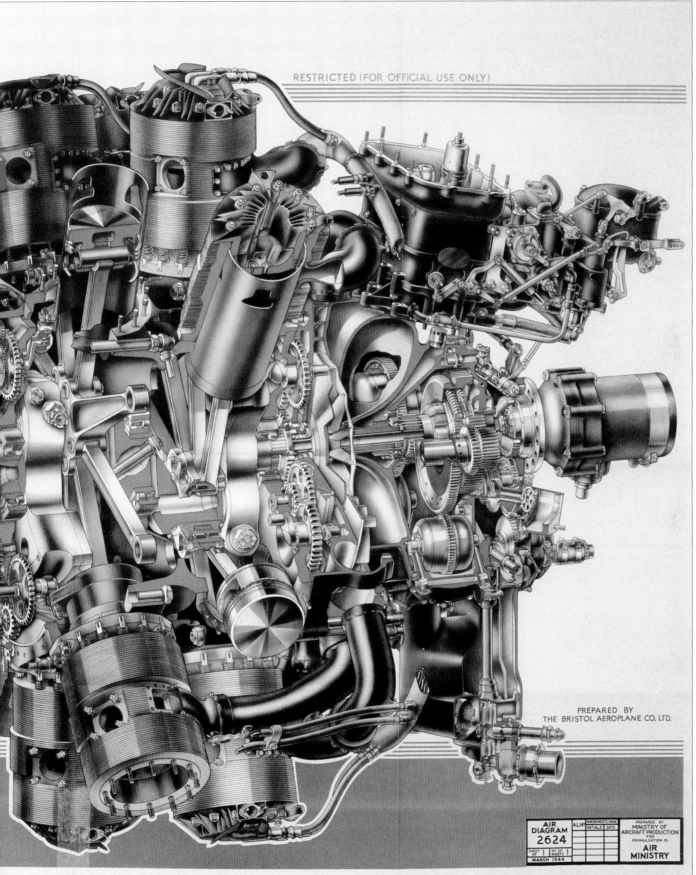

RESTRICTED (FOR OFFICIAL USE ONLY)

PREPARED BY
THE BRISTOL AEROPLANE CO. LTD.

AIR DIAGRAM 2624	ALN°	AMENDMENTS MADE		PREPARED BY MINISTRY OF AIRCRAFT PRODUCTION FOR PROMULGATION BY AIR MINISTRY
SHEET N° 1	N° OF SHEETS 1	INITIALS	DATE	
MARCH 1944				

GREAT BRITAIN

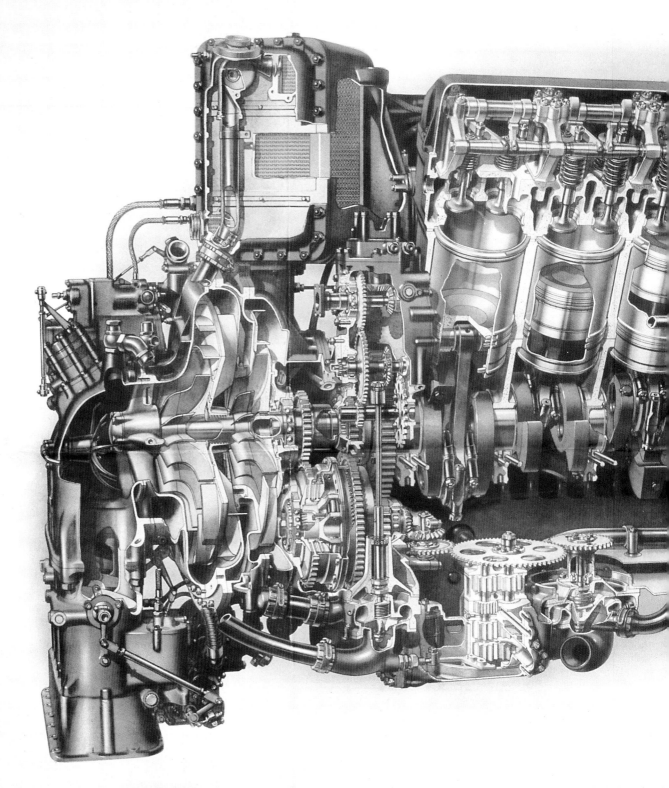

GRIFFON AERO-EN

Two-speed, two-stage supercharger type fitted with St

RTP

PRINTED FOR H M STATIONERY OFFICE BY CHORLEY & PICKERSGILL LTD 52-6767

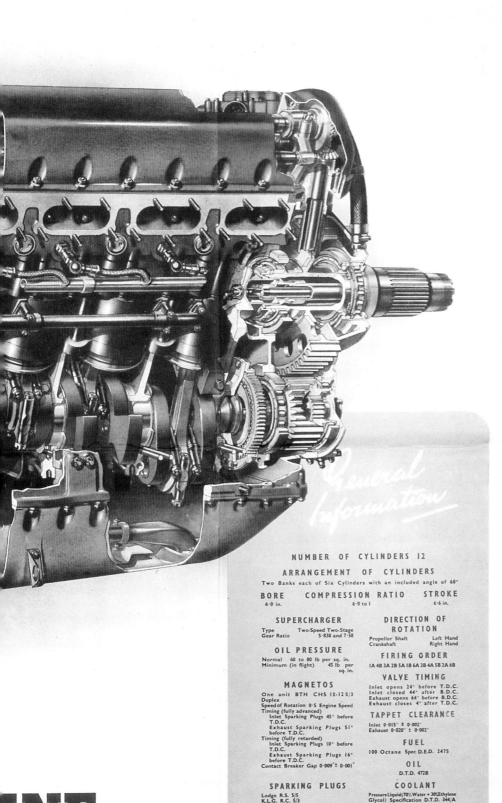

** INE**

...berg carburettor

Griffon Engine

At the outbreak of war the decision was made to initiate production of an engine similar to the Merlin but of a larger capacity. The new Griffon continued the Rolls-Royce policy of fostering the twelve-cylinder 60-degree upright Vee-type liquid-cooled power plant. Basically, the Griffon was a scaled-up Merlin with a capacity of 2,239 cubic inches (36.69 liters) instead of 1,649 (26.99). Remarkably, what should have been a larger engine was in fact shorter than equivalent Merlin! It was also essential that the new Griffon be made to fit in existing Merlin powered fighters. Powered by a 2,000-horsepower Griffon engine, the Spitfire Mk XIV was one of the best fighters of the war.

General Information

NUMBER OF CYLINDERS 12

ARRANGEMENT OF CYLINDERS

Two Banks each of Six Cylinders with an included angle of 60°

BORE	COMPRESSION RATIO	STROKE
6·0 in.	6·0 to 1	6·6 in.

SUPERCHARGER
Type — Two-Speed Two-Stage
Gear Ratio — 5·838 and 7·58

DIRECTION OF ROTATION
Propeller Shaft — Left Hand
Crankshaft — Right Hand

OIL PRESSURE
Normal 60 to 80 lb per sq. in.
Minimum (in flight) 45 lb per sq. in.

FIRING ORDER
1A 4B 3A 2B 5A 1B 6A 3B 4A 5B 2A 6B

VALVE TIMING
Inlet opens 24° before T.D.C.
Inlet closed 44° after B.D.C.
Exhaust opens 64° before B.D.C.
Exhaust closes 4° after T.D.C.

MAGNETOS
One unit BTH CHS 12-12 S/3 Duplex
Speed of Rotation 0·5 Engine Speed
Timing (fully advanced)
Inlet Sparking Plugs 45° before T.D.C.
Exhaust Sparking Plugs 51° before T.D.C.
Timing (fully retarded)
Inlet Sparking Plugs 10° before T.D.C.
Exhaust Sparking Plugs 16° before T.D.C.
Contact Breaker Gap 0·009″ ± 0·001″

TAPPET CLEARANCE
Inlet 0·015″ ± 0·002″
Exhaust 0·020″ ± 0·002″

FUEL
100 Octane Spec D.E.D. 2475

OIL
D.T.D. 472B

SPARKING PLUGS
Lodge R.S. 5/5
K.L.G. R.C. 5/3

COOLANT
Pressure Liquid (70% Water + 30% Ethylene Glycol) Specification D.T.D. 344/A

FOR FURTHER INFORMATION SEE A.P. 2234 K

AIR DIAGRAM 4109	A.L.N°	AMENDMENTS MADE INITIALS	DATE	PREPARED BY MINISTRY OF AIRCRAFT PRODUCTION FOR PROMULGATION BY AIR MINISTRY
SHEET N° 1	N° OF SHEETS 1			
AUG. 1944				

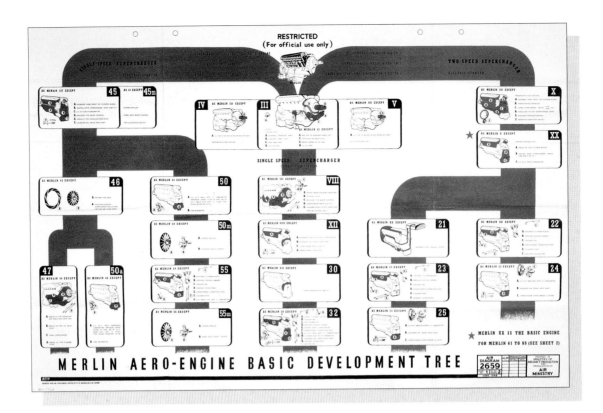

Merlin Aero Engine Development Tree

Many have described the Rolls-Royce Merlin as the greatest aircraft engine of World War II. It powered the famous Spitfire and Mustang and seventeen other fighters and bombers including the Lancaster, Mosquito and the venerable Hawker Hurricane. When the first production Hurricane flew in 1937 it was powered by a Merlin II engine. Takeoff rating at sea level was 890 horsepower, but for short periods combat power could be applied boosting the engine to 1030 horsepower at 16,000 feet. By the end of the war the Merlin 66 engine was capable of producing over 1650 horsepower. There were 150,000 Merlin engines in forty-five different versions built in Great Britain and the United States.

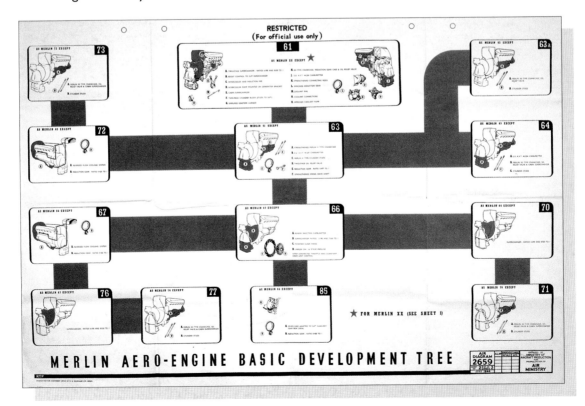

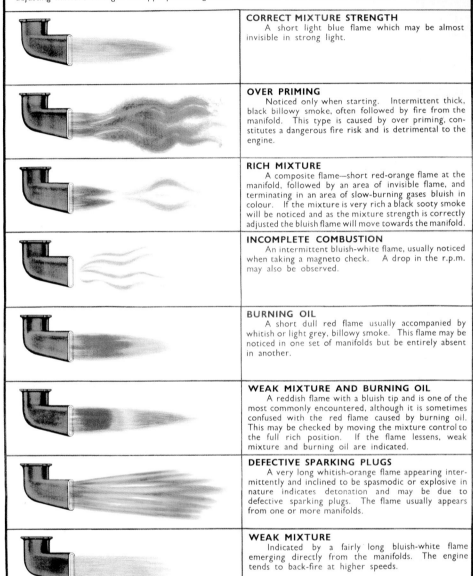

FOR OFFICIAL USE ONLY

GENERAL NOTES.—Exhaust flames will only be observed when an engine is running without an exhaust system or when stub pipes are fitted. Flames will probably not be seen when flame-damping manifolds or exhaust ring collectors are used. The types of flames shown will change as the air/fuel ratio is altered and will be affected by the presence of oil or corrosion inhibitor in the combustion chamber. For methods of adjusting mixture strength the appropriate engine Air Publication Vol. I should be consulted.

CORRECT MIXTURE STRENGTH
A short light blue flame which may be almost invisible in strong light.

OVER PRIMING
Noticed only when starting. Intermittent thick, black billowy smoke, often followed by fire from the manifold. This type is caused by over priming, constitutes a dangerous fire risk and is detrimental to the engine.

RICH MIXTURE
A composite flame—short red-orange flame at the manifold, followed by an area of invisible flame, and terminating in an area of slow-burning gases bluish in colour. If the mixture is very rich a black sooty smoke will be noticed and as the mixture strength is correctly adjusted the bluish flame will move towards the manifold.

INCOMPLETE COMBUSTION
An intermittent bluish-white flame, usually noticed when taking a magneto check. A drop in the r.p.m. may also be observed.

BURNING OIL
A short dull red flame usually accompanied by whitish or light grey, billowy smoke. This flame may be noticed in one set of manifolds but be entirely absent in another.

WEAK MIXTURE AND BURNING OIL
A reddish flame with a bluish tip and is one of the most commonly encountered, although it is sometimes confused with the red flame caused by burning oil. This may be checked by moving the mixture control to the full rich position. If the flame lessens, weak mixture and burning oil are indicated.

DEFECTIVE SPARKING PLUGS
A very long whitish-orange flame appearing intermittently and inclined to be spasmodic or explosive in nature indicates detonation and may be due to defective sparking plugs. The flame usually appears from one or more manifolds.

WEAK MIXTURE
Indicated by a fairly long bluish-white flame emerging directly from the manifolds. The engine tends to back-fire at higher speeds.

AERO-ENGINE EXHAUST FLAMES CHARACTERISTICS

AIR DIAGRAM 2490 | AIR MINISTRY PREPARED BY MINISTRY OF AIRCRAFT PRODUCTION

Aero-Engine Exhaust Flames

Knowing how to maximize engine performance could mean the difference between living to fight another day or ditching in the North Sea.

"During the last two years much progress has been made in teaching pilots the principles of engine handling and exploiting performance. Realism in teaching is difficult to achieve, however, and it is unfortunate that — for many pilots — the first really convincing demonstration they have that there is a right and a wrong way of using their engine and their fuel to achieve a certain performance in speed or range is when they see one aircraft get back to base with plenty to spare and another having to ditch with dry tanks, although both did the same trip."

AIR CREW TRAINING BULLETIN NO. 19, AUGUST 1944

Hercules Supercharger (below)

A supercharger is simply a blower, or air pump, that rams air into an internal combustion engine. Its principal function is to enable the engine to produce more power at a higher altitude. As an aircraft gains altitude the air becomes thinner. The thinner air causes the engine to lose power. The job of the supercharger is to negate this effect. Most, if not all the engines used in combat aircraft during World War II were equipped with a supercharger. These complex devices were marvels of technology. The Hercules two-speed supercharger was mounted on back of the engine — coupled to the engine's crankshaft. The Hercules engine equipped the Beaufighter, Wellington, Stirling, Halifax, Albemarle, Lancaster II, Hastings, Hermes and Viking aircraft.

Scorched Earth Braking (opposite)

This poster clearly warns pilots about the dangers of excessive braking when landing. Over-heated brakes could cause a tire to burn, which could lead to the loss of the aircraft and surrounding buildings.

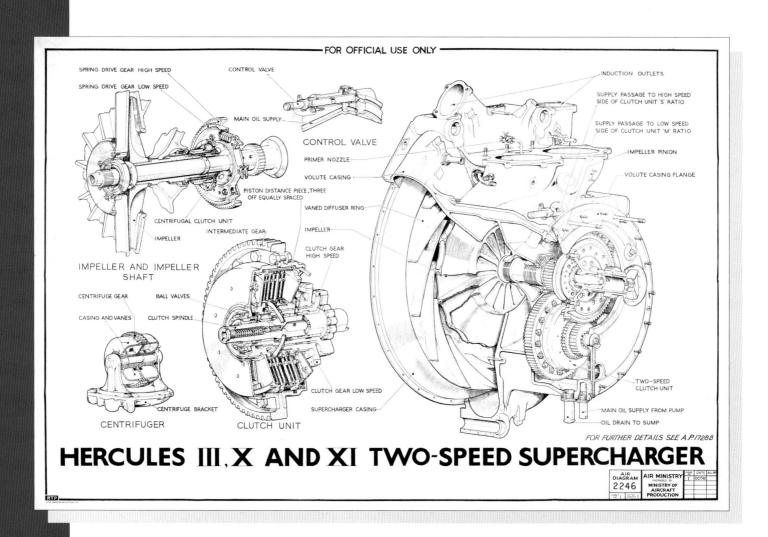

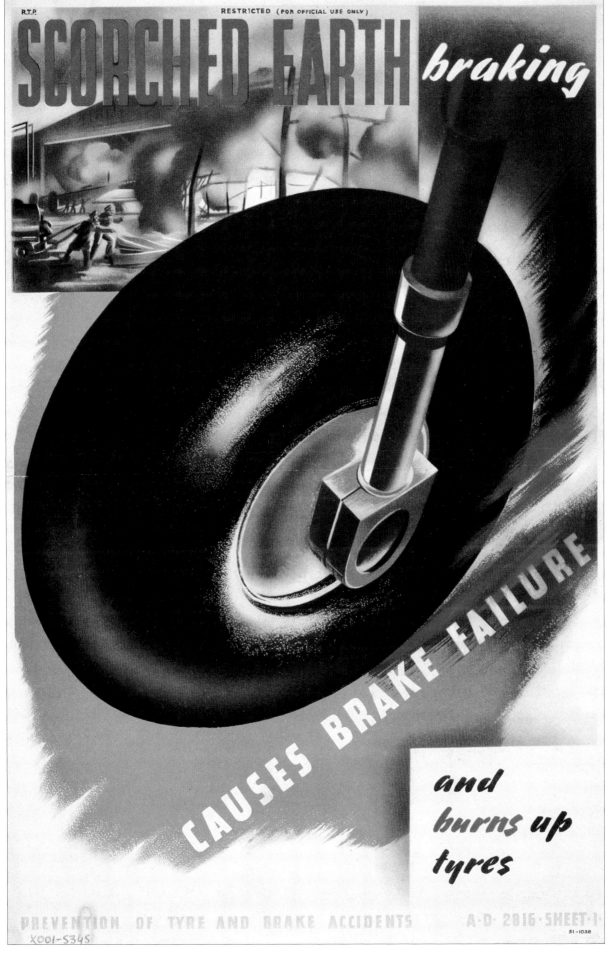

GREAT BRITAIN

Radio Aids

Many radio aids were developed during World War II to aid bomber crews as they navigated toward their targets over Germany, and proved equally useful when returning home. They were also of great benefit to the Germans, who developed a myriad of devices capable of homing in on these transmissions. By November 1943, Bomber Command was able to dispatch over 700 heavy bombers to targets over Germany. Because of the sheer size of the force, the electronic signature it produced gave the Germans more than enough time to prepare. The Germans were constantly amazed that Bomber Command allowed its crews to switch on their electronic equipment for prolonged periods of time.

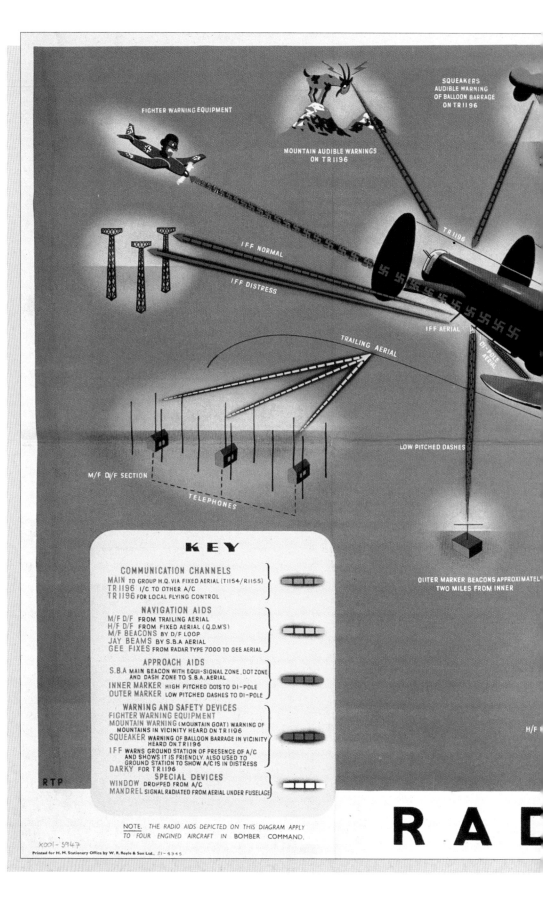

KEY

COMMUNICATION CHANNELS
MAIN TO GROUP H.Q. VIA FIXED AERIAL (TI154/RII55)
TR1196 I/C TO OTHER A/C
TR1196 FOR LOCAL FLYING CONTROL

NAVIGATION AIDS
M/F D/F FROM TRAILING AERIAL
H/F D/F FROM FIXED AERIAL (Q.D.M'S)
M/F BEACONS BY D/F LOOP
JAY BEAMS BY S.B.A AERIAL
GEE FIXES FROM RADAR TYPE 7000 TO GEE AERIAL

APPROACH AIDS
S.B.A MAIN BEACON WITH EQUI-SIGNAL ZONE, DOT ZONE AND DASH ZONE TO S.B.A. AERIAL
INNER MARKER HIGH PITCHED DOTS TO DI-POLE
OUTER MARKER LOW PITCHED DASHES TO DI-POLE

WARNING AND SAFETY DEVICES
FIGHTER WARNING EQUIPMENT
MOUNTAIN WARNING (MOUNTAIN GOAT) WARNING OF MOUNTAINS IN VICINITY HEARD ON TR1196
SQUEAKER WARNING OF BALLOON BARRAGE IN VICINITY HEARD ON TR1196
IFF WARNS GROUND STATION OF PRESENCE OF A/C AND SHOWS IT IS FRIENDLY. ALSO USED TO GROUND STATION TO SHOW A/C IS IN DISTRESS
DARKY FOR TR1196

SPECIAL DEVICES
WINDOW DROPPED FROM A/C
MANDREL SIGNAL RADIATED FROM AERIAL UNDER FUSELAGE

NOTE. THE RADIO AIDS DEPICTED ON THIS DIAGRAM APPLY TO FOUR ENGINED AIRCRAFT IN BOMBER COMMAND.

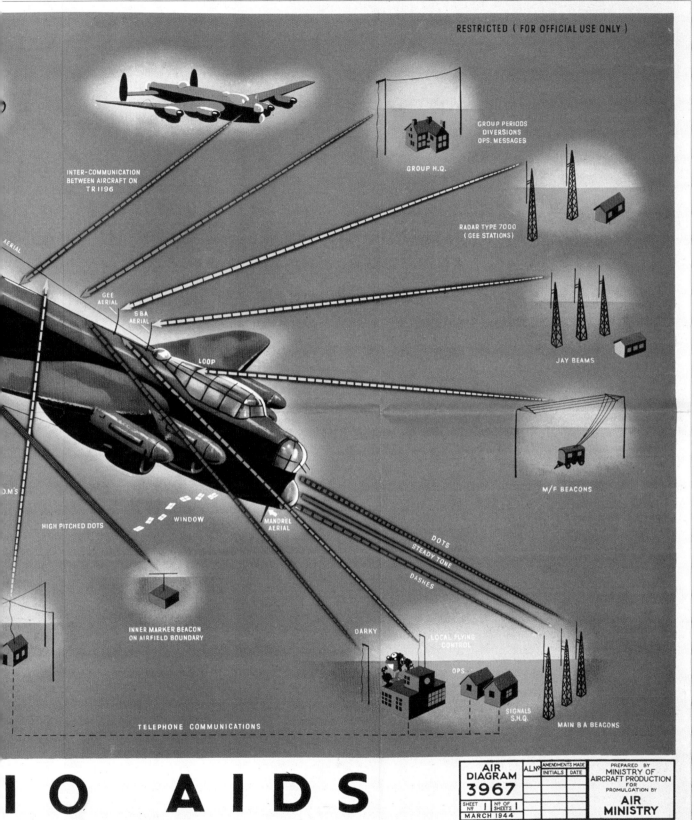

RESTRICTED (FOR OFFICIAL USE ONLY)

INTER-COMMUNICATION
BETWEEN AIRCRAFT ON
TR 1196

GROUP PERIODS
DIVERSIONS
OPS. MESSAGES

GROUP H.Q.

RADAR TYPE 7000
(GEE STATIONS)

AERIAL

GEE
AERIAL

S BA
AERIAL

LOOP

JAY BEAMS

M/F BEACONS

O.M'S

HIGH PITCHED DOTS

WINDOW

MANDREL
AERIAL

DOTS

STEADY TONE

DASHES

INNER MARKER BEACON
ON AIRFIELD BOUNDARY

DARKY

LOCAL FLYING
CONTROL

OPS.

SIGNALS
S.H.Q.

MAIN B A BEACONS

TELEPHONE COMMUNICATIONS

IO AIDS

AIR DIAGRAM 3967	AL N°	AMENDMENTS MADE		PREPARED BY MINISTRY OF AIRCRAFT PRODUCTION FOR PROMULGATION BY
		INITIALS	DATE	
SHEET N° 1	N° OF SHEETS 1			AIR MINISTRY
MARCH 1944				

RESTRICTED (FOR OFFICIAL USE ON

RADIO 150 200
BAROMETRIC

RADIO 100 200
BAROMETRIC

RADIO

HIGH

ALTITUDE INDICATOR LIMIT INDICATOR LIMIT SWITCH

CORRECT

ALTITUDE INDICATOR LIMIT INDICATOR LIMIT SWITCH

LOW

ALTITUDE INDICATOR LIMIT INDICATOR LIMIT SWITCH

The altitude limit switch is shown set at 200 ft. The lights change as the altitude of the aircraft varies 10 ft. above or below the setting of the altitude limit switch.

LIMIT LIGHTS

ALTITUDE INDICATOR
ON/OFF SWITCH

RADIO ALTIMET

PRINTED FOR H.M. STATIONERY OFFICE BY HUDSON SCOTT & SONS LTD. CARLISLE 51—1271

X001-4445

FOR FURTHER INFORMATION SEE

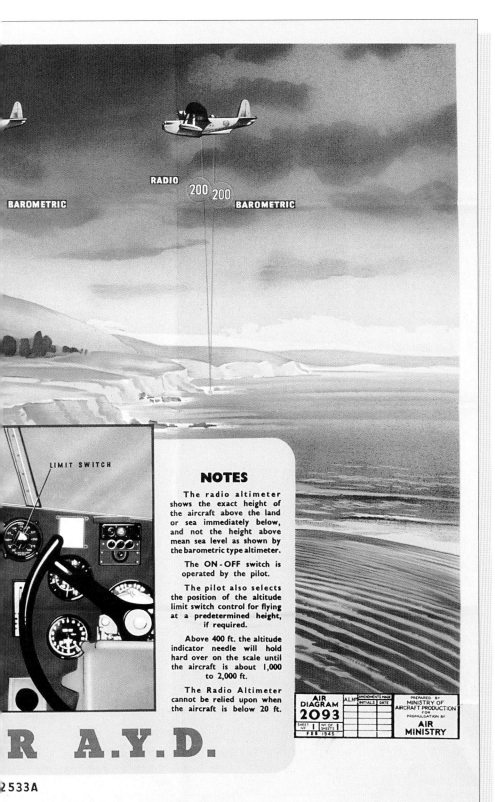

Radio Altimeter

Radio altimeters were far more accurate than the standard barometric type. This wonderful landscape illustration shows the height differences between the two devices. The aircraft featured here is the Short Sunderland.

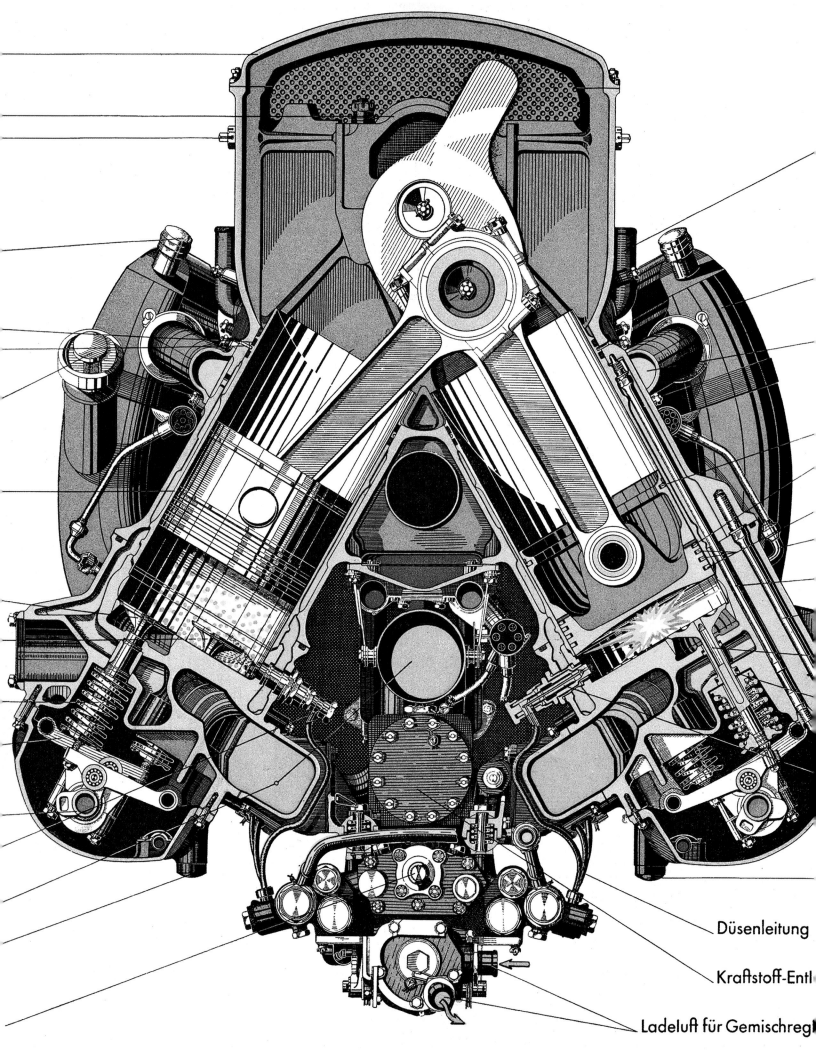

Düsenleitung

Kraftstoff-Entl

Ladeluft für Gemischreg

GERMANY

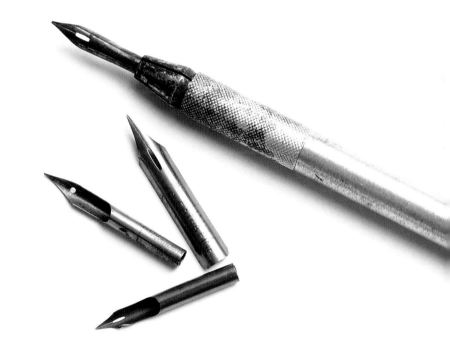

623.74

3560

ERSATZTEIL-LISTE
Fw 190

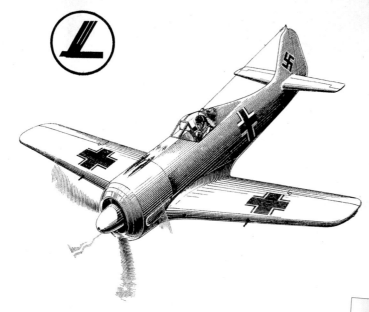

Ausgabe: 1944 Nr. 03

FOCKE-WULF FLUGZEUGBAU G.M.B.H. BREMEN

Berichtigungsstand nach den vierteljährlichen Berichtigungsübersichten

	1943	1944	1945	1946	1947
I					
II					
III					
IV					

3567

ERSATZTEIL-LISTE
Fw 200 C

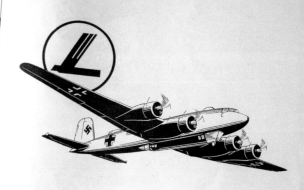

Ausgabe: 1943 Nr. 024

FOCKE-WULF FLUGZEUGBAU G.M.B.H. BREMEN

Berichtigungsstand nach den vierteljährlichen Berichtigungsübersichten

	1943	1944	1945	1946	1947
I					
II					
III					
IV					

Focke-Wulf Fw 190
Schematic (right)

The electrical system schematic for the bomb release mechanism on a Fw 190. The fighter-bomber version of the Fw 190 could carry 1,000 kilograms (2,205 lb) of bombs.

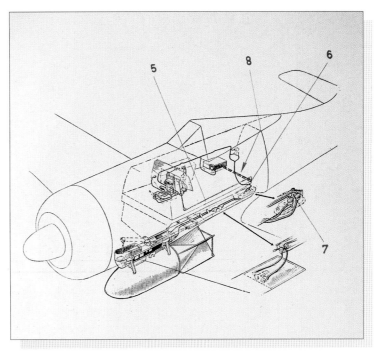

ENTWURF UND BEARBEITUNG:
V. RAMSPECK
NFSK - OBERSTURMBANNFÜHRER

TRANSART-ZEICHNUNGEN:
THOMAS ABEKING

TRANSART AKTIENGESELLSCHAFT
FÜR ZELLGLASKUNSTDRUCK, BERLIN W 50, RANKESTR. 5

VERLAG: SÜRAG VERLAG, OFFENBURG IN BADEN
GESAMTHERSTELLUNG: A. FRISCH, BERLIN W35, LÜTZOWSTR. 64-66

SCHULGLEITER 38
HERAUSGEBER: DER KORPSFÜHRER DES NS-FLIEGERKORPS

Schulgleiter 38 (above)

The cover for the Schulgleiter 38 Glider operating manual. Exact figures are not known, but it is estimated that close to 9,200 SG 38 gliders were built.

Ersatzteil-liste Fw 190 (opposite)

The pen-and-ink drawing on the cover of this parts list manual effectively shows the clean lines of the Fw 190 fighter. Nicknamed the "Butcherbird," it was one of the most effective fighters of World War II.

Ersatzteil-liste Fw 200C (opposite, bottom)

The cover for the Fw 200C Spare Parts List Manual.

Junkers Ju 87

When the war began, the Ju 87 Stuka was a somewhat dated design. Its early success over Poland, Norway, France, Belgium and Holland only delayed the inevitable. When faced with a well-organized and determined fighter defense, the Ju 87 suffered accordingly. During the Battle of Britain, Ju 87 units suffered heavy losses. Between August 13 and 18, 1940, RAF fighters shot down forty-one Ju 87s. On August 19 the Stuka was retired from the battle. When good fighter protection was provided, the Ju 87 was a devastating weapon. The Stuka sank more ships than any other type of aircraft in history and was widely used by all the Axis air forces, including those of Italy, Hungary, Slovakia, Romania and Bulgaria.

JUNKERS-JU 87

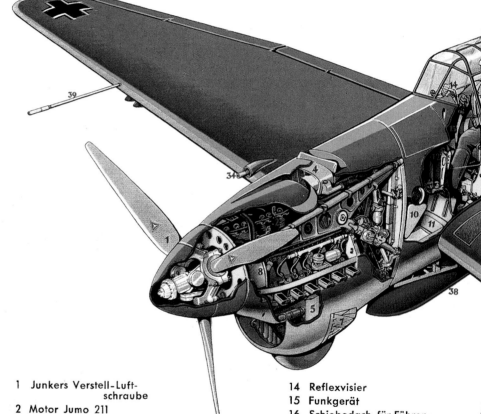

1 Junkers Verstell-Luft-schraube	14 Reflexvisier
2 Motor Jumo 211	15 Funkgerät
3 Motorträger	16 Schiebedach für Führer-sitz
4 Schmierstoffkühler	17 Antennenmast
5 Kühler	18 Schiebedach für Schützensitz
6 Kühlerklappen	19 Linsenlafette mit MG 15
7 Spreizklappen	20 Doppeltrommeln
8 Kühlstoff-Ausgleich-behälter	21 Sauerstofflaschen für Höhenatmer
9 Anlaßwelle	22 Funk-Taste
10 Schmierstoffbehälter	23 Leerhülsensack
11 Abdeckblende	24 Schützensitz (drehbar)
12 Pedal für Seitensteuer	25 Schleppantennenhaspel
13 Steuerknüppel	

Junkers Flugzeug-und-Motorenwerke A.-G., Dessau

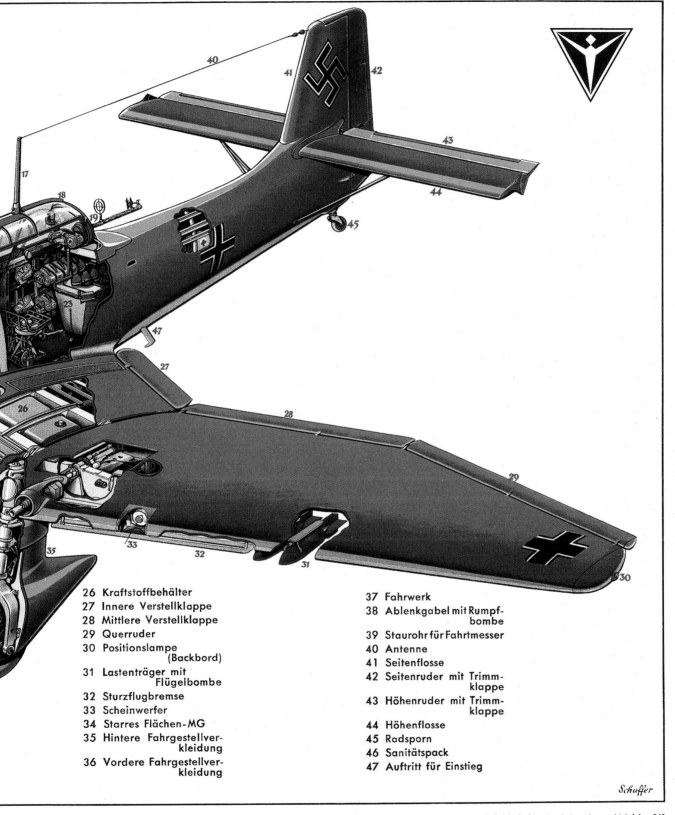

26 Kraftstoffbehälter
27 Innere Verstellklappe
28 Mittlere Verstellklappe
29 Querruder
30 Positionslampe
 (Backbord)
31 Lastenträger mit
 Flügelbombe
32 Sturzflugbremse
33 Scheinwerfer
34 Starres Flächen-MG
35 Hintere Fahrgestellver-
 kleidung
36 Vordere Fahrgestellver-
 kleidung

37 Fahrwerk
38 Ablenkgabel mit Rumpf-
 bombe
39 Staurohr für Fahrtmesser
40 Antenne
41 Seitenflosse
42 Seitenruder mit Trimm-
 klappe
43 Höhenruder mit Trimm-
 klappe
44 Höhenflosse
45 Radsporn
46 Sanitätspack
47 Auftritt für Einstieg

Schäffer

J. F. M.-Lehrmittelabteilung LM-Nr. 561

Junkers Ju 86K

This cutaway drawing shows the export version of the Ju 86 medium bomber. Many nations purchased the Ju 86, including Sweden, Chile, Portugal, South Africa and Hungary. Most were fitted with the Pratt & Whitney Hornet or Bristol Pegasus radial engines. This illustration does not show what type of engine is fitted. The only surviving example of the Ju 86 resides in the Flygvapenmuseum, Sweden.

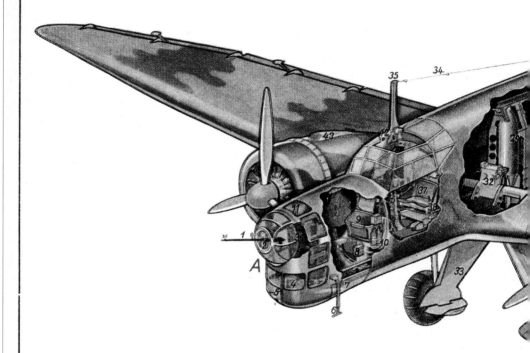

JUNKERS- JU 86 K

A	A-Stand	12	Handhebel für Bomben
B	B-Stand	13	Drehkranzlafette
C	C-Stand	14	Maschinengewehr
1	Maschinengewehr	15	Leertrommelsack
2	Vertikallafette	16	Leuchtpistole
3	Abwurfzentrale	17	Leuchtmunition
4	Zielgerät	18	Munitionsbehälter
5	Schiebefenster	19	Stemmring
6	Staurohr	20	Windschutzschirm
7	Absprungklappe	21	Senkturm (ausgefahren
8	Munitionsbehälter	22	Bodenlafette
9	Leertrommelsack	23	Maschinengewehr
10	Sauerstofflaschen	24	Schlitten mit Munitions
11	Klappfenster	25	Atemgerät

Junkers Flugzeug- und Motorenwerke A. G., Dessau

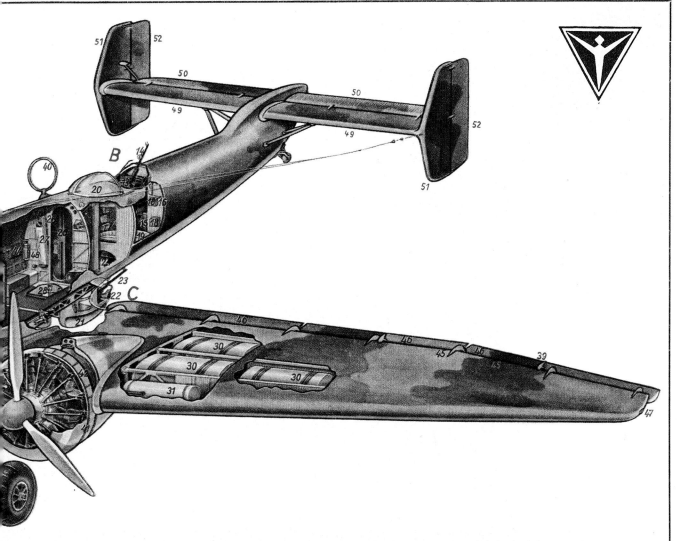

26	Führungsschiene für Senkturm	39	Ausgleichgewichte
27	Federausgleich für Senkturm	40	Peilrahmen
28	Einsteigluke mit Leiter und Leertrommelsack	41	Spreizklappen (Kühlung)
29	Bombenmagazine	42	Auspuffsammelring
30	Kraftstoffbehälter	43	Luftansaugschacht
31	Schmierstoffbehälter	44	Anwerfkurbel
32	Ausfahrvorrichtung für Fahrgestell	45	Querruder
33	Einziehbares Fahrgestell	46	Landeklappen
34	Antenne	47	Positionslampe
35	Antennenmast	48	Feuerlöscher
36	Steuersäule	49	Höhenflosse
37	Führersitz	50	Höhenruder
38	Verstellhebel für Führersitz	51	Seitenflosse
		52	Seitenruder

Zchg. Schaffer

Lehrmittelstelle LM-Nr. 1311

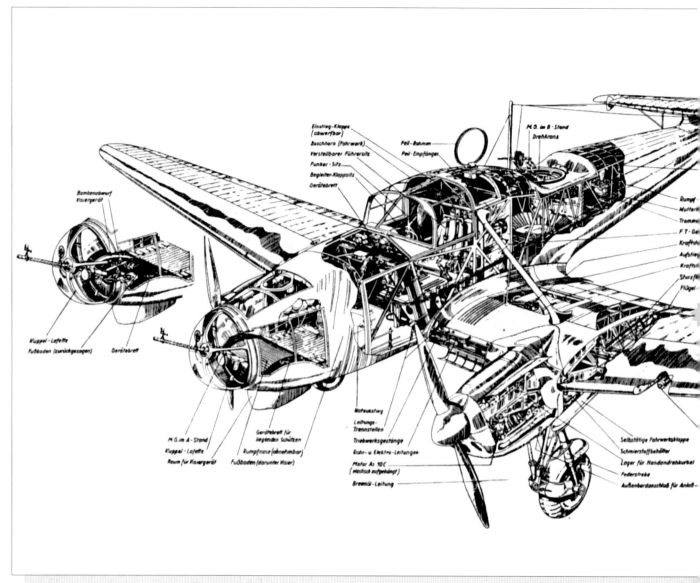

Focke Wulf Fw 58 (above)

The Fw 58 was a very successful utility aircraft in the same class as the British Avro Anson. The version shown in the cutaway drawing is the V2, which introduced gun armament in the form of two MG 15s in the nose and one behind the flight deck. Production reached 1,668 for German operations and 319 for export.

Ju 87 Tropical Component Assemblies and Breakdown (below)

The Ju 87 served in every theater of war in which the Luftwaffe was engaged. In North Africa and the Mediterranean the D-1 version of the Stuka was tropicalized with engine air-intake dust filters to protect the lubrication systems. It was first operational over Bir Hakeim in May 1942.

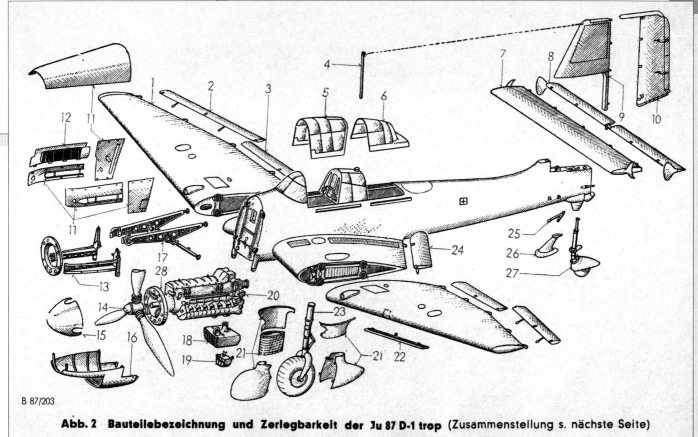

B 87/203

Abb. 2 Bauteilebezeichnung und Zerlegbarkeit der Ju 87 D-1 trop (Zusammenstellung s. nächste Seite)

59 Seitensteuerpedale
60 Klappsitz (Beobachter)
61 MG-FF/M
62 MG 17
63 Leerhülsenauffangnetz
64 Gerätetafel am Spant 12
65 Heizung rechts
66 Allweiler Kraftstoffhandpumpe
 (mit Umschaltventilsatz)
67 Höhentrimm- und Ausgleichsruder
68 Schleppantenne
69 Landeklappensicherung
70 Landeklappe
71 Querruder
72 Quertrimm- und Ausgleichsruder
73 Staurohrmast
74 Scheinwerfer
75 Kraftstoffhauptbehälter
76 Kraftstoffflächenhilfsbehälter
77 Schmierstoffbehälter
78 Bombenklappenwinde
79 Seitenrudergetriebe
80 LEONARD-Umformer (PDS)
81 Steuergerät (PDS)
82 Walzenlafette des MG 131
83 Mannloch im Spant 26
84 Kennlicht
85 Steuerhandrad
86 FT-Geräte
87 Selbstschalterleiste für Bord-
 funkanlage
88 Trimm-Verstelltrieb
89 Bedienbank
90 Motorgondelendstück
91 Behälter für Enteisungsflüssigkeit
92 Anlaßkraftstoffbehälter
93 Kühlstoffbehälter
94 Brandwand
95 Fahrwerkspindel
96 Handkurbel für Motoranlasser
 (nur linkes Triebwerk)
97 Flammendämpfer
98 Fahrgestellklappen
99 Motorbock
100 Motor DB 603 A-1
101 Abgasdüsen

Bf 109 F-1 bis F-4
General Arrangement (below)

The inner workings of the Bf 109F-1 are clearly revealed in this crisp blueprint drawing. The Bf 109F, or Friedrich, was the most aerodynamically refined version of the famous German fighter and was equipped with an engine-mounted cannon firing through the spinner.

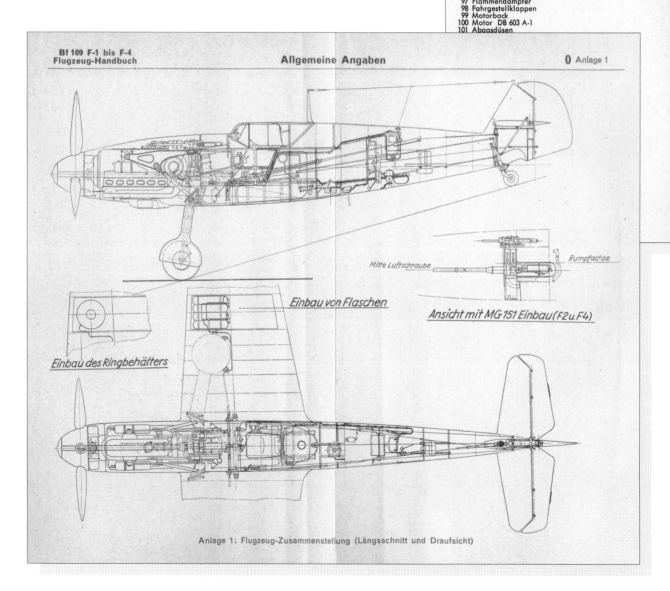

Bf 109 F-1 bis F-4
Flugzeug-Handbuch
Allgemeine Angaben
0 Anlage 1

Mitte Luftschraube
Rumpfachse
Einbau von Flaschen
Ansicht mit MG 151 Einbau (F2 u. F4)
Einbau des Ringbehälters
Anlage 1: Flugzeug-Zusammenstellung (Längsschnitt und Draufsicht)

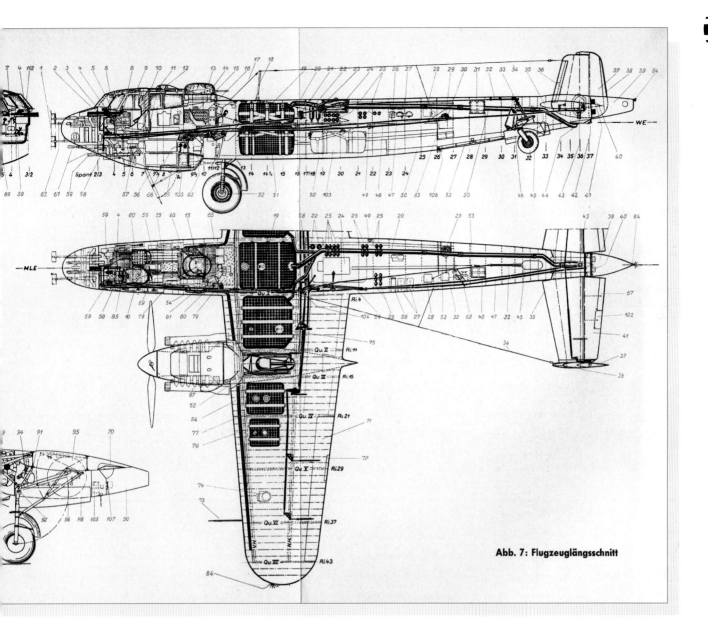

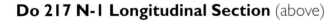

Abb. 7: Flugzeuglängsschnitt

Do 217 N-1 Longitudinal Section (above)

This longitudinal cutaway drawing illustrates the inner workings of the Do 217 night-fighter. Powered by two DB 603 engines and armed with four 20 mm cannon and four 7.9-mm machine guns, the Do 217 night-fighter became a formidable opponent once it appeared in the night skies over occupied Europe in the winter of 1942/43.

Ju 88 Panoramic View of Pilot and Bombardier Positions

The crew of the Ju 88 consisted of a pilot, bomb aimer, flight engineer and radio operator. In the Ju 88 they were grouped together in the front of the aircraft, which, according to British propaganda, was to bolster morale, but in fact made for a cramped and inefficient working space. The pilot sat high on the left; to the right was the bomb aimer who also manned the forward-firing MG 15 machine gun.

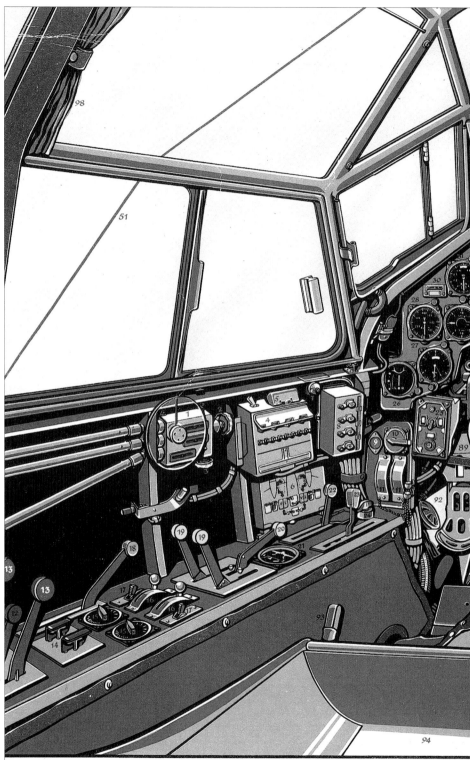

1 Höhentrimmrad mit Sturzflugmarke
2 Querruder-Trimmrad
3 Seitenruder-Trimmrad
4 Umpumpschaltkasten
5 Schnellablaß
6 Umpump-Anzeigegerät
7 Rücktrimmknopf
8 Selbstschalterkasten für Scheinwerfer, Kennlichter, Gerätebeleuchtung und Staurohrbeheizung
9 Netzausschalter
10 Kurssteuerung (Hauptschalter)
11 Zündstecker
12 Laderschaltung
13 FBH-Armatur mit Schnellstop

14 Anlaßschalter
15 Spreizklappenverstellung
16 Luftschrauben-Handverstellschalter
17 Wahlschalter für Luftschraubenverstellung (Hand-Automatik)
18 Leitwerk-Enteisung
19 Gasdrossel
20 Sturzflugbremshebel
21 Fahrwerk- und Landeklappen-Anzeigegerät
22 Fahrwerksbetätigung
23 Landeklappen- und Höhenflossenverstellung
24 Drehsteuerschalter für Spornverriegelung

25 Schalt- u. Kontrollgerät f. Rauchgeräte
26 Anzeigegerät für Funknavigation (Blindlandeanzeiger)
27 Kontakthöhenmesser
28 Fahrtmesser
29 Variometer
30 Schauzeichen für Staurohrbeheizung
31 Grob-Fein-Höhenmesser
32 Wendezeiger
33 Kurszeiger
34 Reflexvisier
35 Horizont
36 Betriebsdatentafel u. Deviationstabelle
37 Fernkursreisel für Kurssteuerung
38 Schauzeichen für Kurssteuerung

39 Tochterkompaß für Kurssteu
40 Ladedruckmesser für Motor
41 Ladedruckmesser für Motor
42 Ferndrehzahlmesser L
43 Ferndrehzahlmesser R
44 Schmierstoff- und Kraftstoffde
45 Kühlstoff-Temperaturmesser für linken Motor
46 Kühlstoff-Temperaturmesser für rechten Motor
47 Funkpeil-Anzeigegerät mit Funkpeil-Tochterkompaß
48 Schalthebel für die starre Rastung des M
49 MG 15
50 MG-Zurrkappe

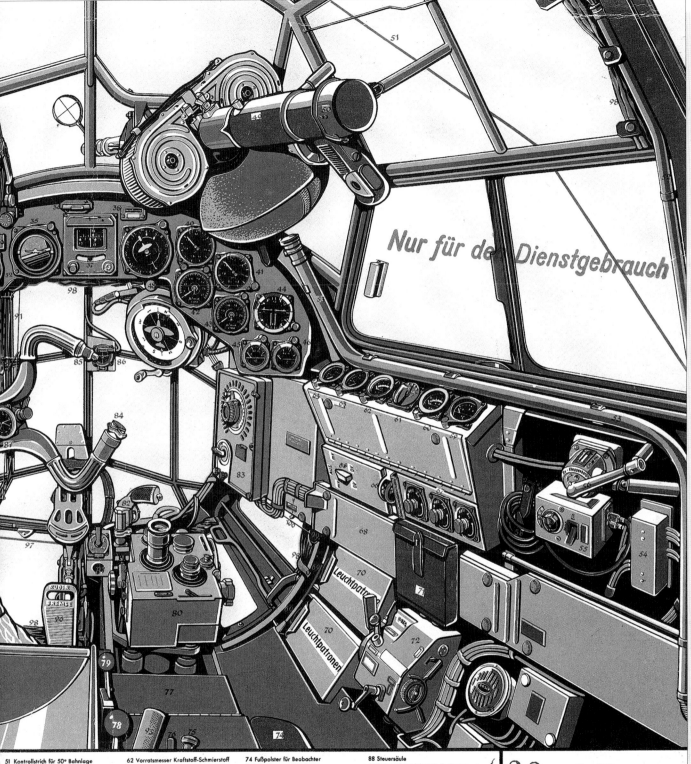

51 Kontrollstrich für 50° Bahnlage
52 Kabelkanal für FT-Anlage
53 Maskenschlauch
 für Beobachter-Atemgerät
54 Trennstelle für Rauch- und Nebel-
 geräte
55 Anschlußdose ADb 12 für Beobachter
 mit Brechkupplung
56 Bombenklappenkurbel
58 FT-Kabel für Kopfhaube für Beobachter
59 Außenlufttemperaturmesser
60 Vorratsmesser Kraftstoff-Schmierstoff
61 Wahlschalter für Kraftstoff- und
 Schmierstoff-Vorratsmesser

62 Vorratsmesser Kraftstoff-Schmierstoff
63 Sauerstoff-Druckmesser für Beobachter
64 Sauerstoff-Druckmesser für Flugzeug-
 führer
65 Zünderschaltkasten ZSK 244 A
66 Bombenwahlschalter
67 Beleuchtungsregler für Gerätebretter
68 Kabelkasten
69 Notwurf für Leuchtpatronen
70 Leuchtpatronenkasten
71 Werkzeugtasche für MG 15
72 Fernbediengerät FBG 1 für Peil- und
 Zielflug-Verkehr
73 Bosch-Signalhorn

74 Fußpolster für Beobachter
75 Kursteuerung-Notauslösung
76 Notzug für Dreiknopfschalter
77 Aufklappbares Kniepolster
78 Bombennotzughebel ,
79 Blindscharfhebel für LM
80 Bomben-Ziel-Gerät II
81 Richtungsgeber Lrg 5
82 Leuchtpistole
83 Reihen-Abwurf-Bediengerät RAB 14 c
84 Kursgeber
85 Bombenknopf
86 Nahkompaß
87 Borduhr

88 Steuersäule
89 Seitenruderpedal mit Laufradbremse
90 Kursvisier
91 Kuvispinne
92 Strahldüse für Heizungsanlage
93 Sitzverstellung (waagerecht)
94 Flugzeugführersitz
95 Sitzverstellung (senkrecht)
96 Ruderbremse (nur alte Flugzeuge)
97 Abkippmarke im Kanzelboden und an
 der Kuvispinne
98 Blendschutz
99 Öse mit Seilzug für vorderen Vorhang
100 Schalter für Kompaßstützung

038

Ju 88

Rundblick
des Flugzeugführers
und
des Bombenschützen

Anforderungszeichen: Fl Üb 8-067

GERMANY

Ju 88 Panoramic View of the Radio Operator's Position

Behind the pilot on the left sat the engineer, who manned the upper rear machine gun, and alongside him on the right was the radio operator, who manned the lower rear gun. All three guns used the 75-round saddle magazine, which had to be changed after just three seconds of firing. Ten of these magazines are clearly visible in the rear section of the aircraft.

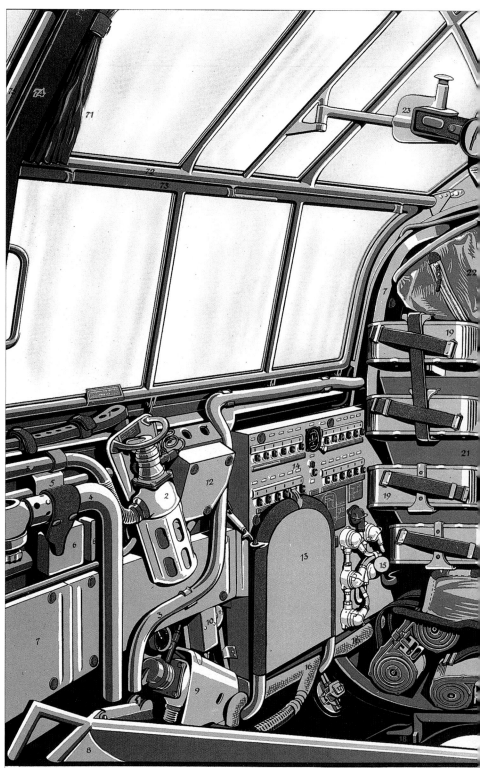

1 Rauchgeräteabwurf-Hebel
2 Atemgerät für Bombenschützen
3 Höhenatmerschlauch
4 Hilfssteuerknüppel
5 Federnde Schelle für Hilfssteuerknüppel
6 Widerstandskästen für Kurssteuerung
7 Kabelkanal
8 Bombenschützensitz (Rückenlehne zurückgeklappt)
9 Atemgerät für Fliegerschützen
10 Schaltschütz für Abwurf R 7
11 Kontaktdose R 115
12 List-Relais R 110

13 Fliegerschützensitz (hochgeklappt)
14 Schalttafel
15 Kraftstoffhandpumpenhebel am Spant 9
16 Beheizung
17 Außenbordanschluß für elektr. Anlage
18 Bodenwanne
19 Doppeltrommel
20 Trommel-Fangnetz
21 Leertrommelkästen
22 Leerhülsenbeutel
23 MG-Zurrung
24 MG 15
25 Hülsensack 15 n A

26 MG-Lagerung
27 Linsenlafette
28 Einrastklinke für FT-Tafel
29 Selbstschalterkasten
30 Verteiler F 36
31 Frequenzwahlschalter für Bake
32 Hinweisschild für FT-Tafel
33 Rasteinstellschlüssel
34 Borduhr
35 Empfänger „Kurz"
36 Empfänger „Lang"
37 Sender „Kurz"
38 Sender „Lang"

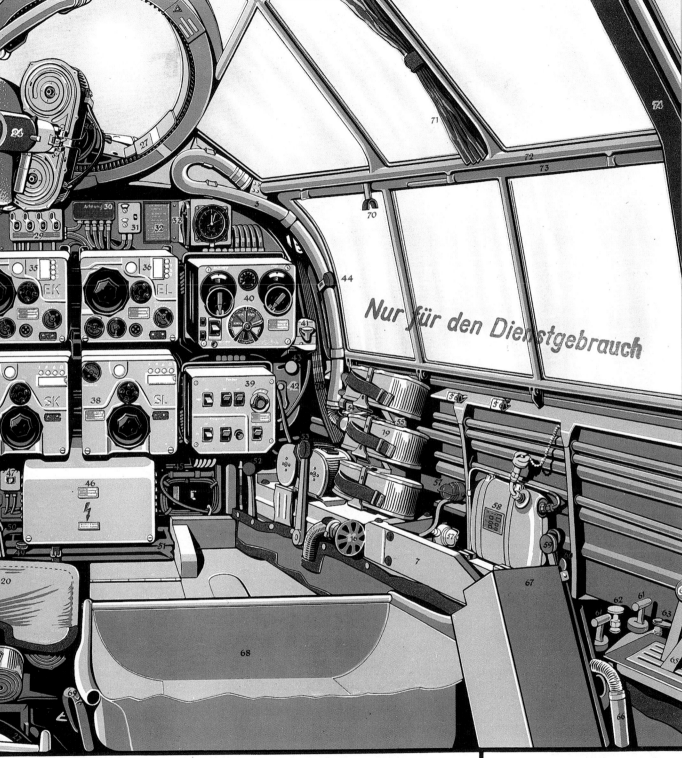

Nur für den Dienstgebrauch

9 Funker-Schaltkasten 13
0 Fernbediengerät FBG 3
 Taste
2 FT-Tafel
3 Riegel für FT-Tafel
4 Bootsauslösehebel
5 Funkerhandlampe
6 Senderumformer
7 Telefon-Zusatzgerät für kurze Welle TZG 10
8 Schultergurt für Fliegerschütze
9 Hebel für Ventilbatterie
0 Behälter für Leiter
 Leiter

52 Notwurfgriff für abwerfbare Außenbehälter
53 Handpumpenhebel für Schmierstoff-Umpump-
 anlage
54 Atemgerät für Funker
55 Doppeltrommellagerung
56 Halterung für Zeitzünderzusatzgerät
57 Stecker für Zeitzünderzusatzgerät
58 Anlaß-Einspritz-Gemischbehälter
59 Bedienhebel für Kraftstoff-Handpumpe
60 Bedienhebel
 für Tragflügel- und Luftschrauben-Enteisung
61 Bediengriff für Führerraumheizung
62 Anlaß-Einspritzpumpe

63 Schaltgriff für Anlaß-Einspritzanlage
64 Bedienhebel für Laderschaltung
65 Bedienhebel für FBH-Armatur
66 Höhenatemschlauch für Flugzeugführer
67 Zünderbatteriekasten ZBK 241/1
68 Funkersitz
69 Verstellhebel für Funkersitz
70 Lyra-Schelle für Funkerhandlampe
71 Blendschutz
72 Abwerfbares Führerraumdach
73 Abwerfbare Seitenteile
74 Spant 6
75 Kabelkanal für FT-Anlage
76 Sauerstoffleitungen

Ju 88

Rundblick

des

Funkers 650

Anforderungszeichen: Fl Üb 8-135

Ju 88 A-1 and A-5 Operation of the Release Mechanism in Dive-Bomb Attacks

The Ju 88 was never meant to be a dive-bomber. The early prototypes were unarmed and were designed to rely on their speed, like the later British Mosquito, to avoid enemy fighters. But before this idea could sink in, the German Air Ministry decreed that the Ju 88 should carry defensive armament and be fitted with dive brakes. This effectively reduced the new Ju 88's speed by 65 kilometers per hour (40 mph). During the war the Ju 88 proved itself an effective dive-bomber. This illustration shows the steps required in order to make a successful dive-bombing run.

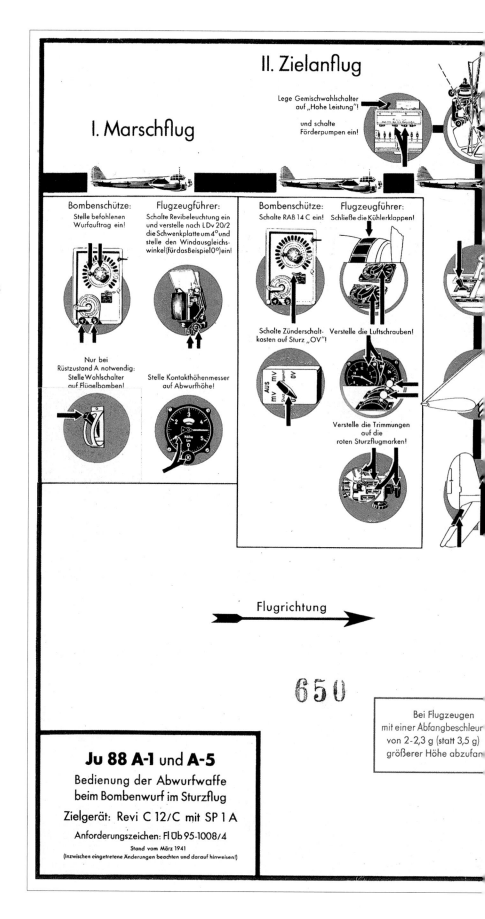

III. Sturzflug

Flugzeugführer:

...n sich Abkippmarken am Kuvi
...am Kanzelboden mit Ziel decken:

Stelle Gasdrosseln
auf Leerlauf

...lter

Ziele
mit Revi so,
daß das Ziel ein Grad
über dem Revikreis liegt!

...d automatisch
...mse ausgefahren

Achte auf roten Stift!

...ppe
...gkeit gestellt

Kontaktbeginn

1250m

Hupe ertönt

Ziel im Abkommpunkt für den Wurf
einen Augenblick ruhig halten!

Drücke
Bombenknopf!

Dadurch
wird durch den Drehschlagmagnet
die Trimmklappe zurückgestellt
und über den Trimmklappenschalter

der
Stromkreis

zum RAB
geschlossen

**Beispiel: Sturzflug in 50 Grad Neigung
mit Sturzflugbremse ohne Wind**

Es soll eine Flügelbombe (RAB Nr. 20) o.V. im Sturzflug
aus 1000 m Höhe geworfen werden

Alle Bilder zeigen die Endstellung!

Nur für den Dienstgebrauch

Ziehe Flugzeug
während des Hupens so, daß
in 1000 m Höhe das Ziel am
unteren Rande des Revikreises
liegt!

Kontaktende

1000m

Flugzeug fängt ab

Bombe fällt sofort

IV.
Nach dem Abfangen

Bei 2-2,3 g Abfangbeschleunigung
weiter ziehen und schwanzlastig
trimmen

V. Übergang
in Reiseflug

Bombenschütze:
Schalte RAB aus!

Flugzeugführer:
Gib langsam Gas!

Stelle
Sturzflugschalter
auf „Ein"!

Dadurch
wird
automatisch
Sturzflugbremse
eingefahren

Roter
Stift

nicht
sichtbar!

Verstelle unter Beachtung der
Drehzahl die Luftschrauben!

Schalte Zünderschaltkasten
auf „Aus"!

AUS mV

0V 0V

Öffne die Kühlerklappen!

L/1005

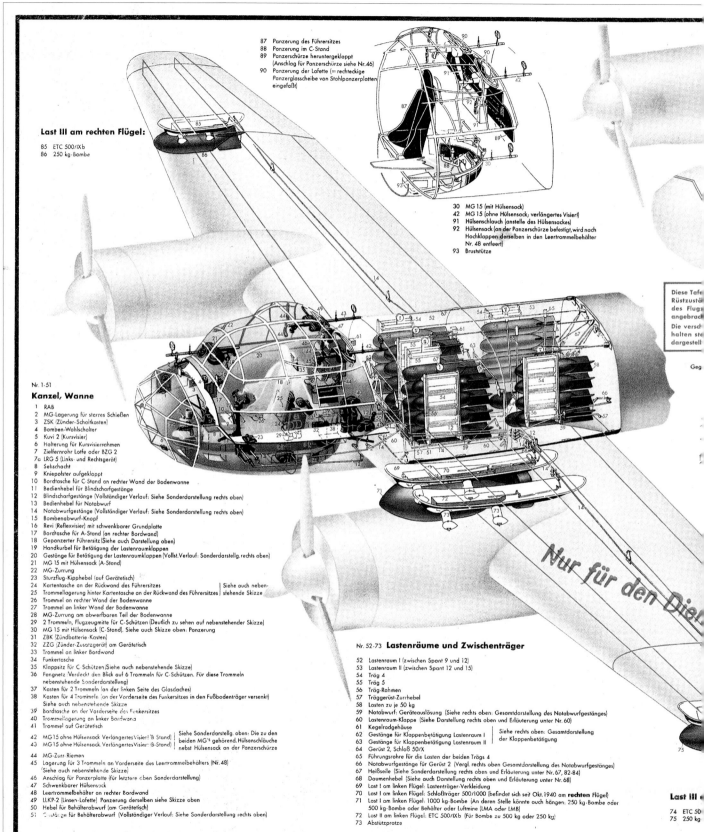

87 Panzerung des Führersitzes
88 Panzerung im C-Stand
89 Panzerschürze heruntergeklappt
(Anschlag für Panzerschürze siehe Nr. 46)
90 Panzerung der Lafette (= rechteckige
Panzerglasscheibe von Stahlpanzerplatten
eingefaßt)

Last III am rechten Flügel:

85 ETC 500/IXb
86 250 kg-Bombe

30 MG 15 (mit Hülsensack)
42 MG 15 (ohne Hülsensack; verlängertes Visier!)
91 Hülsenschlauch (anstelle des Hülsensackes)
92 Hülsensack (an der Panzerschürze befestigt, wird nach
Hochklappen derselben in den Leertrommelbehälter
Nr. 48 entleert)
93 Bruststütze

Diese Taf[el]
Rüstzust[ände]
des Flugz[eug]
angebrac[ht]

Die versch[iedenen]
halten st[...]
dargestell[t]

Geg[...]

Nr. 1-51

Kanzel, Wanne

1 RAB
2 MG-Lagerung für starres Schießen
3 ZSK (Zünder-Schaltkasten)
4 Bomben-Wahlschalter
5 Kuvi 2 (Kursvisier)
6 Halterung für Kursvisierrahmen
7 Zielfernrohr Lotfe oder BZG 2
7a LRG 5 (Links- und Rechtsgerät)
8 Sehschacht
9 Kniepolster aufgeklappt
10 Bordtasche für C-Stand an rechter Wand der Bodenwanne
11 Bedienhebel für Blindscharfgestänge
12 Blindscharfgestänge (Vollständiger Verlauf: Siehe Sonderdarstellung rechts oben)
13 Bedienhebel für Notabwurf
14 Notabwurfgestänge (Vollständiger Verlauf: Siehe Sonderdarstellung rechts oben)
15 Bombenabwurf-Knopf
16 Revi (Reflexvisier) mit schwenkbarer Grundplatte
17 Bordtasche für A-Stand (an rechter Bordwand)
18 Gepanzerter Führersitz (Siehe auch Darstellung oben)
19 Handkurbel für Betätigung der Lastenraumklappen
20 Gestänge für Betätigung der Lastenraumklappen (Vollst. Verlauf: Sonderdarstellg. rechts oben)
21 MG 15 mit Hülsensack (A-Stand)
22 MG-Zurrung
23 Sturzflug-Kipphebel (auf Gerätetisch)
24 Kartentasche an der Rückwand des Führersitzes
25 Trommellagerung hinter Kartentasche an der Rückwand des Führersitzes | Siehe auch neben-
26 Trommel an rechter Wand der Bodenwanne | stehende Skizze
27 Trommel an linker Wand der Bodenwanne
28 MG-Zurrung am abwerfbaren Teil der Bodenwanne
29 2 Trommeln, Flugzeugmitte für C-Schützen (Deutlich zu sehen auf nebenstehender Skizze)
30 MG 15 mit Hülsensack (C-Stand). Siehe auch Skizze oben: Panzerung
31 ZBK (Zündbatterie-Kasten)
32 ZZG (Zünder-Zusatzgerät) am Gerätetisch
33 Trommel on linker Bordwand
34 Funkertasche
35 Klappsitz für C-Schützen (Siehe auch nebenstehende Skizze)
36 Fangnetz Verdeckt den Blick auf 6 Trommeln für C-Schützen. Für diese Trommeln nebenstehende Sonderdarstellung
37 Kasten für 2 Trommeln (an der linken Seite des Glasdaches)
38 Kasten für 4 Trommeln (an der Vorderseite des Funkersitzes in den Fußbodenträger versenkt) Siehe auch nebenstehende Skizze
39 Bordtasche an der Vorderseite des Funkersitzes
40 Trommellagerung an linker Bordwand
41 Trommel auf Gerätetisch
42 MG 15 ohne Hülsensack Verlängertes Visier! (B-Stand) | Siehe Sonderdarstellg. oben: Die zu den
43 MG 15 ohne Hülsensack. Verlängertes Visier (B-Stand) | beiden MG's gehörend. Hülsenschläuche
 | nebst Hülsensack an der Panzerschürze
44 MG-Zurr-Riemen
45 Lagerung für 3 Trommeln an Vorderseite des Leertrommelbehälters (Nr. 48)
(Siehe auch nebenstehende Skizze)
46 Anschlag für Panzerplatte (für letztere oben Sonderdarstellung)
47 Schwenkbarer Hülsensack
48 Leertrommelbehälter an rechter Bordwand
49 LLKP-2 (Linsen-Lafette). Panzerung derselben siehe Skizze oben
50 Hebel für Behälterabwurf (am Gerätetisch)
51 Gestänge für Behälterabwurf (Vollständiger Verlauf: Siehe Sonderdarstellung rechts oben)

Nr. 52-73 **Lastenräume und Zwischenträger**

52 Lastenraum I (zwischen Spant 9 und 12)
53 Lastenraum II (zwischen Spant 12 und 15)
54 Träg 4
55 Träg 5
56 Träg-Rahmen
57 Träggerüst-Zurrhebel
58 Lasten zu je 50 kg
59 Notabwurf: Geräteauslösung (Siehe rechts oben: Gesamtdarstellung des Notabwurfgestänges)
60 Lastenraum-Klappe (Siehe Darstellung rechts oben und Erläuterung unter Nr. 60)
61 Kegelradgehäuse
62 Gestänge für Klappenbetätigung Lastenraum I | Siehe rechts oben: Gesamtdarstellung
63 Gestänge für Klappenbetätigung Lastenraum II | der Klappenbetätigung
64 Gerüst 2, Schloß 50/X
65 Führungsrohre für die Lasten der beiden Trägs 4
66 Notabwurfgestänge für Gerüst 2 (Vergl. rechts oben Gesamtdarstellung des Notabwurfgestänges)
67 Heißseile (Siehe Sonderdarstellung rechts oben und Erläuterung unter Nr. 67, 82-84)
68 Daumenhebel (Siehe auch Darstellung rechts oben und Erläuterung unter Nr. 68)
69 Last I am linken Flügel: Lastenträger-Verkleidung
70 Last I am linken Flügel: Schloßträger 500/1000 (befindet sich seit Okt. 1940 am **rechten** Flügel)
71 Last I am linken Flügel: 1000 kg-Bombe (An deren Stelle könnte auch hängen: 250 kg-Bombe oder 500 kg-Bombe oder Behälter oder Luftmine (LMA oder LMB)
72 Last II am linken Flügel: ETC 500/IXb (Für Bombe zu 500 kg oder 250 kg)
73 Abstützpratze

Last III [...]

74 ETC 50[...]
75 250 kg [...]

L/1005

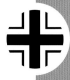

Ju 88 A-1 and A-4 Gun and Bomb-Release Systems

The Ju 88 was a tactical bomber with a moderate range. Early versions of the Ju 88 were capable of carrying twenty-eight 50-kilogram (110 lb) bombs in two fuselage bays. Externally the four big under-wing racks (located between the engines and fuselage) could carry a 250-kilogram (551 lb) bomb. Subsequent versions could carry four 500-kilogram (1,102 lb) bombs. The outer-wing bomb racks were cleared for 250-kilogram (551 lb) bombs. This illustration shows the crew's armor plating along with the defensive armament, storage of ammunition and bomb-release mechanisms.

Nr. 77-84 (Niedrigere Nummern in Übereinstimmung mit Hauptzeichnung)

12 Blindscharfgestänge ⇐⇐⇐ (Nur für Mine!) Bewegungspfeile: Mine soll blind gemacht werden
14 Notabwurfgestänge ◄◄◄ (wirft **gleichzeitig sämtliche** Lasten aus dem Rumpf und von den Tragflächen ab, also auch Mine und Behälter!) Bewegungspfeile: Lasten sollen abgeworfen werden
19 Betätigung der Lastenraumklappen: Handkurbel
20 Betätigung der Lastenraumklappen: Gestänge
61 Betätigung der Lastenraumklappen: Kegelradgehäuse mit Schnecke
62 Betätigung der Lastenraumklappen: Gestänge für Raum I | Bewegungspfeile: Klappen
63 Betätigung der Lastenraumklappen: Gestänge für Raum II | sollen geöffnet werden!
50 **Behälter-**Notabwurf: Hebel (am Gerätetisch)
51 **Behälter-**Notabwurf: Gestänge ◄◄◄ Bewegungspfeile: Behälter soll abgeworfen werden
59 Notabwurf (Siehe Nr. 14): Trägauslösung
60 Lastenraum-Klappe (Jeder der beiden Lastenräume besitzt 2 Klappenpaare. Beide Räume werden gleichzeitig geöffnet
67 Heißseile. Die Nummerierung 1-6 (in der Hauptzeichng. I-VI) entspricht der tatsächlichen Bezeichnung in der Maschine
68 Daumenhebel mit Gestänge für Last I. Bewirkt bei Zug des **Behälter-**Abwurfgestänges den Abwurf des Behälters, bei Zug des **Notabwurf**gestänges den Abwurf der **jeweils** am Lastenträger I hängenden Last (Bombe, Mine, Behälter)
69 Träger-Verkleidung
70 Schloßträger 500/1000 (Nur **einer** vorhanden, und zwar seit Oktober 1940 nicht mehr am linken, sondern am **rechten** Flügel)
72 ETC 500 (verwendbar in Lasten I, II, III)
73 Abstützpratze
77 Luftmine (LMA oder LMB). Nur an Schloßträger 500/1000 möglich (Siehe auch Bemerkung Nr. 70)
78 Last I am rechten Flügel (Siehe hierzu Änderungsvermerk bei Nr. 70)
79 Last II am rechten Flügel
80 500 kg-Bombe an ETC 500
81 250 kg-Bombe an ETC 500
82 Heißbock. **Anwendungsbeispiel** des Heißbocks: Seil Nr. 3 ist über den Bock nach der Gabel am Spornrad gezogen. Die Ruhehaltung dieses Seils steht deshalb leer.
83 Seilführung durch die Bordwand zum Heißbock
84 Seilführung nach der Gabel am Spornrad

94 Abfangvorrichtung in linker Höhenflosse (Stellung der Trimmklappe während des Sturzfluges stark übertrieben dargestellt)

36

(Auf der Großtafel ist die Schrift rot)

Ju 88 A-1 u. A-5
Schuß- u. Abwurfwaffe
Fl Üb 8-178/18
Stand vom 2.1941
Inzwischen eingetretene Änderungen beachten und darauf hinweisen!

J F M - Lehrmittelabteilung, LM - Nr. 3092

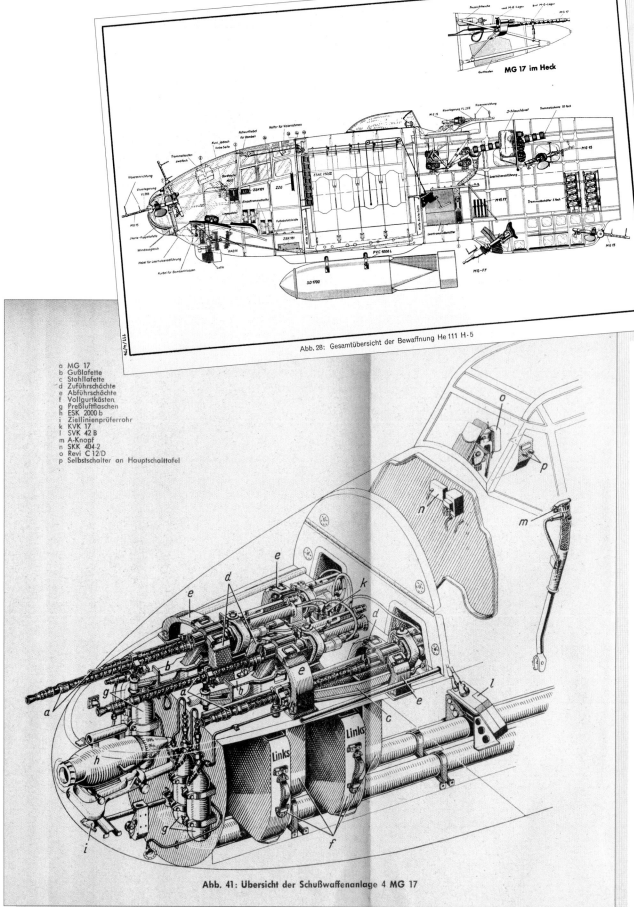

Abb. 28: Gesamtübersicht der Bewaffnung He 111 H-5

a MG 17
b Gußlafette
c Stahllafette
d Zuführschächte
e Abführschächte
f Vollgurtkästen
g Preßluftflaschen
h ESK 2000 b
i Ziellinienprüferrohr
k KVK 17
l SVK 42 B
m A-Knopf
n SKK 404-2
o Revi C 12/D
p Selbstschalter an Hauptschalttafel

Abb. 41: Übersicht der Schußwaffenanlage 4 MG 17

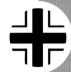
Complete Armament of He III H-5 (opposite, top)

The most widely used bomber during the Blitz of England in the winter and spring of 1941/42 was the Heinkel He III H-5. These aircraft carried most of the heavy bombs and parachute mines that fell on British cities. The He III H-5 was more heavily armed (with seven MG 17 machine guns and one 20 mm cannon) than its predecessors and was equipped with a single remotely controlled fixed machine gun in the tail. It also featured two external bomb racks capable of lifting a 1000-kilogram (2,205 lb) bomb.

Overall View of Gun Installation in the Me 110 (opposite, bottom)

At the beginning of World War II the Bf 110 was the most heavily armed twin-engine fighter in the world. The mix of four 7.92 mm MG 17 machines guns and two 20 mm cannon (the blast tubes can be seen underneath the four machine gun installation) provided a powerful battery for both air-to-air and air-to-ground missions.

The 5 CM BK Cannon in the Me 410 (below)

The BK 5 cannon was the heaviest caliber weapon carried by the Me 410. Its success rate against both ground and air targets was not very high.

Abb. 14: Übersicht 5 cm BK in Me 410 A-1/U 4

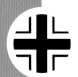

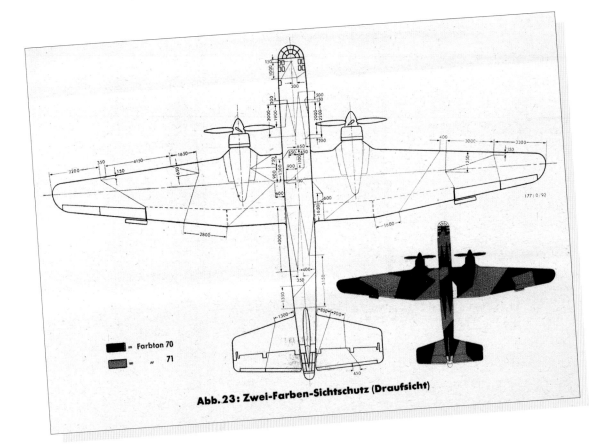

= Farbton 70
= „ 71

Abb. 23: Zwei-Farben-Sichtschutz (Draufsicht)

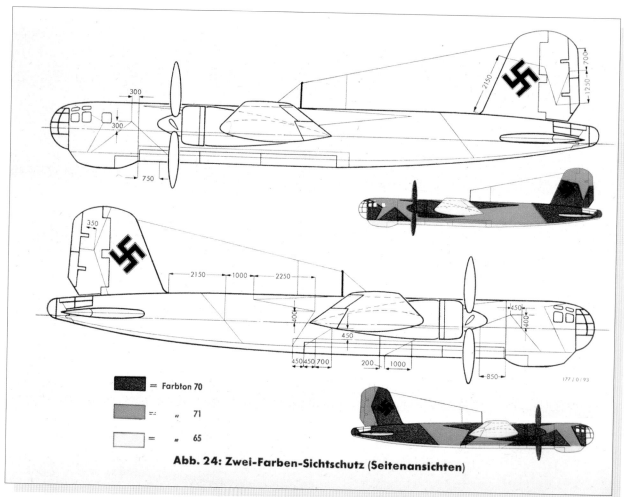

= Farbton 70

= „ 71

= „ 65

Abb. 24: Zwei-Farben-Sichtschutz (Seitenansichten)

MG 81 Z Machine Gun on Swivel Mounting (below)

Taken from the *Arado 196 A-5 Flight Manual*, this illustration shows the MG 81 machine gun on a swivel mounting. The MG 81 was the first aircraft machine gun installed by the Germans in twin mountings. Rate of fire was 1,200 to 1,500 rounds a minute.

Two-Color View Protection He 177 (opposite)

These images show the very precise camouflage pattern to be applied to the He 177.

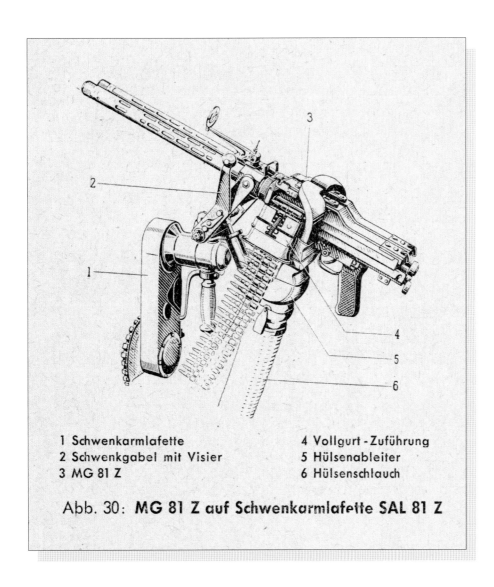

1 Schwenkarmlafette
2 Schwenkgabel mit Visier
3 MG 81 Z
4 Vollgurt-Zuführung
5 Hülsenableiter
6 Hülsenschlauch

Abb. 30: MG 81 Z auf Schwenkarmlafette SAL 81 Z

Vergleichstafel 7
Besondere Merkmale

Maßstab 1:300

Flugzeuge – (See)
Flugboote

Cant Z 501 1	BV 138 4	BV 222 7
Lerwick 2	Do 24 5	Do 18 8
Catalina 3 (Consolidated)	Sunderland . . . 6	Do 26 9

① ②

Aircraft Recognition Service Part 3 Comparison Plates
Seaplanes/Flying Boats

Every air force produced aircraft recognition booklets. This German example highlights the many and varied flying boats used by both sides.

L. Dv. 925/3
Tafel 7

Der Flugzeugerkennungsdienst
Teil 3
Vergleichstafeln / Tafel 7

Flugzeuge – (See)
Flugboote

März 1942

③

④

⑤

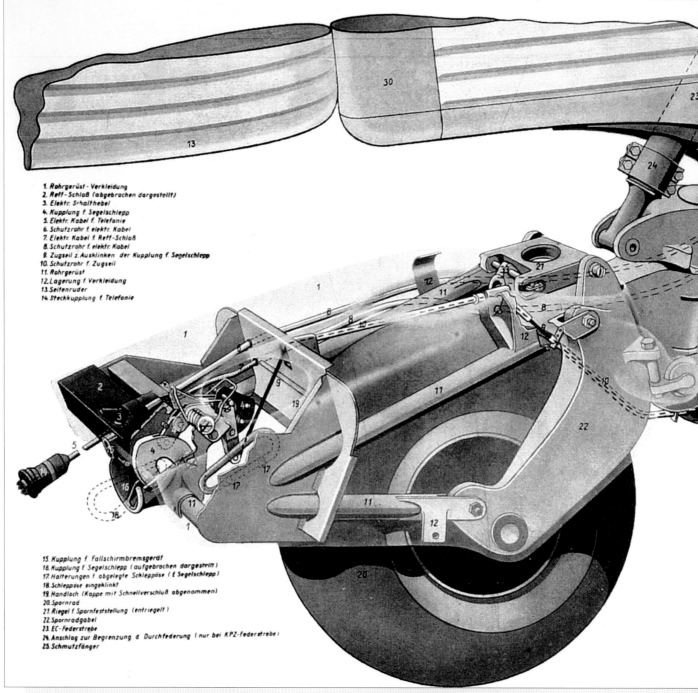

1. Rohrgerüst - Verkleidung
2. Reff-Schloß (abgebrochen dargestellt)
3. Elektr. Schalthebel
4. Kupplung f. Segelschlepp
5. Elektr. Kabel f. Telefonie
6. Schutzrohr f. elektr. Kabel
7. Elektr. Kabel f. Reff-Schloß
8. Schutzrohr f. elektr. Kabel
9. Zugseil z. Ausklinken der Kupplung f. Segelschlepp
10. Schutzrohr f. Zugseil
11. Rohrgerüst
12. Lagerung f. Verkleidung
13. Seitenruder
14. Steckkupplung f. Telefonie

15. Kupplung f. Fallschirmbremsgerät
16. Kupplung f. Segelschlepp (aufgebrochen dargestellt)
17. Halterungen f. abgelegte Schleppöse (f. Segelschlepp)
18. Schleppöse eingeklinkt
19. Handloch (Kappe mit Schnellverschluß abgenommen)
20. Spornrad
21. Riegel f. Spornfeststellung (entriegelt)
22. Spornradgabel
23. EC-Federstrebe
24. Anschlag zur Begrenzung d. Durchfederung (nur bei KPZ-Federstrebe)
25. Schmutzfänger

Ju 52 Tail Wheel Assembly (above)

Early versions of the Ju 52 had a tailskid, but because of the poor airfield conditions usually encountered by the Ju 52, a tail wheel was soon introduced. This greatly improved maneuverability on the ground.

Gnome-Rhone 14 M Engine
(below)

This fine study of the French Gnome-Rhone 14 M engine is found in the Hs 129 aircraft manual. The Gnome-Rhone was chosen to power the Hs 129 after the Argus 410 proved unreliable and did not develop the expected horsepower. Because large numbers of the 700 horsepower (522 kw) Gnome-Rhone were available, it was decided to modify the Hs 129 as quickly as possible to use the bigger and more powerful radial.

Ju 52 3mg 8e

Schlepp-Sporn 6000

Fl Ob 8-208/1

Stand vom Januar 1942

Inzwischen eingetretene Änderungen beachten und darauf hin

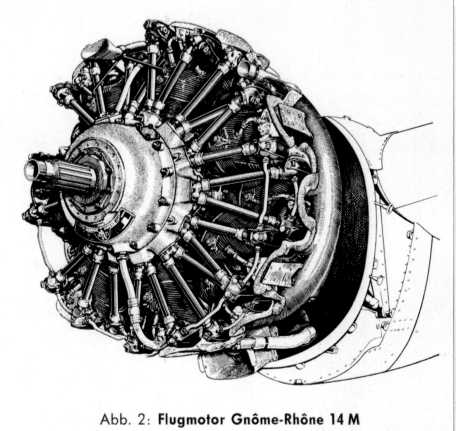

Abb. 2: **Flugmotor Gnôme-Rhône 14 M**

DB 601E Transparent Presentation

This is the first page of a transparent presentation of the DB 601 engine. As you turn the pages, the inner workings of the DB 601 engine are revealed. The DB 601 powered the Bf 109 single-seat fighter and the twin-engine Me 110, Me 210 and Me 410 series of fighters. It had a remarkably clean and uncluttered design and was an excellent example of precision engineering. Because the DB 601 gave out a distinctive clattering sound when accelerating for takeoff, pilots described it as "Thor's Anvil."

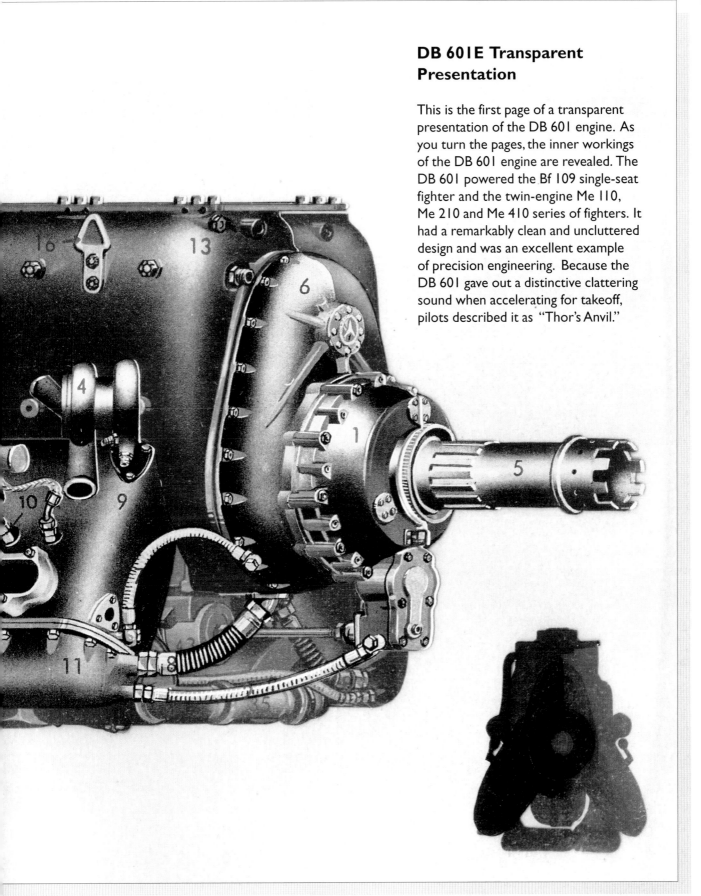

Jumo 211 Engine Cross-Section

The Jumo 211 was a twelve-cylinder inverted-Vee liquid-cooled engine with direct fuel injection and two-speed superchargers. The B-1 engine was rated at 1,200 horsepower and powered the Ju 88 and He 111 twin-engine bombers and the single-engine Ju 87 Stuka dive-bomber.

Kurbelgehäusedeckel

Lagerbügel
Queranker
(niemals lösen)

Anschluß für Kühlstoff-
Ausgleichsleitung

Laufbüchsen-Gummiringe
mit Leckbohrung

Einfüllstutzen für Kühlstoff

Laufbüchse
(mit Kühlstoff umspült)

Auslaßventil

Einlaßventile

Ventilfedern

Schwinghebel

Nockenwelle

Einspritzdüse

Ladeluftkanäle

Abstellfuß

Einspritzpumpenantrieb

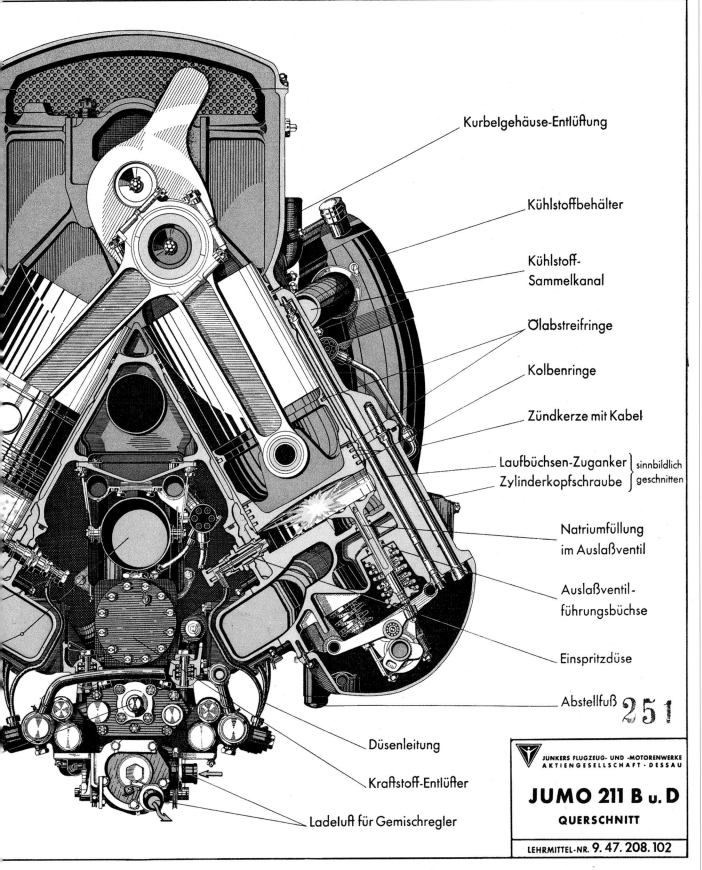

Kurbelgehäuse-Entlüftung

Kühlstoffbehälter

Kühlstoff-
Sammelkanal

Ölabstreifringe

Kolbenringe

Zündkerze mit Kabel

Laufbüchsen-Zuganker } sinnbildlich
Zylinderkopfschraube } geschnitten

Natriumfüllung
im Auslaßventil

Auslaßventil-
führungsbüchse

Einspritzdüse

Abstellfuß 251

Düsenleitung

Kraftstoff-Entlüfter

Ladeluft für Gemischregler

JUNKERS FLUGZEUG- UND -MOTORENWERKE
AKTIENGESELLSCHAFT · DESSAU

JUMO 211 B u. D

QUERSCHNITT

LEHRMITTEL-NR. 9. 47. 208. 102

Jumo 211 Power Plant (right)

Aircraft engines of World War II not only had to provide enough power for flight; they also had to provide electrical and hydraulic power along with direct energy to drive pumps and superchargers. This diagram shows the many gears and clutching mechanisms found in the Jumo 211 engine.

Ju 88 Firewall (below)

If the Jumo 211 engine were removed from the wing of the Ju 88, this is what one would see. The firewall is a fire-resistant transverse bulkhead isolating the engine compartment from other parts of the wing structure.

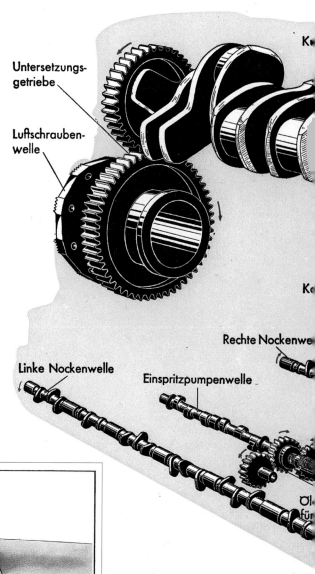

Untersetzungs-getriebe

Luftschrauben-welle

K...

K...

Rechte Nockenwe...

Linke Nockenwelle

Einspritzpumpenwelle

Öl...
für...

Schmierstoff-
Rückförderpu...

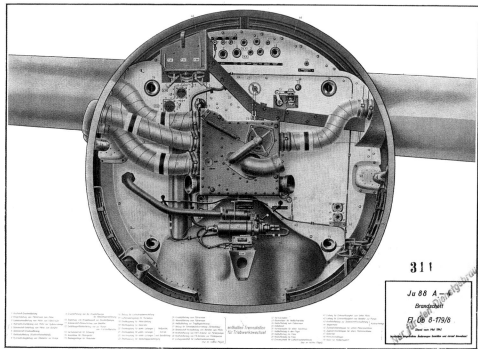

311

Ju 88 A—4
Brandschott

Fl Üb 8-179/8

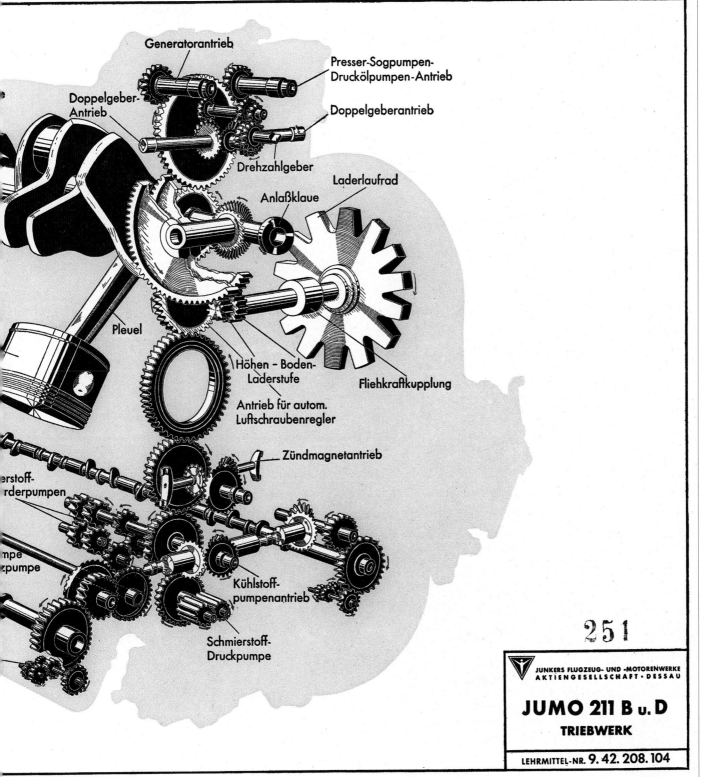

Generatorantrieb

Presser-Sogpumpen-
Drucköpumpen-Antrieb

Doppelgeber-
Antrieb

Doppelgeberantrieb

Drehzahlgeber

Laderlaufrad

Anlaßklaue

Pleuel

Höhen – Boden-
Laderstufe

Fliehkraftkupplung

Antrieb für autom.
Luftschraubenregler

Zündmagnetantrieb

...erstoff-
...rderpumpen

...mpe
...zpumpe

Kühlstoff-
pumpenantrieb

Schmierstoff-
Druckpumpe

251

JUNKERS FLUGZEUG- UND -MOTORENWERKE
AKTIENGESELLSCHAFT · DESSAU

JUMO 211 B u. D
TRIEBWERK

LEHRMITTEL-NR. 9. 42. 208. 104

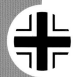

Entlüftung

Saugventil
Überdruckventil

Dampf

Luft
Doppelventil

Entlüftung
im Betrieb bei Auffüllung

Einfüllkopf

Pumpenentlüftung
bei Auffüllung

Kühlstoffpumpe

zum Pumpen-
ablaßstutzen

Zylinderköpfe

Laufbüchsen

Wasserleiste

Dampfluftabscheider

Ausgleichsbehälter

Ringkühler

Kühlerablaßstutzen

Nebenstromleitung

251

JUNKERS FLUGZEUG- UND -MOTORENWERKE
AKTIENGESELLSCHAFT · DESSAU

JUMO 211 B u. D

KUHLSTOFFKREISLAUF

LEHRMITTEL-NR. 9. 47. 208. 106

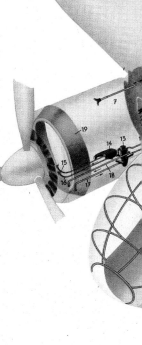

1 Schmierstoffbehälter
2 Behälterfüllkopf
3 Vorratsgeber für Vorr
4 Behälterkopf für den
 der Entlüftungsleitung
5 Ablaßventil
6 Ventilbatterie (mit FE
 gekuppelt)
7 Entlüftungsleitungen
8 Sickerleitungen

L/1005

Jumo 211 Coolant Circulation (left)

When fitted to the Ju 88, the liquid-cooled Jumo 211 engine had the appearance of a large air-cooled radial. This was because of the circular engine and oil radiator mounted on the front of the engine. Airflow was controlled by gills as in a radial engine. This cutaway diagram shows the plumbing involved in a typical liquid-cooled engine.

Ju 188 Oil System Engine BMW 801 (below)

Both the Jumo 213 liquid-cooled engine and the BMW 801 radial air-cooled engines powered the Ju 188. This diagram illustrates the oil tanks and distribution system required for the BMW 801 engine.

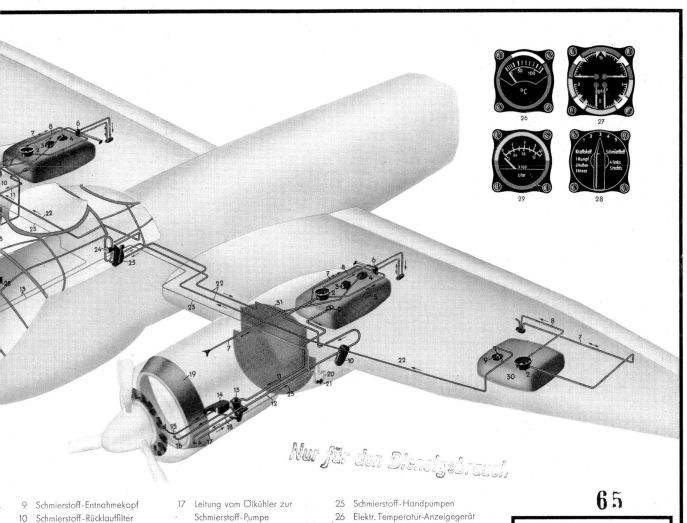

Nur für den Dienstgebrauch

9	Schmierstoff-Entnahmekopf	17	Leitung vom Ölkühler zur Schmierstoff-Pumpe
10	Schmierstoff-Rücklauffilter		
11	Schmierstoff-Vorlaufleitungen	18	Leitung von der Schmierstoff-Pumpe zum Ölkühler
12	Schmierstoff-Rücklaufleitungen		
13	Schmierstoff-Pumpe	19	Ölkühler
14	Ölsumpf	20	Kraftstoff-Leitung } Kaltstart
15	Getriebölrücklaufleitungen	21	Absperrhahn
16	Schmierstoffleitungen zum Getriebe	22	Schmierstoff-Umfüllleitungen
		23	Schmierstoff-Meßleitungen
		24	Dreiwegehahn

25	Schmierstoff-Handpumpen
26	Elektr. Temperatur-Anzeigegerät
27	Vierfach-Druckanzeigegerät für Kraft- und Schmierstoff
28	Schalter für Vorratsmessung
29	Vorratsmesser für Kraft- und Schmierstoff
30	Schmierstoff-Zusatzbehälter 100 (106) Ltr.
31	Brandspant

65

**Ju 188
Schmierstoffanlage**

Gesamtübersicht mit BMW 801

Stand vom Januar 1943

Inzwischen eingetretene Änderungen beachten und darauf hinweisen!

JFM-Lehrmittelabteilung, LM-Nr.3046

GERMANY

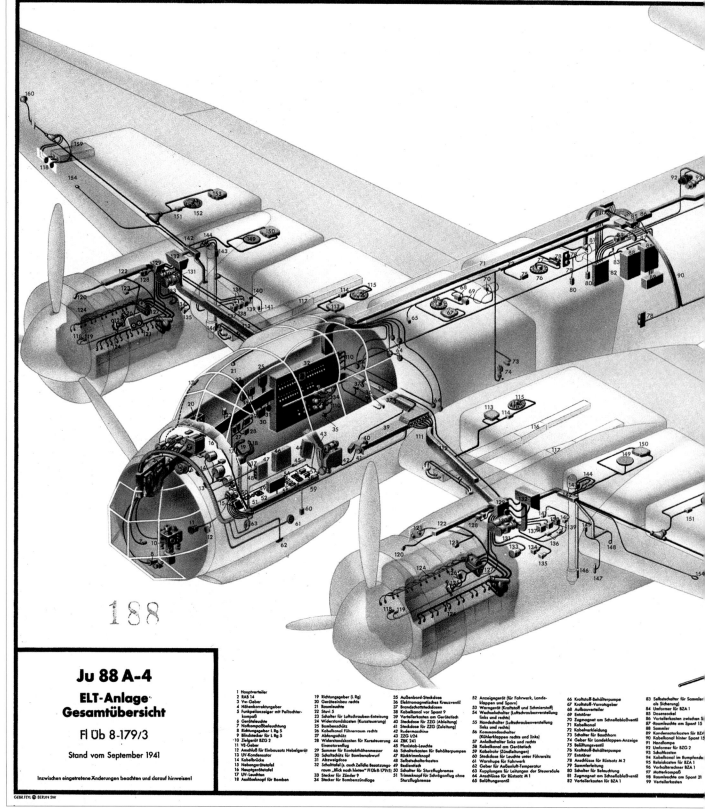

188

Ju 88 A-4

ELT-Anlage Gesamtübersicht

Fl Üb 8-179/3

Stand vom September 1941

Inzwischen eingetretene Änderungen beachten und darauf hinweisen!

GEBR. FEYL ⊕ BERLIN SW

1 Hauptverteiler	19 Richtungsgeber (l. Rg)	35 Außenbord-Steckdose	52 Anzeigegerät (für Fahrwerk, Landeklappen und Sporn)	66 Kraftstoff-Behälterpumpe	83 Selbstschalter für Sammler als Sicherung
2 RAB 14	20 Geräteeinbau rechts	36 Elektromagnetisches Kreuzventil	53 Warngerät (Kraftstoff und Schmierstoff)	67 Kraftstoff-Vorratsgeber	84 Umformer für BZA 1
3 Ve-Geber	21 Raumleuchte	37 Brandschottsteckdosen	54 Wechselschalter (Luftschraubenverstellung links und rechts)	68 Außbauverteiler	85 Dosensockel
4 Höhenkorrekturgeber	22 Stuvi 5	38 Kabelkanal vor Spant 9	55 Handschalter (Luftschraubenverstellung links und rechts)	69 Entstörer	86 Verteilerkasten zwischen Spant 15
5 Funkpeilanzeiger mit Peiltochterkompaß	23 Schalter für Luftschrauben-Enteisung	39 Verteilerkasten am Gerätetisch links und rechts	56 Kommandoschalter	70 Zugmagnet am Schnellablaßventil	87 Raumleuchte am Spant 15
6 Geräteleuchte	24 Widerstandskasten (Kurssteuerung)	40 Steckdose für ZZG (Ableitung)	57 Anlaßschalter links und rechts	71 Kabelkanal	88 Sammler
7 Notkompaßbeleuchtung	25 Kombenschütz	41 Steckdose für ZZG (Zuleitung)	58 (Kühlerklappen rechts und links)	72 Kabelverkleidung	89 Kondensatorkasten für BZG 1
8 Richtungsgeber l. Rg 5	26 Kabelkanal Führerraum rechts	42 Rudermaschine	59 Kabelkanal am Gerätetisch	73 Schalter für Baschhorn	90 Kabelkanal hinter Spant 15
9 Blindstecker für l. Rg 5	27 Abfangschütz	43 ZZG I/24	60 Kabelrohr (Zündleitungen)	74 Geber für Landeklappen-Anzeige	91 Handlampe
10 Zielgerät BZG 2	28 Widerstandskasten für Kurssteuerung	44 ZBK 241	61 Steckdose für Leuchte unter Führersitz	75 Belüftungsventil	92 Umformer für BZG 2
11 VE-Geber	29 Summer für Kontakthöhenmesser Einmotorenflug	45 Plexistab-Leuchte	62 Geber für Außenluft-Temperatur	76 Kraftstoff-Behälterpumpe	93 Schaltkasten
12 Anschluß für Einbausatz Nebelgerät	30 Schaltschütz für Bombenabwurf	46 Schalterkasten für Behälterpumpen	63 Kupplungen für Leitungen der Steuersäule	77 Entstörer	94 Kabelkanal im Rumpfende
13 UV-Kondensator	31 Abzweigdose	47 Rückfrimmknopf	64 Anschlüsse für Rüstsatz M 1	78 Anschlüsse für Rüstsatz M 2	95 Relaiskasten für BZA 1
14 Kabelbrücke	32 Schalttafel (s. auch Zeildia Besatzungsraum "Blick nach hinten" Fl Üb-179/5)	48 Selbstschalterkasten	65 Belüftungsventil	79 Sammelleitung	96 Vorhalterechner für BZA 1
15 Nebengerätetafel	33 Stecker für Zünder 9	49 Bedientisch		80 Schalter für Beleuchtung	97 Mutterkompaß
16 Hauptgerätetafel	34 Stecker für Bombenzündlage	50 Schalter für Sturzflugbremse		81 Zugmagnet am Schnellablaßventil	98 Raumleuchte am Spant 21
17 UV-Leuchten		51 Trimmknopf für Schräganflug ohne Sturzflugbremse		82 Verteilerkasten für BZA 1	99 Verteilerkasten
18 Auslöseknopf für Bomben					

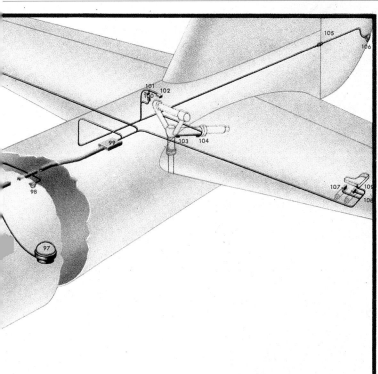

Ju 88 A-4 Electrical Installation (left)

Generally speaking, the German Luftwaffe's electrical aircraft systems were far better than those of the Allies. By the second half of the war, the Allies had shown considerable improvement and were producing systems as good or better than the Germans.

BMW 323 Radial Engine (below)

The Fw 200 Condor was powered by four BMW 323R-2 Fafnir radial piston engines. This diagram, taken from the *Spare Parts List Manual* of the Fw 200C version, shows the access panels open to reveal easy access to the engine itself.

Endschalter (Sporn ausgefahren)	118 Induktivgeber für Kraftstoffverbrauch	134 Geber (Generator) für Drehzahlmessung	
Endschalter (Sporn eingefahren)	119 Hubmagnet für arm-reich Regulierung	135 Geber (Generator) für Verbrauchsmessung	
Geber für Sporn-Anzeige	120 Geber für Kühlstoff-Temperatur	136 Kondensator	
Verriegelungsschalter eingefahren	121 Triebwerks-Gerätebrett	137 Anlaß Trafo-Summer	
Verriegelungsschalter ausgefahren	122 Kanal am Motorträger	138 Magnet-Schalter	
Steckkupplung für Hecklicht	123 Kühlstoff-Warngeber (wird ab Nov. 41	139 Regler für Generator	
Hecklicht	nicht mehr eingebaut)	140 Kupplung für A-5 Triebwerk	
Zugmagnet für Abfangautomatik	124 Zündgeschirr	141 Schalter für Fahrwerksverkleidung-Anzeige	
Schalter für Trimmklappen (Ruhestromkontakt)	125 Kühlerspreizklappenmotor mit	142 Kanal hinter Brandschott	
Schalter für Trimmklappen (Arbeitsstromkontakt)	Nachlaufschalter	143 Verriegelungsschalter eingefahren	
Kupplung zum Tragflügel rechts	126 Entstörer für Kühlerspreizklappenmotor	144 Kupplungen für Fahrwerksschalter	151 Entstörer
Kupplung zum Tragflügel links	127 Zündmagnet I und II	(eingefahren, ausgefahren)	152 Kraftstoff-Behälterpumpe
Kabelkanäle in den Flächen	128 Schaltschütz für Luftschrauben-Verstellung	145 Druckknopfmomentschalter	153 Vorratsgeber (Kraftstoff)
Kraftstoffvorratsgeber	129 Verteilerkasten	146 Verriegelungsschalter (ausgefahren)	154 Anschluß für Rauchgerät
Entstörer	130 Generator	147 Schalter für Boschhorn	155 Scheinwerfer
Behälterpumpe	131 Anlasser	148 Geber für Fahrwerk-Anzeige	156 Staurohr
Schloßträger 500/1000 (Last I)	132 Verteilerkasten am Brandschott	149 Schmierstoff-Behälterpumpe (vorgesehen)	157 Schmierstoff-Behälterpumpe
ETC 500 (Last II)	133 Umkehrmotor (Luftschrauben-Verstellung)	150 Schmierstoff-Vorratsgeber	158 Anschluß für Nebelgerät
			159 ETC 500 (Last III)
			160 Kennlicht

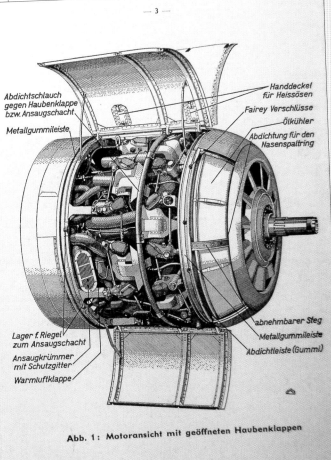

Abb. 1: Motoransicht mit geöffneten Haubenklappen

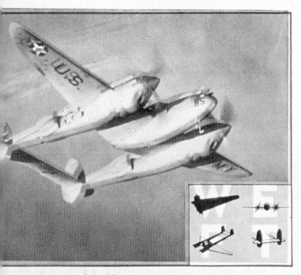

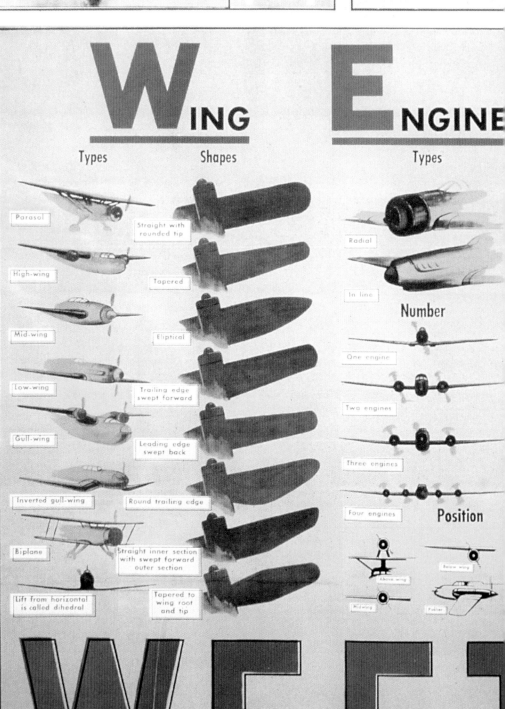

Wing

Types	Shapes
Parasol	Straight with rounded tip
High-wing	Tapered
Mid-wing	Eliptical
Low-wing	Trailing edge swept forward
Gull-wing	Leading edge swept back
Inverted gull-wing	Round trailing edge
Biplane	Straight inner section with swept forward outer section
Lift from horizontal is called dihedral	Tapered to wing root and tip

Engine

Types

Radial

In line

Number

One engine

Two engines

Three engines

Four engines

Position

Above wing

Below wing

Midwing

Pusher

WEFT

UNITED STATES

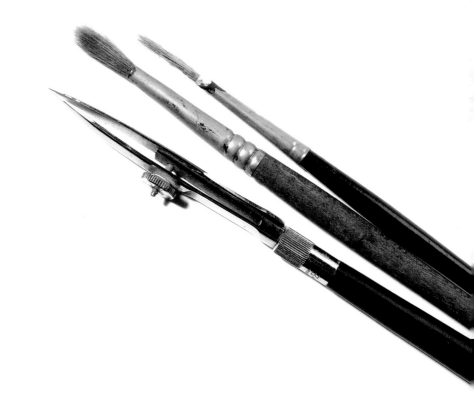

B-17F Familiarization and Inspection Manual for the B-17F

The lavishly illustrated cutaway drawings of the B-17F on this page and the next represent some of the best work done by illustrators during World War II. The artist is unknown, but his work is exemplary. These drawings focus on the forward armament and the pilot's compartment and would be used to familiarize new crews with the structure and various systems found in the B-17.

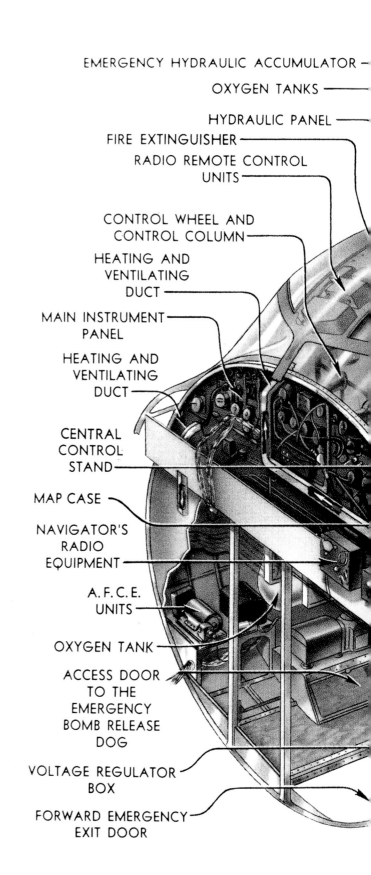

EMERGENCY HYDRAULIC ACCUMULATOR

OXYGEN TANKS

HYDRAULIC PANEL

FIRE EXTINGUISHER

RADIO REMOTE CONTROL UNITS

CONTROL WHEEL AND CONTROL COLUMN

HEATING AND VENTILATING DUCT

MAIN INSTRUMENT PANEL

HEATING AND VENTILATING DUCT

CENTRAL CONTROL STAND

MAP CASE

NAVIGATOR'S RADIO EQUIPMENT

A.F.C.E. UNITS

OXYGEN TANK

ACCESS DOOR TO THE EMERGENCY BOMB RELEASE DOG

VOLTAGE REGULATOR BOX

FORWARD EMERGENCY EXIT DOOR

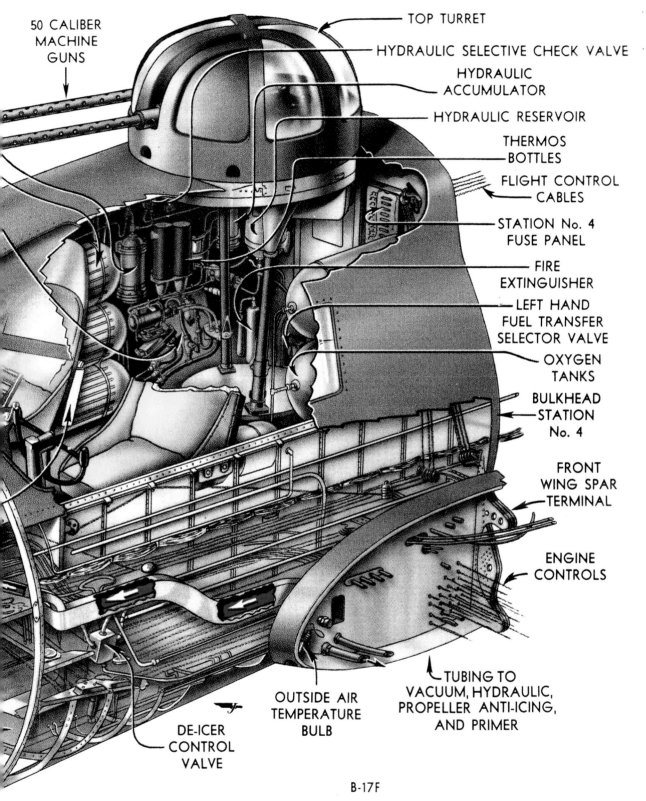

50 CALIBER MACHINE GUNS

TOP TURRET

HYDRAULIC SELECTIVE CHECK VALVE

HYDRAULIC ACCUMULATOR

HYDRAULIC RESERVOIR

THERMOS BOTTLES

FLIGHT CONTROL CABLES

STATION No. 4 FUSE PANEL

FIRE EXTINGUISHER

LEFT HAND FUEL TRANSFER SELECTOR VALVE

OXYGEN TANKS

BULKHEAD STATION No. 4

FRONT WING SPAR TERMINAL

ENGINE CONTROLS

TUBING TO VACUUM, HYDRAULIC, PROPELLER ANTI-ICING, AND PRIMER

OUTSIDE AIR TEMPERATURE BULB

DE-ICER CONTROL VALVE

ULKHEAD No. 3

B-17F

PILOT'S COMPARTMENT

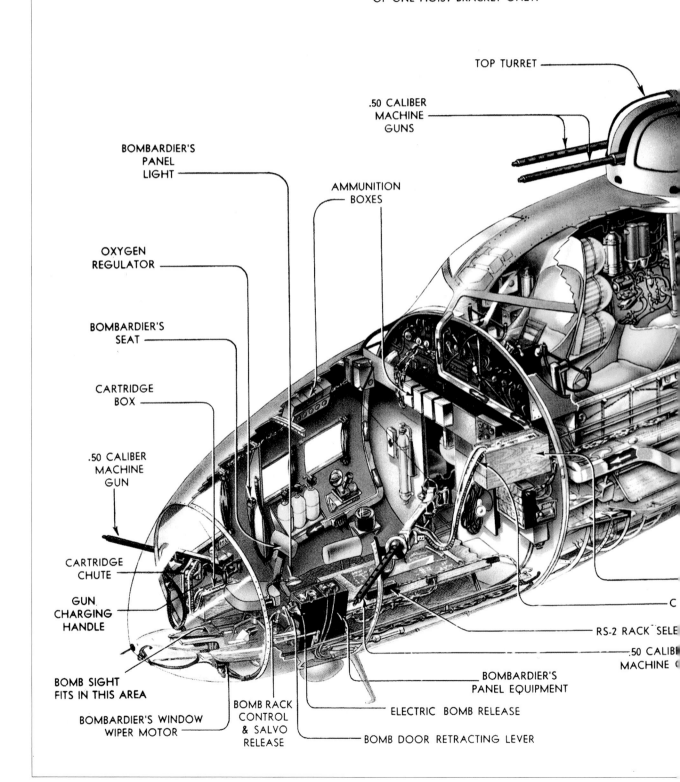

BOMB HOIST BRACKET
FITS ON EITHER BOMB RACK AS SHOWN HERE.
B-17F IS EQUIPPED WITH ONE HOIST BRACKET
BECAUSE THERE IS ROOM FOR THE OPERATION
OF ONE HOIST BRACKET ONLY.

TOP TURRET

.50 CALIBER
MACHINE
GUNS

BOMBARDIER'S
PANEL
LIGHT

AMMUNITION
BOXES

OXYGEN
REGULATOR

BOMBARDIER'S
SEAT

CARTRIDGE
BOX

.50 CALIBER
MACHINE
GUN

CARTRIDGE
CHUTE

GUN
CHARGING
HANDLE

C

RS-2 RACK SELE

.50 CALIB
MACHINE G

BOMB SIGHT
FITS IN THIS AREA

BOMBARDIER'S
PANEL EQUIPMENT

ELECTRIC BOMB RELEASE

BOMBARDIER'S WINDOW
WIPER MOTOR

BOMB RACK
CONTROL
& SALVO
RELEASE

BOMB DOOR RETRACTING LEVER

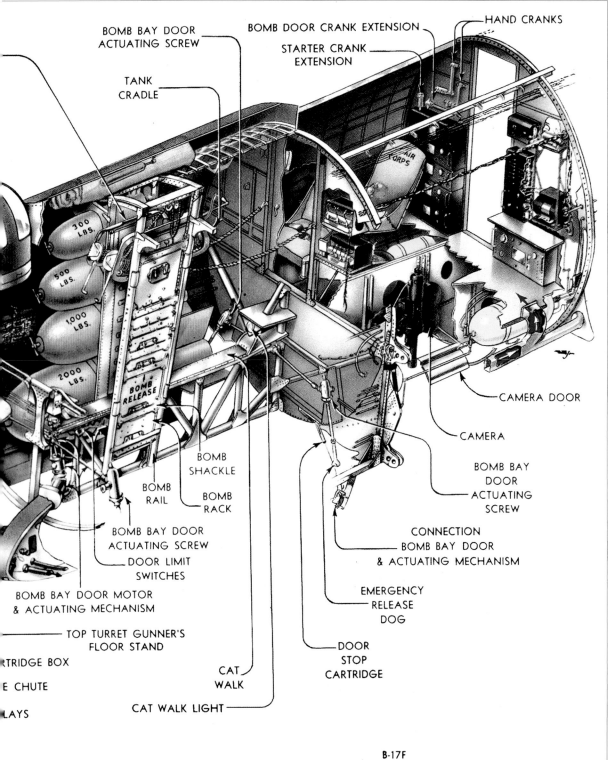

BOMB BAY DOOR
ACTUATING SCREW

BOMB DOOR CRANK EXTENSION

HAND CRANKS

STARTER CRANK
EXTENSION

TANK
CRADLE

300 LBS.

500 LBS.

1000 LBS.

2000 LBS.

BOMB RELEASE

CAMERA DOOR

CAMERA

BOMB BAY
DOOR
ACTUATING
SCREW

BOMB
SHACKLE

BOMB
RAIL

BOMB
RACK

BOMB BAY DOOR
ACTUATING SCREW

DOOR LIMIT
SWITCHES

CONNECTION
BOMB BAY DOOR
& ACTUATING MECHANISM

EMERGENCY
RELEASE
DOG

BOMB BAY DOOR MOTOR
& ACTUATING MECHANISM

TOP TURRET GUNNER'S
FLOOR STAND

RTRIDGE BOX

E CHUTE

LAYS

CAT
WALK

DOOR
STOP
CARTRIDGE

CAT WALK LIGHT

B-17F

ARMAMENT

FORWARD COMPARTMENTS

12

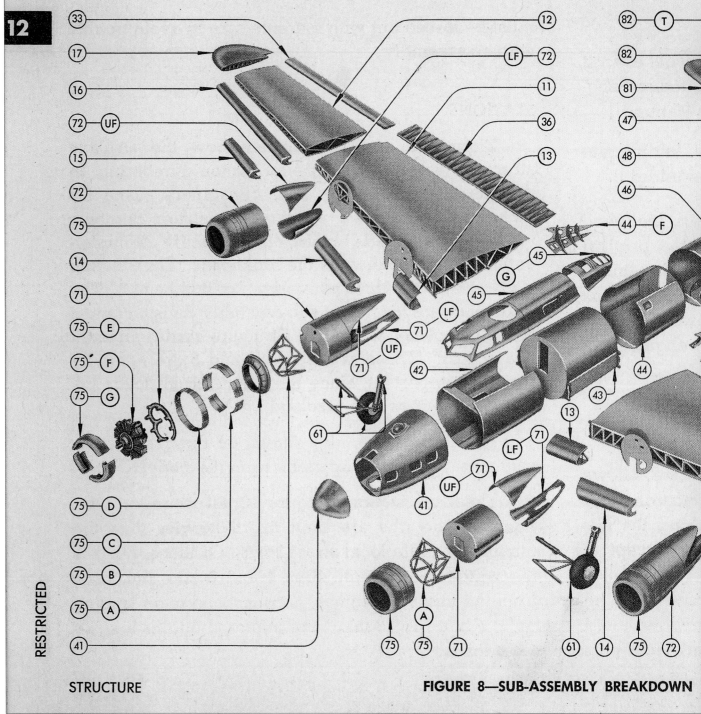

STRUCTURE

FIGURE 8—SUB-ASSEMBLY BREAKDOWN

B-17 Sub-Assembly Breakdown (above)

During the World War II the B-17 underwent thousands of modifications, but the basic design never changed. The wing, for example, was exactly the same on every model. The biggest change to occur was the lengthening of the fuselage to accommodate the tail gunner's station. This led to the design of the distinctive and large dorsal fin, which not only strengthened the rear of the aircraft but also increased it stability.

Comparison B-17, B-29, and B-24 (below)

America's three principal strategic bombers. Compared to the B-17 and B-24, the B-29 was twice as heavy and had close to double the takeoff horsepower. Its range and bomb-carrying ability made it a "true" strategic bomber.

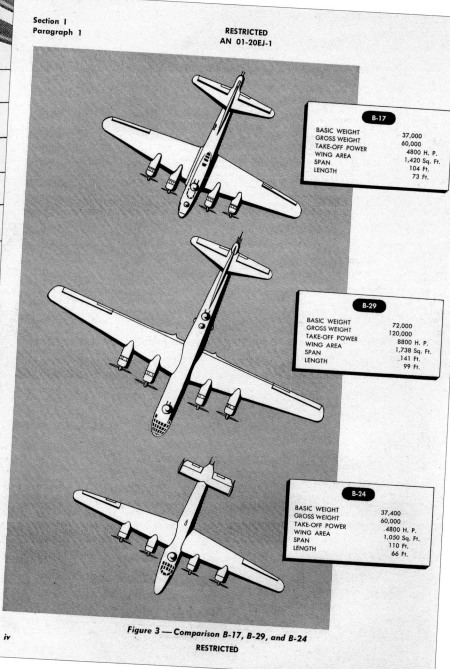

Section 1
Paragraph 1

RESTRICTED
AN 01-20EJ-1

B-17	
BASIC WEIGHT	37,000
GROSS WEIGHT	60,000
TAKE-OFF POWER	4800 H. P.
WING AREA	1,420 Sq. Ft.
SPAN	104 Ft.
LENGTH	73 Ft.

B-29	
BASIC WEIGHT	72,000
GROSS WEIGHT	120,000
TAKE-OFF POWER	8800 H. P.
WING AREA	1,738 Sq. Ft.
SPAN	141 Ft.
LENGTH	99 Ft.

B-24	
BASIC WEIGHT	37,400
GROSS WEIGHT	60,000
TAKE-OFF POWER	4800 H. P.
WING AREA	1,050 Sq. Ft.
SPAN	110 Ft.
LENGTH	66 Ft.

iv

Figure 3 — Comparison B-17, B-29, and B-24
RESTRICTED

INDEX

1 Bomb Sight
2 Bomb Release Quadrant
3 Nose Gun — .50 Cal.
4 Bombardier-Navigator's Seat
5 Heater & Defroster
6 Flying Suit Heater Plug
7 Compass, Magnetic
8 Drawing Board
9 Alarm Bell
10 Pitot Tube
11 Navigator's Dome
12 Navigator's Radio Compass Ind.
13 Map Case
14 Confidential Locker
15 Navigator's Table
16 Parachute Stowage
17 Ammunition Stowage
18 Automatic Flight Control
19 Nose Wheel Doors

20 Nose Wheel
21 Pilot's Rudder and Brake Controls
22 Pilot's Pedestal
23 Pilot's Seat
24 Pilot's Control Column
25 Instrument Panel
26 Co-Pilot's Sun Visor
27 Feathering Controls
28 Hydraulic Accumulator
29 Batteries
30 Anti-icer Fluid Tank

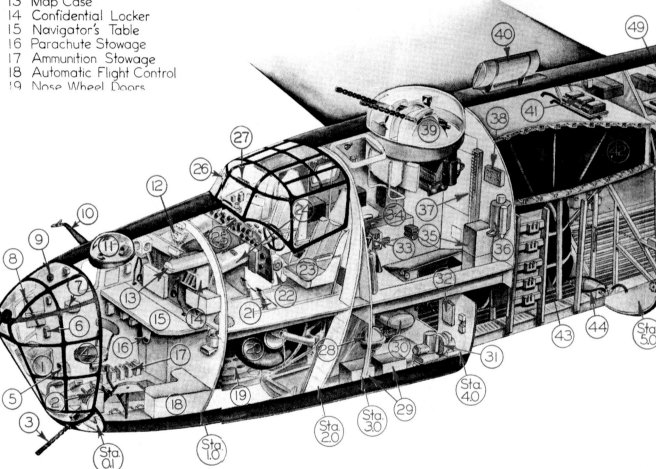

Figure 61. Cu

Cutaway Fuselage of the B-24D

The B-24D model was the first Liberator variant to make it into mass production. This cutaway drawing shows the early version with a single machine gun in the ventral gun position. Later versions were equipped with a retractable ball turret. There were 2,722 D models built.

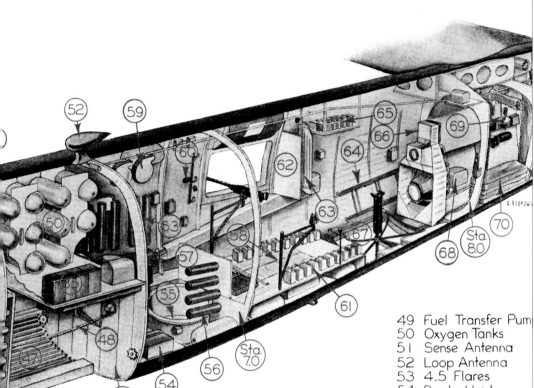

V BOBROW

Fuselage

31 Auxiliary Power Unit
32 Tool Kit
33 Heater, Radio Operator's
34 Radio Operator's Seat
35 Transmitter Tuning Units, Stowage
36 Thermos Jug
37 Fuel Sight Gage
38 Generator Switch Panel
39 Martin Power Driven Turret
 Two .50 Cal. Guns
40 Life Raft
41 Radio Receivers, Command
42 Wing Self Sealing Fuel Cells
43 Bomb Bay Auxiliary Self Sealing
 Fuel Cells
44 Fuel Pump
45 Bomb Release Unit
46 Bomb Racks
47 Bomb Bay Doors
48 Safety Cord

49 Fuel Transfer Pum[
50 Oxygen Tanks
51 Sense Antenna
52 Loop Antenna
53 4.5 Flares
54 Bomb Hoist
55 Lower Turret Well
56 N.8 Flares
57 Armor Plate
58 Side Gun Mount
59 Tail Turret Ammuni[
60 Wind Deflector C[
61 Ammunition Stowa[
62 Armor Plate
63 Flare Chute
64 Engine Work Platf[
65 Drift Flares
66 Camera Mount
67 Entrance, Camera [
 Gun Mount
68 Automatic Flight [
69 Turret Actuating [
 System
70 Engine Covers
71 Consolidated Hyd[
 Turret Two .50

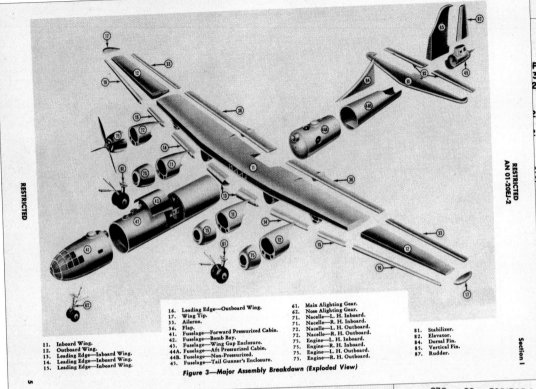

Figure 3—Major Assembly Breakdown (Exploded View)

11. Inboard Wing.
12. Outboard Wing.
13. Leading Edge—Inboard Wing.
14. Leading Edge—Inboard Wing.
15. Leading Edge—Inboard Wing.
16. Leading Edge—Outboard Wing.
17. Wing Tip.
33. Aileron.
36. Flap.
41. Fuselage—Forward Pressurized Cabin.
42. Fuselage—Bomb Bay.
43. Fuselage—Wing Gap Enclosure.
44A. Fuselage—Aft Pressurized Cabin.
44B. Fuselage—Non-Pressurized.
45. Fuselage—Tail Gunner's Enclosure.
61. Main Alighting Gear.
62. Nose Alighting Gear.
71. Nacelle—L. H. Inboard.
71. Nacelle—R. H. Inboard.
72. Nacelle—L. H. Outboard.
72. Nacelle—R. H. Outboard.
75. Engine—L. H. Inboard.
75. Engine—R. H. Inboard.
75. Engine—L. H. Outboard.
75. Engine—R. H. Outboard.
81. Stabilizer.
82. Elevator.
84. Dorsal Fin.
85. Vertical Fin.
87. Rudder.

RESTRICTED
RESTRICTED AN 01-20EJ-2
Section I

B-29 Major Assembly Breakdown (above)

Immediately after the attack on Pearl Harbor a massive B-29 manufacturing program was organized. Huge plants were built across the United States. Major components were manufactured in over sixty new factories. The engine nacelles, which were as big as the P-47 Thunderbolt fighter, were built at a new plant in Cleveland, and final assembly was organized at three of the world's largest buildings — Bell at Marietta, Martin at Omaha, and Boeing at Wichita. A fourth line was later set up by Boeing at Renton.

Ford B-24 Breakdown (right)

Ford B-24 Assembly Breakdown Diagram. During the war the Ford Plant at Willow Run, near Detroit, produced an astonishing 200 B-24s a month, plus 150 sets of parts for other assembly lines.

BOMBARDIER'S ENCLOSURE
PITOT TUBES
FUS. NOSE SECT. UPPER FRT. O.1 TO 2.0
PILOT'S ENCLOSURE
FUS. NOSE SIDE PANEL R.H. O.1 TO 4.15
FUS. NOSE SIDE PANEL L.H. O.1 TO 4.15
PILOT'S FLOOR
RADIO OPERATOR'S FLOOR
FUS. NOSE BOTTOM PANEL
HAND RAIL. ITEM 10 IS A GROUP OF SMALL PARTS INSTALLED INTO ITEM 5.
TRUSS BLKHD. STA. 4.1
FUS. NOSE SEC. UPPER REAR DECK. 2.0-4.0
BOMB RACK
-32 L/R SEGMENTS BLKHD. STA. 4.0 SEGM'TS.
(-139 L/R)(-140 L/R) BOMB BAY DRS.
LOWER LONGERON 4.0 TO 6.0
BLKHD. 5.0 L.H. PORTION.
BLKHD. 5.0 R.H. PORTION.
SIDE PANEL L.H. 4.15 TO 5.25
SIDE PANEL R.H. 4.15 TO 5.25
TRUSS REAR BOMB RACK.
FUS. TOP DECK ABV. WING. 4.2 TO 5.1
SEGMENT BLKHD. 6.0
NOT REQUIRED
DOOR BLKHD. 6.0
FLOOR 5.1 TO 6.0
FUS. SIDE PANEL BELOW WING 5.25 TO 6.0 L.H.
FUS. SIDE PANEL BELOW WING 5.25 TO 6.0 R.H.

938	28	32B1785-2	
933	29	32F9712	HYDRAULIC RESERVOIR TANK
939	30	32B1788	FUS. UPPER R.H. SECT. 5.0 TO 7.7
939	31	32B1787	FUS. UPPER L.H. SECT. 5.0 TO 7.7
939	32	32B1786	FUS. BOTTOM SECT. 6.0 TO 7.7
939	33	32B1794-0	FUS. TAIL SECT. AFT. STA. 7.7
947	34	32F5800-3	TAIL TURRET
947	35	32GF8227	G. L. MARTIN ELEC. PWR. DRIVEN TUR SK 6276
947	36	32GF8673	SPERRY TURRET
945	37	32T9352	STABILIZER
945	38	32T10503-2L/R	ELEVATOR ASSEMBLY
945	39	32T8050-0	FINS
945	40	32T10115-3L/R	RUDDERS
936	41	32W9375	WING CENTER SECT. VERT.
937	41	32W1701-P	WING CENTER SECT. HORIZ. (INCL. M
937	41A	32G1039-4	FUEL CELLS L/R.
943	42	32W520-2L/R	WING CENTER SECT. TRAILING EDGE
943	42	32W9350 L/R	SHORT SECTION
943	43	32W500-2L/R	FLAP.
943	44	32W9337L/R	CENTER WING SECT. LEADING EDGE.
943	45	32W9338L/R	WING CENTER SECT. LEADING EDGE. BETWEEN NAC.
943	46	32W2067-2L/R	INBD. NACELLE TO WING L.E. FAIRIN
943	47	32W2068-2L/R	INBD. NACELLE TO WING L.E. FAIRIN
943	48	32W2069 L/R	NACELLE L.E. ATTACHING STUB INB
935	49	32W2070L/R	NACELLE L.E. CONNECTION STUB &
943	50	32W302-0L-0R	WING CENTER SEC. LEADING EDGE
932	51	32B045-2	TRUSS FUS. TO WING 4.1 TO 4.2 ITE
	52		GROUP OF LOOSE PARTS INST. AT NOT REQUIRED
947	53	32W521-3L/R	FLAP TRACK SUPPORTS
			GROUP OF LOOSE PARTS INST. AT
935	54	32W12003-135L/R	WING OUTER PANEL
935	55	32W026 L/R	WING OUTER PANEL TRAILING EDGE
945	56	32W10573-2L/R	AILERON
935	57	32W9392 L/R	WING OUTER PANEL LEADING EDGE
935	58	32W1024-0L/R	WING TIP
	59		COMBINED WITH ITEM 32
947	60	32L003	NOSE LANDING GEAR

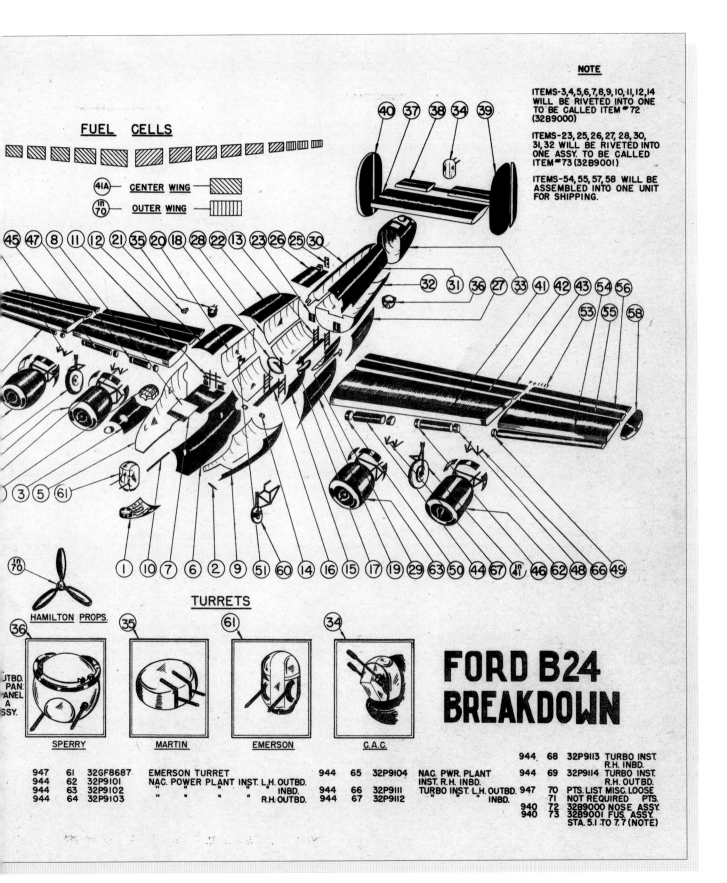

ARMAMENT & FIELDS

German Air Craft

Armament &
Fields of Fire

This book was produced by the Material Center Experimental Engineering Section of the U.S. Army Air Force. It contained drawings of the various German aircraft in service with three angle views showing the areas of defensive fire.

OF FIRE

Prepared by
MATERIEL CENTER
EXPERIMENTAL ENGINEERING
SECTION
WRIGHT FIELD — DAYTON, OHIO.

★

U.S. ARMY AIR FORCES

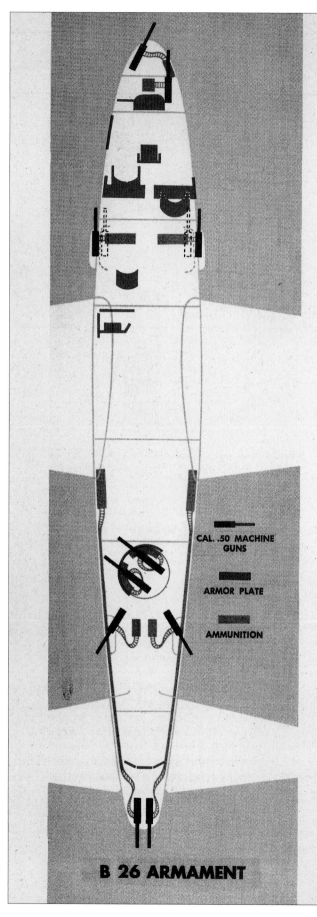

CAL. .50 MACHINE GUNS

ARMOR PLATE

AMMUNITION

B 26 ARMAMENT

GUNNERY

Gunnery missions are acid tests of your ability as an airplane commander. No other single type of mission places such a high demand on your ability to coordinate and control your crew, nor so closely approximates the problems you meet on every combat mission. **Your objective on gunnery missions is maximum training with maximum safety.**

Preparation

You, as airplane commander, are responsible for seeing your entire crew is briefed and that the members understand each gunnery mission. All members of your crew must be present and must give their undivided attention to the brief as it is delivered.

Gunnery mission briefs cover all normal items, such as target regulations, route to be flown, weather, etc., and particular emphasis is placed on fire control instructions.

Supervision

Your ship's gunnery officer is usually your bombardier-navigator. He is assisted by your armorer-gunner. In addition, on all gunnery practice missions, you carry a gunnery instructor who also assists your bombardier-navigator. This team is responsible to you for the safe and efficient conduct of all details of a gunnery mission. They supervise the installation, adjustment and loading of all guns. They act as trouble-shooters and advisers during flight. They supervise the proper clearing and stowing of all guns after firing is completed before leaving the target area. They supervise the dismounting, return, repair, and cleaning of all guns. They see that all brass and unexpended ammunition is returned to the armament section,

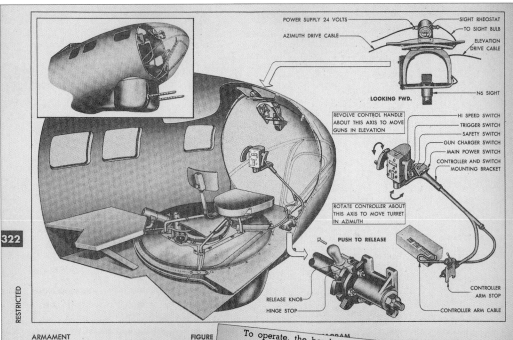

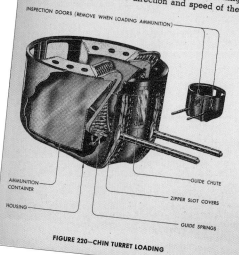

POWER SUPPLY 24 VOLTS — SIGHT RHEOSTAT
AZIMUTH DRIVE CABLE — TO SIGHT BULB
ELEVATION DRIVE CABLE

N6 SIGHT

LOOKING FWD.

REVOLVE CONTROL HANDLE ABOUT THIS AXIS TO MOVE GUNS IN ELEVATION

HI SPEED SWITCH
TRIGGER SWITCH
SAFETY SWITCH
GUN CHARGER SWITCH
MAIN POWER SWITCH
CONTROLLER AND SWITCH MOUNTING BRACKET

ROTATE CONTROLLER ABOUT THIS AXIS TO MOVE TURRET IN AZIMUTH

PUSH TO RELEASE

CONTROLLER ARM STOP

RELEASE KNOB
HINGE STOP
CONTROLLER ARM CABLE

322

RESTRICTED

ARMAMENT FIGURE

To operate, the bombardier opens a latch and swings the controller from its stowed position against the right-hand side of the fuselage. The main power switch is on the front of the controller. A reflecting type sight is suspended at eye level from the ceiling of the compartment. The direction and speed of the

INSPECTION DOORS (REMOVE WHEN LOADING AMMUNITION)

AMMUNITION CONTAINER
HOUSING
GUIDE CHUTE
ZIPPER SLOT COVERS
GUIDE SPRINGS

FIGURE 220—CHIN TURRET LOADING

guns are controlled by handle-bar type levers. Each lever is equipped with a safety brake switch to stop the turrets should the gunner relax his grip; a spring trigger switch for firing the guns, and a high speed switch for fast tracking speeds.

The speed of the guns in azimuth and elevation can be varied from ¼° per second to 12° per second in high speed. The guns may be hand cranked in emergency. The guns are ordinarily hand charged.

The type N-6 open sight is synchronized with the guns through flexible drive shafts. The type N-6 open sight has a rheostat to control the intensity of the light of the two concentric circles which project on the sight glass. The center of the field of view is the center of these circles and is the point at which the guns are aimed.

Operation—

1. Unlock control latch.
2. Swing controller into combat position and lock.
3. Move power switch to "on" position.
4. Adjust intensity of sight reticle.

319

RESTRICTED

ARMAMENT

B-26 Gunnery

(opposite)

The B-26 was the most heavily armed medium bomber of the war. In this diagram there are twelve .50-caliber machine guns, the same number as on the B-17G heavy bomber.

B-17 Chin Turret Controls (top)

The Bendix chin turret was the only remote-controlled turret mounted on the B-17. It was the bombardier's job to man the guns while sitting in what was the most exposed part of the aircraft. Attacking enemy pilots had the luxury of being protected by an engine and a bullet-resistant windscreen directly in front of them. For the bombardier manning the front guns, the only hope he had was that his shots were more accurate than those of his enemies.

The Bendix turret was one of the best examples of American engineering and design. Bendix was asked to produce a turret that could fit onto the front of the B-17 without impeding the work of the bombardier. In just a few short months Bendix had prototyped a powered twin-gun turret.

B-17 Chin Turret Loading

"The B-17 is apparently particularly vulnerable to nose attacks which are level or high, perhaps reflecting the inability of the chin turret to fire higher than 26 degrees above the horizon, and inability of the upper turret to depress below 5 degrees."

AN EVALUATION OF DEFENSIVE MEASURES TAKEN TO PROTECT BOMBERS FROM LOSS AND DAMAGE, NOVEMBER 1944

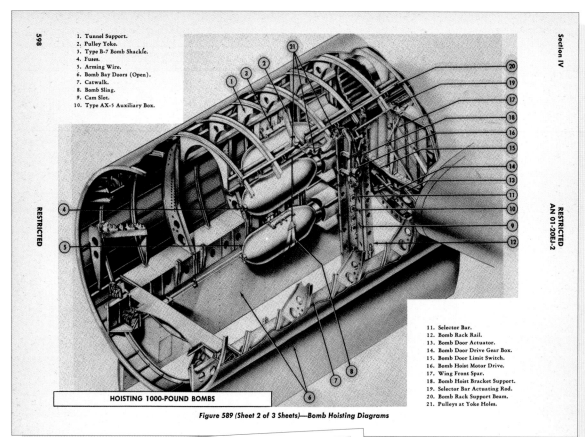

598

RESTRICTED

Section IV

RESTRICTED
AN 01-20EJ-2

1. Tunnel Support.
2. Pulley Yoke.
3. Type B-7 Bomb Shackle.
4. Fuses.
5. Arming Wire.
6. Bomb Bay Doors (Open).
7. Catwalk.
8. Bomb Sling.
9. Cam Slot.
10. Type AX-5 Auxiliary Box.

11. Selector Bar.
12. Bomb Rack Rail.
13. Bomb Door Actuator.
14. Bomb Door Drive Gear Box.
15. Bomb Door Limit Switch.
16. Bomb Hoist Motor Drive.
17. Wing Front Spar.
18. Bomb Hoist Bracket Support.
19. Selector Bar Actuating Rod.
20. Bomb Rack Support Beam.
21. Pulleys at Yoke Holes.

HOISTING 1000-POUND BOMBS

Figure 589 (Sheet 2 of 3 Sheets)—Bomb Hoisting Diagrams

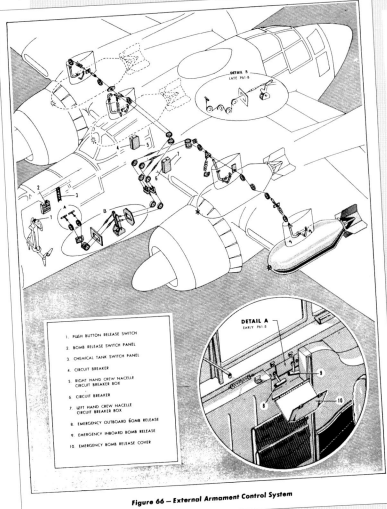

1. PUSH BUTTON RELEASE SWITCH
2. BOMB RELEASE SWITCH PANEL
3. CHEMICAL TANK SWITCH PANEL
4. CIRCUIT BREAKER
5. RIGHT HAND CREW NACELLE CIRCUIT BREAKER BOX
6. CIRCUIT BREAKER
7. LEFT HAND CREW NACELLE CIRCUIT BREAKER BOX
8. EMERGENCY OUTBOARD BOMB RELEASE
9. EMERGENCY INBOARD BOMB RELEASE
10. EMERGENCY BOMB RELEASE COVER

DETAIL B
LATE P61 B

DETAIL A
EARLY P61 B

Figure 66 — External Armament Control System

External Armament Control System (left)

The P-61B version of the Black Widow was equipped with four wing pylons stressed for drop tanks or bombs. By the time the P-61 entered service in Europe in mid-1944 the number of German aircraft roaming the night skies were few and far between. The new P-61 was soon used in the night intruder role, attacking enemy rolling stock and fixed positions. The Pacific theater, however, provided more action for the P-61. There it racked up an impressive score of Japanese bombers and fighters.

Hoisting 1000-Pound Bombs
(opposite)

The B-29 was equipped with two enormous bomb bays. The long, tall bays had their own bomb-hoisting winches to facilitate loading. Internally the B-29 could carry up to 20,000 pounds (9075 kg).

A Message for You — from the B-29 Gunner's Information File Manual (below)

This illustration shows a B-29 in formation with a Lockheed P-38 Lightning. These two aircraft never operated together. Although a long-range fighter, the P-38 was never used as an escort fighter for the B-29. That role was filled by the single-engine P-51 Mustang.

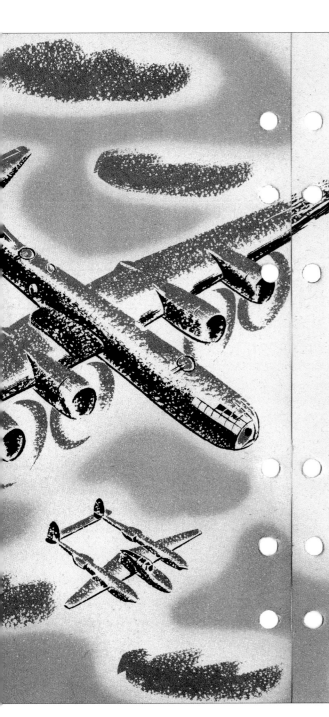

A MESSAGE FOR YOU

This Information File is *your* book and is designed to aid you in becoming better acquainted with the CENTRAL-STATION FIRE-CONTROL SYSTEM on the B-29 Bomber. It will aid in qualifying you to assist the C. F. C. specialists perform their ground maintenance and check duties on the System and its armament. Furthermore, it will enable you to determine whether the required armament, maintenance and ordnance inspections have been met by the personnel assigned to do that work.

You will find check lists and procedures in the text, which you may follow to assure yourself that everything in the CENTRAL-STATION FIRE-CONTROL SYSTEM is in perfect operating condition before you go into combat. In addition, there are lots of tips and suggestions which are important to your job as a gunner, so use them and here's luck.

Know Your Equipment and How to Use It

Remember, "The Pilot takes the plane up, but, the Gunner keeps it up."

RESTRICTED

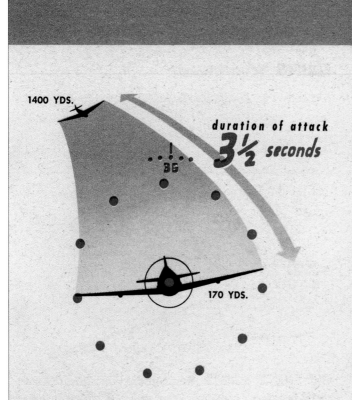

1400 YDS.

duration of attack
3½ *seconds*

170 YDS.

ON NOSE ATTACKS open fire at longer range because of the extremely high relative speed between your bomber and the fighter. Fire to kill at 1,400 yards. You will have to be plenty sharp on these attacks because in some cases the relative speed will be as high as 1,000 feet per second. This means that the duration of the attack will only be approximately 3½ seconds. *Brother, think that over!*

RESTRICTED GIF 5-23

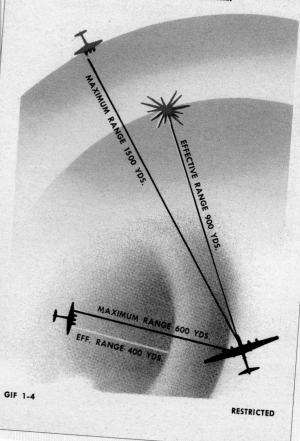

INCREASED RANGE

Fire range is increased to a point where your fire power is effective beyond the limits of most fighters. This means, you can get him before he gets you, which means you get the break.

MAXIMUM RANGE 1500 YDS.

EFFECTIVE RANGE 900 YDS.

MAXIMUM RANGE 600 YDS.

EFF. RANGE 400 YDS.

GIF 1-4

RESTRICTED

On Nose Attacks

German and Japanese head-on attacks on Allied bombers were among the most effective but difficult methods to shoot down a four-engine bomber. The closing speeds were so high the attacking fighter only had two to three seconds of firing time at close range. The defending gunner could open fire at a much higher range, but he too only had a few seconds in which to score any hits.

Increased Range

The B-29's armament consisted of twelve .50-caliber (12.7 mm) machine guns in four remote-controlled turrets and one manned tail turret. It was the gunner's responsibility to utilize his guns to maximum effect. Causing a fighter to break off his attack early or before he had a chance to open fire was just good as shooting him down. Knowing when to fire was a critical factor.

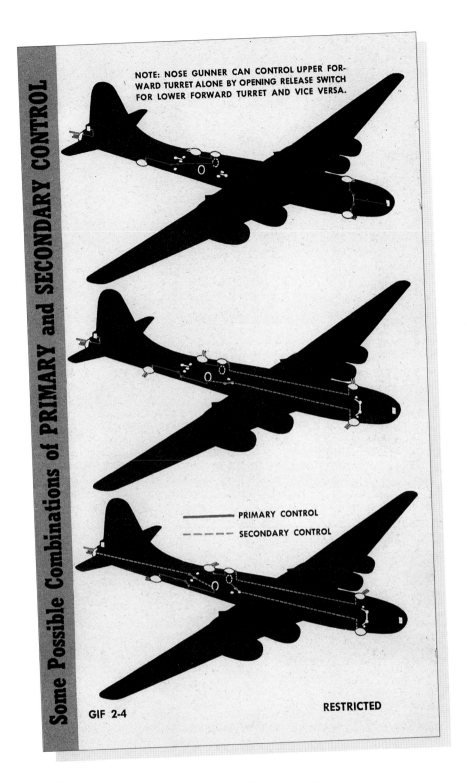

NOTE: NOSE GUNNER CAN CONTROL UPPER FOR-WARD TURRET ALONE BY OPENING RELEASE SWITCH FOR LOWER FORWARD TURRET AND VICE VERSA.

————————— PRIMARY CONTROL

— — — — — SECONDARY CONTROL

GIF 2-4

RESTRICTED

Primary and Secondary Control B-29

The B-29 was equipped with a revolutionary fire control system. Using an analog computer, the system was set up so that the central (upper) gunner controlled both upper turrets, the left and right gunners operated the lower rear turret, the bombardier manned the lower forward turret, and the tail gunner (in his own pressurized compartment) controlled the rear turret. The genius of the system was that it allowed the gunners to override the system and assume control of the other turrets when required.

SINGLE ENGINE JAP

WHEN SEEN HEAD-ON, JAPANESE SINGLE-ENGINE AIRCRAFT GENERALLY APPEAR TO HAVE ROUND NOSES.
WING IS ALMOST ALWAYS SET LOW, WITH EVEN DIHEDRAL FROM THE ROOTS (*i.e.*, NO BREAK IN THE WING)

ZEKE

OSCAR

FRANK

JACK

TONY

GEORGE

JILL

MYRT

TOJO

JUDY 33

JUDY 11

GRACE

TWIN ENGINE JAP

SINGLE FIN AND RUDDER SET ABOVE A LOW, FLAT TAILPLANE ARE CHARACTERISTIC OF ALL JAPANESE TWIN-
ENGINE AIRCRAFT SEEN IN HEAD-ON VIEW. THE WING POSITION USUALLY RANGES BETWEEN MID AND LOW

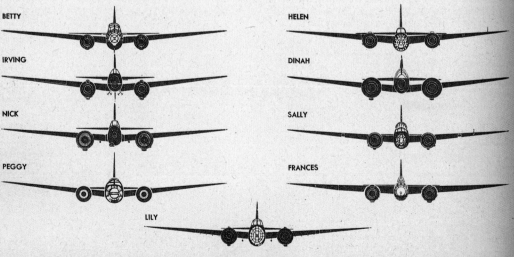

BETTY

IRVING

NICK

PEGGY

HELEN

DINAH

SALLY

FRANCES

LILY

IN CONTRA
THAN LOW

FM-2

SB2C

P-47

P-40

EITHER TWIN
BOMBERS

P-61

PV-1

B-25

A-26

JAP VS. U.S.

NATIONAL CHARACTERISTICS ARE NOT A NEW SYSTEM OF CHART POINTS
RECOGNITION TRAINING BUT ARE A SUPPLEMENTAL AID JAPANESE CO
TO UNDERSTANDING ENEMY AND OUR AIRCRAFT. THIS FOLLOWED IN

RESTRICTED

SINGLE ENGINE U.S.

EIR JAPANESE COUNTERPARTS, MOST U.S. SINGLE-ENGINE PLANES ARE MORE MID-WING

MINENT WING BREAK IS ALSO CHARACTERISTIC OF MOST U.S. CARRIER-BASED TYPES

F6F

TBM

F4U

P-51

SBD

TWIN ENGINE U.S.

D RUDDERS OR A DIHEDRAL TAILPLANE ARE CHARACTERISTIC OF ALL U.S. TWIN-ENGINE

TERS EXCEPT THE NEW F7F TIGERCAT. HIGH (SHOULDER) OR MID-WING PREDOMINATES

P-38

PV-2

A-20

F7F

NERAL DIFFERENCES IN U.S. AND CONTRASTS IN BEAM AND PLAN VIEWS. THE CHARTS ARE
CRAFT SEEN HEAD-ON. IT WILL BE A DETAILED FOLLOW-UP TO THE OUTLINE OF NATIONAL
SUES BY DIAGRAMS ILLUSTRATING DESIGN STYLES THAT APPEARED IN THE MARCH JOURNAL.

RESTRICTED

U.S. Army Navy Journal of Recognition

The *U.S. Army Navy Journal of Recognition* was the equivalent of the *British Aircraft Recognition Journal*. Published monthly, it not only covered aircraft, but ships and armored vehicles as well. This is an examination of the head-on views of the various fighters and bombers doing battle in the Pacific.

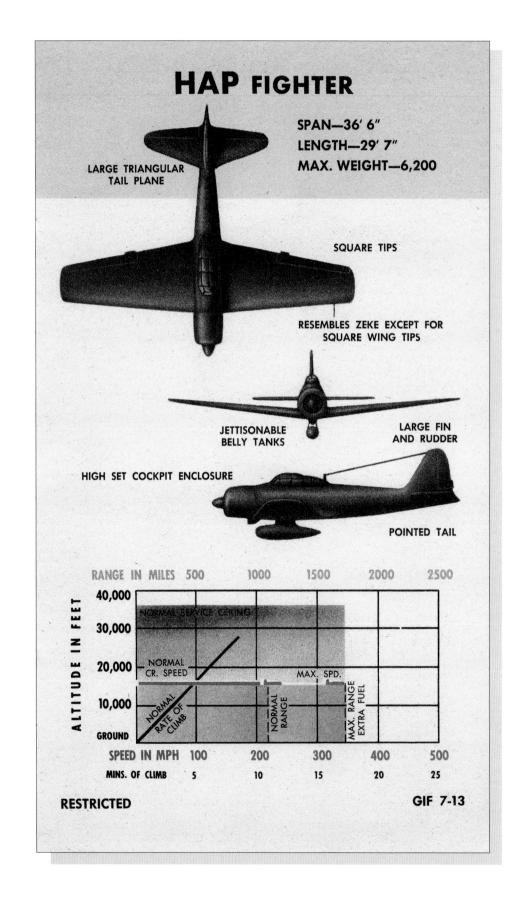

HAP FIGHTER

SPAN—36' 6"
LENGTH—29' 7"
MAX. WEIGHT—6,200

LARGE TRIANGULAR
TAIL PLANE

SQUARE TIPS

RESEMBLES ZEKE EXCEPT FOR
SQUARE WING TIPS

JETTISONABLE
BELLY TANKS

LARGE FIN
AND RUDDER

HIGH SET COCKPIT ENCLOSURE

POINTED TAIL

RANGE IN MILES 500 1000 1500 2000 2500

ALTITUDE IN FEET

40,000

NORMAL SERVICE CEILING

30,000

20,000

NORMAL
CR. SPEED

MAX. SPD.

NORMAL
RATE OF
CLIMB

NORMAL RANGE

MAX. RANGE
EXTRA FUEL

10,000

GROUND

SPEED IN MPH 100 200 300 400 500

MINS. OF CLIMB 5 10 15 20 25

RESTRICTED

GIF 7-13

Aircraft Profiles in the B-29 Gunner's Information File

The B-29 Gunner's Information File included a number of enemy aircraft identification profiles. Although the B-29 did not see service in Europe, this manual contains more German aircraft profiles (six) than Japanese (two).

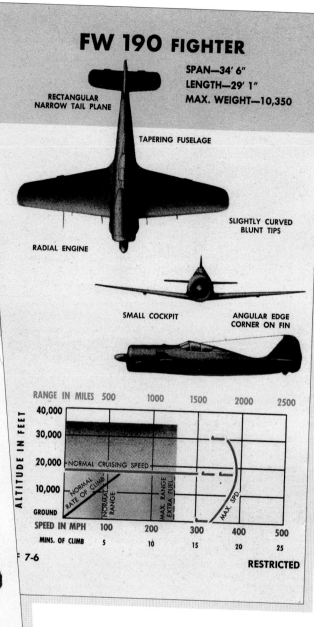

FW 190 FIGHTER

SPAN—34' 6"
LENGTH—29' 1"
MAX. WEIGHT—10,350

RECTANGULAR NARROW TAIL PLANE

TAPERING FUSELAGE

RADIAL ENGINE

SLIGHTLY CURVED BLUNT TIPS

SMALL COCKPIT

ANGULAR EDGE CORNER ON FIN

RANGE IN MILES 500 · 1000 · 1500 · 2000 · 2500

ALTITUDE IN FEET — 40,000 · 30,000 · 20,000 · 10,000 · GROUND

NORMAL CRUISING SPEED

NORMAL RATE OF CLIMB

NORMAL RANGE

MAX. RANGE EXTRA FUEL

MAX. SPD.

SPEED IN MPH 100 · 200 · 300 · 400 · 500
MINS. OF CLIMB 5 · 10 · 15 · 20 · 25

F 7-6

RESTRICTED

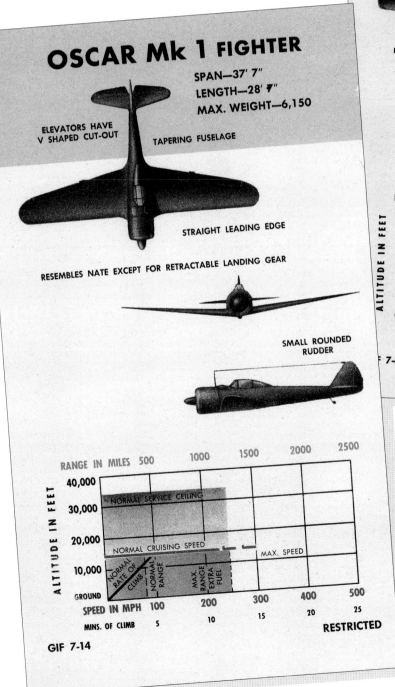

OSCAR Mk 1 FIGHTER

SPAN—37' 7"
LENGTH—28' 7"
MAX. WEIGHT—6,150

ELEVATORS HAVE V SHAPED CUT-OUT

TAPERING FUSELAGE

STRAIGHT LEADING EDGE

RESEMBLES NATE EXCEPT FOR RETRACTABLE LANDING GEAR

SMALL ROUNDED RUDDER

RANGE IN MILES 500 · 1000 · 1500 · 2000 · 2500

ALTITUDE IN FEET — 40,000 · 30,000 · 20,000 · 10,000 · GROUND

NORMAL SERVICE CEILING

NORMAL CRUISING SPEED

MAX. SPEED

NORMAL RATE OF CLIMB

NORMAL RANGE

MAX. RANGE EXTRA FUEL

SPEED IN MPH 100 · 200 · 300 · 400 · 500
MINS. OF CLIMB 5 · 10 · 15 · 20 · 25

RESTRICTED

GIF 7-14

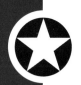

By the time *The B-29 Gunner's Information File* was issued, the German fighters described in the identification section were either a failure (Me 210), or used in another role for which they were not designed (night-fighter, Me 110), or considered second-best in performance as compared to the newer Allied fighters (Me 109G).

ME 109G FIGHTER

SPAN—32' 7"
LENGTH—29' 4"
MAX. WEIGHT—7,230

SMALL TAILPLANE

BULLET SHAPED FUSELAGE

ROUNDED TIPS SQUARE TIPS ON ME 109E

HIGH SET ELEVATOR

SUPERCHARGER AIR INLET

TWIN RADIATORS AND OIL COOLER UNDER WINGS

LOW COCKPIT

SMALL FIN & RUDDER

RANGE IN MILES 500 1000 1500 2000 2500

40,000
30,000
20,000 NORMAL CRUISING SPEED
10,000 NORMAL RANGE MAX. RANGE EXTRA FUEL MAX. SPEED
GROUND

SPEED IN MPH 100 200 300 400 500
MINS. OF CLIMB 5 10 15 20 25

RESTRICTED

Wing guns reduce: speed 25 mph, service ceiling 1000 ft., climb 8%

GIF 7-5

ME 210 FIGHTER, LIGHT BOMBER

SPAN—53' 9"
LENGTH—40' 3"
MAX. WEIGHT—24,750

SLIM TAPERING FUSELAGE

GUN BLISTER EACH SIDE

ROUNDED TIPS

NACELLES PROJECT BEYOND NOSE

TRIANGULAR TALL SINGLE FIN

"BULGED" GREENHOUSE FORWARD

RANGE IN MILES 500 1000 1500 2000 2500

ALTITUDE IN FEET
40,000
30,000 NORMAL SERVICE CEILING
20,000
NORMAL
10,000 CRUISING SPEED NORMAL RATE OF CLIMB NORMAL RANGE MAX. SPEED MAX. RANGE EXTRA FUEL
GROUND

SPEED IN MPH 100 200 300 400 500
MINS. OF CLIMB 5 10 15 20 25

GIF 7-8 *Normal performance as fighter (as of Sept. 43)* RESTRICTED

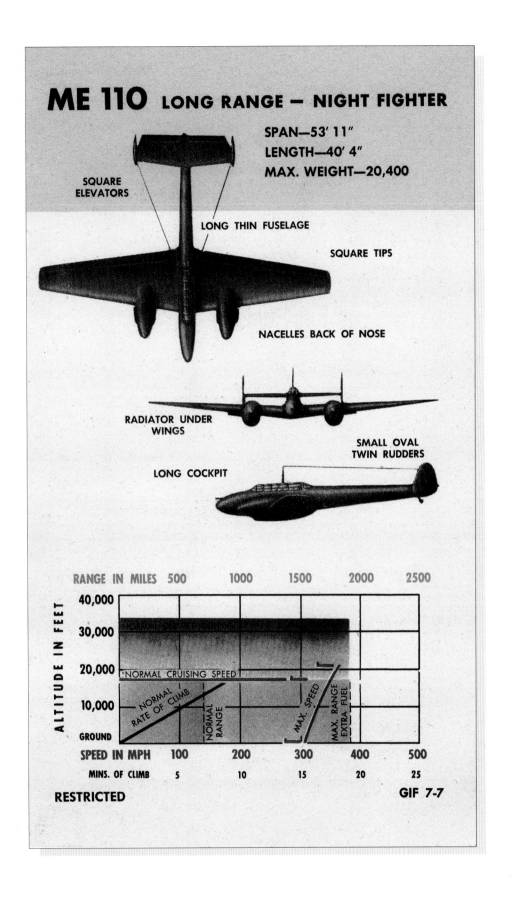

ME 110 LONG RANGE — NIGHT FIGHTER

SPAN—53' 11"
LENGTH—40' 4"
MAX. WEIGHT—20,400

SQUARE ELEVATORS

LONG THIN FUSELAGE

SQUARE TIPS

NACELLES BACK OF NOSE

RADIATOR UNDER WINGS

SMALL OVAL TWIN RUDDERS

LONG COCKPIT

RANGE IN MILES 500 1000 1500 2000 2500

ALTITUDE IN FEET
40,000
30,000
20,000 NORMAL CRUISING SPEED
10,000
GROUND

NORMAL RATE OF CLIMB
NORMAL RANGE
MAX. SPEED
MAX. RANGE EXTRA FUEL

SPEED IN MPH 100 200 300 400 500
MINS. OF CLIMB 5 10 15 20 25

RESTRICTED

GIF 7-7

WEFT Is a System for Aircraft Identification

WEFT — Wing – Engine – Fuselage – Tail was a system designed to help ground and naval personal quickly identify both Allied and enemy aircraft. This system may have worked well for the person on the ground, but for pilots in the air identifying enemy troops on the ground was a haphazard effort at best. During the Allied campaign in Tunisia it was not unusual for ground troops to be attacked by their own aircraft. It got to the point that Allied aircrew were regularly fired upon by their own troops and said that WEFT meant "Wrong every fucking time."

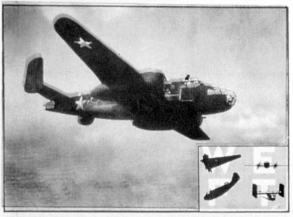

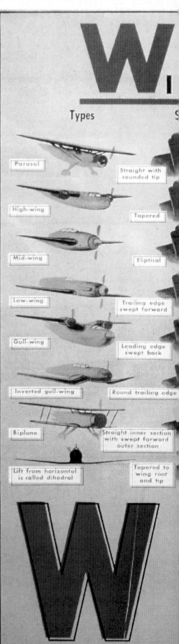

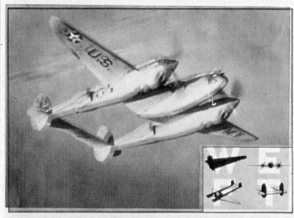

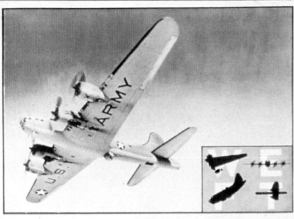
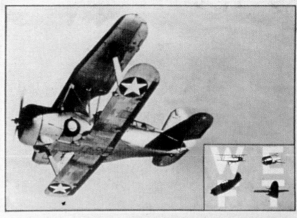

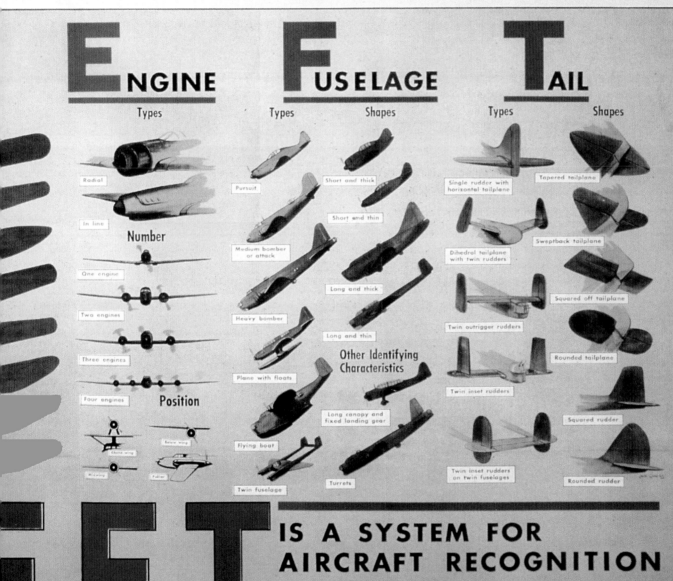

ENGINE

Types

Radial

In line

Number

One engine

Two engines

Three engines

Four engines

Position

Above wing

Mid wing

Below wing

Faired

FUSELAGE

Types

Pursuit

Medium bomber or attack

Heavy bomber

Plane with floats

Flying boat

Twin fuselage

Shapes

Short and thick

Short and thin

Long and thick

Long and thin

Other Identifying Characteristics

Long canopy and fixed landing gear

Turrets

TAIL

Types

Single rudder with horizontal tailplane

Dihedral tailplane with twin rudders

Twin outrigger rudders

Twin inset rudders

Twin inset rudders on twin fuselages

Shapes

Tapered tailplane

Sweptback tailplane

Squared off tailplane

Rounded tailplane

Squared rudder

Rounded rudder

EFT IS A SYSTEM FOR AIRCRAFT RECOGNITION

The great number of different aircraft designs complicates the problem of identification. It can be solved, however, by learning the particular features and shapes characteristic of certain planes and types. The above layout illustrates a number of these. No attempt is made to display every type of wing, engine, fuselage or tail section. These illustrations represent averages and have features found in aircraft of all nations.

The WEFT system emphasizes the parts an aircraft spotter can most readily see, recognize and describe quickly and accurately. From a combination of these features not only can the nationality of the plane often be determined even when insignia is difficult to see, but the type of operation, distance from base, and possible additional forces may also be anticipated. This information is vital to carry out the countering operations.

Zeke 52

The Technical Air Intelligence Unit was the primary evaluation formation concerned with flying captured Japanese aircraft. They also produced a wealth of visual information on dimensions, performance, and armament and armor protection. This information was made available to aircrew and ground personnel.

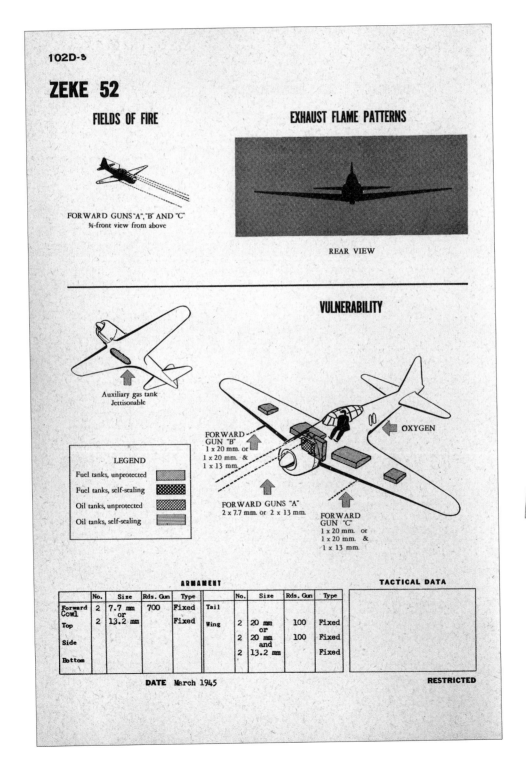

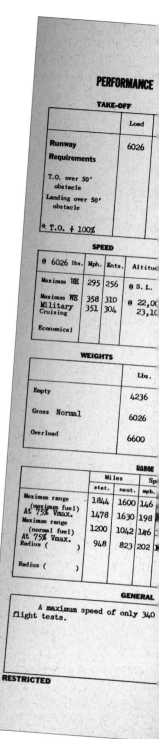

CHARACTERISTICS

ZEKE 52

CLIMB—CEILING

	lbs.	Feet	Min.
6026			
...te @ S.L.		3140	1
...te @ 8,000 ft.		3340	1
...me to 10,000'			3.6
...me to 20,000'			7.8
...rvice ceiling 35,100'			

AIRCRAFT

Duty Fighter

Designation Type 0 Model 52

Description Low-wing Monoplane

Mfg. Mitsubishi & Nakajima

Engines 1 Crew 1

Construction All Metal

BOMBS—CARGO

	No.	Size	Total Lbs
...al			
...num	2	60 kg	264
or	10	32 kg	704

ENGINES

	H. P.	Altitude
Take-off	1120	S.L.
Normal	830	1500'
Military	1080	9300'
	950	21600'
War Emerg.	1210	8000'

Mfg. Nakajima

Model Sakae 31 A

Type Radial

Cylinders 14 Cooling Air

Supercharger 2 Speed

Propeller 3-Blade Diam. 10'
 C.S.

Fuel - Take-off 92 Cruising 92

FUEL

	U.S. gal.	Imp. gal.
...in	156	129
...al (Removable)		
...al (drop)	87	72
	243	201

DIMENSIONS

Span 36.1' Length 29.8'
Height 9.2' Wing area 230 sq.ft.

Fuel gal.		Bombs	Cargo
U. S.	Imp.	lbs.	lbs.
243	201	None	None
243	201	None	None
156	129	None	None
156	129	None	None

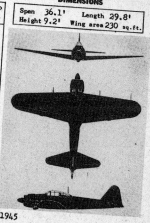

...been obtained in

DATE March 1945

ZEKE 32 (HAMP)

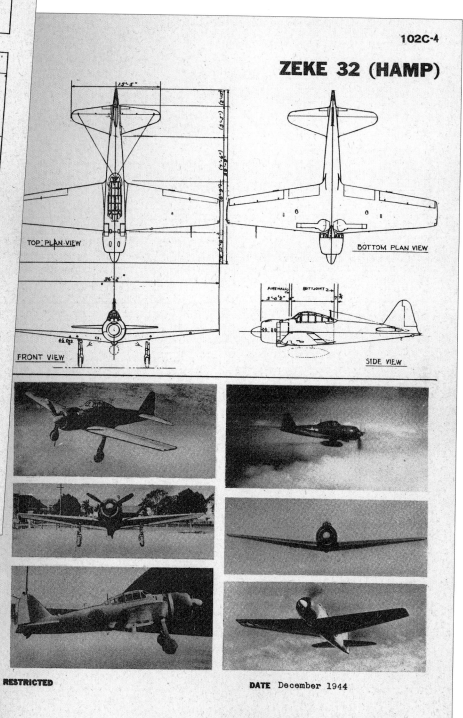

TOP PLAN VIEW

BOTTOM PLAN VIEW

FRONT VIEW

SIDE VIEW

DATE December 1944

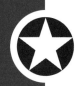

Radius of Action Is Navigator's Problem (below)

The navigator was a crucial member of any aircrew. His ability to guide the aircraft to the target and home again without wasting fuel often meant the difference between life and death. The art of determining the geographical position and maintaining the desired direction of an aircraft relative to the Earth's surface was a critical function.

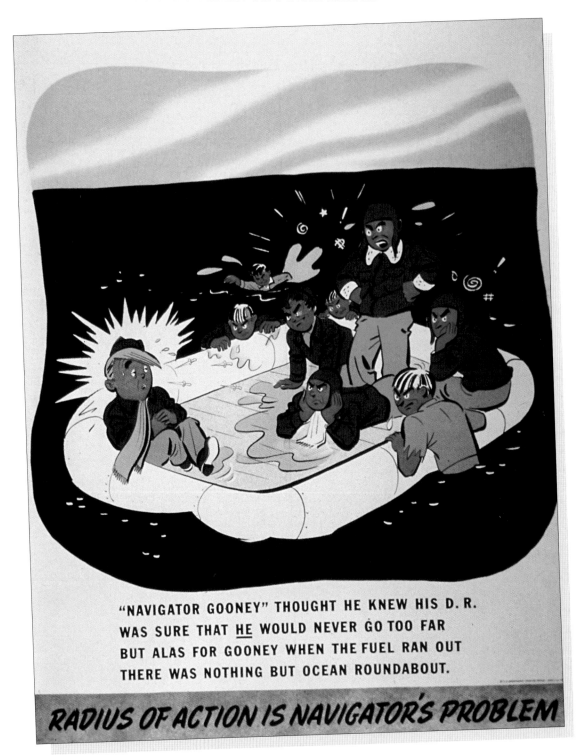

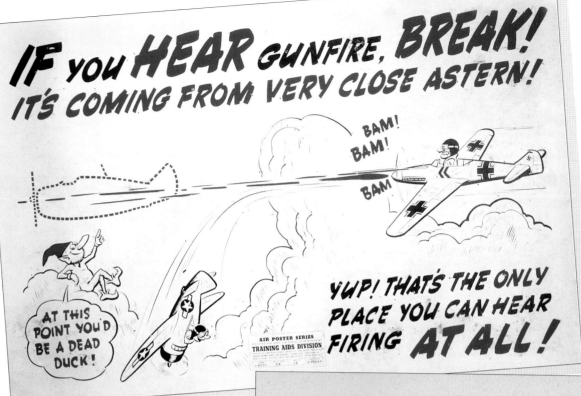

If You Hear Gunfire…
(above)

The U.S. Army Air Force Training Aid Division produced numerous posters highlighting the different dos and don'ts of fighter versus fighter combat. Most of the pilots who were shot down during the war never saw the aircraft responsible for their demise. This poster was designed to address that problem.

Section 2: Normal Operation (right)

Before every flight it was the pilot's responsibility to do a visual check of the aircraft.

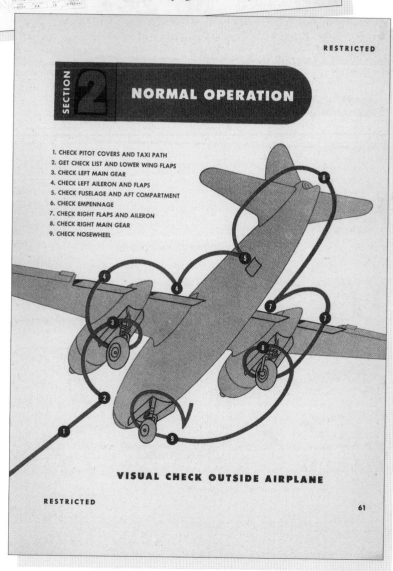

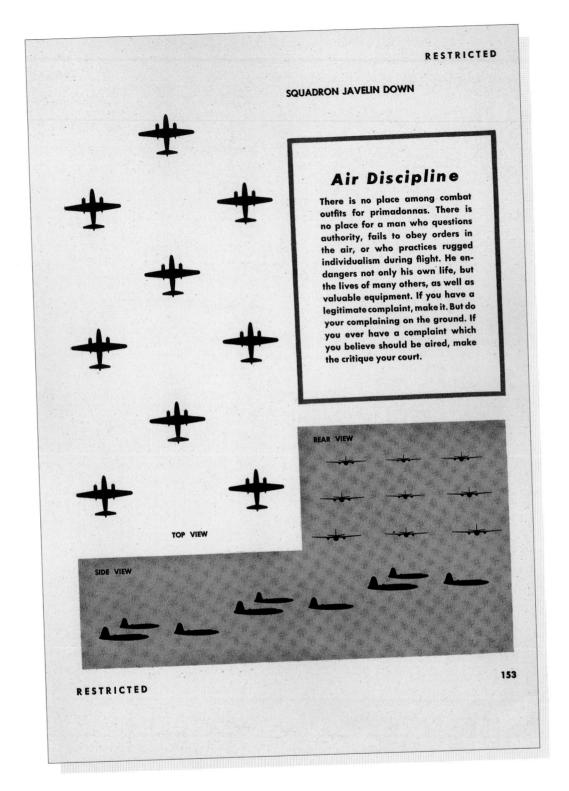

Air Discipline (above)

Flying in a prescribed pattern, or formation, increases offensive and defensive strength. Arrangement of a formation is usually based upon the strength, disposition and employment of the individual combat unit.

Formation Flying (opposite)

Introduction page for formation flying, taken from the *B-26 Flight Manual*.

FORMATION FLYING

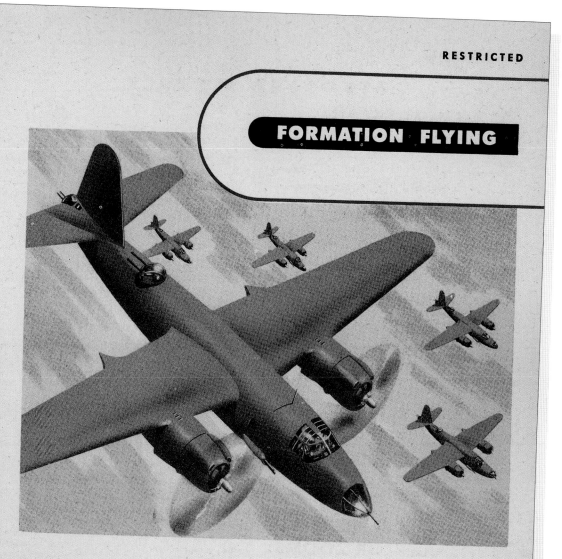

When you get to combat you will find that your best insurance for becoming a veteran of World War II is a good, well-planned, well-executed formation. Formation flying is just about everything in combat. Groups which are noted for their efficiency in formation flying are usually as well-known for their low casualty rate and their effective operations.

A properly flown formation affords you many advantages and much better protection. Controlled firepower, maneuverability and movement of a number of aircraft, concentrated bombing pattern, better fighter protection—

these are some of the desirable things which good formations provide.

Don't Straggle

Don't straggle—the one cardinal rule you must always follow when flying formation. A straggler in combat is asking for it. **Stay in position.** A straggler cuts down on the maneuverability, loses added protection and leaves a gap which endangers all of the other airplanes in the formation.

The Jap and the Hun will do all they can to make you straggle. Don't make their job easier.

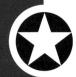

B-24
Speed — Endurance — Economy (right)

The B-24's exceptional range meant it played a major role in the longest battle of World War II. During the Battle of the Atlantic, the B-24 could spend up to three hours on patrol 1,100 miles (2,040 km) from base. As more aircraft became operational the B-24 was able to close the "Atlantic Gap." This was an area of the North Atlantic where German U-boats could operate free of patrolling aircraft. Liberators were also the first aircraft to make North Atlantic crossings a matter of routine.

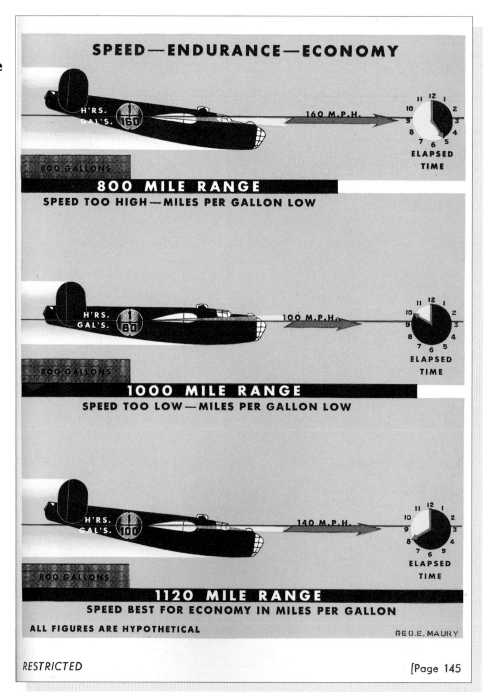

SPEED — ENDURANCE — ECONOMY

H'RS. GAL'S. 160 160 M.P.H. ELAPSED TIME

800 GALLONS
800 MILE RANGE
SPEED TOO HIGH — MILES PER GALLON LOW

H'RS. GAL'S. 80 100 M.P.H. ELAPSED TIME

800 GALLONS
1000 MILE RANGE
SPEED TOO LOW — MILES PER GALLON LOW

H'RS. GAL'S. 100 140 M.P.H. ELAPSED TIME

800 GALLONS
1120 MILE RANGE
SPEED BEST FOR ECONOMY IN MILES PER GALLON

ALL FIGURES ARE HYPOTHETICAL GEO.E.MAURY

RESTRICTED [Page 145

B-17 Emergency Exits (opposite, above)

Between 1942 and 1945, B-17s in Europe flew 291,508 sorties. Of that number, 4,688 were shot down in combat. With a crew of up to ten men that meant 46,880 aircrew were either killed or taken prisoner. During the war the Germans took a total of 90,000 U.S. airmen prisoner.

Abandoning the Airplane in Water —
P-61 Black Widow (opposite, below)

Although this illustration shows the crew where they should exit in case of ditching, it does not show where the dinghy is located!

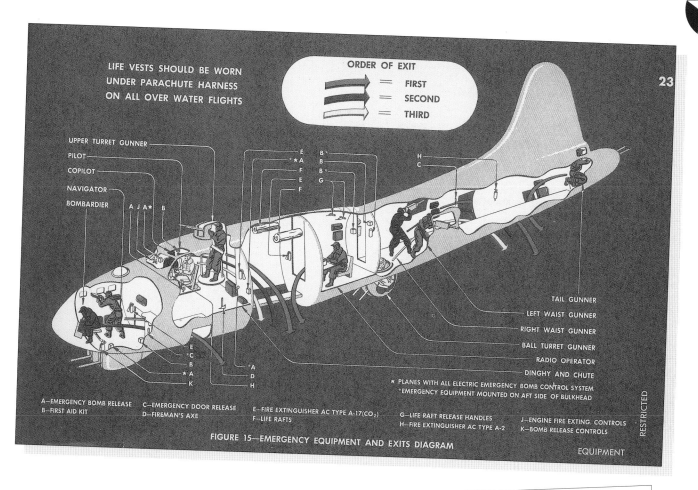

LIFE VESTS SHOULD BE WORN
UNDER PARACHUTE HARNESS
ON ALL OVER WATER FLIGHTS

ORDER OF EXIT

= FIRST
= SECOND
= THIRD

UPPER TURRET GUNNER
PILOT
COPILOT
NAVIGATOR
BOMBARDIER

A J A★ B

E
★A
F
E
F

B★
B
B★
G

H
C

TAIL GUNNER
LEFT WAIST GUNNER
RIGHT WAIST GUNNER
BALL TURRET GUNNER
RADIO OPERATOR
DINGHY AND CHUTE

E
★C
B
★ A
K

★A
D
H

★ PLANES WITH ALL ELECTRIC EMERGENCY BOMB CONTROL SYSTEM
★EMERGENCY EQUIPMENT MOUNTED ON AFT SIDE OF BULKHEAD

A—EMERGENCY BOMB RELEASE
B—FIRST AID KIT

C—EMERGENCY DOOR RELEASE
D—FIREMAN'S AXE

E—FIRE EXTINGUISHER AC TYPE A-17(CO₂)
F—LIFE RAFTS

G—LIFE RAFT RELEASE HANDLES
H—FIRE EXTINGUISHER AC TYPE A-2

J—ENGINE FIRE EXTING. CONTROLS
K—BOMB RELEASE CONTROLS

FIGURE 15—EMERGENCY EQUIPMENT AND EXITS DIAGRAM

RESTRICTED

EQUIPMENT

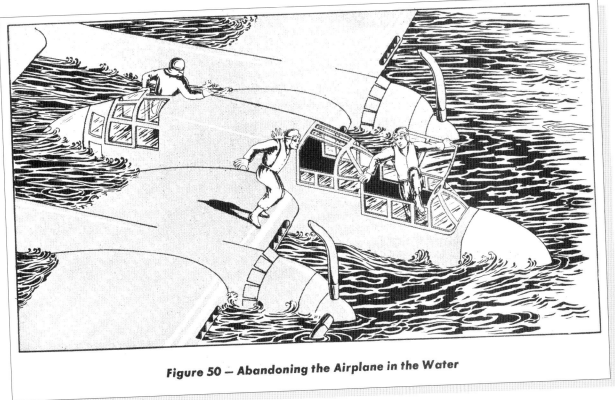

Figure 50 — Abandoning the Airplane in the Water

Emergency Exits B-29 (below)

B-29s flew the longest bombing missions of the war. With a bomb load of 12,000 pounds (5,443 kg), the B-29 had a range of 3,700 miles (5,954 km). Most if not all of the bombing missions were flown over water. Many B-29s and their crews were forced to ditch or bail out to and from their targets in Japan. An elaborate air-sea rescue system was set up involving aircraft, ships and submarines. At war's end, fourteen submarines, twenty-one Navy seaplanes, nine "Super Dumbos" (B-29s modified to carry a lifeboat) and five ships were on station ready to respond.

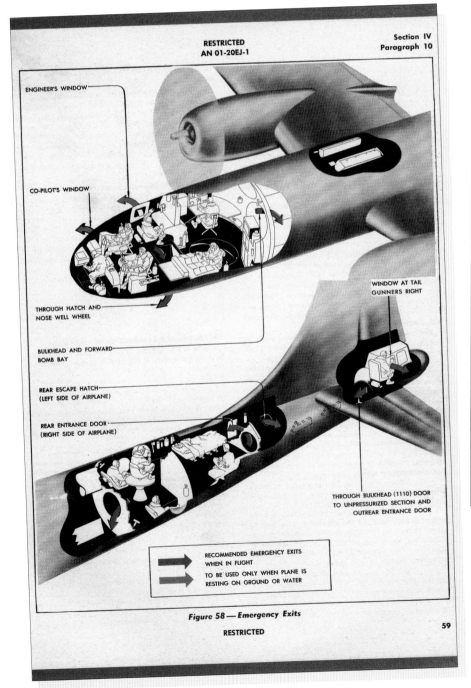

Figure 58 — Emergency Exits

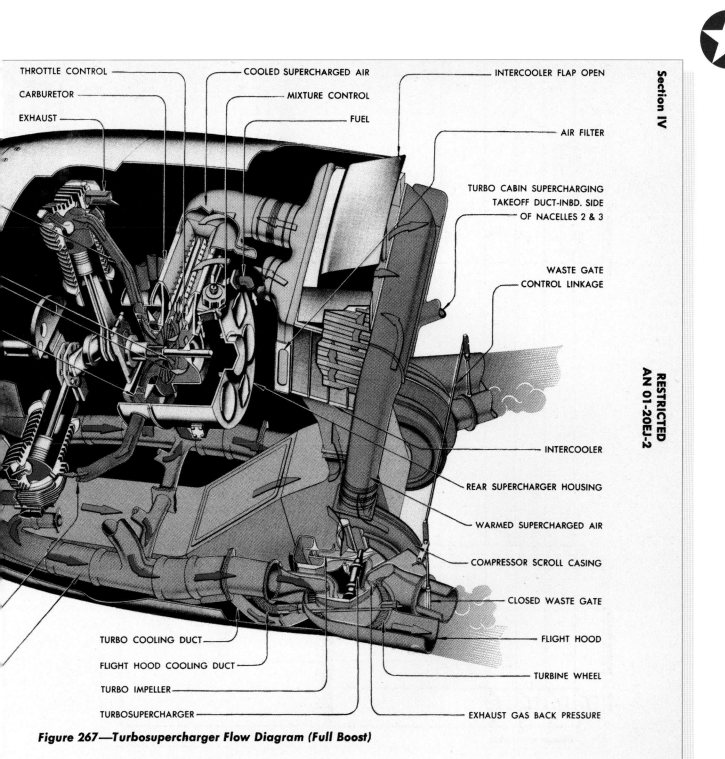

THROTTLE CONTROL

CARBURETOR

EXHAUST

COOLED SUPERCHARGED AIR

MIXTURE CONTROL

FUEL

INTERCOOLER FLAP OPEN

AIR FILTER

TURBO CABIN SUPERCHARGING
TAKEOFF DUCT-INBD. SIDE
OF NACELLES 2 & 3

WASTE GATE
CONTROL LINKAGE

INTERCOOLER

REAR SUPERCHARGER HOUSING

WARMED SUPERCHARGED AIR

COMPRESSOR SCROLL CASING

CLOSED WASTE GATE

FLIGHT HOOD

TURBINE WHEEL

EXHAUST GAS BACK PRESSURE

TURBO COOLING DUCT

FLIGHT HOOD COOLING DUCT

TURBO IMPELLER

TURBOSUPERCHARGER

Figure 267—Turbosupercharger Flow Diagram (Full Boost)

Turbo Supercharger Flow Diagram (above)

Four Wright R-3350-23 Duplex Cyclone engines powered the
B-29. Each power plant was equipped with two General Electric
turbo superchargers developing 2,200 horsepower (1641 kw)
for takeoff.

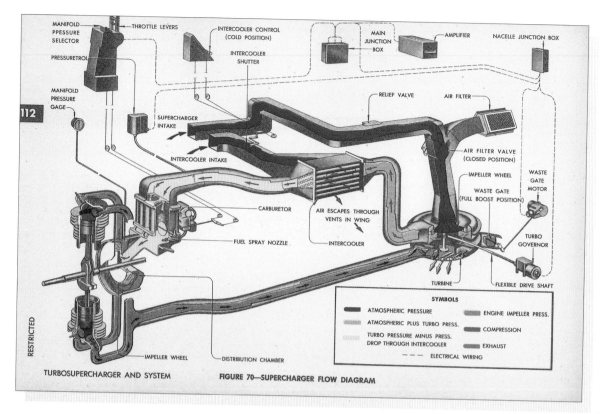

112

RESTRICTED

MANIFOLD PPESSURE SELECTOR

THROTTLE LEVERS

INTERCOOLER CONTROL (COLD POSITION)

MAIN JUNCTION BOX

AMPLIFIER

NACELLE JUNCTION BOX

PRESSURETROL

INTERCOOLER SHUTTER

MANIFOLD PRESSURE GAGE

RELIEF VALVE

AIR FILTER

SUPERCHARGER INTAKE

INTERCOOLER INTAKE

AIR FILTER VALVE (CLOSED POSITION)

IMPELLER WHEEL

WASTE GATE MOTOR

WASTE GATE (FULL BOOST POSITION)

CARBURETOR

AIR ESCAPES THROUGH VENTS IN WING

TURBO GOVERNOR

FUEL SPRAY NOZZLE

INTERCOOLER

TURBINE

FLEXIBLE DRIVE SHAFT

IMPELLER WHEEL

DISTRIBUTION CHAMBER

SYMBOLS

ATMOSPHERIC PRESSURE

ENGINE IMPELLER PRESS.

ATMOSPHERIC PLUS TURBO PRESS.

COMPRESSION

TURBO PRESSURE MINUS PRESS. DROP THROUGH INTERCOOLER

EXHAUST

ELECTRICAL WIRING

TURBOSUPERCHARGER AND SYSTEM

FIGURE 70—SUPERCHARGER FLOW DIAGRAM

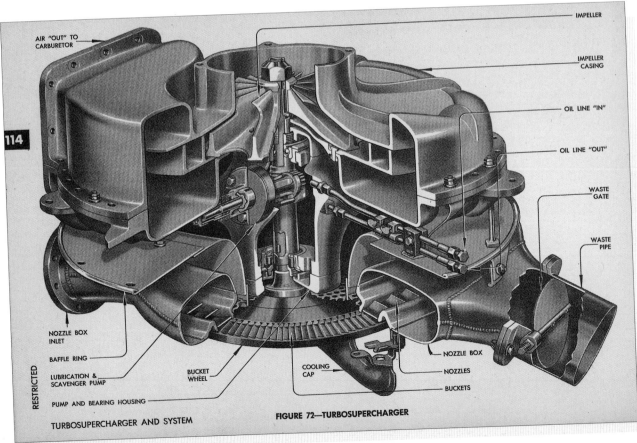

114

RESTRICTED

AIR "OUT" TO CARBURETOR

IMPELLER

IMPELLER CASING

OIL LINE "IN"

OIL LINE "OUT"

WASTE GATE

WASTE PIPE

NOZZLE BOX INLET

BAFFLE RING

LUBRICATION & SCAVENGER PUMP

PUMP AND BEARING HOUSING

BUCKET WHEEL

COOLING CAP

NOZZLE BOX

NOZZLES

BUCKETS

TURBOSUPERCHARGER AND SYSTEM

FIGURE 72—TURBOSUPERCHARGER

Boeing B-17G Field Service Manual — Supercharger Diagram Flow (opposite, top)

The turbo supercharger was a complex engineering marvel, and how it worked is clearly illustrated in this Boeing diagram. Turbo superchargers utilize all or a portion of the exhaust gases from the engine to drive a turbine, which in turn drives the blower, sending compressed air back into the engine. The B-17 and B-24 used General Electric turbo superchargers. Equipped with the turbo, the B-17 had unmatched high-altitude performance with a ceiling of 35,000 feet. This was thousands of feet better than the British Lancaster and Halifax four-engine bombers, each equipped with single-stage supercharged engines.

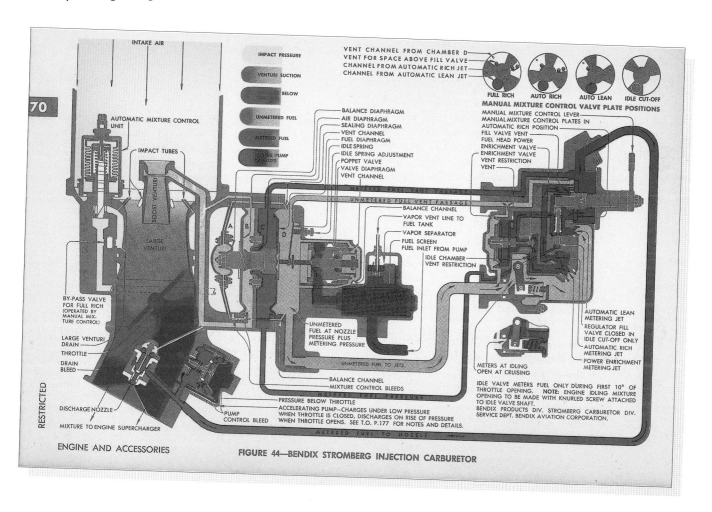

FIGURE 44—BENDIX STROMBERG INJECTION CARBURETOR

B-17 Turbo Supercharger
(opposite, bottom)

Turbo superchargers operated at such high temperatures that they required high-temperature metals such as high nickel alloys. Essentially they used same technologies and materials found in the early jet engines.

Bendix Stromberg Injection Carburator (above)

The job of the carburetor was to mix liquid fuel with air in just the right amount for proper combustion. This mixture could be changed depending on the circumstances, and contrary to some reports, U.S. combat aircraft did not use engines equipped with fuel injection. Instead they used a pressure carburetor, such as the Bendix Stromberg carburetor, that injected fuel into the final stage of supercharging.

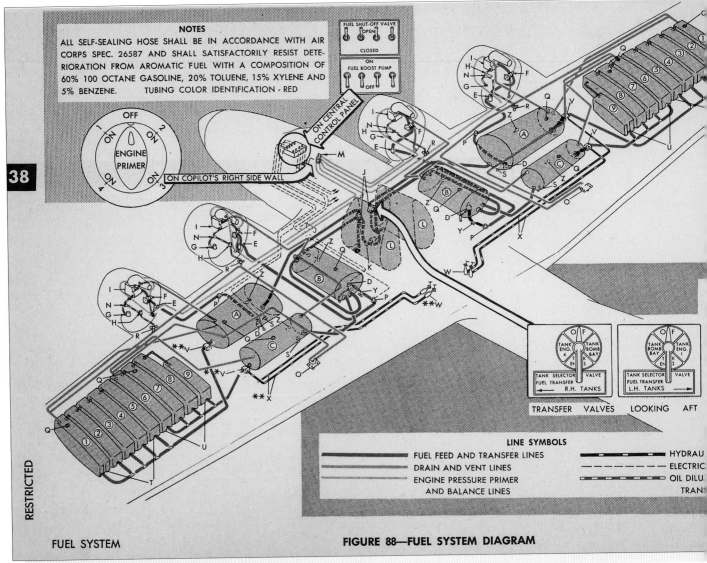

FUEL SYSTEM

FIGURE 88—FUEL SYSTEM DIAGRAM

Fuel System Diagram (above)

The B-17F was the first truly battle-worthy Fortress. The most noticeable change from the E model was the near doubling of fuel capacity with the installation of nine additional fuel tanks in the wing. These were located just outside of the outboard engines and added 250 miles to the B-17's practical range.

B-17 Replenishing Diagram (opposite, top)

Maximum fuel load for B-17 was 2,800 gallons, and a fully loaded Fortress drank fuel at a prodigious rate, over 400 gallons an hour climbing to altitude and 200 cruising to the target.

B-17 Lubrication Chart (opposite, bottom)

Constant maintenance was necessary to keep a heavy bomber such as the B-17 combat-ready. It used hundreds of gallons of fuel and oil on every mission, and used vast quantities of lubricants to keep vital parts moving.

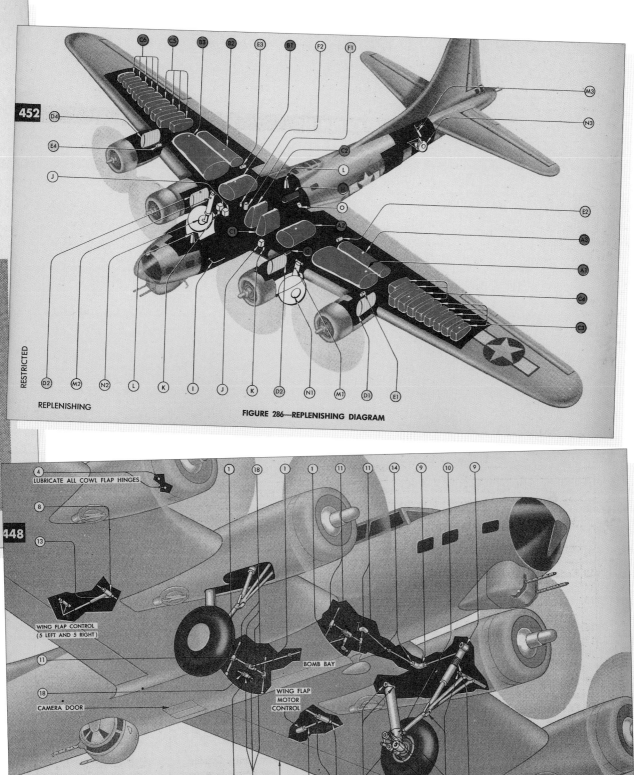

452

REPLENISHING

FIGURE 286—REPLENISHING DIAGRAM

LUBRICATE ALL COWL FLAP HINGES

WING FLAP CONTROL
(5 LEFT AND 5 RIGHT)

CAMERA DOOR

MANUAL CONTROL WING FLAPS
(SERVICE IN CAMERA PIT)

BOMB BAY

WING FLAP
MOTOR
CONTROL

WING FLAP

AILERON TRIM TAB

448

LUBRICATION

FIGURE 284—LUBRICATION CHART—SHT. 1

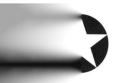

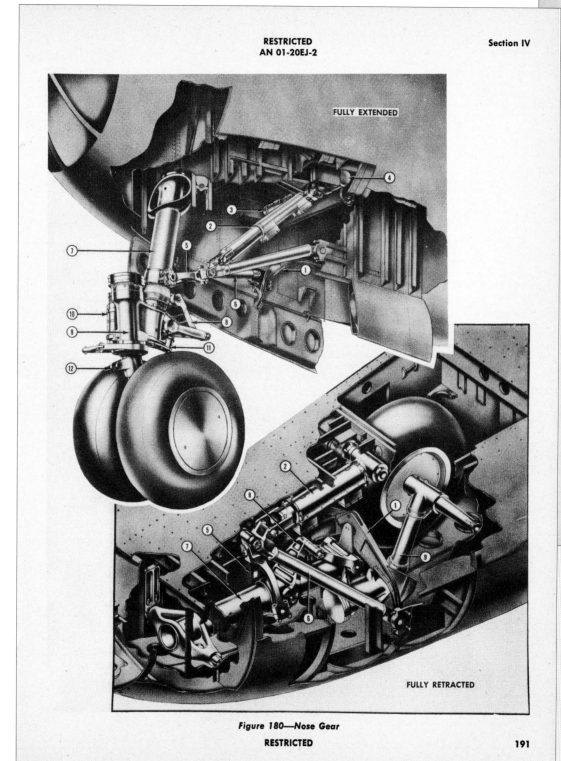

FULLY EXTENDED

FULLY RETRACTED

Figure 180—Nose Gear

LOCK RING
WHEEL RIM
BRAKE DRUM
BLEEDER FITTING
ROLLER BEARING
BRAKE FRAME
BRAKE BLOCK
TIRE RETAINING RING

BRAKES OFF

BRAKES ON

GRAPHIC WAR

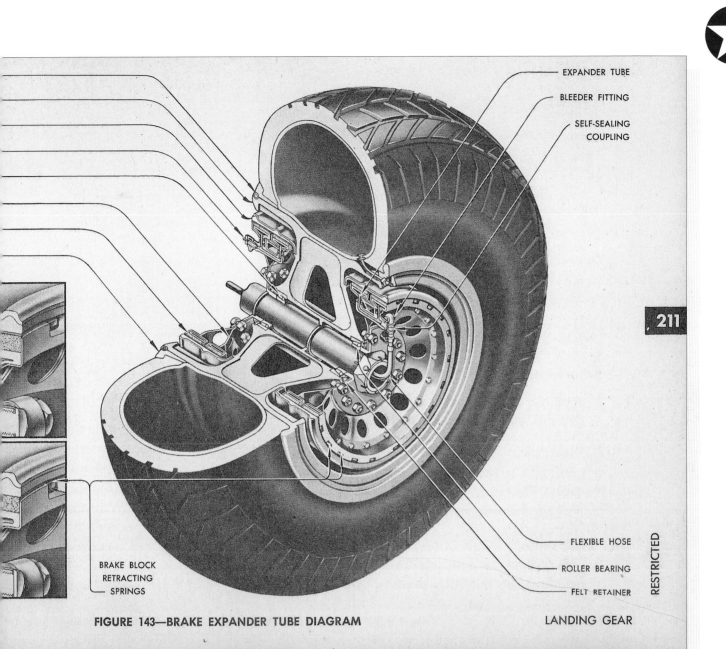

EXPANDER TUBE

BLEEDER FITTING

SELF-SEALING COUPLING

211

FLEXIBLE HOSE

ROLLER BEARING

RESTRICTED

FELT RETAINER

BRAKE BLOCK RETRACTING SPRINGS

FIGURE 143—BRAKE EXPANDER TUBE DIAGRAM

LANDING GEAR

Nose Gear (opposite)

The B-29 was large and heavy bomber that required a sturdy undercarriage. The prototype was equipped with single main wheels, but these were replaced in production to a twin-wheel configuration. These wheels retracted forward into the engine nacelle while the nose wheel retracted backward to lie in a well below the forward cabin.

B-17 Brake Expander Tube Diagram (above)

Takeoff and landing have always been the most critical stages of flight. Most combat pilots would agree, but would add that flying over enemy territory was "the" most critical of all.

After every landing, the tires and braking systems on all heavy and medium bombers were inspected. Tires were checked for cracks or bad burns. If undetected, these flaws could lead to a blown tire and the loss of the aircraft.

винт —

нет ли внешних повреждений (пробоин, царапин) на лопастях и коке и заметной погнутости лопастей;

люки моторного капота —

закрыты ли замки крышек нижних люков, имеется ли контровая шпилька на замке крышки переднего люка;

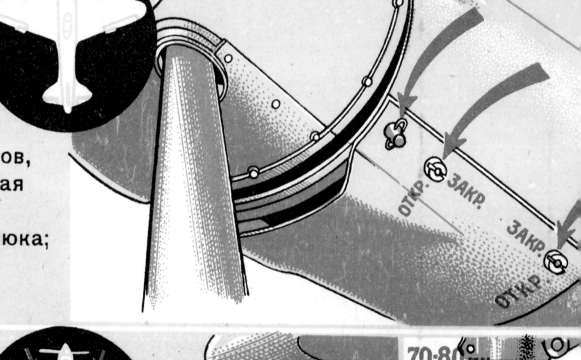

ОТКР. ЗАКР. ЗАКР. ОТКР.

шасси —

нормально ли накачаны пневматики, нормальна и одинакова ли осадка обеих амортизационных стоек;

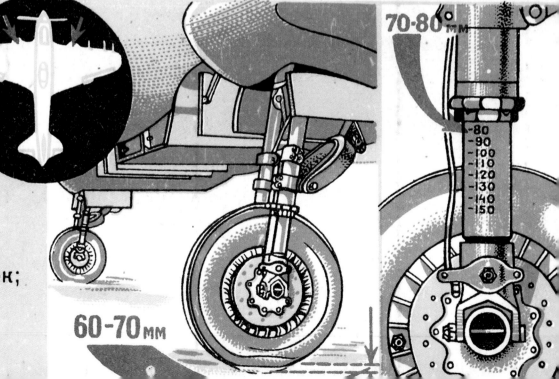

70-80 мм

-80
-90
-100
-110
-120
-130
-140
-150

60-70 мм

SOVIET UNION

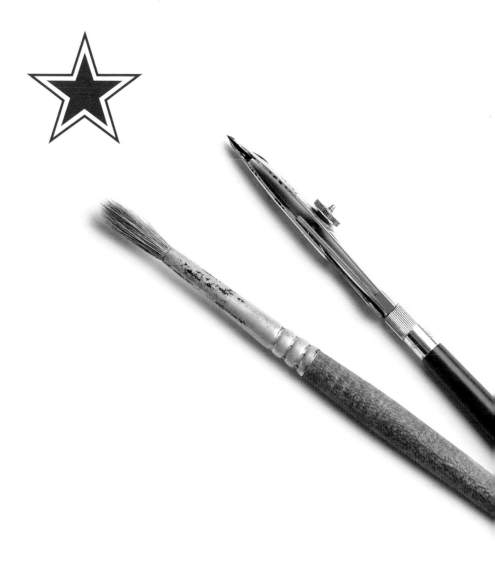

Il-2 Shturmovik Cockpit Diagram

The Il-2 Shturmovik cockpit was a very clean and well laid-out design. It was also one of the most heavily armored aircraft in the air during the war. A heavy case-hardened armor plate one-piece tub surrounded the pilot. The back of the tub was sealed off by a 13 mm thick piece of armor plate. The pilot also had the benefit of an armored-glass canopy and a 65 mm thick armored windscreen.

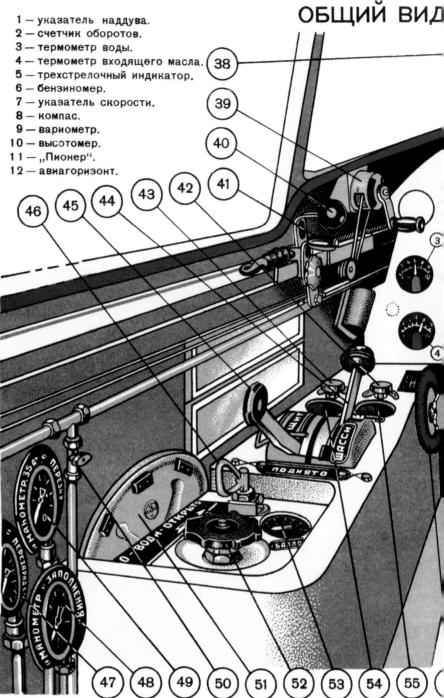

ОБЩИЙ ВИД

1 — указатель наддува.
2 — счетчик оборотов.
3 — термометр воды.
4 — термометр входящего масла.
5 — трехстрелочный индикатор.
6 — бензиномер.
7 — указатель скорости.
8 — компас.
9 — вариометр.
10 — высотомер.
11 — „Пионер".
12 — авиагоризонт.

30 — выключатель обогрева сбрасывателя.
31 — выключатель вибратора.
32 — выключатель освещения приборной доски.
33 — выключатель освещения кабины.
34 — радиоприемник.
35 — переключатель бензиномеров.
36 — рукоятка пожарного крана.
37 — манометр баллона запуска.
38 — прицел ПБП-1.
39 — катушка триммера.
40 — рукоятка нормального газа.
41 — рукоятка высотного корректора.
42 — соединительный кран.

43 — тормозной кран.
44 — рукоятка крана шасси.
45 — рукоятка крана щитков.
46 — дополнительный кран.
47 — манометр перезарядки.
48 — манометр заполнения.
49 — манометр перезарядки.
50 — специальный кран.
51 — штурвальчик шторки вод
52 — запорный кран.
53 — манометр бортового балл
54 — манометр тормозов.
55 — манометр воздушной сети
56 — штурвальчик управления

...БИНЫ САМОЛЕТА Ил-2

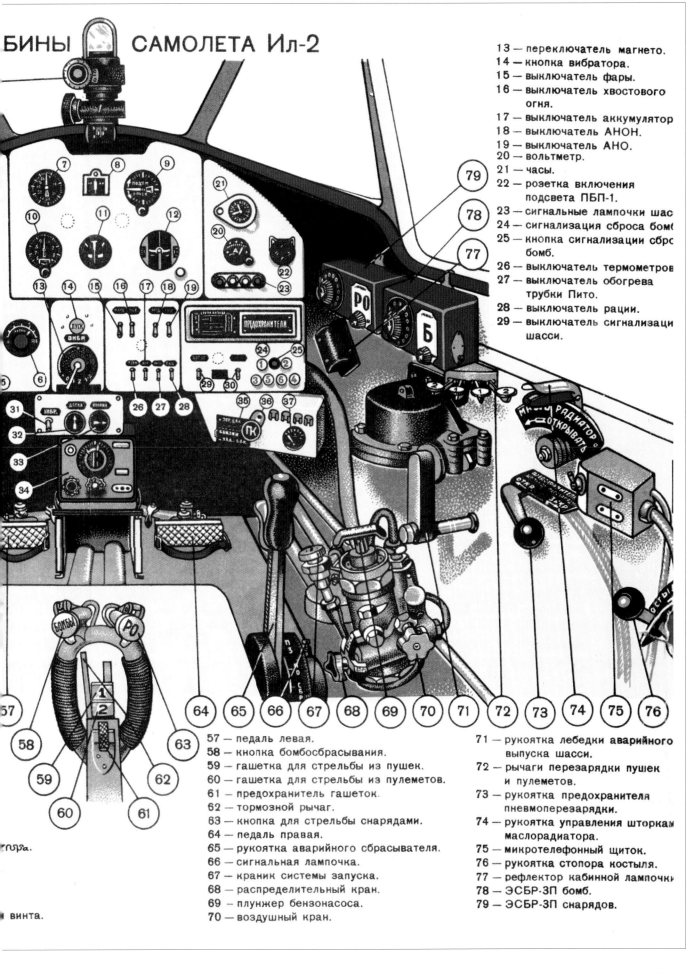

13 — переключатель магнето.
14 — кнопка вибратора.
15 — выключатель фары.
16 — выключатель хвостового огня.
17 — выключатель аккумулятор
18 — выключатель АНОН.
19 — выключатель АНО.
20 — вольтметр.
21 — часы.
22 — розетка включения подсвета ПБП-1.
23 — сигнальные лампочки шас
24 — сигнализация сброса бом(
25 — кнопка сигнализации сбро бомб.
26 — выключатель термометров
27 — выключатель обогрева трубки Пито.
28 — выключатель рации.
29 — выключатель сигнализаци шасси.

57 — педаль левая.
58 — кнопка бомбосбрасывания.
59 — гашетка для стрельбы из пушек.
60 — гашетка для стрельбы из пулеметов.
61 — предохранитель гашеток.
62 — тормозной рычаг.
63 — кнопка для стрельбы снарядами.
64 — педаль правая.
65 — рукоятка аварийного сбрасывателя.
66 — сигнальная лампочка.
67 — краник системы запуска.
68 — распределительный кран.
69 — плунжер бензонасоса.
70 — воздушный кран.

71 — рукоятка лебедки аварийного выпуска шасси.
72 — рычаги перезарядки пушек и пулеметов.
73 — рукоятка предохранителя пневмоперезарядки.
74 — рукоятка управления шторкам маслорадиатора.
75 — микротелефонный щиток.
76 — рукоятка стопора костыля.
77 — рефлектор кабинной лампочк(
78 — ЭСБР-ЗП бомб.
79 — ЭСБР-ЗП снарядов.

Operation of Il-2 Armament Controls (right)

Page 63 of the Il-2 manual. Translated, it reads: (Top Image) When approaching the target: close the gills of the oil cooler and maintain a speed of 300-320 km/h according to the instrument readings.

(Bottom Image)
To fire the cannons, press trigger 1.
To fire the machine guns, press trigger 2.
To fire the cannons and machine guns simultaneously, press both triggers.

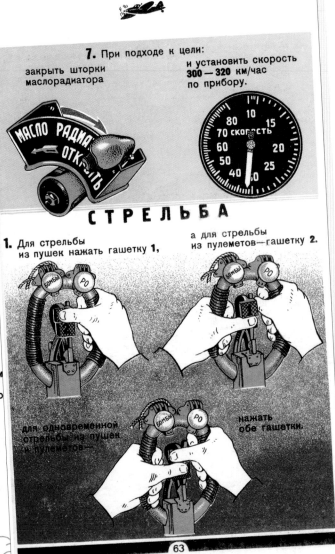

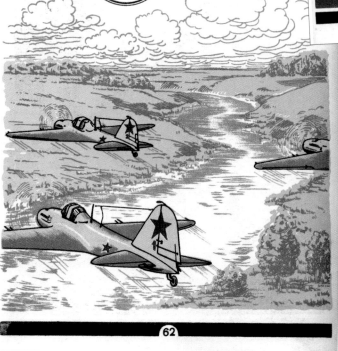

Inside Cover Page of the Il-2 Manual Armament Controls Section (left)

This landscape drawing showing three Il-2s in formation advises: "When carrying out general orientation, increase the level of the air and terrain observation, and follow the signals of the leader when flying in formation."

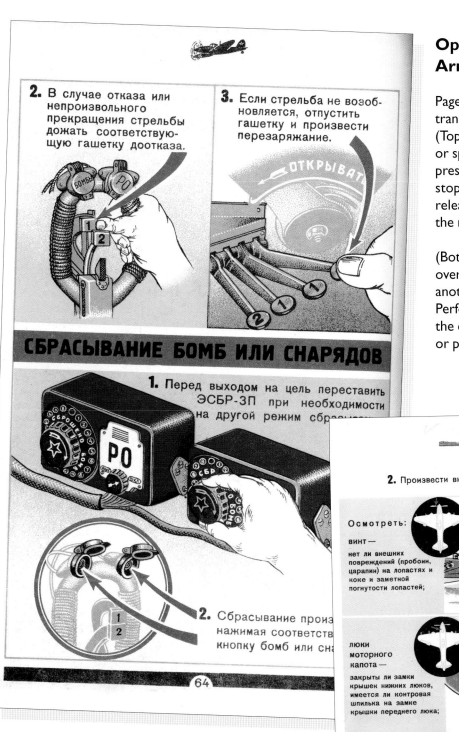

Operation of Il-2 Armament Controls (left)

Page 64 of the Il-2 flight manual translated:
(Top Image) "In case of a failure or spontaneous termination of fire, press the corresponding trigger till stop. If the firing did not restart, release the trigger and perform the reloading."

(Bottom Image) "Before coming over a target, set the ESBR-3P to another dropping mode if necessary. Perform the dropping by pressing the corresponding button of bombs or projectiles."

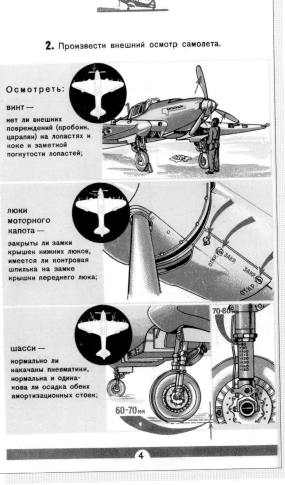

Il-2 Preflight Diagram (right)

Before every flight it was the pilot's responsibility to make an external check of his aircraft.

SOVIET UNION

Lavochkin La-7 Fighter Fuselage Cutaway (right), Wing Cutaway (below), Engine Cowling (opposite, top), Cockpit Schematic (opposite, bottom)

During World War II, Russian fighters used wood extensively in their construction. The two cutaway drawings of the Lavochkin La-7 fuselage and wing reveal the liberal use of wood. Described as unsophisticated and somewhat crude, as compared to the aircraft produced by the manufacturing techniques of the west, the La-7 proved a deadly fighter, and the Germans considered it the most dangerous threat on the Eastern Front.

Russian pilots have described the cockpit as well laid-out with accessible controls and logical instrument arrangement.

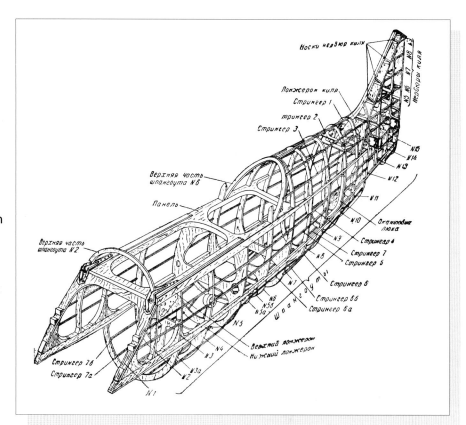

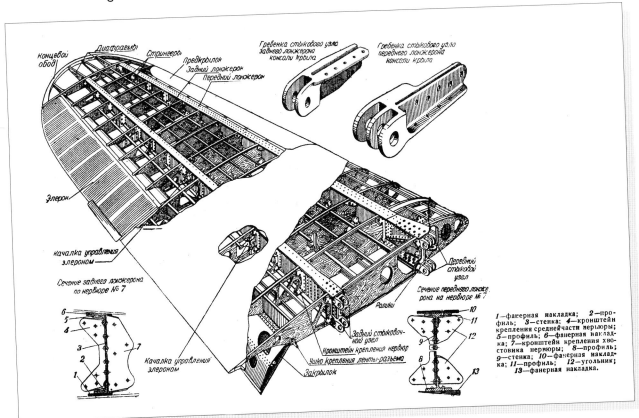

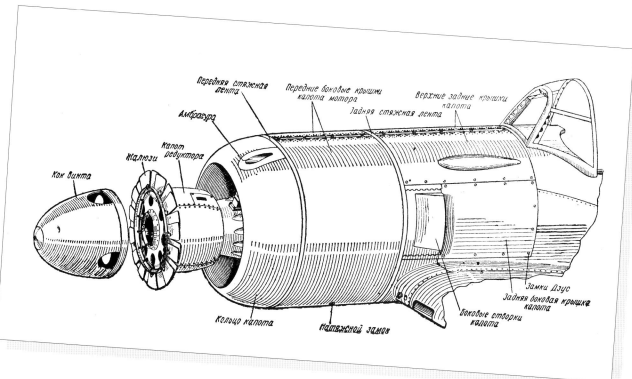

Кок винта — Жалюзи — Капот редуктора — Амбразура — Передняя стяжная лента — Передние боковые крышки капота мотора — Задняя стяжная лента — Верхние задние крышки капота — Кольцо капота — Натяжной замок — Боковые створки капота — Замки Дзус — Задняя боковая крышка капота

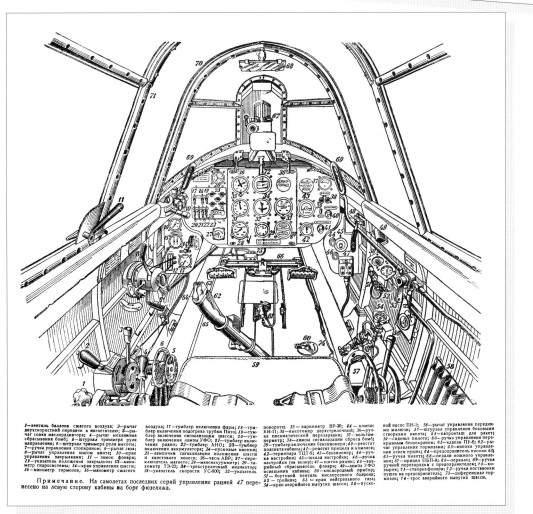

1—вентиль баллона сжатого воздуха; 2—рычаг двухскоростной передачи к магнетателю; 3—рычаг сбрасывания бомб; 6—штурвал триммера руля направления; 6—штурвал триммера руля высоты; 7—ручка управления стопкраном; 8—рычаг газа; 9—рычаг управления шагом винта; 10—кран управления закрылками; 11—замок фонаря; 12—указатель положения закрылков; 13—манометр гидросистемы; 14—кран управления шасси; 16—манометр тормозов; 16—манометр сжатого воздуха; 17—тумблер включения фары; 18—тумблер включения подогрева трубки Пито; 19—тумблер включения сигнализации шасси; 20—тумблер включения лампы УФО; 21—тумблер включения радио; 22—тумблер АНО; 23—тумблер включения аккумулятора; 24—пусковые кнопки; 26—лампочки сигнализации положения шасси и хвостового колеса; 26—часы АВР; 27—переключатель магнето; 28—манновакуумметр; 29—тахометр ТЭ-22; 30—трехстрелочный индикатор; 31—указатель скорости УС-800; 32—указатель поворота; 33—вариометр ВР-30; 34—компас КИ-11; 36—высотомер двухстрелочный; 36—ручка пневматической перезарядки; 37—вольтамперметр; 38—лампы сигнализации сброса бомб; 39—тумблер включения бензиномера; 40—реостат подсветки кабины; 41—реостат прицела и компаса; 42—термопара ТЦТ-9; 43—бензиномер; 44—ручка настройки; 45—шкала настройки; 46—ручка настройки (на волну); 47—шиток рации; 48—аварийный сбрасыватель фонаря; 49—лампы УФО освещения кабины; 50—кислородный прибор; 51—бортовой вентиль кислородного баллона; 52—тройник; 53—кран нейтрального газа; 54—кран аварийного выпуска шасси; 55—пусковой насос ПН-1; 56—рычаг управления передними створками капота; 57—штурвал управления боковыми створками капота; 58—патронташ для ракет; 59—сиденье пилота; 60—ручка управления перекрывным бензонасосом; 61—клапан ПУ-6; 62—рычаг управления тормозами; 63—кнопка управления огнем пушек; 64—предохранитель кнопки; 65—ручка пилота; 66—педали ножного управления; 67—прицел ПБП-1а; 68—зеркало; 69—ручка ручной перезарядки с предохранителем; 70—кольцо аварийного выпуска шасси; 71—створка фонаря; 72—ручка постановки пушек на предохранитель; 73—дифференциал тормозов; 74—трос аварийного выпуска шасси.

Примечание. На самолетах последних серий управление рацией 47 перенесено на левую сторону кабины на борт фюзеляжа.

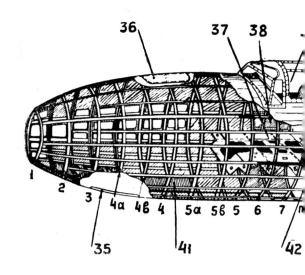

Fuselage Structure of the Ilyushin DB-3m Bomber and Engine Cowling (right)

Not nearly as well known as the B-17 or Avro Lancaster, the DB-3 was one of the greatest bombers of World War II. Employed in enormous numbers, the DB-3 saw service as a tactical and strategic bomber as well as a torpedo attack aircraft. Over 6,800 had been delivered when production ceased in 1944.

Wing Structure and Center Section of the Petlyakov Pe 2 (below)

This drawing details the wing structure and center section of the Petlyakov Pe-2 bomber. The Pe-2's slim fuselage and clean aerodynamic properties made it difficult for intercepting German fighters to shoot down. Just over 11,400 examples were produced.

1 — 34 — рамы (шпангоуты), 3 пилота, 39— фонарь пилота, 4 узел, 44-—задний верхний сты пол (мягкий), 50 — нижний за пятка, 53— киль, 54— узлы кр

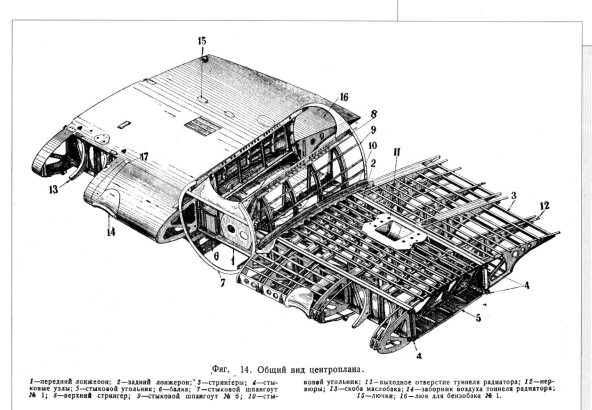

Фиг. 14. Общий вид центроплана.

1—передний лонжерон; 2—задний лонжерон; 3—стрингеры; 4—сты-ковые узлы; 5—стыковой угольник; 6—балка; 7—стыковой шпангоут № 1; 8—верхний стрингер; 9—стыковой шпангоут № 6; 10—сты-ковой угольник; 11—выходное отверстие туннеля радиатора; 12—нер-вюры; 13—скоба маслобака; 14—заборник воздуха тоннеля радиатора; 15—лючки; 16—люк для бензобака № 1.

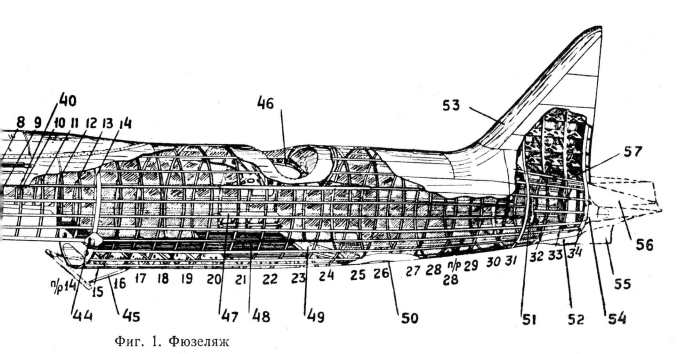

Фиг. 1. Фюзеляж

ний передний люк, 36 — астрономический (аварийный) люк, 37 — пол пилота, 38 — кабина
ручень, 41— передний пол, 42— перегородка задняя, 43— передний верхний стыковой
узел, 45—раскосы, 46— задняя жесткость, 47— подножка, 48— задний пол, 49— задний
люк, 51 — узлы крепления переднего лонжерона фюзеляжа, 52 — предохранительная
я заднего лонжерона стабилизатора, 55— чехол, 56— хвостовой обтекатель, 57—жест-
кость рамы № 34

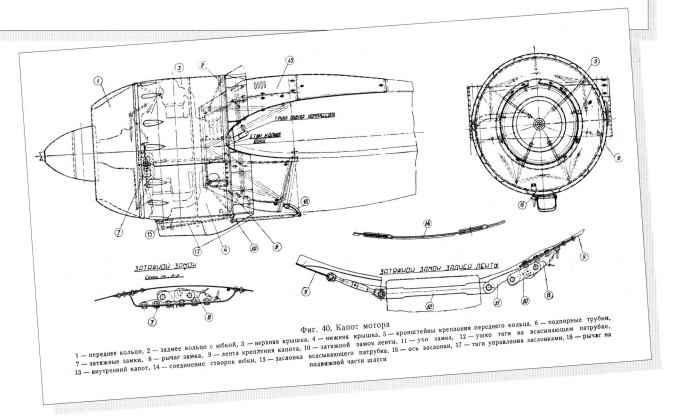

Фиг. 40. Капот мотора

1 — переднее кольцо, 2 — заднее кольцо с юбкой, 3 — верхняя крышка, 4 — нижняя крышка, 5 — кронштейны крепления переднего кольца, 6 — подпорные трубки,
7 — затяжные замки, 8 — рычаг замка, 9 — лента крепления капота, 10 — затяжной замок ленты, 11 — ухо замка, 12 — ушко тяги на всасывающем патрубке,
13 — внутренний капот, 14 — соединение створок юбки, 15 — заслонка всасывающего патрубка, 16 — ось заслонки, 17 — тяги управления заслонками, 18 — рычаг на
подвижной части шасси

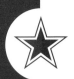

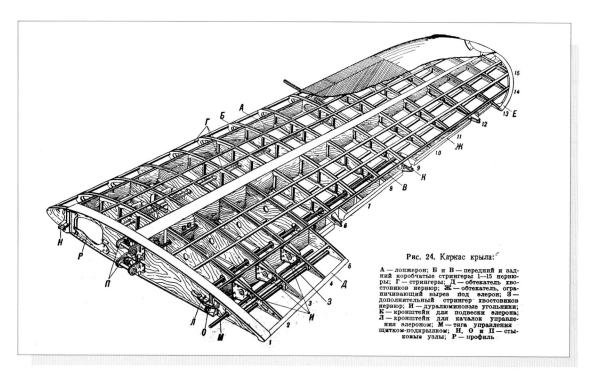

Рис. 24. Каркас крыла:

А — лонжерон; Б и В — передний и задний коробчатые стрингеры 1—15 нервюры; Г — стрингеры; Д — обтекатель хвостовиков нервюр; Ж — обтекатель, ограничивающий вырез под элерон; З — дополнительный стрингер хвостовиков нервюр; И — дуралюминовые угольники; К — кронштейн для подвески элерона; Л — кронштейн для качалок управления элероном; М — тяга управления щитком-подкрылком; Н, О и П — стыковые узлы; Р — профиль

Mikoyan MiG-3 Wing Structure (above)

The detailed cutaway drawings above and opposite reveal the inner structure of the MiG-3. The outer panel wing structure of the MiG-3 fighter was made of wood. The plywood and laminated wood used in the wing spars of the MiG-3 was birch; the other laminated parts (ribs and stringers) were made of pine. But the MiG-3 was not entirely made of wood. The fuselage center section comprised a truss structure made of metal. This mix of wood and metal construction gave the MiG-3 a respectable performance, but by 1942 it could no longer keep up with the new versions of the German Bf 109 and Fw 190 fighters.

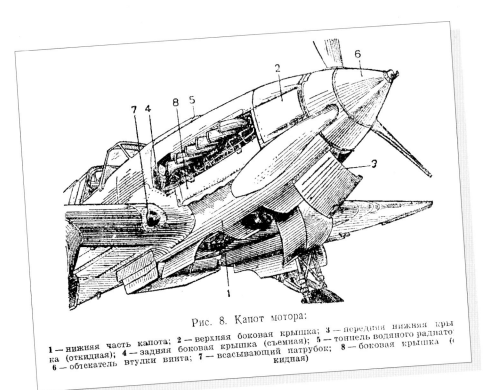

Рис. 8. Капот мотора:

1 — нижняя часть капота; 2 — верхняя боковая крышка; 3 — передняя нижняя крышка (откидная); 4 — задняя боковая крышка (съемная); 5 — тоннель водяного радиато[...] 6 — обтекатель втулки винта; 7 — всасывающий патрубок; 8 — боковая крышка ([...] кидная)

Il-2 Shturmovik Engine Cowling Details (left)

This diagram shows the armored cowling and other access panels hinged open. The Il-2 was powered by a single AM-38, 1665-horsepower engine.

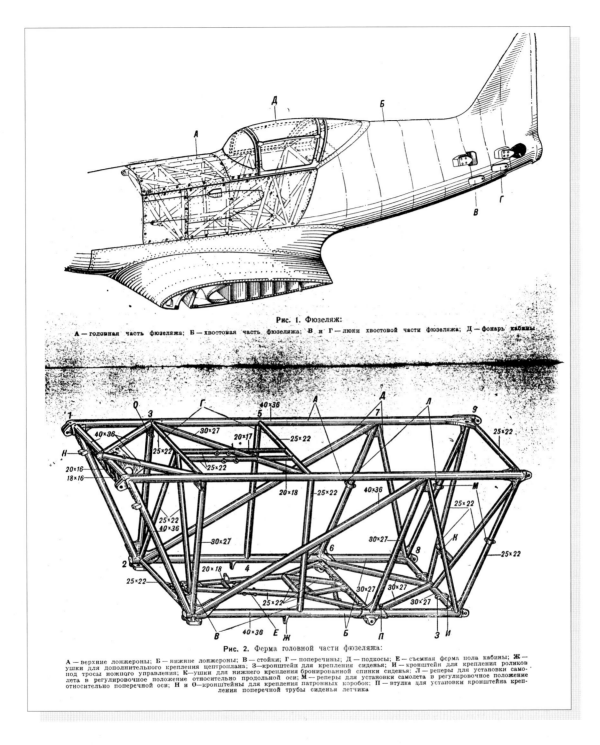

Рис. 1. Фюзеляж:

А — головная часть фюзеляжа; Б — хвостовая часть фюзеляжа; В и Г — люки хвостовой части фюзеляжа; Д — фонарь кабины

Рис. 2. Ферма головной части фюзеляжа:

А — верхние лонжероны; Б — нижние лонжероны; В — стойки; Г — поперечины; Д — подкосы; Е — съемная ферма пола кабины; Ж — ушки для дополнительного крепления центроплана; З — кронштейн для крепления сиденья; И — кронштейн для крепления роликов под тросы ножного управления; К — ушки для нижнего крепления бронированной спинки сиденья; Л — реперы для установки самолета в регулировочное положение относительно продольной оси; М — реперы для установки самолета в регулировочное положение относительно поперечной оси; Н и О — кронштейны для крепления патронных коробок; П — втулка для установки кронштейна крепления поперечной трубы сиденья летчика

Mikoyan MiG-3 Fuselage and Truss Structure (above)

The MiG-3 fuselage and truss structure of the metal fuselage center section.
The rest of the aircraft was made of plywood and compacted wood components.

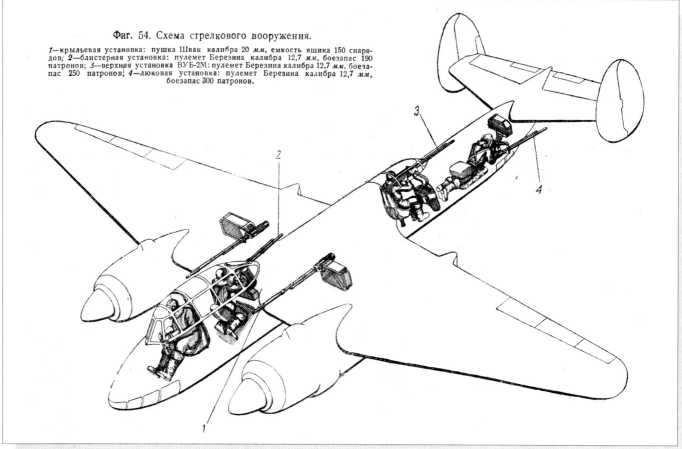

Фиг. 54. Схема стрелкового вооружения.

1—крыльевая установка: пушка Швак калибра 20 *мм*, емкость ящика 150 снаря-дов; *2*—блистерная установка: пулемет Березина калибра 12,7 *мм*, боезапас 190 патронов; *3*—верхняя установка ВУБ-2М: пулемет Березина калибра 12,7 *мм*, боеза-пас 250 патронов; *4*—люковая установка: пулемет Березина калибра 12,7 *мм*, боезапас 300 патронов.

Tupolev Tu-2 Armament Layout (above)

The Tu-2 was one of the most outstanding bomber designs of the war. Well liked by its crews, it was reliable, well-armed and a formidable attack aircraft. Armament consisted of three manually aimed 12.7 mm Beresin BS machine guns and two 20 mm ShVAK cannon fixed in the wing roots with 200 rounds of ammunition each.

Liquid-Cooled M 103 Engine (opposite, top)

A rather simple cross-section drawing of the 960-horsepower liquid-cooled M-103 engine. The M-103 powered later versions of the Tupolev SB-2 tactical bomber.

Nose Turret of the Tupolev SB-2 Bomber (opposite, bottom)

The nose turret armament of the SB-2 light bomber consisted of two 7.62 mm ShKAS machine guns. The SB-2 was the Soviet Union's first all-metal stressed-skin bomber and was armed with four 7.62 mm machine guns and up to 1,100 pounds (500 kg) of bombs.

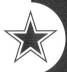

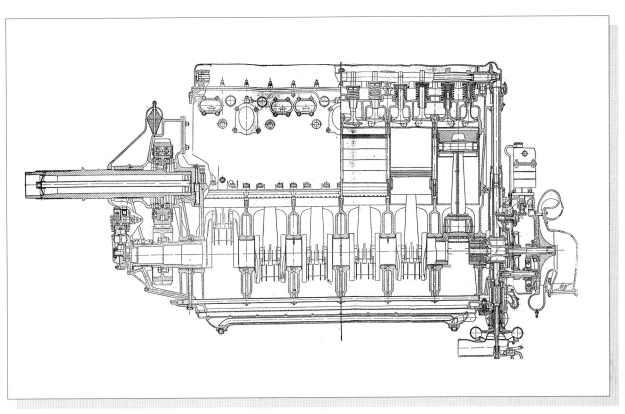

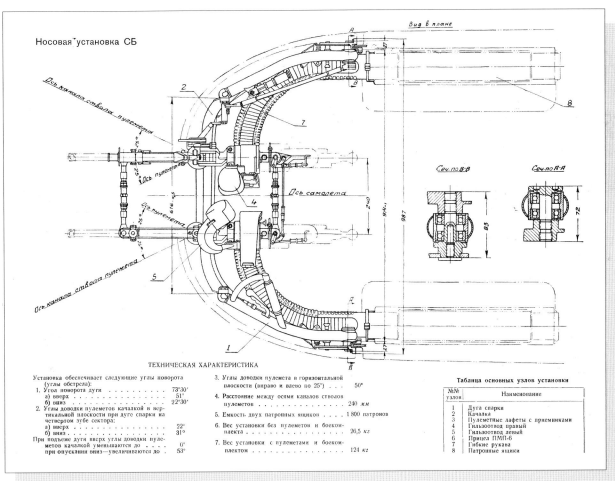

Носовая установка СБ

Вид в плане

Ось канала ствола пулемета

Ось пулемета

Ось самолета

Ось пулемета

Ось канала ствола пулемета

Сеч. по В-В

Сеч. по А-А

ТЕХНИЧЕСКАЯ ХАРАКТЕРИСТИКА

Установка обеспечивает следующие углы поворота (углы обстрела):
1. Угол поворота дуги 73°30′
 а) вверх 51°
 б) вниз 22°30′
2. Углы доводки пулеметов качалкой в вертикальной плоскости при дуге спарки на четвертом зубе сектора:
 а) вверх 22°
 б) вниз 31°
При подъеме дуги вверх углы доводки пулеметов качалкой уменьшаются до 0°
 при опускании вниз—увеличиваются до 53°

3. Углы доводки пулемета в горизонтальной плоскости (вправо и влево по 25°) . . . 50°
4. Расстояние между осями каналов стволов пулеметов 240 мм
5. Емкость двух патронных ящиков 1 800 патронов
6. Вес установки без пулеметов и боекомплекта 26,5 кг
7. Вес установки с пулеметами и боекомплектом 124 кг

Таблица основных узлов установки

№№ узлов	Наименование
1	Дуга спарки
2	Качалка
3	Пулеметные лафеты с приемниками
4	Гильзоотвод правый
5	Гильзоотвод левый
6	Прицел ПМП-6
7	Гибкие рукава
8	Патронные ящики

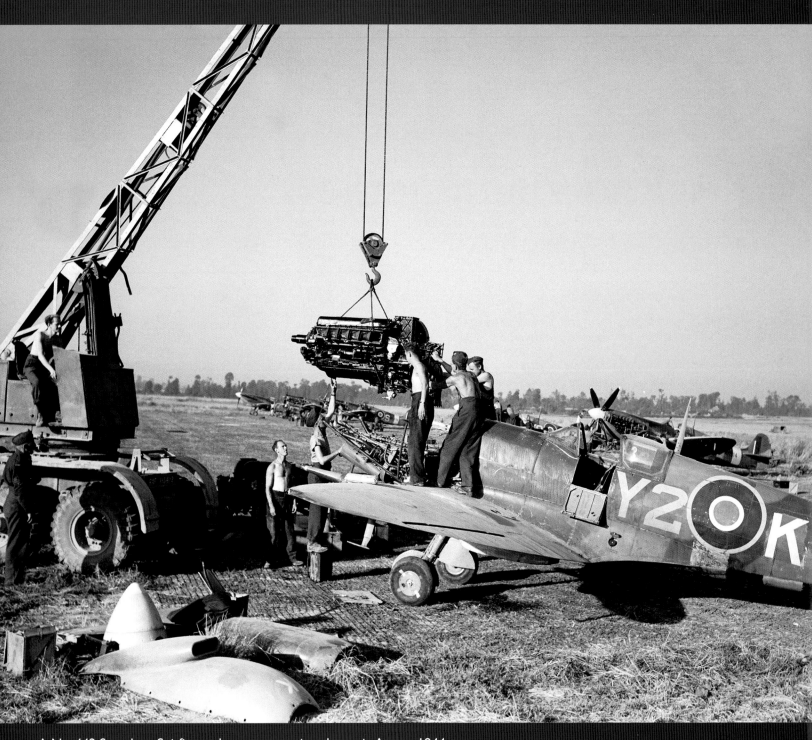

A No. 442 Squadron Spitfire undergoes an engine change in August 1944.

Acknowledgments

This book would not be possible without the help and support of my family and friends. I would like to thank John Denison and Kathy Fraser and everyone at the Boston Mills Press, Firefly Books and PageWave Graphics.

The following people gave their time and expertise to help make this book possible. Grateful thanks to Peter Castle, Roy Cross, Dan Patterson, Fiona Hale, Ron Dick, Phil Wilkinson, Sarah Kuss Shivler, Dawne Dewey, Piotr Lopalewski, Jan Hoffmann, Peter Elliot, Iain Duncan, Joanne M. G. London, Ilya Grinberg, Sven Scheiderbauer, Peter Devitt, Nick Stroud, Brett Stolle, Guennadi Sloutski, N. Polikarpov and Kristine L. Kaske.

I would also like to thank the following museums and archives: the Canada Aviation Museum, Ottawa; the RAF Museum, London; the National Archives, Washington D.C.; Wright State University, National Aviation Hall of Fame, the Museum of the USAF, Dayton, Ohio; the National Air and Space Museum, Washington D.C.

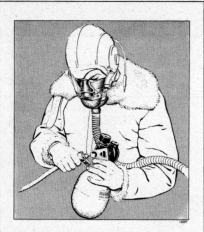

Figure 75 — Filling Portable Bottle

To recharge portable bottles, connect recharging nipples to the filler valve on any supply hose in the distributing lines.

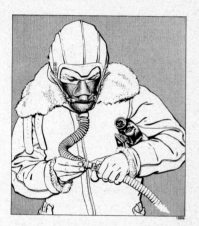

Figure 76 — Disconnecting from Regulator

Remove the end connection of the mask hose from the fitting on the end of the feeder hose coming from the demand regulator.

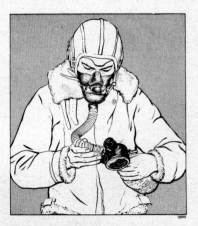

Figure 77 — Connecting Portable Bottle

Open the spring cover of the regulator connection and snap in the male fitting on end of the mask hose. Clamp portable unit to clothing.

Bibliography

American Warplanes of World War II. London, England: Aerospace Publishing Ltd., 1995

Atkinson, Rick. *An Army at Dawn.* New York, New York: Henry Holt and Company, 2002

Bowan, Martin W. *USAF Handbook 1939-1945.* Mechanicsburg, PA; Stackpoole Books, 1997

Carter, William, and Spencer Dunmore. *Reap the Whirlwind: The Untold Story of 6 Group, Canada's Bomber Force of World War II.* Toronto, Canada: McClelland and Stewart Inc., 1991

Clark, R. Wallace. *British Aircraft Armament, Volume 1: RAF Gun Turrets from 1914 to the Present Day.* Sparkford Nr Yeovil, Somerset: Patrick Stephens Limited, 1993

Donald, David., ed. *Warplanes of the Luftwaffe.* London, England: Aerospace Publishing Ltd., 1994

English, Allan D. *The Cream of the Crop.* Montreal: McGill-Queen's University Press, 1996

Ethell, Jeffrey L. et al. *Great Book of World War II Airplanes.* Twelve Volumes. New York: Bonanza Books, 1984

Freeman, Roger A. *B-17 Fortress at War.* New York: Charles Scribner's Sons, 1977

Greenhouse, Brereton, and Stephen. J. Harris, William C. Johnston, William G.P. Rawling. *The Crucible of War 1939-19345: The Official History of the Royal Canadian Air Force Volume III.* Toronto: University of Toronto Press Inc. in cooperation with the Department of National Defence and the Canada Communications Group, Publishing, Supply Services of Canada, 1994

Gunston, Bill. *Classic World War II Aircraft Cutaways.* Michelin House, 81 Fulham Road, London. Osprey Publishing, 1995

Halliday, Hugh A. *Typhoon and Tempest: The Canadian Story.* Toronto, Canada: CANAV Books, 1992

Hardesety, Von. *Red Phoenix: The Rise of Soviet Air Power 1914-1945.* Washington D.C., Smithsonian Institution, 1982

Hogg, Ian V. *The Guns 1939-45.* New York, New York: Ballantine Books Inc., 1970

Holmes, Tony. *Hurricane Aces 1939-40.* Botley, Oxford: Osprey Publishing, 1998

Jane's Fighting Aircraft of World War II. New Jersey: Crescent Books, 1994

Jarrett, Philip ed. *Aircraft of the Second World War.* 33 John Street, London: Putnam Aeronautical Books, 1997

Kaplan, Philip, Currie Jack. *Round the Clock.* New York: Random House Inc, 1993

Lake, Jon. *Halifax Squadrons of World War 2.* Botley, Oxford: Osprey Publishing, 1999

March, Daniel, J. *British Warplanes of World War II.* London, England: Aerospace Publishing Ltd, 1998

Middlebrook, Martin, and Chris Everitt. *The Bomber Command War Diaries.* Wrights Lane, London: Penguin Books Ltd, 1990

Murray, Williamson. *The Luftwaffe, 1933-45 Strategy for Defeat.* Washington D.C., Brassey's, 1989

O'Leary, Michael. *VIII Fighter Command at War 'Long Reach'.* Botley, Oxford: Osprey Publishing, 2000

Peden, Murray. *A Thousand Shall Fall.* Toronto: Stoddart Publishing, 1988

Perkins, Paul. *The Lady.* Charlottesville, VA: Howell Press, Inc., 1997

Price, Dr. Alfred. *Aggressors: Patrol Aircraft versus Submarine.* Charlottesville, Virginia: Howell Press

Price, Dr. Alfred. *Luftwaffe Handbook.* New York. Charles Scribner's Sons, 1977

Price, Dr. Alfred. *Spitfire Mark I/II Aces 1939-41.* 81 Fulham Road, London: Osprey Publishing, 1996

Remington, Roger R. *American Modernism Graphic Design, 1920 to 1960.* New Haven, CT: Yale University Press, 2003

Sakaida, Henry. *Imperial Japanese Navy Aces 1937-45.* 81 Fulham Road, London: Osprey Publishing, 1998

Scutts, Jerry. *German Night Fighter Aces of World War 2.* Botley, Oxford: Osprey Publishing, 1998

The Official World War II Guide to the Army Air Forces. New York, New York: Bonanza Books, 1988

Weal, John. *Bf 109F/G/K Aces of the Western Front.* Botley, Oxford: Osprey Publishing, 1999

Periodicals

Buttler, Tony. "Database de Havilland Mosquito." *Aeroplane.* November 2000

Eleazer, Wayne. "Supercharged." *Airpower.* November 2001

Hall, Tim. "Cutaway Kings Peter Endsleigh Castle." *Aeroplane.* November 1999

Hall, Tim. "Cutaway Kings Roy Cross." *Aeroplane.* September 2000

Mitchell, Fraser-Harry. "Database Handley Page Halifax." *Aeroplane.* May 2003

Price, Dr. Alfred. "The First Cruise Missile." *Aeroplane.* March 2001

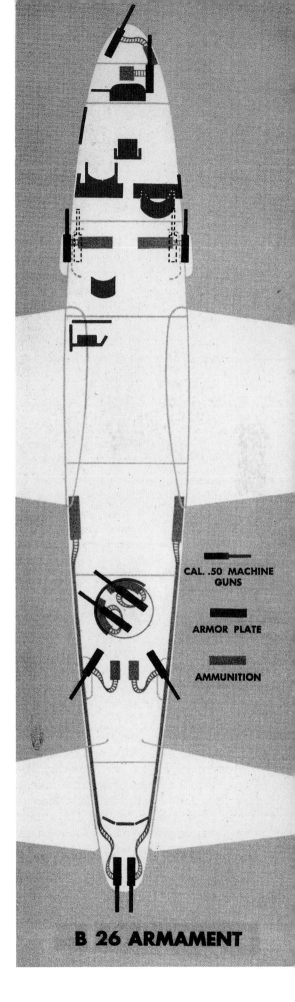

CAL. .50 MACHINE GUNS

ARMOR PLATE

AMMUNITION

B 26 ARMAMENT

Public Records

Air Crew Training Bulletin No. 19, August 1944

Air Crew Training Bulletin No. 22, February 1945

Air Defence Pamphlet Number Eight, "Barrage Balloons," November 1942

Air Technical Intelligence Group Advanced Echelon Far East Air Forces, Tokyo Japan. *Flying Safety in the Japanese Air Forces. Report No. 251* December 15, 1945

Japanese Aircraft Carrier Operations Part I. Air Technical Intelligence Group No. 1 October 4&5 1945

The National Archives, Washington, D.C.

Photo Credits

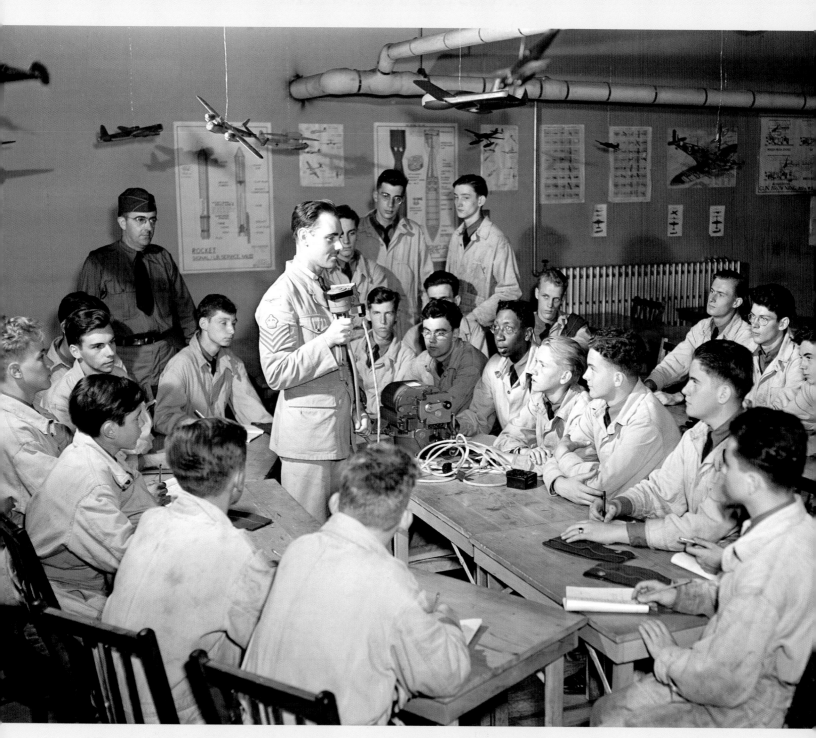

U.S. cadets in Canada. With a backdrop of air diagrams, various cutaway drawings and posters and aircraft recognition models hanging from the ceiling, these eager students are learning the fine art of aerial photography. September 1942.

Index